DIVE GUI
The
PHILIPPINES

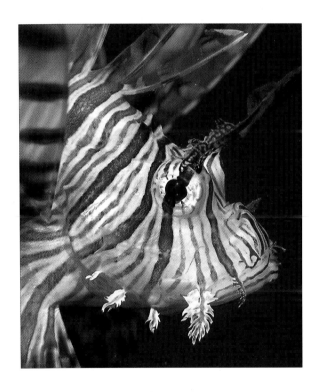

JACK JACKSON

Series Consultant: Nick Hanna

**NEW
HOLLAND**

Diving legend Jack Jackson is the author of 18 books and hundreds of magazine articles. His other titles have included *Dive Guide to Malaysia* and New Holland's award-winning *Top Dive Sites of the World*, for which he acted as principal consultant. He is a fellow of the Royal Photographic Society in underwater photography.

This third edition published in 2006 by
New Holland Publishers (UK) Ltd
London • Cape Town • Sydney • Auckland
www.newhollandpublishers.com

Garfield House	80 McKenzie Street	14 Aquatic Drive	218 Lake Road
86–88 Edgware Road	Cape Town 8001	Frenchs Forest, NSW 2086	Northcote, Auckland
London W2 2EA, UK	South Africa	Australia	New Zealand

10 9 8 7 6 5 4 3 2 1

ISBN 10: 1 84537 629 3
ISBN 13: 978 1 84537 629 1

Publishing manager: Jo Hemmings
Series editor: Pete Duncan
Editors: Charlotte Fox, Paul Barnett
Assistant editor: Kate Parker
Design concept: Philip Mann, ACE Ltd
Design/cartography: ML Design, William Smuts
Production: Joan Woodroffe

Reproduction by Unifoto, Cape Town
Printed and bound in Malaysia by Times Offset (M)) Sdn Bhd

Photographic Acknowledgements
All photographs by Jack Jackson with the exception of the following:
Gary Bell 163 (Pipefish), Abbie Enock 8, 9, 28, 75, 115; Footprints 21, 161 (Blenny);
J.J./A. Rafiq 52; Bill Wood 162 (Goby)

Front cover: *Schooling (Pennant) Bannerfish over Basterra Reef.*
Spine: *Brightly coloured gorgonian sea whip.*
Back cover top: *The author on a live-aboard dive boat.*
Back cover bottom: *Cove on Coron Island.*
Title page: *Close-up of a beautiful but deadly lionfish.*
Contents page: *Vivid red gorgonian sea fan, Basterra Reef.*

AUTHOR'S ACKNOWLEDGEMENTS
Writing a guide book of this nature requires the help and goodwill of local experts, dive operators and divemasters, who contribute their time and knowledge. Of the many people who helped me with my diving and research for this edition in the Philippines, I would like to give special thanks and appreciation to:

- Eduardo Jarque Jr, European Regional Director of the Philippines Department of Tourism, for his help with the project
- Singapore Airlines, for transporting me to the Philippines with all my diving equipment and underwater cameras
- Tony Wood and Ernie Long of Whitetip Divers, who performed amazing feats of organization and communication that enabled me to spend the maximum time on diving research but still meet most of the diving operators
- The Citystate Tower Hotel for accommodation in Manila
- Cesar G. Jalosjos and Rhoel D. Hamoy of Dakak Aqua Sports and MV *Svetlana* for the diving at Dapitan Bay and from Zamboanga to the Jolo group of islands in the Sulu Archipelago
- Pearl Farm Beach Resort and Jojo Tinitigan for the diving at Samal Island
- Albert Y. Pingoy, Jeffrey M. Ramos, Jacinto (Boyboy) E. Napalit Jr. and Yoyong Salucot of Whitetip Divers Davao-Socsksargen for further diving in the Gulf of Davao and together with local expert Chris Dearne of the Cambridge Farm Hotel for accommodation and the diving in Sarangani Bay off General Santos City
- Alan Nash, Andy Norman and Tommy Soderstrom, of Asia Divers, for accommodation, hospitality and a *banca* that enabled me to meet all the operators around Puerto Galera
- Rick Kirkham for the new dive sites at Puerto Galera
- Ito Tuason and Michael R. Buhian for the diving at Club Noah Isabelle
- Jim Goll and Noynoy S. Alonzo of Sea Dive PADI Resort for a private safari covering the diving off Coron
- Jurgen Warnke, Dirk Fahrenbach, Rolf Winkelhausen and Eric Laurel of Club Paradise/Maricaban Bay Marina Resort and Philippine Divers for the diving there
- Karl (Kalle) H. Epp, Margit Botta and Lindy Stewart of Savedra–Great White for the diving at 'Airport' dive site and accommodation that enabled me to meet all the operators at Panagsama Beach, Moalboal
- Larry B. Montenegro and Blessie Alano of Liloan Beach resort for a private safari covering the diving at Santander, Sumilon Island, Siquijor Island, and together with Paul Rhodes and Alvin Pascobello, Apo Island
- Alona Tropical Beach Resort/Sea Explorers for accommodation that enabled me to visit all the operators at Alona Beach, Bohol
- Giso Stuhldreher of Genesis Divers for a private safari that with René Gutsche covered the diving at Camiguin Island and with Guenter Grumbach and Claas Lindner covered the diving off Southern Leyte
- David Jackson of Davliz Travelodge Hotel Resort for accommodation at Southern Leyte

PUBLISHERS' ACKNOWLEDGEMENTS
The publishers gratefully acknowledge the generous assistance during the compilation of this book of Nick Hanna, for his involvement in developing the series and consulting throughout, and Dr Elizabeth M. Wood for acting as Marine Consultant and contributing to *The Marine Environment*.

PHOTOGRAPHY
The author's photographs were taken using Nikonos III, Nikonos V, Nikon F-801s and Nikon F-90 cameras. The Nikonos cameras were used with 15mm and 28mm Underwater Nikkor lenses. The Nikon F-801s and F90 cameras were housed in either of two waterproof aluminium housings and used with 14mm, 24mm, 55mm macro and 105mm macro lenses. Both of these housings were manufactured by the Austrian company Subal.

All the photographs were taken with the addition of electronic flash to replace the colour filtered out by the water. A SEA and SEA 300TTL Strobe was used with the Nikonos III and either a Nikon SB-24 Speedlight in a Subal housing or a Hugyfot/Subtronic Hugystrobe HST300 Professional was used with the other cameras. The film stock used was Fujichrome Velvia and Fujichrome RDP.

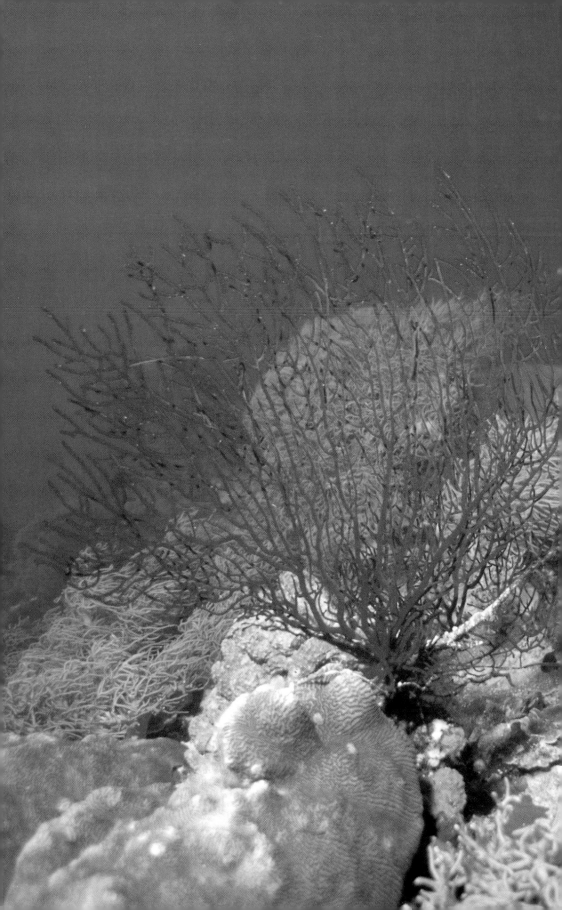

CONTENTS

How to Use this Book

THE REGIONS
The dive sites included in this book are arranged within five main regions: Luzon, Mindoro, Palawan, the Visayas and Mindanao. Regional introductions describe the key characteristics and features of each region covered in the book.

THE SUB-REGIONS
The larger geographical regions are divided into smaller sub-regions, usually ordered from northwest to southeast. Sub-regional introductions provide background information on climate, the environment, points of interest, and advantages and disadvantages of diving in the locality.

THE MAPS
A map is included near the front of each regional or subregional section. The prime purpose of the maps is to identify the location of the dive sites described and to provide other useful information for divers and snorkellers. Though reefs are indicated, the maps do not set out to provide detailed nautical information such as exact reef contours or water depths. In general the maps show: the locations of the dive sites, indicated by white numbers in red boxes corresponding to those placed at the start of the individual dive site descriptions; the locations of key access points to the sites (ports, marinas, beach resorts and so on); reefs, wrecks and lighthouses and travel information.

MAP LEGEND

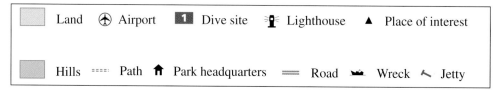

Land ✈ Airport **1** Dive site ⚲ Lighthouse ▲ Place of interest

Hills ⠿ Path ♠ Park headquarters ═ Road ⚓ Wreck ⚓ Jetty

THE DIVE SITE DESCRIPTIONS
Within the geographical sections are descriptions of the premier dive sites in that region. Each site description starts with a number, a star rating and a selection of symbols indicating key information. Crucial practical details (on location, access, conditions, and average and maximum depths) precede the description of the site, its marine life and special points of interest.

THE STAR RATING SYSTEM

Each site has been awarded a star rating, with a maximum of five red stars for diving and five blue stars for snorkelling.

Diving

★★★★★ **first class**
★★★★ **highly recommended**
★★★ **good**
★★ **average**
★ **poor**

Snorkelling

★★★★★ **first class**
★★★★ **highly recommended**
★★★ **good**
★★ **average**
★ **poor**

THE SYMBOLS

 Can be done by diving (applies to all sites except those that are good purely for snorkelling)

Can be reached by swimming from the nearest shore (even if in order to get to the shore, you need to take a boat)

Can be reached by local boat

Can be done by snorkelling

Can be reached by live-aboard boat

Suitable for all levels of diver

THE REGIONAL DIRECTORIES

A 'regional' directory', which will help you plan and make the most of your trip, is included at the end of each regional or sub-regional section. Here you will find, where relevant, practical information on how to get to an area, where to stay and eat, dive facilities, film processing and hospitals. Local 'non-diving' highlights are also described, with suggestions for sightseeing and excursions.

OTHER FEATURES

At the start of the book you will find practical details and tips about travelling to and in the Philippines, as well as a general introduction to the country itself. Also provided is a wealth of information about the general principles and conditions of diving in the area, together with advice on learning to dive and snorkel. Throughout the book, double-page features and small fact panels on topics of interest to divers and snorkellers are included. As the end of the book are sections on the marine environment (including coverage of marine life, conservation and codes of practice) and underwater photography and video. Also to be found here is information on health, safety and first aid.

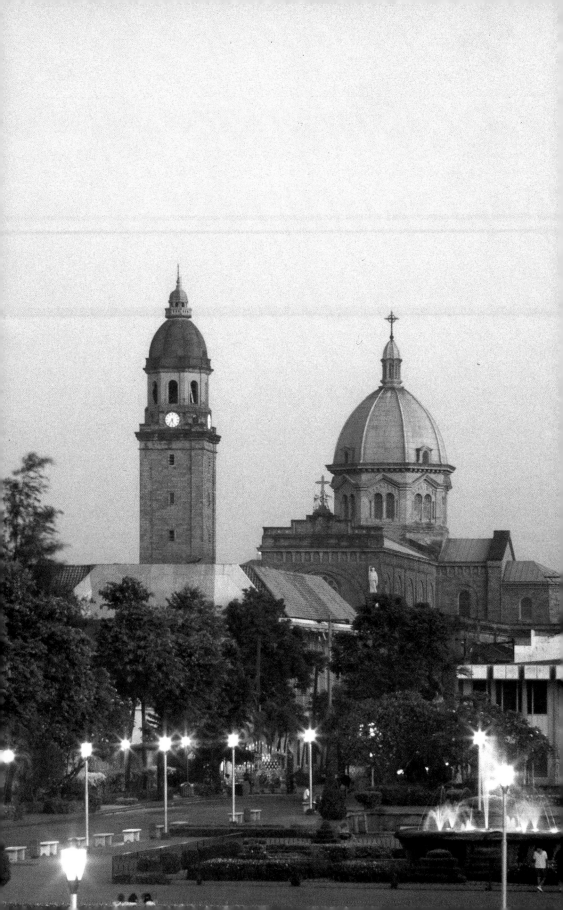

INTRODUCTION
TO THE
PHILIPPINES

The Republic of the Philippines is an archipelago of 7107 tropical islands and islets set in deep blue waters that contain some of the richest marine-life systems on earth. It is the second largest archipelago in the world after Indonesia, though more compact – so inter-island travel is easy.

The islands stretch nearly 1850km (1150 miles) in a narrow north–south configuration and span 1100km (680 miles) east to west. Only 2000 are inhabited, and no more than about 500 are larger than 1km² (0.39 sq miles); 2500 of them are not even named. Their strategic position separating the South China Sea and the Pacific Ocean, with the Celebes Sea to the south, is reflected in their history as a regional trading centre, battleground and cultural meeting point. Their neighbours are Taiwan to the north, Borneo to the southwest, Indonesia to the south, Vietnam to the west and the Belau (Palau) group to the east. Off the eastern shores lies the Philippines Trench, one of the world's deepest points, reaching 10,500m (34,450ft) below sea level.

With so many islands the irregular, rugged coastline extends 35,000km (21,700 miles), with numerous natural harbours, white sandy beaches and 34,000 km² (13,124 sq miles) of coral reefs. Inland, the country can be rugged, with mountains, lush forests, caves and water-falls. There are 37 volcanoes, 17 of which are classed as active.

The islands can be divided conveniently into four groups. **Luzon**, the largest and most northern island, contains 55% of the 61 million population and the capital, Manila. The nearby islands of Mindoro and Marinduque, to the south, are normally included with Luzon. The **Visayas** are a closely packed island group between Luzon and Mindanao, the largest being Bohol, Cebu, Leyte, Masbate, Negros, Panay and Samar. Cebu is the central island of the group, with Cebu City being the shipping hub for all the Philippines. **Mindanao** is the large island to the south and, to the west, the long narrow strip of **Palawan** is part of 1700 islands that make up Palawan Province.

The country is divided into 14 regions – including the National Capital Region (or Metro Manila) and the Cordillera Autonomous Region – 73 provinces and 60 cities. The economy

Opposite: *Manila, the capital, is the starting point for most visitors to the Philippines.*
Above: *Puerto Azul, a beautiful resort typical of those found in the area.*

is based on light industry and agriculture, the chief products being rice, maize, coconut, pineapple and sugar. Naturally, being surrounded by so much water, a large proportion of the population relies on the sea for food. The land is rich in cobalt, copper, gold, iron, nickel and silver deposits. The textile, clothing and home-appliance industries are well developed, and those of aquaculture and micro-circuits are expanding fast.

After the excesses of the Marcos years, the administration under presidents Cory Aquino and Fidel Ramos produced an era of stability, industrialization and economic growth that attracted foreign investors. This has continued under President Joseph Estrada. As well as industry, tourism has increased, 40% of tourists being Japanese.

HISTORY

The early Negrito/Malay/Polynesian inhabitants of the Philippines were little disturbed until a thousand years ago, when Arab, Chinese, Indian and Indonesian traders arrived. Islam was introduced in the 14th century, sweeping across the southern islands.

> **THE FLYING SPORTSMAN CARD**
>
> Scuba divers with a valid 'C'-card can, on presentation of a valid Flying Sportsman Card, obtain an extra 30kg (66 pounds) baggage allowance over the normal checked allowance on Philippines Airlines domestic flights. These cards, valid for two years, can be obtained from any PAL sales/ticket office in the Philippines, though it is best to apply in Manila. Two 2.5cm x 2.5cm (1in x 1in) identity photographs and a photocopy of your 'C'-card are required. A processing fee is charged both for the issue of a new card and for the renewal of an old one.
>
> My own experience was that the card took two weeks to be issued, but during that time the airline, on all domestic flights, accepted the receipt instead.

In 1521 AD the Portuguese explorer Ferdinand Magellan, in the service of Spain, landed on Homonhon, an uninhabited island to the south of Samar. He soon moved on to the flourishing trading port of Zebu (Cebu), converting the local people to Christianity and claiming the land for Spain. Later expeditions were conducted in the name of King Philip II of Spain, who named the country Pilipinas, and permanent Spanish colonial occupation began in 1565. From 1565 until Mexican independence in 1821 the Philippines was administered by the Viceroy of New Spain (Mexico). After 1821 Spain ruled directly. Spanish hopes of finding a fortune in spices and gold were soon disappointed and they had to make many costly military operations to put down internal uprisings. The lack of development caused the Philippines to be a burden on the Mexican treasury until 1782, when the profitable tobacco crop was introduced to northern Luzon.

Up to 1815, the main Spanish economic activity was the galleon trade between Manila and Acapulco. The Spanish were harassed by the Portuguese and the Dutch, and later the British, who took brief custody of Manila in 1762-4, as a result of the Seven Years' War in Europe.

Throughout the Spanish occupation, small rebellions were common, but all were ruthlessly put down. However, Spain's defeat by the British in 1762 persuaded the Filipinos that their oppressors were not invincible. The first major revolt occurred in Cavite in 1872. It was soon put down, but the execution of three Filipino priests awakened a national consciousness.

In 1892 several secret societies were organized to act against the Spanish authorities. Foremost amongst these was the Philippines League, founded in 1891 by José Rizal, and the more radical Katipunan ('Highest and Most Respectable Association of the Sons of the People'). The Spanish discovered what was happening in August 1896 and the insurrectionists began armed hostilities. Although José Rizal was executed in December 1896, the rebel force, under Emilio Aguinaldo, was initially successful, but reinforcements from Spain won the day and in August 1897 Aguinaldo and the Spanish Governor-General signed a pact guaranteeing Spanish reform within three years. However, domestic events were overshad-

owed by the Spanish-American war. In 1898 war between Spain and the USA ended in victory for the latter, and the Filipinos hoped to profit by winning independence after 327 years of Spanish rule; but the USA bought the colony from Spain and ruled until 1942, when the Japanese occupied the islands. The Allies retook the islands in 1945 and the US took control once more until full independence was achieved in July 1946.

THE PEOPLE

The Philippines' most outstanding feature is its people, a mixture of Malay, Chinese, Spanish and American. Filipinos have been described as having emerged from 350 years in a convent and 50 years in Hollywood! They are a fascinating blend of east and west, with ancient and modern ways, and a spontaneous love of pleasure. They comprise 111 cultural and linguistic groups; the dominant religion is Catholicism, with a significant number of Protestants and Muslims.

The Philippines is the world's third-largest English-speaking country, after the USA and the UK. Pilipino, a form of Tagalog, is the national language, but English is used for commercial and legal transactions. The literacy rate is high, at 88%.

Some six million Filipinos make up **cultural minority groups**, though this number includes four million Muslims. About 25,000 are Negritos, dark-skinned people, probably the original Filipinos, and the rest are individual tribal groupings of Malay/Polynesian origin. They tend to live in their own culture, in remote areas, rather than mixing in with modern Filipino society.

The tribes most likely to be encountered by divers are the Bajau, Ifugao, Mangyan and Yakan. The **Bajau Sea Gypsies** live in the Sulu Archipelago, in the south of the Philippines, and also across in Borneo and Indonesia. Most of them have given up the gypsy life, living either on their small boats (*lipas*) or in stilt houses over the water, though often on very remote islands and sandbanks. They survive mainly from fishing, but some of them gather sea cucumbers for Chinese restaurants and others cultivate seaweed, which is exported to Japan. The **Ifugao** tribe live in the mountains of northern Luzon, where they are responsible for the beautiful Banaue rice terraces. Some of the older ones still dress in their traditional red costume while others merely wear it to pose for tourist cameras. More than 50,000 members of the **Mangyan** tribe still live in Mindoro. Most of them have retreated into the mountainous interior, but there are some villages near Puerto Galera that divers can arrange to visit. The **Yakan** are Muslims who mainly inhabit Basilan Island, south of Zamboanga (on Mindanao), though some of them have settled near Zamboanga itself. Mostly living by agriculture and cattle breeding, they are famous for their weaving.

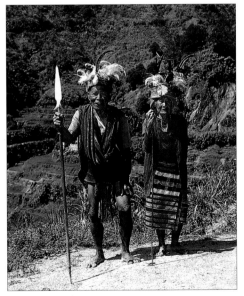

Ifugao tribesman and woman at Banaue, North Luzon. These mountain people are famous for building magnificent rice terraces.

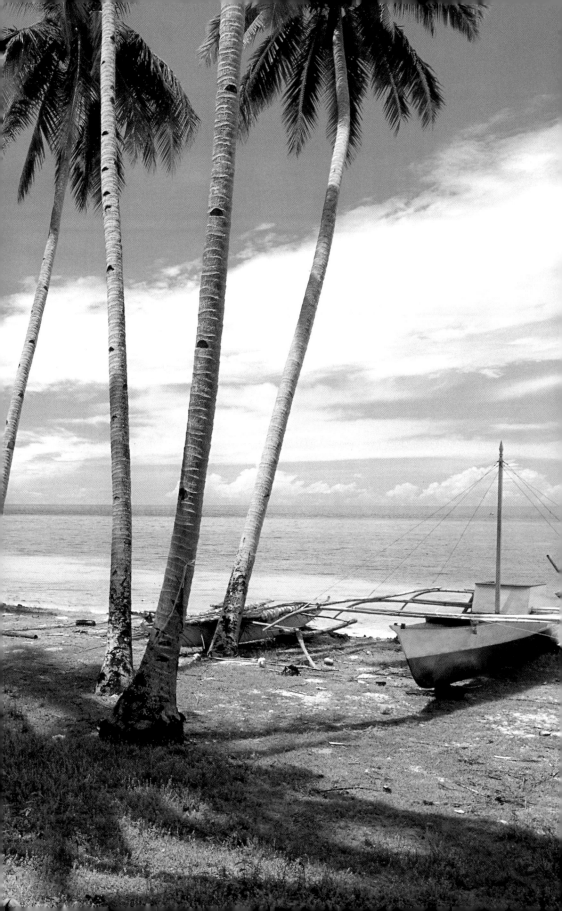

TRAVELLING TO AND IN THE PHILIPPINES

Most of the world's major international airlines operate services to the Philippines' main airport – Ninoy Aquino International Airport (NAIA) in Metro Manila. The best connections are with Singapore Airlines who fly to Manila and Cebu daily via Singapore. Other popular carriers from Europe are Malaysia Airlines and Royal Brunei Airlines. Philippine Airlines (PAL) itself has a severely restricted service and does not currently fly from Europe. Mactan International Airport, in Cebu, is also served by direct flights from Japan, Singapore and Hong Kong. Most ports in the Philippines can be reached by sea, but there are no official international passenger routes. If you do arrive by sea you will require an outbound air ticket before you will be allowed entry.

ENTRY FORMALITIES

Citizens of China, India and socialist countries require a visa before being allowed entry into the Philippines. Citizens of other countries will be given a 21-day visa upon arrival, so long as they have a current passport and an onward or return air ticket. If you intend to stay longer than 21 days but less than 59 days you may obtain a multiple-entry 59-day visa from your nearest Philippines Consulate, prior to arrival. Visas can be extended within the country for a fee, the length of stay being up to the discretion of the immigration personnel.

Customs

Items for personal use are not a problem. Duty-free allowances are 400 cigarettes, 100 cigars or 500g (18oz) of tobacco and two bottles of alcohol of not more than one litre each. Prohibited items include weapons, ammunition, explosives, obscene material and gambling equipment. Foreign currency in excess of US$3000 must be declared on entry, and it is wise to keep all certificates of currency exchange until you leave. In theory you can reconvert pesos to hard currency at the airport before you leave, but the banks may be closed. Up to 500 pesos may be exported, but they have no value outside the Philippines. It is best to spend any excess of local currency.

Opposite: *Alona Beach, Panglao Island, Bohol, where there is excellent snorkelling.*
Above: *Passengers disembarking at Caticlan on Panay Island.*

HEALTH

The Philippines is a clean country, but you should exercise caution in remote areas. Tap water is safe to drink in towns and large resorts, but may not be so in smaller resorts and may be too salty to drink in others. Bottled drinks are always available, though carbonated drinks and beer are often cheaper than mineral water. Freshly cooked food and peeled fruit are safe to eat. Food cooked fresh in front of you at roadside stalls and small restaurants can be safer to eat than the food in luxury hotels, where it is often cooked earlier and then reheated. Power cuts may cause refrigeration to be irregular.

Malaria is a problem only in parts of Palawan and remote Mindoro and Mindanao. Some of the strains of malaria in Southeast Asia are now immune to prophylactics, but taking these will still be helpful. Remember to start taking the tablets two weeks before your trip and to continue for six weeks after your return. Dengue fever, like malaria carried by mosquitoes, can also occur. Insect repellent and mosquito nets should be used where necessary. AIDS is a growing problem, but not on the same scale as in some other parts of Southeast Asia.

Hospital standards are variable. Those in major cities and private clinics are generally better than those in outer areas, but even so they are not very good: repatriation would be wise in the case of an emergency. Certainly all the richer locals go abroad for any significant hospital treatment. Foreigners can usually buy prescription drugs over the counter in pharmacies, but these may not have had refrigerated storage. Do not forget the strength of the sun on a white beach.

VACCINATIONS
A certificate of vaccination against yellow fever is necessary for visitors travelling to the Philippines from endemic areas. As with visiting any other Third World country, it is wise to be immunized in advance against the following: Hepatitis A Tetanus Typhoid Polio Meningitis The newest Cholera.

TIME
The local time in The Philippines is GMT plus 8hrs.

MONEY

The unit of Philippines currency is the peso, which is divided into 100 centavos.

Most credit cards are widely accepted; credit-card fraud does exist, as in any other country. Travellers' cheques are also widely accepted, with most hotels and exchange offices requesting to see the certificate of issue from your bank. The larger cities have a remarkable number of legal money changers, often streets full of them, but you may have to ask around for one that changes travellers' cheques. Remarkably, the bigger hotels give a better exchange rate for travellers' cheques than many exchange offices on the street. It can be difficult to change travellers' cheques in many diving areas, even in Boracay, Puerto Galera, Moalboal and Bohol; but cash dollars will always be accepted.

The US dollar is the most accepted foreign currency to carry in remote places, but most hard currencies will be accepted in the cities and larger hotels. There is no real black market, so avoid anyone who approaches you in the street.

ELECTRICITY

The electricity supply is mostly 220 volts, 60 cycles, though the actual voltage is often much less, particularly in the provinces. Brownouts and blackouts are much less of a problem than in the past, but unplug any appliances during power cuts or periods of low voltage, as there may be heavy surges when the electricity returns to normal. A major problem is that most of the plugs and sockets are of the standard US two- or three-flat-pin type, normally used for 110 volts. To make matters worse, there are some 110-volt supplies using plugs and sockets

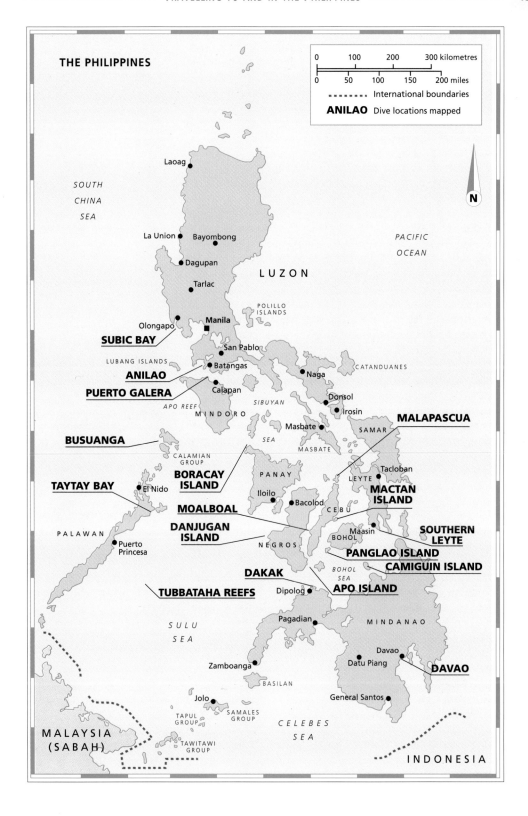

of the Continental European two-round-pin type normally associated with 220 volts! Where three-flat-pins are used, the earth pin is not interlocked as in Europe, so two-pin plugs can still be inserted.

Many larger hotels now have a system where a plastic rectangle that is permanently attached to the room key, or is the room key itself, must be inserted into a slot in your room for the electricity to be switched on. This is a nuisance if you wish to charge batteries or keep the air-conditioning on while you are out. Many of these systems can be kept switched on by inserting a piece of stiff cardboard or plastic into the slot.

COMMUNICATIONS

Communications have improved recently in the Philippines. Most areas now have cellular telephones and there are more overland telephone lines than before; many diving operators have their own e-mail address, access to an internet café or to someone else with e-mail. However, telephone access is not always reliable, and some operators choose to have their web sites based in America or Europe.

There remain other difficulties. A few areas do not yet have telephone connections while, in others, the communications can be interrupted by power failures. Some of the larger resort hotels have set up their own satellite communications systems, but this does not mean that they will answer your enquiries. A notorious problem in the Philippines is that, if you do not manage to get through to a decision-making person when you call, the staff you actually speak to are likely not to pass on your message. However, some of the best diving is in areas with poor communications.

ACCOMMODATION

Accommodation has improved over recent years, as cheaper establishments continue to be knocked down and replaced by new facilities. There is a range of accommodation to suit all tastes, from the very basic to relatively upmarket establishments. Suggestions for where to stay are given in the Regional Directory at the end of each regional section.

FESTIVALS

January: 1, New Year's Day; 1st Sunday, Three Kings; 2nd Tuesday, Black Nazarene, Manila; 3rd weekend, Ati-Atihan, Boracay; Sto Niño de Cebu; 4th weekend, Dinagyang, Iloilo.

February: 1–3, Feast of Our Lady of Candles; 11, Feast of Our Lady of Lourdes, Quezon City.

March/April: movable, Holy Week; Friday before Palm Sunday, Feast of the Virgin de Turumba; Palm Sunday; Holy Monday; Maundy Thursday; Good Friday; Easter Sunday.

May: whole month, Santacruzan; 6, pilgrimages to Corregidor; 15, Pahiyas .

June: 22–25, Halaran Festival; 24, Manila Day; Feast of St John the Baptist.

October: 3, Feast of Our Lady of Solitude; 2nd Sunday, La Naval de Manila.

November: 1, All Saints' Day.

December: 1 Dec–2 Jan, Christmas; 8, Feast of Our Lady of Immaculate Conception; 8–9, Feast of Our Lady of Caysasay; 16–25, Misas de Gallo; 24, Christmas Eve; Last Sunday, Bota de Flores; 28, Holy Innocents' Day; 30, José Rizal Day; 31, New Year's Eve.

Islamic Festivals: different holidays and feasts are celebrated in the Islamic areas of the Philippines. These follow a lunar calendar and thus fall 11 days earlier each year. They include Muslim New Year; The Prophet Mohammed's Birthday; Ramadan; Eid-al-Fitr; Eid-al-Hajj.

Opposite: *Dive boats at the beach on Balicasag Island. The island has some of the best diving in the Philippines.*

FIESTAS

The Philippines is a country of fiestas, during which everything else stops. If one occurs during your visit there is no point in getting uptight about time lost – it is better to join in the fun. Fiestas celebrate harvests, births and victories, as well as religious events. Like all modern religions, the Catholicism of the Spanish was overlaid on existing practices, with events taking place on dates formerly associated with Animistic rituals. Celebrations are found in every ethnic group and may be large regional events, or small local happenings. Activities centre on the church, from where they proceed into the community.

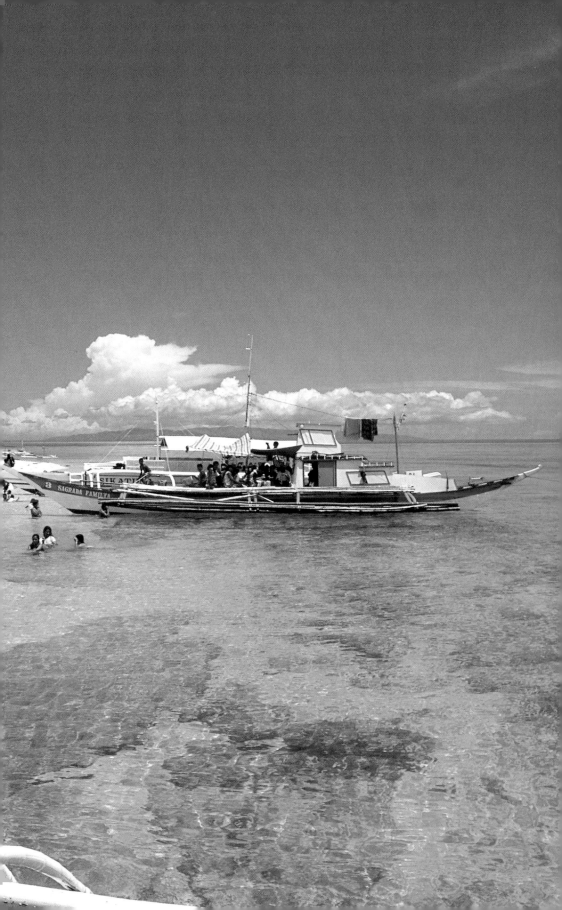

GETTING AROUND

By air: By western standards, domestic flights are cheap and are the best way to cover long distances, or to travel between islands. However, in recent years air transportation has deteriorated, with Philippine Airlines (PAL) cutting back on routes. PAL still flies several times a day to major destinations, once or twice a week to smaller ones. Now that they are privatized they may rationalize flights to less busy areas. For example, Kalibo (for Boracay) will have several flights a day from Manila, but in the low season some of these may be cancelled to fill a later flight. All PAL flights give the standard 20kg (44lb) checked baggage allowance; with a 'Flying Sportsman Card' you can take 30kg (66lb) extra.

Recent times have been hard for smaller airlines. A number still run regularly, some flying STOL (Short Take-Off and Landing) aircraft to small airstrips. If the aircraft is not a jet the limit is 10kg (22lb) checked baggage. Most planes cannot use dirt airstrips after heavy rain.

Some up-market resorts have agreements with carriers for their own destinations; prices are accordingly higher, but you have priority if the flight is overbooked.

There are two domestic terminals at Manila Airport, so make sure that you use the right one depending on your intended carrier. Departure tax on international flights is US$14 and on domestic flights 100 Pesos, paid at separate counters after check-in.

By land: It is cheaper to travel by bus and boat, but it can be tiring and, in some areas, dusty. There are air-conditioned buses between all larger destinations. Roads can be bad after typhoons and earthquakes. For shorter journeys, and in cities, you have a choice between jeepneys plying fixed routes, taxis or motorized tricycles.

The ubiquitous jeepney – 'folk art on wheels' – started life as a vehicle cobbled together from second-hand jeep parts left behind by the Allied Forces at the end of World War II. If you are not carrying much luggage, jeepneys or tricycles can be fun, though on dirt roads you can get very dusty. In some areas you may have to use a jeepney for a couple of hours, with your baggage on the roof, so keep a smaller bag inside for film or anything else that can be damaged by sun, dust or rain. There can be a problem with pickpockets in major cities, but rarely in remote areas. Tricycles (pedal or motorized) may be the only transport in some places.

Taxis are a problem in most parts of the world, and they are no better or worse here. Bigger hotels and airports have modern air-conditioned taxis. These cost three times the normal price, but for that you are getting a comfortable ride, no hassle and a knowledgeable driver. Once you know what the correct going rate should be, you can pick up passing taxis at the roadside that may, or may not, have air-conditioning, proper door-locks and dubious suspension, brakes and engine. You barter a price before you get in, but the driver may stop en route and insist on more money. If you have luggage, make sure you get it out of the taxi before you pay the fare. If there are plenty of taxis around, you can take your pick, but late at night you may not have much choice. Meters never mean anything in taxis.

Some up-market resorts have their own courtesy bus or car service from local airports. If you are booked ahead, ignore taxi drivers who pester you, insisting that such a service does not exist, until you have thoroughly checked things out, particularly at Cebu Airport.

By sea: Inter-island ferry services have improved immensely with the introduction of modern high-speed, air-conditioned super-catamarans, which operate efficiently and have short turnaround times. These are an ideal way of travelling between islands for divers, as there is no worry about flying after diving. Cheaper ferries by contrast tend to be crowded, with poor food and poor toilets. However, if you have plenty of time, no luggage and are away from the main tourist routes, there will always be a boat or *banca* that will take you to the next island.

Major shipping lines advertise in newspapers and will have ticket offices in the cities and/or at the quay. Smaller operators will sell tickets and just take cash, on the quay or on the boat. When using *bancas*, expect to get wet on the crossing.

TOURIST OFFICES

Department of Tourism website: http://www.dotpcvc.gov.ph

Manila Head Offices

Department of Tourism, DOT Building, Agrifina Circle, Rizal Park, Metro Manila; tel +63-2-5267545/fax +63-2-5231929; e-mail: webmaster@wowphilippines.com.ph; website: www.wowphilippines.com.ph

Philippine Convention & Visitors Corporation, 4th Floor, Suite 10-17, Legaspi Towers, 300 Roxas Boulevard, PO Box EA-459, Manila; tel +63-2-5259318/fax +63-2-5216165, e-mail: pcvnet@mnl.sequel.net

Domestic Tourist Information Centres

CORDILLERA ADMINISTRATIVE REGION

DOT Complex, Gov. Pack Road, Baguio City 2600; tel 074-4427014/fax 074-4428848

Regional Office No I, Oasis Country Resort, National Highway, Bgy. Sevilla, San Fernando, La Union 2500; tel 72-8882411/fax 72-8882098; e-mail: dotregion1@pldtdsl.net

Regional Office No II, Second Floor Tuguegarao Supermarket , Tuguegarao, Cagayan 3500; tel/fax 078-8441621; e-mail: dotr02@yahoo.com; website: www.dotregion2.com

Regional Office No III, Paskuhan Village Complex, San Fernando, Pampanga 2000; tel 045-9612665/fax 045-9612612, e-mail: dot3@wowluzoncentral.com; website: www.wowluzoncentral.com

National Capital Region & Regional Office No IV, Room 208, DOT Building, T. M. Kalaw Street, Ermita, Manila 1000; tel 32-5241969/fax 32-5267656; e-mail: dot4@visitsoutherntaga-log.com; website: www.visitsoutherntagalog.com

Regional Office No V, Regional Center Site, Rawis, Legazpi City 4500; tel 52-4820712/fax 52-8205066; e-mail: dotr5@globalink.net.ph; website: http://wowbicol.com

Regional Office No VI, Western Visayas Tourism Center, Capitol Ground, Bonifacio Drive, Iloilo City 5000; tel 033-3375411/fax 033-3350245; e-mail: deptour6@mozcom.com; website: http://corporate.mozcom.com/dot

Regional Office No VII, Ground Floor, LDM Building, Lapu Lapu Street, Cebu City 6000; tel 32-2542811/fax 32-2542711; e-mail: dotr7@cvis.net.ph

Regional Office No VIII, Ground Floor, Foundation Plaza Building, Leyte Park Resort Compound, Magsaysay Boulevard, Tacloban City 6500; tel 53-3212048/fax 53-3255279; e-mail: dotev@skyinet.net

Regional Office No IX, Lantaka Hotel, Valderrosa Street, Zamboanga City 7000; tel 62-9910218/fax 62-9930030; e-mail: dotr9@pldtdsl.net

Regional Office No X, A. Velez Street, Cagayan de Oro City 9000; tel 88-726394/fax 88-723696 c/o PTA; e-mail: dotr10@yahoo.com

Regional Office No XI, Door No 7, Magsaysay Park Complex, Sta. Ana District , Davao City 8000; tel 82-2216955/fax 82-2210070; e-mail: dotr11@philwebinc.com

Regional Office No XII, Second Floor, COMSE Building, Quezon Avenue, Cotabato City 9600; tel 64-4211110/fax 64-4217868; email: dot12@mozcom.com

Regional Office No XIII, No. 174 km. 2, J. C. Avenue, Butuan City 8600; tel 85-2255712/fax 85-3416371; email: dot13@yahoo.com

Bacolod Field Office, Bacolod Plaza, Bacolod City 6100; tel 34-29021/fax 34-4332853

Boracay Field Office, Balabag, Boracay, Malay, Aklan 5608; tel 36-5060094/fax 36-2883689; website: www.boracay.com.ph

Overseas Offices

AUSTRALIA: Philippine Department of Tourism, Level 1, Philippine Centre, 27–33 Wentworth Avenue, Sydney, NSW 2000, Australia; tel +61-2-92830711/fax +61-2-92830755, e-mail: pdotsydney@ozemail.com.au

CHINA: Philippine Tourism Office, Embassy of the Philippines, Room 14-01 CITIC Tower A, Beijing, Peoples Republic of China, 10004; tel: +86-10-65128809 (trunk line)/ +86-10-85262330 (direct line)/fax +86-10-85262331; e-mail: dotbei@philembassy-china.org
Philippine Consulate General, Office of the Tourism Representative, 14th Floor, United Centre, 95 Queensway, Admiralty, Hong Kong, China; tel +852-2-8238544/ fax +852-2-866521; e-mail: pdothk@netvigator.com; website: www.wowphilippines.com.hk

GERMANY: Philippine Department of Tourism, Kaiserhofstrasse 15, 60311 Frankfurt am Main 1, Germany; tel +49-69-20893/ fax +49-69-285127, e-mail: phildot-fra@t-online.de

JAPAN: Philippine Embassy, 5-15-5 Roppongi, Minato-Ku, Tokyo, 106-8537, Japan; tel +81-3-55621583/fax +81-3-55621593, e-mail: dotjapan@gol.com
Philippine Tourism Center, 2nd Floor, Dainan Building, 02-19-23 Shinmachi, Nishi-ku, Osaka 500, Japan; tel +81-6-5355071/ fax +81-6-5351235

SINGAPORE: Philippine Tourism Office, 400 Orchard Road, 06-24 Orchard Towers, Singapore 238875; tel +65-7387165/ fax +65-7382604; e-mail: philtours_sin@pacific.net.sg

UK: Embassy of the Philippines, Cultural & Tourism Office, Department of Tourism, 146 Cromwell Road, London SW7 4EF, UK; tel +44-207-8351100/fax +44-207-8351926, e-mail: infotourism@wowphilippines.co.uk; website: www.wowphilippines.co.uk

USA: Philippine Center, 556 Fifth Avenue, New York NY10036; tel +1-212-5757915/fax +1-212-3026758; e-mail: pdotny@aol.com
Philippine Consulate General, Suite 216, 3660 Wilshire Boulevard 900, Los Angeles, CA90010; tel +1-213-4874525/ fax +1-213-3864063; e-mail: pdotla@aol.com

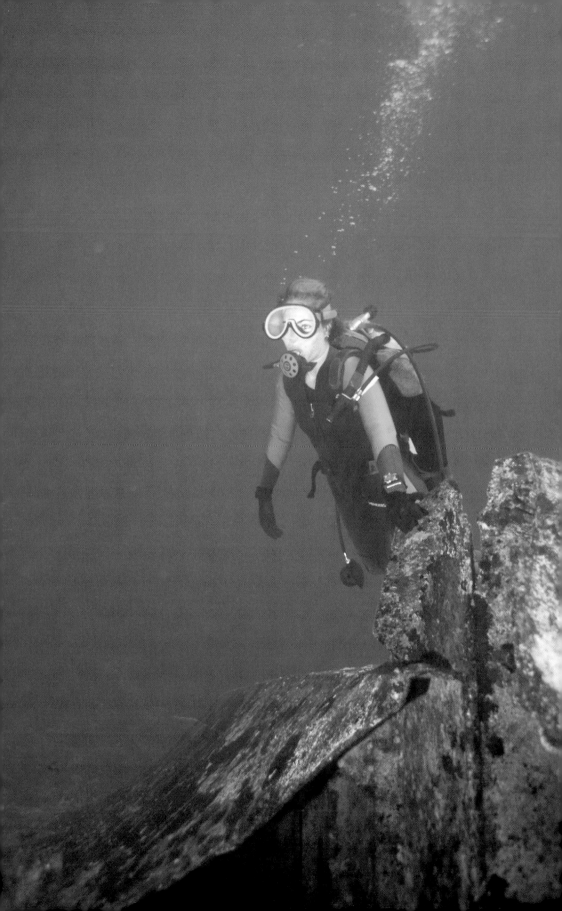

DIVING IN THE PHILIPPINES

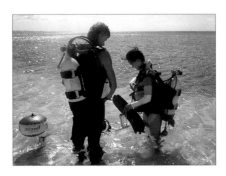

Scientists believe that the triangle formed by the Philippines, Peninsular Malaysia and Papua New Guinea is where most of the Pacific's marine organisms evolved before they spread out to colonize other oceans. This area has the widest variety of marine species in the world.

Twenty years ago the Philippines was considered to be a world-class diving destination, particularly attractive to divers (especially underwater photographers) from the West. Then news got out about blast, cyanide and *muroami* fishing, together with the export of shells and corals (one area even had its Marine Sanctuary status repealed by local politicians) and the international diving world lost interest. Fortunately, things have changed fast.

Since the first edition of this guide, diving in the Philippines has gone from strength to strength. Many local people now understand that protecting the marine environment is more beneficial to them than damaging it by destructive fishing methods or overfishing. Several local communities have designated marine sanctuaries or are restricting fishing areas to allow fish stocks to revive and are actively protecting their own localities against outside fishermen. In some areas commercial pearl, lobster and fish farms even police their domains with armed guards. Most Filipino divers have become conservation conscious, often providing voluntary labour for conservation work. As a result of all this, fishermen are reporting improved catches and those who dive regularly in the Philippines say that they are seeing more fish on each dive.

There was a small amount of coral bleaching on shallow-water stony corals due to the higher-than-normal surface water temperatures associated with the 1998 El Niño–Southern Oscillation phenomenon, but nowhere near as much as occurred in the southern Indian Ocean, and now there are already signs of recovery. The Philippines also hit the headlines when environmentalists noticed the fishing of Whale Sharks for the Taiwanese market. However, this was subsequently banned and Whale Shark watching tours (by boat only) were set up at Donsol in Sorsogon province.

Opposite: *Exploring the wreck of the Tristar B on the Basterra Reef.*
Above: *Preparing for a shore dive.*

The net result is a visible improvement all round. Most reefs around shore-based resorts have not seen any destructive fishing for several years, and though it still occurs in some areas it is on the decrease. The best news is that, in warm waters with strong currents, soft corals and *Acropora* stony corals grow much faster than used to be thought. Many reefs are visibly regenerating, albeit with different species than originally.

New areas have been opened up, there are many more operators and most operators are now both more professional in their outlook and qualified to give instruction to higher standards. The better ones are staffed by enthusiastic divers who have aggressively sought new locations and worked out the local tide tables to ensure that they dive good sites at optimum times. Technical diving has really taken off with some of the best training and opportunities for technical diving in Southeast Asia, including deep reefs, wrecks and underwater cave systems. In fact Puerto Galera was the location for two deep diving world records in 1999, one breathing air and the other breathing Trimix.

In recent years, divers have descended en masse on Malapascua Island, a new sleepy destination just off the tip of Cebu, where a Pelagic Thresher Shark cleaning station had been found at Monad Shoal. The sharks are still there but diver numbers and fishermen have taken their toll so you are less likely to get close to them nowadays. The Thresher Sharks are found all year round and Manta Rays between June and January. There is also muck diving and wrecks, including a Cebu to Manila ferry and Japanese vessels from World War II.

> ### TYPHOONS
>
> The word 'Typhoon' comes from the Cantonese *tai fung* (great wind). Locally called a *baguio*, it is a tropical cyclone in which the surface windspeed exceeds 119km per hour (76 miles).
>
> Typhoons form over warm oceans when several thunderstorms release heat as moisture that condenses to form rain. The centre, or 'eye', is a calm area about 30km (19 miles) in diameter and of very low barometric pressure. Around the eye, cyclonic winds spread over an area up to 1500km (930 miles) in diameter, with the maximum intensity just outside the eye. Winds circling the eye are accompanied by torrential rain and can reach 300km (190 miles) per hour in extreme cases.
>
> In the Philippines the typhoon season is June to November. They are most common north of 15°N and very rare south of 10°N. There is a three-stage warning system in the Philippines. Signal One means a possible typhoon within 72 hours, Signal Two within 48 hours and Signal Three within 36 hours. With 7107 islands in this archipelago, there will always be good, safe diving in the lee of an island somewhere!

Diver photographing staghorn corals (Acropora sp.). With perseverance the results of underwater photography can be spectacular.

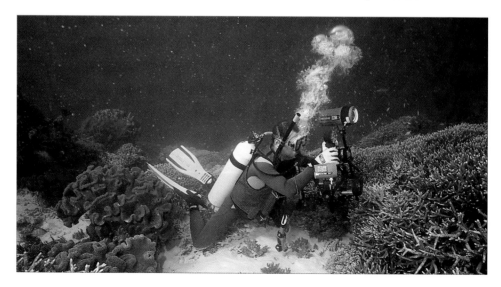

Another type of diving that has become popular with visiting divers is the dive safari. Using larger *bancas* or boats, they are transported to different areas for diving but spend the nights at resorts on land. In this way they dive several areas over a holiday and can also visit local attractions on land.

> ### TIDES
>
> Divers should understand tides so as to be able to pick the best time to dive: neap tides and slack water for wreck diving or photography, spring tides and full flow for more chance of encounters with pelagic species.

DIVING CONDITIONS

The climate of the Philippines is tropical, with an average year-round temperature of 32°C (89°F). There are pronounced seasons – the cooler dry season, which averages 23°C (73°F), from November to February, and the wet season from June to October. These are related to the two monsoon seasons: the northeast monsoon (Amihan) from November to March features strong winds, while the southwest monsoon (Habagat) from June to November, is typified by more gentle and predictable winds that only intensify during typhoons. Typhoons do occur, though these have little effect on the southern half of the country. April and May are reliably calm throughout the archipelago. The area most affected by the weather is the Tubbataha Reefs, which are dived comfortably only from March to the end of June.

Water temperatures vary from 25°C (77°F) in the cooler season to 31°C (88°F), so most divers will be happy to wear a lycra skin or old T-shirt and trousers for protection against coral. Photographers tend not to move around very much and will be glad of a 3–4mm (⅛in) wetsuit, especially if doing more than two dives per day.

Underwater visibility is variable. Mid-oceanic waters can have a visibility up to 100m (110yd), but coastal waters may often be affected by a number of factors, including rain, run-off, decaying organic matter, disturbed bottom sediment, industrial and domestic pollution, landfill, quarrying, volcanic eruptions and plankton blooms. Local mineral deposits and/or mining may affect the colour of the water, a phenomenon that is usually noticed by photographers. Heavy rain can also often set off a plankton bloom, particularly near sites of domestic and agricultural run-off, which nowadays tends to be rich in phosphates.

Visibility will obviously be better over deep water, a rocky bottom or coral bottom. Ebb tides carry sand from beaches and sediment off the top of reefs, so visibility usually improves on a flood tide.

In common with any open-water area, most of the diving sites in the Philippines experience strong currents, especially at times of spring tides. Novices should take expert advice at these times and preferably be accompanied by an instructor. In areas of strong current, it is worth carrying a high-visibility rescue tube or flag, so that if necessary you can attract the attention of your boat cover. Snorkellers, too, should understand the problems of tides.

DIVE OPERATORS

Currently the Philippines is the cheapest place in the world to learn to dive. Training is available by instructors from most of the world's training agencies including BSAC, CMAS, NASDS, NAUI, PADI, SSI and VIT, but PADI is by far the most common.

Some years ago counterfeit PADI manuals and 'C' Cards circulated in the Philippines and a few bogus instructors from that period still exist. If you are going to take any course of instruction, make sure that it is under the auspices of an internationally recognized training agency and check out your instructor's certification: make sure it is current and quotes instructor status, and that the person you are dealing with is indeed the same person who will actually be with you in the water performing the instruction.

<table>
<tr><td>

**TRAVELLING DIVERS'
CHECK LIST**

- Mask
- Snorkel
- Fins
- Regulator with contents gauge (recently serviced)
- Buoyancy compensator device (stabilizing jacket)
- Weight belt
- Compass
- Diving knife
- Diving computer (preferably with depth gauge and tables as backup)
- Wetsuit or lycra skin, if necessary
- Wetsuit bootees, preferably with hard soles
- Inflatable rescue tube or other surface marker buoy
- Whistle or powered whistle
- Diving logbook
- Anti-fog solution (liquid detergent or toothpaste works just as well and is cheaper!)
- Wet bag for diving gear
- Dry bag for cameras, medicines, etc.

Spares kit
- Mask and straps
- 'O' rings
- Fin straps
- Knife straps
- Any necessary tools for small repairs
- Small first-aid kit
- Any necessary batteries

</td></tr>
</table>

The standard of diving operations varies enormously. Most of the smaller operations depend on walk-in trade from budget travellers and are organized accordingly. Most operators do not have their own accommodation. Where several operations exist in the same area, check them all out; the cheapest may not represent the best deal.

All recognized diving operators will be registered with the Philippine Commission on Sports Scuba Diving (PCSSD). A good way to compare operators is to look at the quality and age of the equipment used for diver training. The best operators renew their equipment yearly. Where necessary, I have indicated the better operators that I think are suitable for serious divers from overseas. There are certain to be others who will improve and expand in the near future. I have deliberately omitted some dive operators that are advertising but did not have an operation working when I visited. More than one internationally known dive operation, attached to a major resort, has ceased when its expatriate manager moved on.

Except for live-aboard boats, most Philippines diving is from motorized outrigger boats called *bancas*, the modern equivalent of a dug-out canoe with twin outrigger poles. They are sometimes called pumpboats, because the early ones were powered by small pump engines. They give a wet, and sometimes alarming, ride in rough seas. Larger versions, called *basnigs*, have been used to get to the Tubbataha Reefs, and one still sees them being used there occasionally by local sports fishermen; but they are not strong enough for stormy weather.

If you pay for diving, as opposed to a package, the cost of the dive boat will not normally be included. The daily cost of the *banca* will be an additional charge, divided by the number of paying clients.

DIVING EMERGENCIES

The Philippines has modern medical facilities in the major cities, but you cannot expect them to be available in remote areas. It is always wise to have a travel and medical insurance that includes repatriation by Air Ambulance in the case of a serious accident or illness. If you do not have specialist diving insurance, make sure that you pay the necessary extra premium on your travel and medical insurance to cover diving activities.

Recompression Chambers

At the time of writing there are several active hyperbaric chambers in the Philippines. They are mostly called into use to treat local fishermen who have been using surface-supply (hookah) apparatus, the occasional sport diver or commercial diver.

Batangas City: St Patricks Hospital, Lopez Jaena Street, Batangas City 4200; tel 43-7238388 (Contact: Dr Michael Francis M. Perez, mperezmd@batangas.net.ph)

Cavite City: Sangley Recompression Chamber, NSWG, Philippine Fleet, Naval Base Cavite, Sangley Point, Cavite City; tel 46-5242061

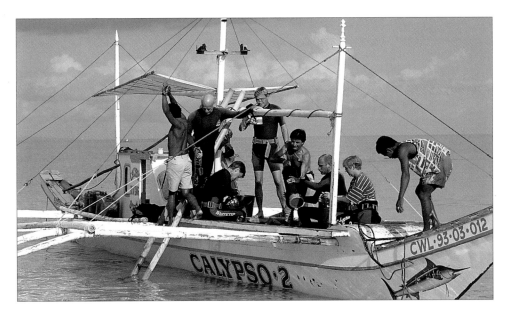

Cebu: VISCOM Station Hospital, Camp Lapu Lapu, Lahug, Cebu City; tel 032-310709 (Contact: Mamerto Ortega or Macario Mercado)
Manila: AFP Medical Center, V. Lunar Road, Quezon City; tel 02-9207183 (Contact: Jojo Bernado MD or Fred C. Martinez)
Subic Bay: Subic Bay Freeport Zone, SBMA, Olongapo City; tel 47-2527952 (Contact: Lito Roque or Rogelio Dela Cruz)

Evacuation Assistance
AFP Search & Rescue Facilities, GHQ, Philippine Air Force, Villamor Air Base, Pasay City, Metro Manila; tel 02-9117996

On board a diving banca, *at White Sand Beach, Boracay, which offers good diving for all levels of experience.*

THE PCSSD

PCSSD (Philippine Commission on Sports Scuba Diving), Tourism Building, Rizal Park, Ermita; tel 2-599031, is an organization that oversees the development, promotion and professionalism of the diving industry in the Philippines and promotes marine conservation projects in areas of high tourist value.

LIVE-ABOARD DIVING
Live-aboard diving has several advantages over shore-based diving. It entails less carrying of heavy equipment, no long swims over shallow fringing reefs and, in particular, being able to dive remote offshore reefs and wrecks. Photographers have less sand to damage 'O' rings, more time to sort out cameras between dives, and can charge batteries between dives as well as at night. There are fewer restrictions on night dives and you have three to five dives each day instead of heading back to shore after two. Live-aboards appear expensive but you get more dives for your money and all food is included, so they are good value for serious divers.

On the minus side, some boats are too high or too light in the water, so they roll about. Some people cannot sleep on a rocking boat and really rough weather can be frightening. Some comforts may have to be foregone; for example, few boats have enough fresh water for everyone to shower daily on trips of more than a week. Also, the weather is cooler at sea, so warm clothing is needed.

Boats advertising unlimited no-decompression diving differ in their interpretation of this statement – some mean only three dives per day and others do not offer night diving. It is worth asking to have exactly what is on offer put in writing before booking, though remember to allow for lost dives due to bad weather, lack of safe anchorage and sailing overnight between sites. If you are diving up to five times per day, the prudent use of dive computers is essential.

The main area of live-aboard diving in the Philippines is the Sulu Sea, particularly Tubbataha and the surrounding reefs and islands. This area can have extremely rough weather, so a boat that is both reliable and seaworthy is important. The larger and heavier the boat, the more stable it will be in bad weather so long as it is not too high and its engines do not fail. Before booking a live-aboard, it is worth making enquiries about its record of reliability.

Because of bad weather, the season when dive boats can operate around Tubbataha is quite short. These boats have to be kept working, so they operate in other areas for the rest of the year. If you can afford it, they are also a great way to dive some of the better areas and sites normally serviced by shore-based operations.

The MY Tristar A live-aboard dive boat, off Bancoran Island in the Sulu Sea. Live-aboards are the only way to dive remote offshore reefs.

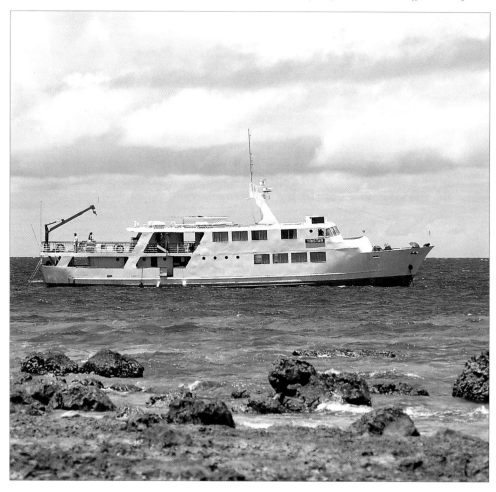

Whale Sharks could be called common in parts of the Philippines. Before the hunting of Whale Sharks was banned in 1998 and the hunters were encouraged to run Whale Shark tours, the animals had been caught traditionally with spears and gaffs from small boats in the Visayas and Mindanao regions. The six-man crews often caught four Whale Sharks in a day.

Then, in late 1997, a concentration of Whale Sharks was discovered that had been visiting the mouth of Donsol River for generations. They had not previously been fished in this area, which is part of the Bicol region of southern Luzon. There were so many Whale Sharks that a dozen or more could be encountered in a single day without the use of spotter planes. The Whale Sharks were monitored by the World Wildlife Fund – Philippines, Silliman University, Hubbs-SeaWorld Research Institute, Scripps Institution of Oceanography, the US National Oceanographic and Atmospheric Administration, and the Philippines Department of Agriculture. The local authorities at Donsol issued a resolution to protect the sharks and to develop ecotourism involving Whale Shark interaction tours.

However, the news of the find attracted buyers of Whale Sharks from the Visayas region and seven sharks were killed and sold for export under licence to Taiwan. This caused nationwide alarm and WWF – Philippines immediately expressed concern that the population could be eradicated and asked for a moratorium on the fishery and trade in Bicol until sufficient data could be gathered on population size, movement and sustainable use.

News soon reached the national press accompanied with bloody pictures of the animals being butchered and conservationists were incensed. As a result of lobbying, on 26 March 1998, Fisheries Administrative Order No. 193 was issued prohibiting the catching, selling, purchasing and possessing, transporting and exporting of Whale Sharks throughout the Philippines. This order also covered Manta Rays, which had also been fished in large numbers in the Visayas and Mindanao.

Organized Whale Shark expeditions, including swimming with the 'Butanding' – the local name for the animal – then transformed the sleepy, fishing village of Donsol into a major ecotourism destination almost overnight. Small boats now take the tourists to see Whale Sharks between January and May. The animals arrive in January, the number of Whale Sharks is highest in March and April, and then the numbers dwindle again towards the end of May. In June when the rains arrive, the weather gets rough and the sea-surface choppy so the area reverts to being just another sleepy town.

The animals can be anywhere in a large area of sea so there is never any guarantee of success, but in January 2005, *Time* Magazine identified the WWF-supported Whale Shark interaction programme off the Philippines' Donsol River as the 'Best Place for an Animal Encounter'.

Local fishermen have become tour-boat operators, and others have been trained as spotters to scan the water for the slowly moving shadows and fins. While most tourists prefer the view from on deck, others slip quietly into the water to get a close view. Only snorkelling is permitted and flash photography is not allowed. A code of conduct prevents tourists from touching the animals.

Donsol has become known as the Whale Shark capital of the world. Based on 2004 figures one can sight as many as 30 Whale Sharks in a day; the maximum reported is 57. The only problem is that the plankton can be so thick that getting a good photograph is rare.

Donsol is only one of many good areas for sighting Whale Sharks in the Philippines' waters. There are many good spots but Bohol and Southern Leyte are particularly good.

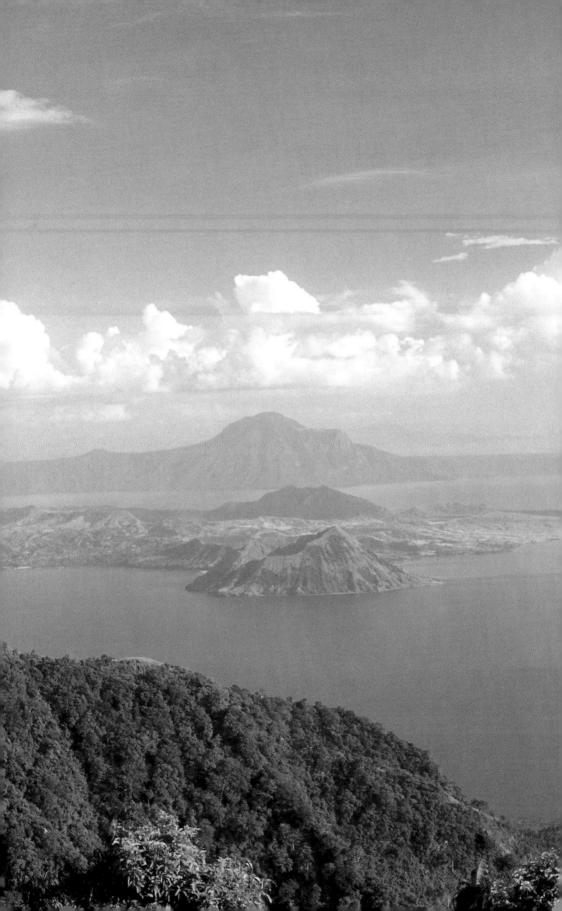

LUZON

The island of Luzon accounts for approximately one third of the land area of the Philippines. The landscape of Luzon is mainly mountainous, covering over 100,000 sq km (38, 610 sq miles), and includes three major volcanoes, Taal, Mount Mayo and Pinatubo. About half the population of the Philippines live on Luzon and it is the most important industrial and agricultural island in the archipelago. It is also the home of the nation's capital city, Manila, which has a population of more than 9 million.

La Union and Subic Bay

Luzon's northwest coastline was popular with divers in the 1970s, but destructive fishing and siltation, especially since the eruption of Mount Pinatubo, have narrowed the diving interest down to the World War II wrecks and other relics.

La Union

La Union, at the northern end of the Lingayen Gulf, is a thriving beach-resort area catering for European tourists and expatriate residents; its most popular beaches are around Bauang, just south of San Fernando. Most visitors do not seem to mind the 6hr bus trip from Manila or the 2hr down the mountain from Baguio. San Fernando airport is now open again.

Diving is possible all year round, the best season being April to June. From a diver's point of view, the main interest is the La Union Tanks; although these are not worth a special journey, they make a good day out if you are already in the area. Many US M10A1E tanks were lend-leased to the UK during World War II. The British gave them heavier guns and loaned several of them to Australia, who used them with great success in the Philippines campaign. At the end of the war they were dumped in the South China Sea.

Four of these tanks can now be dived at 40m (130ft) beside Fagg Reef, 4km (2.5 miles) offshore north of Poro Point (the point west of San Fernando). Three of them are together, with the fourth some 20m (65ft) to the east.

Opposite: *Taal volcano at Tagaytay. Set within a crater lake, it last erupted in 1965.*
Above: *Sabre Squirrelfish (Adioryx (Sargocentron) spinifer).*

SUBIC BAY

Subic Bay was originally established as a naval base by the Spanish in 1885, when they realized that it had better deepwater facilities and did not suffer from the malaria problems of their existing base at Cavite, in Manila Bay.

In April 1898 war broke out between Spain and the USA, and the US Asiatic Squadron, under Commodore George C. Dewy, set sail from Hong Kong to attack the Spanish fleet. The Spanish scuttled the gunboat *San Quintin* at the eastern entrance of the bay between Grande Island and Chiquita Island (where she remains today, as a dive site – see Site 6). They intended to defend the western entrance with the wooden cruiser *Castilla*, but they changed their minds and retreated to Manila Bay. Filipino revolutionaries took advantage of this, setting up their own revolution, but this was eventually quashed by the Americans when they decided to take over the area in late 1899. They began establishing the naval base in 1900.

WORLD WAR II

In World War II, Subic Bay and Olongapo were heavily bombed and eventually overrun by the Japanese. On 11 December 1941, Japanese Zero aircraft strafed the Catalina patrol aircraft used by the base, sending seven of them to the muddy bottom; they have not yet been found by divers.

USS NEW YORK

The battle cruiser USS *New York* was built in Philadelphia in 1891. A protected cruiser of 8150 tons, 116m (380ft 6in) long by 19.8m (64ft 10in) beam, with a speed of 21 knots, she carried 18 guns in her main battery and was driven by triple expansion 16,000hp engines. She saw service in North Atlantic and Asiatic fleets until 1911 when she took her second name, *Saratoga*, becoming the flagship for various fleets in World War I. In 1917 she took a third name, *Rochester*. In 1931 the old ship headed for her final tour of duty on the Asiatic Station. Decommissioned on 29 April 1933 and laid up at the back of Subic Bay, the ex-USS *New York* had been credited with the longest service span of any comparable ship. With the approach of the Japanese forces, she was towed into a deep part of Subic Bay and scuttled in December 1941.

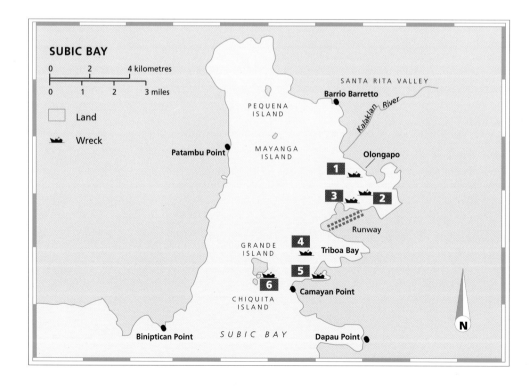

On 14 December the Japanese inflicted heavy bombing on Olongapo and by 24 December it was obvious that the situation at Subic Bay was hopeless. The order was given to destroy the station and withdraw. Olongapo and the base were torched and the old station ship, the ex-USS New York, was towed out into the bay and scuttled. The Japanese army marched into Olongapo on 10 January 1942. The Americans re-took Subic Bay at the end of January 1945, established a new Olongapo just inland of its pre-war site, and built up the Subic Bay Naval Base to be the US Navy's largest supply depot outside the USA.

THE ERUPTION OF MOUNT PINATUBO
On 15 June 1991 Mount Pinatubo, just 33km (20 miles) from Subic Bay, erupted with a force eight times greater than the Mount St Helen's eruption of 18 May 1980. Volcanic ash rose high into the atmosphere, affecting the world's weather for several years and, more locally, smothering everything to a depth of 30cm (1ft). Further earthquakes and a typhoon passing over northern Luzon turned the event into a 36hr nightmare, with many deaths. All non-essential base personnel and dependants were evacuated, but most had returned by the end of September, by which time the base had been largely cleared up and got back into operation. However, that month the Military Bases Agreement of 1967 expired and the Philippines Senate voted to reject any further agreements. The Americans were given three years to leave.

The US forces' withdrawal, in November 1992, was a bonus for divers. During the US administration, civilian diving was prohibited on the wrecks in Subic Bay, so most of the many wrecks there remained untouched. Now they are available to divers, and one major dive operator has set up a diving shop and watersports operation within the old naval base, which is now a free port zone.

ACCESSIBLE WRECKS
The more accessible wrecks have been explored and wreck-diving courses have been set up on those that are safest to penetrate for divers with less experience. The ash from Mount Pinatubo has smothered most of the coral and lies deep on the wrecks, so visibility is often poor. Most of the bay is sheltered, with little current, so this ash is not going to clear quickly. However, it does not affect the wreck diving. There is plenty to see and yet more to be found. Although the coral life is poor, the fish life can be good. Turtles still nest in front of the base. The better wrecks for diving have been buoyed underwater, to make it harder for the local fishermen to find them. The bay is policed to stop people stealing from the wrecks, and operators require permits for divers. The area can be dived all year round, but the best visibility is from December to May. Assuming that Mount Pinatubo does not erupt again, the ash will in time slowly clear and the visibility improve. When that happens, all the dives listed below are likely to warrant an extra star.

MANILA GALLEONS

From 1565 to 1815 the Manila galleons plied the oceans between the Philippines and Acapulco, Mexico, a journey taking 5–8 months, carrying the products of the Orient to the west in exchange for European manufactured goods and New World gold and silver. Some forty galleons were lost over this time, with the modern-day search for their remains being focussed on the Atlantic and Caribbean legs of the voyage. One of the largest and richest of the galleons, the *Nuestra Señora de la Concepción*, was known to have sunk off Saipan in the northern Mariana Islands on 20 September 1638 and was salvaged by the Spanish in 1684. Most of the galleons were built at Cavite on Manila Bay and loaded with cloves and pepper from the Spice Islands (the Moluccas), camphor from Borneo, delicate silks, porcelain and fine rugs from China, cotton cloth from India, ivory from Cambodia and gemstones from Burma, Sri Lanka and Thailand.

1 ORYOKU MARU

★★★

Location: 400m (437yd) west of Alava Pier.
Access: 10min by banca.
Conditions: Calm but with some current; it is worth trying to dive at the times of neap tides. Visibility varies from 5m (15ft) to 15m (50ft), depending on the tide.
Average depth: 15m (50ft)
Maximum depth: 20m (65ft)
This wreck from 1944 has for navigational reasons been flattened by explosives, so is now a tangled mass forming an artificial reef, with good marine life including clownfish, triggerfish, catfish, angelfish, butterflyfish, batfish, Spotted Sweetlips, barracuda, fusiliers and the occasional lobster or turtle.

2 SEIAN MARU

★★★

Location: Between Alava Pier and the northern end of the runway.
Access: 15min by banca.
Conditions: Generally calm with little current. It is worth trying to dive at times of neap tides. Visibility 5m (15ft) to 15m (50ft), depending on the tides.
Average depth: 18m (60ft)
Maximum depth: 27m (90ft)
Sunk by the US Navy in 1945, this 30,000-ton Japanese cargo vessel lies on its port side in 27m (90ft). With cavernous holds, the ship is easy to penetrate and has plenty of marine life, including sponges, sweetlips, Coral Trout, angelfish, butterflyfish, batfish, barracuda, Bluespotted Ribbontail Rays and fusiliers.

3 THE EX-USS NEW YORK

★★★★

Location: Between Alava Pier and the northern end of the runway, west–southwest of the Seian Maru.
Access: 15min by banca.
Conditions: Generally calm with little current. It is worth trying to dive at times of neap tides for better visibility which varies from 3m (10ft) to 15m (50ft).
Average depth: 15m (50ft)
Maximum depth: 27m (90ft)
This World War I protected cruiser, built in 1891, was scuttled in 1941 and now lies on its port side in 27m (90ft). Areas damaged by the explosions are clearly evident. Experienced divers can penetrate the wreck easily,

but the most impressive features are the large 20cm (8in) guns, which are still in position and intact. Given good visibility this would be a great wreck for photographers, but I was unlucky, and had to concentrate on wide-angle close-ups, particularly of the business end of the gun barrels, at 17m (55ft).

 There is quite a lot of soft coral, together with sponges and hydroids, lionfish, triggerfish, Spotted Sweetlips, Bluespotted Ribbontail Rays, fusiliers and batfish. A very big grouper has been seen near the propellers, and other groupers can be found in the main companionway. While going through a 5m (16ft) safety stop on the shotline, I was kept company by several inquisitive squid.

4 AN LST

★★★

Location: Between the southern end of the runway and Grande Island.
Access: 20min by banca.
Conditions: Generally calm, but usually with some current, which can be strong. It is worth trying to dive here at times of neap tides. Visibility 5m (15ft) to 15m (50ft).
Average depth: 32m (105ft)
Maximum depth: 35m (115ft)
This landing craft, sunk in 1946, sits upright in 35m (115ft) of water with its ramp open. At a slightly greater depth than the other wrecks, it is still a safe dive as there is little to penetrate. The deck, at 31m (102ft), offers plenty of marine life, soft corals, sponges and hydroids. There are several shoals of small fish such as sweepers, fusiliers, lionfish, pufferfish, batfish and sweetlips.

5 EL CAPITAN

★★★★

Location: By the inner channel marker buoy of Ilanin Bay.

Access: 20min by *banca*. You can tie up to the marker buoy.

Conditions: Generally calm but with some current. Visibility 3m (10ft) to 15m (50ft). Best dived on a flood tide.

Average depth: 12m (40ft)

Maximum depth: 20m (65ft)

This small freighter (of unknown date) lies on its port side with its stern at 5m (16ft) and its bow at 20m (65ft). You can penetrate through the accommodation area at 18m (60ft), but the shallow parts have the most marine life, which is quite prolific and great for photography if you are lucky enough to have good visibility.

This wreck is well known for its congregations of large lionfish, but it also has plenty of batfish, sweetlips, fusiliers and barracuda. There are lots of shoals of small fish, good soft corals, sponges and hydroids, Thorny Oysters, Fluted Oysters, clams and some *Acropora* corals in the shallower sections, with damselfish.

The superstructure of the El Capitan wreck in Subic Bay, coated in Tubastrea cup corals and sponges.

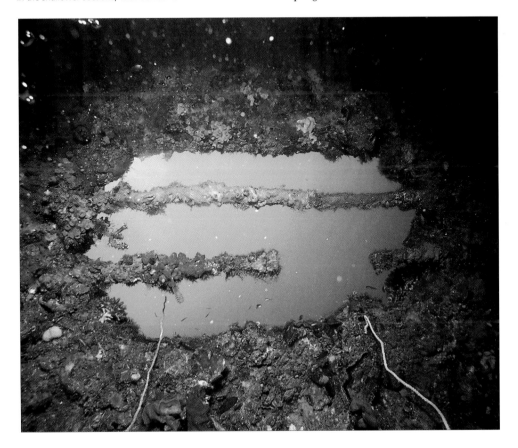

6 SAN QUINTIN
★★

Location: Between Grande Island and the smaller Chiquita Island.
Access: 25min by *banca* to just south of Grande Island.
Conditions: Generally calm but less sheltered than the inner bay, so can get rough. There is usually some current.
Average depth: 12m (40ft)
Maximum depth: 16m (52ft)
In 1898 the Spanish scuttled the gunboat *San Quintin* and two old merchant ships between Grande Island and the smaller Chiquita Island to block the eastern entrance to Subic Bay against any US attacks. There is not much left of the wreck now, but there is healthy marine life. This popular wreck was subject to illegal salvage in 2004 together with wrecks in Silanguin Bay.

Coral growth on the business end of the 20cm (8 in) gun of the ex-USS New York (scuttled in December 1941).

THE 'HELL SHIP' ORYOKU MARU

As the US forces pushed north on 13th December 1944, the former Japanese luxury liner *Oryoku Maru*, evacuating personnel from Manila to Japan in convoy with four merchant ships, was attacked by fighter aircraft from the USS *Hornet*. The attack left hundreds of Japanese dead and wounded, but the Americans did not know, until after the war, that 1619 American and Allied prisoners were crammed into three holds below deck and over a hundred died in the attack. Severely damaged, the *Oryoku Maru* limped into Subic Bay where the Japanese disembarked. The next morning US aircraft attacked the ship again, but this time the Japanese guards ordered the prisoners on deck. The American pilots recognized the white bodies and called off their attack. The 1350 surviving prisoners were now forced to swim ashore and crowded into a fenced-in tennis court. The following day, three more US aircraft sank the ship where she lay. The *Oryoku Maru* remains where she went down. One of her guns was removed and placed in front of the American Legion Post in Olongapo, as a memorial to the prisoners that were lost.

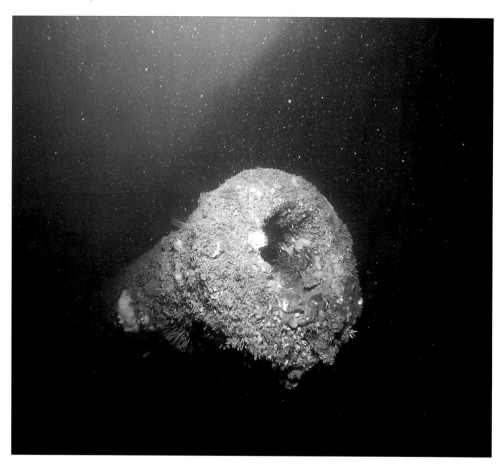

HOW TO GET THERE

To get to La Union, you can fly from Manila to Baguio, then take a 2hr bus ride to San Fernando using either Marcita Liner or Philippine Rabbit. Alternatively, you can travel by Philippine Rabbit direct from Manila (6hr); there are several departures each day from the terminus on Rizal Avenue Extension, near the Chinese Cemetery in Caloocan. Swagman Travel operate an Angeles/La Union/Baguio/Angeles bus service with connections to Manila (Swagman Travel, 1133 Guerrero Street, Ermita, Manila 1000; tel 02-5238541; e-mail: bookings@swaggy.com; website: www.swaggy.com). But the easiest way to get to San Fernando is by car. During the rainy season, check the roads have not been closed by mud slides.

To get to Subic Bay from Manila you can take a Victory Liner bus to Olongapo (2–3hr, depending on Manila's traffic). These leave every 30min from the Victory Liner bus stations at Pasay and Caloocan. (You cannot buy a return ticket; I queued for nearly an hour for my ticket back from Olongapo.) From Olongapo bus station, take a motor tricycle or any blue jeepney to Barrio Barretto, or a motor tricycle to the Freeport zone; motor tricycles are not allowed into this zone, so you must ask at the gate for a representative of the dive operator or hotel to come and fetch you. Swagman Travel operate a bus service to Subic Bay from Manila, or you can fly.

The ferry service with a Supercat 6 called OK Ka Ferry to or from Manila is recommended. Operators can transfer you from the ferry terminal to the resort.

WHERE TO STAY

La Union
The area has beach resorts of all standards and gets busy during Filipino holidays. None of the resorts caters specifically for diving.

Upper Price Range
Acapulco Beach Resort Barangay San Francisco, San Fernando; tel 072-412696 Has a shuttle service into town.

Bali Hai Beach Resort Paringao, Bauang, La Union; tel 72-2425679/fax 72-415480; e-mail: balihai@balihai.com.ph; website: www.balihai.com.ph. Just outside San Fernando. Can be booked through Swagman Travel (address above).

Medium Price Range
Cabaña Beach Resort Paringao, Bauang, La Union; tel 72-2425585/fax 72-2423107; e-mail: cabana@sflu.com

Coconut Grove Beach Resort Km 263 National Highway, 2501 Bauang, La Union; tel 72-8884276/fax 72-8885381; e-mail: resort@coco.com.ph; website: www.coco.com.ph. Has a resident dive operation.

Lower Price Range
Casa Blanca Hotel Rizal Street, San Fernando; tel 72-871235

Subic Bay
Upper Price Range
Subic International Hotel Rizal Cor. Sta. Rita Road, Subic Bay Freeport Zone, Olongapo City; tel 47-2522222/fax 47-8945579; e-mail: sales@subichotel.com; website: www.subichotel.com.

Medium Price Range
Marmont Resort Hotel Barrio Barretto, Subic Bay, Olongapo; tel 047-2225571 An old-style hotel.

White Rock Resort Hotel Matain, Subic Bay, Olongapo; tel 47-2222378/fax 47-2324446; e-mail: sales@whiterockresorthotel.com; website: www.whiterockresorthotel.com.

Lower Price Range
By the Sea Barrio Barretto, Subic Bay, Olongapo; tel 047-2224560 Small, clean and friendly.

Blue Rock Resort Baloy Long Beach, Barrio Barretto Olongapo; tel 47-2249042/fax 47-2227910; e-mail: info@bluerocksubic.com; website: www.bluerocksubic.com.

Ocean Adventure and Camayan Beach Resort Camayan Wharf, West Ilanin Forest Area, Subic Bay Freeport Zone, 2222; tel 47-2528982; e-mail: info@oceanadventure.com.ph; website: www.oceanadventure.com.ph.

WHERE TO EAT

La Union
Because of the considerable Chinese influence in this area the Chinese restaurants are worth a visit. The Mandarin House on Quezon Avenue is good. San Fernando is noted for its seafood. The local delicacy, 'jumping shrimp salad', is perhaps not for everyone: tiny shrimps are marinated alive in spiced vinegar and lime.

Subic Bay
One of the best places to eat in the area is **Capt'n Gregg's Bar and Restaurant** 44 National Highway, Barrio Barretto; tel 047-3842342/fax 032-8135677 Owned by Australian Brian Homan, well known for his salvage work on historic wrecks in the Philippines, this offers top seafood and imported Australian steaks. The bar is the main meeting place for divers in the area and houses a small museum of artefacts salvaged from historic wrecks.

Blue Rock Resort (see above for address)

Johan's Adventure and Wreck Dive Centre Midway in Baloy Beach, Olongapo City 2200; tel/fax 47-2248915; e-mail: johan@subicdive.com; website: www.subicdive.com.

Ocean Adventure and Camayan Beach Resort (see above for address)

DIVE FACILITIES

La Union
Ocean Deep Diver Training Center PO Box 180, San Fernando, La Union, 2500; tel 72-8884440; e-mail: tim@oceandeep.biz; website: www.oceandeep.biz. Luzon's first 5-Star Gold Palm IDC Centre including Trimix.

Subic Bay
Blue Rock Resort (see above for address) PADI, SSI and TDI training.

Johan's Adventure and Wreck Dive Centre (see above for address) Nitrox, deep and wreck diving training with PADI, CMAS, ANDI and IANTD instruction.

Masterdive Magellan's Landing, Lot 14 Argonaut Highway, SBMA, Olongapo City; tel 47-2525987; e-mail: masterdive@gmx.net; website: www.master-dive.com. Recreational and technical diving, including Nitrox to all levels with PADI, TDI and IANTD training.

Ocean Adventure and Camayan Beach Resort (see above for address)

Manila Dive Shops
See the South Luzon regional directory on page 43 for details of dive shops in Manila.

DIVING EMERGENCIES

Recompression Chamber: Subic Bay Freeport Zone, SBMA, Olongapo City; tel 047-2527952

Olongapo City General Hospital Olongapo City, Zambales

LOCAL HIGHLIGHTS

Having been a centre for the US Fleet's R&R, Olongapo has countless bars, nightclubs, massage saloons and cinemas, and some of the best live music in the Philippines. The bars in Subic Bay and Barrio Barretto are simpler.

However, the area has much more than beer and 'hospitality girls'. A good all-round holiday destination, it is fast being developed for business and tourism. It has an airport of international size and standard, a casino, duty-free shopping in the former Commissary, and the old officers' quarters have been converted into a hotel. The electrical generating system was big enough for the naval base and the dry-dock facilities, so brownouts are unlikely.

There are many beaches and caves to the north and around Barrio Barretto, and this is one of the few areas left with complete jungle cover and even monkeys. You can go jungle or mountain-trekking, visit Mt Pinatubo on foot or by helicopter, visit the local tribes and resettlement sites, tour the old Clark Air Base or the Pinatubo Museum, play golf, cruise in *La Gallega* or partake in almost all watersports. If time permits, head for Banaue for its famous rice terraces and Ifugao tribespeople.

Anilao

The close proximity of Anilao to Manila (124km; 77 miles) has made it a popular centre for day and weekend trips not only for diving but for other sea sports, though it does not have good beaches. Not so long ago divers from Manila would drive down here with their own equipment and hire one of the local *bancas*. Nowadays, most of the early diving camps have become holiday-camp style water sports resorts, some of which specialize in diving while others offer diving among various other facilities.

The hilly Calumpan Peninsula has few roads and little in the way of flat land for building, so some of the resorts here and those on the offshore islands can be reached only by *banca*. Most are quite basic and not all have certified diving instructors so, if you wish to take a certification course, organize this in advance and make sure that it is with an international certification agency.

DIVING AND CURRENTS

Most of the diving consists of coral slopes or steps of small drop-offs and shallow coral gardens among sandy patches. The smaller fish life is profuse. There are crinoids

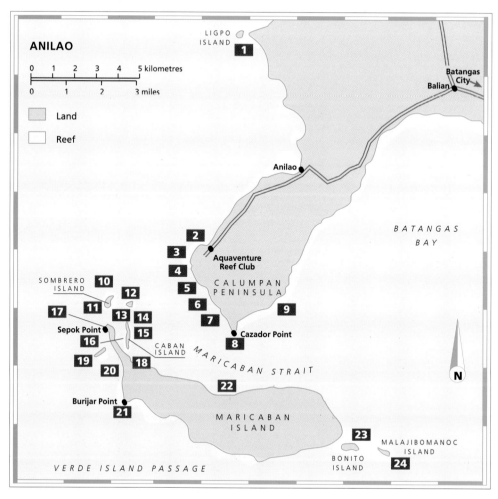

everywhere and lots of nudibranchs. Some marine sanctuaries have been set up in conjunction with the Haribon Foundation and the PCSSD, and a few sites have fixed mooring buoys to minimize anchor damage. In common with other open-water areas, most of the dives can have some fierce currents. Snorkellers, novices and underwater photographers should check the tide tables and try for slack water. Many shallow areas can be snorkelled but, with strong currents common, it is wise if snorkellers have *banca* cover. Diving is good all year round, the best season being November till May. Aquaventure Reef Club is the top operator for serious divers; all access details given for the following sites are from the club.

1 LIGPO ISLAND
★★★

 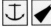

Location: Just west of Ligpo Point.
Access: 40min north by *banca*.
Conditions: Generally calm, but this dive can have some very fierce currents that change quickly. Not a dive for novices when currents are running. Visibility can reach 25m (80ft).
Average depth: 27m (90ft)
Maximum depth: 61m (200ft)
This small island can be circumnavigated on one dive, but you may have to seek shelter from the current. There is a small drop-off and a cave on the east side and an undersea mount on the west side, which slopes off very deep. The east (shoreward) side has all the expected reef fish and invertebrates, but when the current is running various pelagic species can appear out of the depths on the west side. At neap tides, this is a good night dive, with lots of flat worms, nudibranchs, moray eels, catfish and squid.

2 THE CATHEDRAL
★★★

Location: Just off Bagalangit Point.
Access: 5min by *banca* south along the west coast of the Calumpan Peninsula, until 140m (150yd) off Bagalangit Point.
Conditions: Generally calm but can have some strong currents that make photography difficult. Visibility can reach 25m (80ft). The site is best dived at neap tide.
Average depth: 19m (62ft)
Maximum depth: 30m (100ft) plus
This is a Marine Park Sanctuary and probably the best-known Philippine dive site. Originally quite barren, it has been seeded with coral from elsewhere and is now, due to incessant fish-feeding, teeming with fish. (Please don't feed the fish.) The *banca* anchors in shallow water and you swim down and out across sand with small coral heads, soon to be met by hordes of fish hoping to be fed. The site itself resembles a roofless cavern consisting of two large sea mounts, between which is a small cross

planted at 15m (50ft) by the then Philippine President, Fidel Ramos, in 1983 and blessed by Pope John Paul II. The site drops away in small steps, but becomes less interesting below 24m (78ft). When the current is running there are colourful feather stars and inflated soft corals everywhere. Lots of colourful sponges and nudibranchs, hydroids, sea squirts, Feather Duster Worms and algae coat the rocks in between stony corals with Christmas-tree Worms in the corals.

The fish that pester you to be fed include all the smaller angelfish, butterflyfish, wrasse, triggerfish, Moorish Idols, surgeonfish, damselfish and pufferfish. There are lots of parrotfish, anthias, trumpetfish, cornetfish and hawkfish, some blue Linckia sea stars, sea cucumbers, small barrel sponges and anemones with clownfish. My dive buddy, Betty Sarmiento, pointed out a huge Frogfish to me.

3 EAGLE POINT
★★★★

Location: Just west of Eagle Point, south of the Cathedral (Site 2).
Access: 7min by *banca* south along the west coast of the Calumpan Peninsula.
Conditions: Generally calm with a gentle current. Visibility can reach 20m (65ft).
Average depth: 10m (33ft)
Maximum depth: 18m (60ft)
This is an easy dive, similar to the Cathedral (Site 2), with a shallow drop-off from 8m (25ft) to 18m (60ft). There are plenty of small reef fish, sponges, nudibranchs and feather stars.

4 KOALA
★★

Location: South of Eagle Point (Site 3).
Access: 10min by *banca*.
Conditions: Generally calm with a medium current. Visibility can reach 20m (65ft).
Average depth: 18m (60ft)

Maximum depth: 24m (80ft)

A gradual slope from 9m (30ft) to 24m (80ft), Koala is a good dive for novices with soft corals, stony corals, some big boulders, small reef fish and anemones with clownfish.

5 ARTHUR'S ROCK
6 DEAD POINT

★★★★

Location: Off the small point south of Koala (Site 4).
Access: 15min south by *banca*.
Conditions: Generally calm with little current, though it can get up to medium. Visibility can reach 20m (65ft).
Average depth: 10m (33ft)
Maximum depth: 21m (70ft)

Similar dives to Koala (Site 4), these two sites gradually slope from 5m (16ft) to 21m (70ft), offering small coral heads on sand, plenty of small reef fish, sponges, feather stars, soft corals, hydroids and anemones with clownfish.

7 TWIN ROCKS

★★★★

Location: Southeast of Twin Rocks.
Access: 25min by *banca*.
Conditions: Generally calm with just a slight current. Visibility can reach 20m (65ft).
Average depth: 6m (20ft)
Maximum depth: 12m (40ft)

The remains of a capsized barge lie here on a gradual slope, with sponges, algae, hydroids, feather stars and small reef fish; sometimes shoals of barracuda and squid are seen.

8 MAINIT POINT

★★★★

Location: The southernmost point of the Calumpan Peninsula, known as Cazador Point on the charts.
Access: 30min by *banca* south until off Mainit Point.
Conditions: This site is more exposed than most in this area. Currents can be very strong and afternoon winds can make the surface choppy and spoil the visibility. Best dived on a flood tide, preferably at the time of neap tides. Visibility can reach 25m (80ft).
Average depth: 15m (50ft)
Maximum depth: 30m (100ft)

Some rocks break the surface. A gradual set of boulders forms mini drop-offs from 5m (16ft) to 30m (100ft) plus. Due to the currents the marine life is plentiful and varied,

HARIBON FOUNDATION

The PATA (Pacific Asia Travel Association) Foundation allocated a total of $100,000 in grants in 1994. Among the environmental grants was one to the Haribon Foundation for new equipment, patrol boats and permanent mooring buoys for the marine sanctuaries which it helps to operate in the Anilao diving area.

Sustainable development in the Philippines has always been the basis of the Haribon Foundation's activities. Their marine programme actively encourages community-based resource management, so that local communities gain rather than lose economically from the establishment of marine sanctuaries.

Divers and dive centres can become involved. For further information contact:

Haribon Foundation
Suites 401–404 Fil-Garcia Tower, Kalayaan Avenue, Diliman Quezon City
tel 2-4364363; e-mail: communication@haribon.org.ph
website: www.haribon.org.ph

especially when the currents are running. There are good corals and the fish life includes Moorish Idols, Porcupine Pufferfish, snappers, Powder-blue Surgeonfish, jacks, scorpionfish, wrasse and fusiliers, as well as all the smaller reef fish, many angelfish and butterflyfish.

There is a cave at 7m (23ft) in which Whitetip Reef Sharks have been seen resting. The boulders are festooned with soft corals and anemones, together with many crinoids, colourful Linckia sea stars and nudibranchs. Because of the fierce currents, I had to shelter behind rocks to be able to photograph.

9 RED ROCK

★★

Location: The east side of the Calumpan Peninsula, opposite Arthur's Rock.
Access: 40min by *banca* round the southern end of the Calumpan Peninsula.
Conditions: Generally calm with a slight current. Visibility can reach 20m (65ft).
Average depth: 8m (25ft)
Maximum depth: 12m (40ft)

An underwater coral mound with lots of feather stars, nudibranchs, soft corals, hydroids and small fish. Sergeant Majors and other damselfish including clownfish in anemones, chromis, anthias, dottybacks, hawkfish, cardinalfish, spinecheeks, blennies, Dartfish Gobies, boxfish, small pufferfish, angelfish, butterflyfish and parrotfish may all be found.

Opposite: *Bright blue sea squirt (Rhopalaea crassa) and mixed corals.*

10 BEATRICE ROCK
★★★★

Location: North of Sombrero Island at the northern end of Maricaban Strait.
Access: 40min by *banca* southwest across Maricaban Strait.
Conditions: Generally calm, with strong currents, but this site is exposed enough to get very rough at times. Best dived at times of neap tides. Visibility can reach 25m (80ft).

Average depth: 14m (45ft)
Maximum depth: 27m (90ft)

Beatrice Rock offers a series of short drop-offs with channels in between, from 5m (16ft) to 27m (90ft), and a pinnacle rising from 14m (45ft) to 8m (25ft). There are large barrel sponges, good gorgonians, black corals, soft corals, stony corals, anemones with clownfish, nudibranchs and sea stars. The site is densely populated with just about all the reef fish you could expect, including shoals of triggerfish, snappers, surgeonfish, jacks and anthias. Occasionally, turtles and Blue-ringed Octopuses have been seen here.

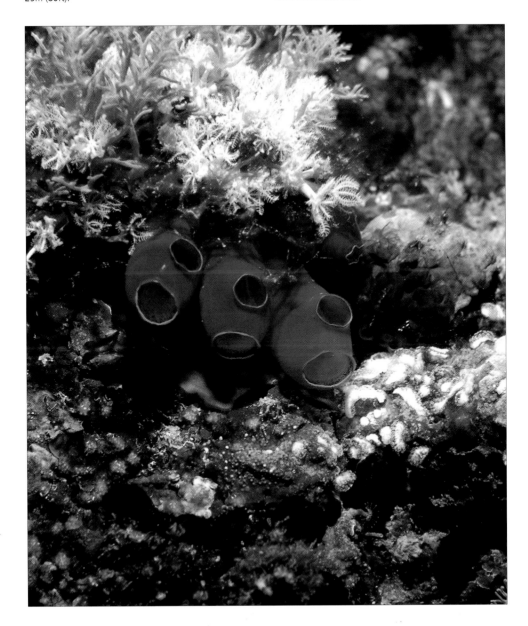

11 SOMBRERO ISLAND

★★★★

Location: North of Sepok Point, the northern end of Maricaban Island.
Access: 40min by *banca* southwest across the Maricaban Strait until northwest of Sombrero Island.
Conditions: Generally calm with a strong current, but it can get rough on the surface. Visibility can reach up to 25m (80ft).
Average depth: 10m (33ft)
Maximum depth: 18m (60ft)
A medium slope from 5m (16ft) to 18m (60ft), the site contains much the same marine life as Beatrice Rock, but the fish life is less prolific.

12 BAHURA

★★★★

Location: North of Caban Island.
Access: 30min by *banca* southwest across the Maricaban Strait.
Conditions: Generally calm with very strong currents, but can also get very rough on the surface. Best dived at times of neap tides. Visibility can reach 25m (80ft).
Average depth: 15m (50ft)
Maximum depth: 30m (100ft)
This dive consists of slopes, small drop-offs, overhangs and swim-throughs. It is much the same as Beatrice Rock (Site 10) with teeming fish life and fierce currents.

13 LAYAG-LAYAG

★★★★★★★

Location: The northwest corner of Caban Island.
Access: 30min by *banca* southwest across the Maricaban Strait.
Conditions: Generally calm with medium to fierce currents, this is considered to be a good snorkelling site, but it is essential that would-be snorkellers understand tide tables and choose slack water. Visibility can reach 30m (100ft).
Average depth: 10m (33ft)
Maximum depth: 18m (60ft)
Extensive coral formations cover a steep though shallow slope from 5m (16ft) to 18m (60ft). Currents can be fierce, so the choice of slack water and preferably neap tides is essential.

The coral is teeming with marine life and often has very good visibility. All the expected smaller reef fish are to be seen and, when the currents are running, shoals of

THE WRECK OF THE SAN DIEGO

On 14 December 1600 the Spanish merchant galleon *San Diego*, hastily fitted out for war and heavily overloaded, sailed from Manila Bay in an attempt to repel two Dutch vessels, the *Mauritius* and the *Eendracht*, that were intent on plundering incoming Manila galleons. In a bungled manoeuvre, the *San Diego* hit the *Mauritius* at full sail and sank rapidly.

The testimonies of various survivors led Franck Goddio, founder of the European Institute of Underwater Archaeology, and his team to believe that the wreck must be somewhere close to the southeast end of Fortune Island. For three weeks in April 1991 they sailed the survey catamaran *Kaimiloa* up and down the suspected area, eventually locating the remains of the *San Diego* at 52m (170ft). In January 1992, after the typhoon season, they began excavating the wreck jointly with the National Museum of the Philippines, financed by the ELF Foundation, the cultural arm of France's largest petroleum company.

Among more than 34,000 archaeological items that have been recovered are fine porcelain, jewellery and coins.

pelagic fish are common. This dive is known for its very large Spanish Dancer nudibranchs.

14 KIRBY'S ROCK

★★★★★★★★

Location: The northeast face of Caban Island.
Access: 30min by *banca* southwest across Maricaban Strait.
Conditions: Generally calm with strong currents. Snorkellers should choose slack water and stay on the shallow reef, inshore of the rock. Visibility up to 30m (100ft).
Average depth: 12m (40ft)
Maximum depth: 33m (108ft)
Kirby's Rock sticks out of the water. On its shoreward side it drops to 5m (16ft), from where the reef slopes upwards to the shore. This side of the rock and the reef to the shore have good coral cover and fish life, including soft and leathery corals, crinoids, hydroids, Feather Duster Worms, Christmas-tree Worms, blue sea squirts, Linckia sea stars, cushion stars and Bohadschia sea cucumbers, and is teeming with reef fish.

On the seaward side the rock drops as a wall to 20m (65ft) and then shelves slowly off on sand with coral patches to 33m (108ft). This wall is rich with soft corals, colourful crinoids, good-size barrel sponges, white finger sponges, hydroids, sea stars, medium-size gorgonian sea fans, segmented worms and many different species of nudibranchs and flat worms. On my visit the wall was covered in small, bright yellow Cucumaria sea cucumbers.

The bottom of the wall has several crevices harbouring moray eels, and there are many whip corals and anemones with clownfish among the coral heads on the sand. There are lots of colourful wrasse, most species of reef fish and the occasional pelagic visitor. This is an ideal dive for photographers, if you are able to hit slack water.

15 CABAN COVE
★★☆☆

Location: The central east face of Caban Island.
Access: 30min by *banca* southwest across the Maricaban Strait.
Conditions: Generally calm with little current. Visibility can reach 20m (65ft).
Average depth: 10m (33ft)
Maximum depth: 15m (50ft)
This is generally a sheltered dive so long as you avoid the outer ends of the cove, where currents can be strong on occasion. The gradual coral slope from 7m (23ft) to 15m (50ft) steepens as you get deeper. A good dive for novices, with mixed corals and lots of small fish.

Opposite: *A Coral (Trout) Grouper (Cephalopholis miniata) waits under a gorgonian sea fan for its prey.*

16 DARYL LAUT
★★

Location: The west side of Caban Island.
Access: 35min by *banca* southwest across Maricaban Strait.
Conditions: Generally calm. Visibility can reach 20m (65ft).
Average depth: 20m (65ft)
Maximum depth: 27m (90ft)
This minor wreck dive, from 12m (40ft) to 27m (90ft), is interesting for novices, with plenty of smaller reef fish.

17 SEPOK WALL
★★★★

Location: West of Sepok Point.
Access: 45min by *banca* southwest across Maricaban Strait.
Conditions: Generally calm with a medium current, but it can get rough. Visibility can reach 30m (100ft).
Average depth: 15m (50ft)
Maximum depth: 27m (90ft)

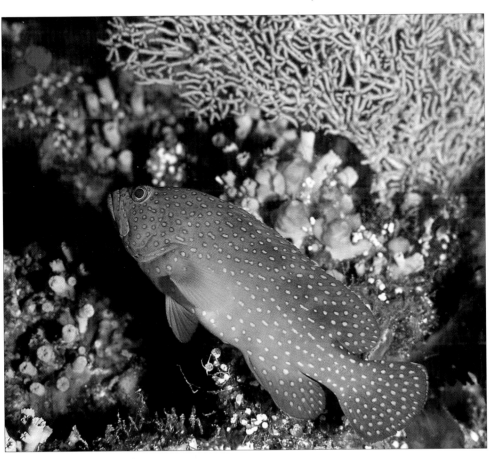

Normally an easy and very pretty dive, with good coral gardens around 5m (16ft) and a wall dropping to 27m (90ft). The shallow water teems with a profusion of small reef fish, while the wall has bigger reef fish, Barrel Sponges, nudibranchs, sea cucumbers and pelagic visitors.

18 BETHLEHEM
★★

Location: The southern end of Caban Island.
Access: 40min by *banca* southwest across Maricaban Strait.
Conditions: Generally calm with a little current. Visibility can reach 20m (65ft).
Average depth: 10m (33ft)
Maximum depth: 15m (50ft)
On this steep coral slope – from 5m (16ft) to 15m (50ft) – you find a mixture of soft and stony corals, hydroids, crinoids and small reef fish.

19 MAPATING ROCK
★★★★★

Location: Southwest of Sepok Point.
Access: 60min by *banca* around the northwest end of Maricaban Island. This is open water and it is easily missed.
Conditions: Generally calm with very strong currents, but can become rough. Visibility can reach 30m (100ft).
Average depth: 20m (65ft)
Maximum depth: 40m (130ft)
This submerged rock is surrounded by a shallow area at 12m (40ft), which ends in a series of drop-offs down to 40m (130ft). The area is large, and the currents really are fierce; this is a site for experienced divers only. The marine life is profuse, with all kinds of fish, several pelagic species and sometimes Whitetip Reef Sharks and Grey Reef Sharks.

20 MERRIEL'S ROCK
★★★

Location: The central part of the northwest face of Maricaban Island, north of Burijar Point.
Access: 60min by *banca* southwest across the Maricaban Strait and around the northwest tip of Maricaban Island.
Conditions: Generally calm with strong currents, but it can become very rough. Visibility can reach 25m (80ft).
Average depth: 18m (60ft)
Maximum depth: 24m (80ft)
Strong to fierce currents may be encountered in this cluster of shallow reefs and gullies. The site is rich in many different species of coral, anemones with clownfish, lots of the smaller reef fish, surgeonfish, sting rays, pufferfish and boxfish. It is best dived in the morning, as it can get rough on the surface in afternoon winds.

21 DEVIL'S POINT
★★

Location: The southwest point of Maricaban Island; known as Burijar Point on the charts.
Access: 65min by *banca* southwest across the Maricaban Strait and across the northwest end of Maricaban Island.
Conditions: Calm with medium-strong currents, but can get rough with strong currents. Visibility up to 25m (80ft).
Average depth: 15m (50ft)
Maximum depth: 24m (80ft)
A coral slope from 6m (20ft) to 24m (80ft) with good mixed corals and lots of small fish.

22 RED PALM
★★★★★★

Location: On Maricaban Island 2.5km (1 1/2 miles) directly south, opposite Mainit Point (Cazador Point).
Access: 40min by *banca*, south of Mainit Point to Maricaban Island. The PCSSD buoy on the beach was once a fixed mooring for this dive site.
Conditions: Generally calm with a medium-strong current. Visibility can reach 25m (82ft).
Average depth: 10m (33ft)
Maximum depth: 24m (80ft)
A steep coral slope from 3m (10ft) to 24m (80ft), Red Palm has good boulder corals and very large lettuce corals. There are colourful crinoids everywhere, Feather Duster Worms, Christmas-tree Worms, some very large anemones and several different types of clownfish. The small reef fish life is prolific, including all the angelfish, butterflyfish, Orangestriped Triggerfish, lionfish and pufferfish.

23 BONITO (CULEBRA) ISLAND
24 MALAJIBOMANOC ISLAND
★★★

Location: The eastern end of Maricaban Island.
Access: 75min by *banca* across the Maricaban Strait.
Conditions: Generally calm with strong currents, but both areas can become rough. Visibility can reach 25m (80ft).
Average depth: 18m (60ft)
Maximum depth: 24m (80ft)
These two marine sanctuaries have patches of coral heads on sandy slopes from 6m (20ft) to 24m (80ft). Malajibomanoc ('Feather Chicken') Island has hot springs at 20m (65ft). When Taal volcano increases its activity, this area does also, releasing curtains of fine bubbles. The east side of Malajibomanoc Island has two pinnacles rising from a coral slope at 20m (65ft) to 8m (25ft). There are good soft and stony corals, barrel sponges and crinoids. The fish life is plentiful, and Blacktip Reef Sharks can often be seen.

How to Get There

Because it is close to Manila, this area is mostly visited as a day or weekend trip, often by divers with their own vehicles.

Some of the resorts are quite basic. They are situated along the coast of Balayan Bay, from Ligpo Point to Bagalangit Point. Some do not have access by road, so you have to make the last part of the journey by *banca* from Anilao.

This is not an area in which to turn up unannounced, as the resorts will not have stocks of food or *bancas* on call. All the resorts have Manila contact numbers and you can organize bookings and transport through these and through Manila dive shops.

Buses for Batangas run from the BLTB terminal on E De Los Santos Avenue, Pasay City. From Batangas you can get a jeepney to Anilao and a jeepney or *banca* to the resorts.

Where to Stay/Dive Facilities

These dive resorts offer facilities and lodging.

Anilao Outrigger Resort Solo, Anilao Mabini, Batangas. Makati Booking Office: Cruise Island Adventure Inc., Fourth Floor Room 405, Metro Star Building, 1005 Metropolitan Avenue, Makati City; tel 2-8906778/fax 2-7296571; e-mail: info@outrigger.com.ph; website: www.outrigger.com.ph

Anilao Seasports Centre Anilao, Mabini, Batangas; tel 0912-3438685. Manila Office: 1169 Antipolo Street, Rizal Village, Makati City; tel 02-8976625/fax 02-8976177 PADI training.

Aquaventure Reef Club PADI Resort Third Floor Aquaventure House, 7805 St Paul corner Mayapis Streets, San Antonio Village, Makati City, 1203; fax 2-8957932; e-mail: booking@aquareefclub.com; website: www.aquareefclub.com Long-established. PADI, NAUI and SSI training. All boatmen are certified divers.

Aqua Tropical Sports Resort Bo. Ligaya, Anilao, Mabini, Batangas; tel 0912-3189041. Manila Office: Suite 201 Manila Midtown Hotel, P. Gil corner M. Adriatico Street, Ermita, Manila; tel 02-5231989/fax 02-5222536; website: www.divephil.com/batangas/aquatrop Part of Dive Buddies. CMAS, NAUI, PADI and SSI training.

Dive & Trek San Pablo, Bauan, Batangas. Booking Office: 15 Clipper Avenue, Bayview Village, Tambo, Parañaque City; tel 02-8338021/fax 02-8338020; e-mail: sales@diveandtrek.com; website: www.diveandtrek.com. PADI courses to Divemaster level.

Eagle Point Resort Bo. Bagalangit, Mabini, Batangas; tel 43-9860177/fax 43-9860187. Manila Sales Office: Ground Floor, Somerset

Millenium 104 Aguirre Street, Legaspi Village, Makati City 1227; fax 02-8133553; e-mail: rsvn@eaglepoint.com.ph; website: www.eaglepoint.com.ph PADI training.

El Pinoy Dive Inn Anilao, Batangas; website: www.divephil.com/batangas/elpinoy. Part of Dive Buddies.

Maya–Maya Reef Club Bo. Natipuan, Nasugbu, 4231 Batangas; tel 0918-9097170/fax 0918-9320483; e-mail: enquiry@mayamaya.com; website: www.mayamaya.com PADI training.

Planet Dive Resort San Teodoro, Mabini, Batangas. Booking office: Unit 101, Delsa Mansion 44, Scout Boromeo corner Scout Torillo, Brgy South Triangle, Quezon City; tel 2-4106193; e-mail: bookings@planetdive.net; website: www.planetdive.net.

Sunbeam Marine Sports Looc Bagalangit, Mabini, Batangas; tel 0919-7674816; e-mail: anilao_diving@yahoo.com.ph; website: www.divesunbeam.com PADI training.

Vistamar Beach Resort San Jose, Anilao, Mabini, Batangas; tel 0912-3043076. Manila: 15420 E. Rodriguez Avenue, San Agustin, Moonwalk Parañaque; tel 2-3724865; http://alltravelnetwork.com/philippines/vistamar PADI training.

Manila Dive Shops

Aqua One Aquaventure House, 7805 Saint Paul corner Mayapis Streets, San Antonio Village, Makati City 1203; tel 2-8992831/fax 2-8992551; e-mail: scubadiving@aqua-one.net; website: www.aqua-one.com Aqua One have branches in Manila and Cebu and also own Aquaventure Reef Club.

Dive Buddies Philippines Ground Floor Robelle Mansion Building, 877 J. P. Rizal Street, Makati City; tel 02-8997388/fax 02-8997393; e-mail: center@divephil.com; website: www.divephil.com Also another branch in Makati.

Eureka Dive Inc. 38 Rockwell Drive, Suite 306, Rockwell Center, Makati City 1200; tel 2-7560170; e-mail: eurekadive@eurekadive.com; website: www.eurekadive.com

Philippine Technical Divers Main Office: 1419-B Pablo Ocampo Sr. Avenue, Brgy. San Antonio, Makati City 1203; tel 2-8966016/fax 2-8966391; e-mail: info@philtech.net; website: www.philtech.net

Scuba World Inc. Main Office, 1181 Vito Cruz Extension, Kakarong Street, Makati City;

Diving Taal Volcano

Taal volcano, north of Anilao, lies inside a crater lake, Lake Taal; what makes the volcano so famous is that it also has a crater lake of its own. As a result of repeated eruptions, this area, once connected to the sea, is now 16km (10 miles) inland, and the lakes contain some unique specimens that have adapted from a sea-water to freshwater existence.

Intrigued by stories of sunken towns, in the late 1980s Texan diver Tom Hargrove made 76 dives in the lake's near-zero visibility, some to 40m (130ft), finding ancient walls, stone steps and clay pots. His most remarkable exploit was to climb into the volcano's crater and, together with his son Miles and Keith Ingram, dive in the steaming lake; the water – basically dilute sulphuric acid (it has a pH of 2.7) – bleached their swimming costumes!

Lake Taal is also famous as home to the smallest fish found in the world, *Pandaka pygmea*, which has an adult length of 1.9cm (3/4in).

tel 2-8953551/fax 2-8908982; e-mail: info@scubaworld.com.ph; website: www.scubaworld.com.ph Several branches around the Philippines.

Diving Emergencies

AFP Medical Center, V. Lunar Road, Quezon City, Metro Manila; tel 02-9207183.

Makati Medical Center 2 Amorsolo Street, Makati, Metro Manila; tel 02-8159911/fax 02-8195423

Local Highlights

Taal lake and volcano are the main local areas of interest. *Bancas* can be hired to visit the volcano. Also, even if you do not plan to dive there, it is worth taking the SI-KAT ferry from Batangas to Puerto Galera to see the beautiful entrance to Puerto Galera from the sea.

Corals belong to the Phylum Coelentera. A single coral animal, the polyp, has one or more rings of tentacles, surrounding a mouth leading to the main body cavity. The tentacles carry stinging nematocysts for catching prey.

CORAL STRUCTURE

Stony corals have calcium carbonate skeletons and their polyps have smooth tentacles arranged in rings of six or multiples of six, (hexacorals). Soft corals lack a solid skeleton and their polyps have feather-like (pinnate) tentacles arranged in rings of eight (octocorals). Internally polyps are partitioned by sheets of tissue extending inwards from the cavity wall (the mesenteries), on which the sex cells ripen yearly. The polyp walls have three layers, the middle layer being the equivalent of the 'jelly' in jellyfish. Cells within the outer layer produce the skeleton, which in stony corals forms the septa, which also extends into the centre of the polyp. The shapes formed by the polyp wall and the septa are unique for each species.

BUDDING POLYPS

Some species remain solitary, most are modular, a single polyp budding to replicate itself repeatedly to produce colonies. Polyps can be male, female, hermaphroditic or asexual.

Budding occurs in different ways. In one method the ring of tentacles becomes oval, the mouth moves to one end and a second mouth develops at the other end. The tentacle ring then constricts between the two mouths and finally parts, leaving two identical polyps. In some corals several secondary mouths develop, resulting in several separate polyps. In others incomplete restriction occurs leaving adjacent polyps with only partial separation.

In brain corals, lines of partially-budded polyps with many mouths appear in an elongated ring of tentacles with no separation between the mouths. These forms of budding are intratentacular. Extratentacular budding, occurs when a new polyp grows outside the tentacle ring of the parent, producing a completely separate polyp.

Cup and mushroom corals remain as one large polyp and its corallite. Mushroom corals live as individuals. Young attached polyps grow upwards until too large for the stalk then break off and roll away. Branching corals are often broken. Some fragments attach to another substratum and grow a new colony. Whip corals restrict small pieces at their tips that break off and start another colony.

Acropora branching corals have two types of polyps. The axial polyps grow longer with-

Small reef fish are usually found in large numbers around coral growth.

Soft tree coral (Dendronephthya rubeola) with mixed corals and sponges.

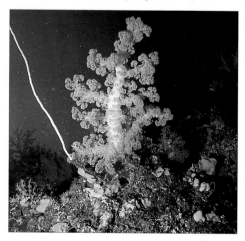

out pulling up and laying base plates. As they grow they bud off radial polyps. These methods of reproduction produce identical copies of the parent; but living organisms gain from a mixing of genes in sexual reproduction.

SPAWNING

After a full moon in early summer most species spawn en masse. Eggs and sperm float to the surface, hoping to cross-fertilize with their own kind. Surviving fertilized larvae (planulae) find a substratum, become a polyp, secrete a skeleton and then bud. In some corals the eggs are fertilized while still in the polyp and the developing larvae are released over long periods.

ZOOXANTHELLAE

Tropical waters, though low in nutrients have some reef-building stony corals growing 30cm (12in) annually. The reason for this anomaly is a symbiotic relationship between the coral and microscopic single-celled algae, (zooxanthellae), which also account for the corals' colours. At night coral animals extend their tentacles to catch plankton. Their waste products (phosphates, nitrates and carbon dioxide) are absorbed by the zooxanthellae.

In daylight, most stony coral tentacles are retracted and the tissues containing zooxanthellae are spread out to catch the sunlight. The algae grow by photosynthesis, their waste products, oxygen and organic nutrients, being absorbed by the coral animal.

Photosynthesis also alters the chemical environment within the coral tissue, precipitating limestone, increasing the rate of skeletal formation and cementing loose debris together. Some corals also ensnare bacteria and zooplankton in mucus secreted by the polyps.

Corals prefer water temperatures of 24-29°C (75-84°F) and 34-36% salinity. Reef-building corals in shallow water pile their algae into many layers and often grow into branching colonies, maximizing the amount of algae available. In deeper water with less light they flatten out.

Corals without zooxanthellae are found in shady areas. Soft corals do not generally rely on symbiotic algae, or have hard skeletons. Colonies are composed mainly of gelatinous material from within the polyp wall. They have some limestone support, tiny crystalline sclerites, which sometimes project outside the animal as defensive spines.

Most soft corals are dull brown/off-white. The colourful *Dendronephthya* species have coloured clerites. Fan and whip corals, have sclerites and a skeleton of proteins, similar to human hair, finger nails and rhinoceros horn.

Below left and right: *The stony corals, which include the fast-growing staghorn corals (Acropora sp.), are the builders of the reef.*

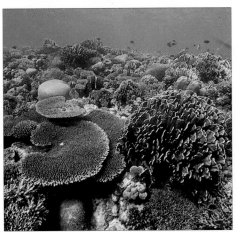
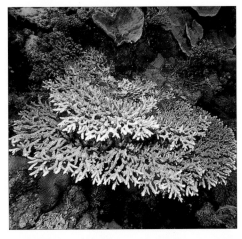

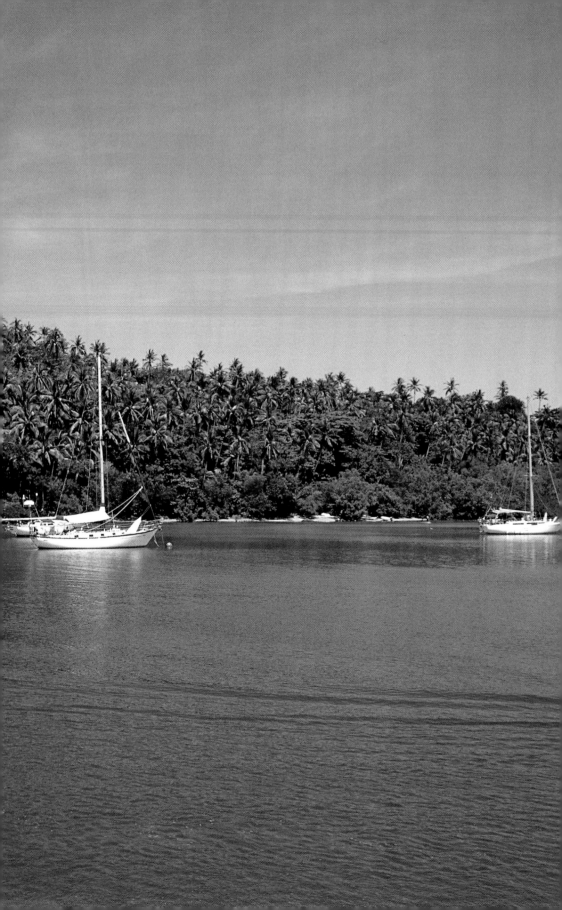

MINDORO

The island of Mindoro lies south of Luzon and is divided into two provinces, Mindoro Occidental in the west and Mindoro Oriental in the east. It is the coastal areas which are populated while the inland forest and mountainous areas are home to various tribal peoples. Fishing, rice cultivation and coconut plantations are the main agricultural activities on the island. Mindoro Occidental is not a tourist destination whereas Mindoro Oriental has become a popular venue for travellers.

Puerto Galera and Apo Reef

Situated 150km (95 miles) from Manila on a beautiful natural harbour, with many fine beaches, sheltered coves and a backdrop of lush green hills, Puerto Galera ('Port of Galleons') has been since the 10th century a port where ships can safely shelter from typhoons. Billed as the 'pearl of Mindoro', this is now an international travellers' beach resort. In the early days the area earned a bad name, with hastily built huts crammed on top of each other, budget travellers, 'hospitality girls' and soft drugs. Some areas are still very crowded with bars and discotheques, but others are beautiful places to stay. Many expatriates have fallen in love with the place, married local girls and set up their own accommodation and diving operations.

The drugs problem is now a thing of the past and Puerto Galera has become a popular destination, particularly for divers. The better-organized dive operations now arrange their own ferries, so that clients can cross from Batangas in the evening instead of being reliant on the SI-KAT ferry. This enables expatriate divers from Manila to stay in Puerto Galera for a full weekend and saves international diving groups from losing a day of diving.

There are several beaches within walking distance of each other (though not if you are carrying luggage). The focal point is Poblacion (the town centre), where the ferries dock. The busy heart is Sabang Beach, with its plentiful nightlife, discos and resorts. Small and Big La Laguna Beaches are slower-paced resort areas with nice beaches and better snorkelling.

Opposite: *Yachts in the beautiful sheltered bay of Puerto Galera.*
Above: *An attractively striped nudibranch or sea slug (Casella sp.).*

SCIENTIFIC STUDY

For nearly 50 years Puerto Galera has attracted scientists studying the ecostructure of micro-organisms, animals and plants. The University of the Philippines Marine Biological Station was set up in 1934 and, in 1974, the UNESCO Man and Biosphere Program International declared the area a research centre and the reefs a Marine Reserve. While some other destinations are designated Marine Reserves and then allow divers and fishermen to do whatever they like, the residents and operators of Puerto Galera actively support marine conservation and police their own reefs.

DIVING AROUND PUERTO GALERA

The diving around Puerto Galera is famous for its diversity. There are all standards, from easy dives for training and novices to high-voltage dives in strong currents and some deep dives where large animals are encountered. Diving clubs, particularly with expatriate members from Manila and Hong Kong, continually return for more. The area is noted for its opportunities for macro-photography, fish and invertebrates, but there are plenty of larger subjects to photograph, plus corals, gorgonians, barrel sponges and whip corals. The reefs are forever changing with the tides. Battery charging can be a problem for photographers, as brownouts and low voltage are common.

Realistically, there are too many dive operators, and new ones are still appearing, sometimes cheekily setting up in front of well-established organizations. The better operators have been there almost since the beginning; the directors are still enthusiastic, still teach novices and (of note for serious divers) understand tide tables and use the stronger currents to good effect (there is a 2.2m [7ft] tide range in $6^{1}/_{2}$ hr). The top dive operator is Asia Divers, with several outlets along the beaches. Close on their tail are South Sea Divers, La Laguna Beach Club and Dive Center, Frontier Divers, Atlantis and Capt'n Gregg's.

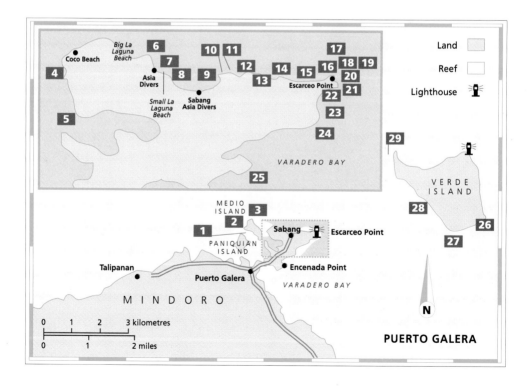

Diving is possible all year round, with the best time being March to October. There is good snorkelling along most of the rocks from the eastern end of Sabang Beach to Escarceo Point. All dives are treated as drift-dives; the *banca* follows your bubbles. All times and directions in the following sites are given from Asia Divers on Small La Laguna Beach.

In good weather, day trips go out among the further islands (see Sites 26–9). These dives are possible from Puerto Galera, Anilao or a live-aboard boat, but are nearest to Puerto Galera. Malajibomanoc Island (see page 42) can also be reached from here.

PANDAN ISLAND AND APO REEF

Pandan Island is a small, rustic island 3km (2 miles) off the west coast of Mindoro. Designated a marine park by the local government and the local operator, the coral reef, which starts at the white sand beach, has 80% coral cover and good fish life. More importantly, Pandan Island has the nearest dive operator to Apo Reef, a large offshore reef system beginning 32km (21 miles) away that used to be among the best diving in the Philippines until destructive fishing methods caused considerable damage to the corals. Now itself a marine sanctuary, Apo Reef is starting to recover.

The whole northeast side of Apo Reef consists of drop-offs and overhangs where Whitetip Reef and Grey Reef Sharks, turtles, barracuda and shoals of snappers are common. The best areas for corals are around Apo Island (not to be confused with the island of the same name off Negros) at depths between 10 and 40m+ (33 and 130ft+), with *Acropora* table corals, staghorn corals, *Porites* corals, fire corals and a variety of soft corals. The northern, eastern and southern sides have steep walls, turtles and pelagic species – recently Hammerhead Sharks and Manta Rays have frequently been spotted. However, the currents are unpredictable and make the northern dive sites difficult for novices. The western side of the island is more of a slope, which makes it easier for less experienced divers. There is a turtle sanctuary and a ranger station on Apo Island.

1 MANILA CHANNEL
★★★★☆☆☆☆

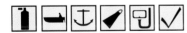

Location: The channel between Medio and Paniquian Islands.
Access: 15min by *banca* west around the northwest tip of Medio Island to the western end of Coral Gardens.
Conditions: Usually calm with a slight current, though it can get rough. Visibility can reach 20m (65ft).
Average depth: 12m (40ft)
Maximum depth: 13m (43ft)
The corals in shallow water here were affected by coral bleaching associated with the 1998 El Niño-Southern Oscillation phenomenon, but there are signs of recovery. The dive follows rubble coral and sand along the edge of a 2m (6ft) to 3m (10ft) drop-off. Over the drop-off there is an abundance of good stony and soft corals, though these are mostly of the beige rather than the more colourful varieties. Large leathery corals are everywhere, together with lots of mushroom corals and bubble coral. There are several types of anemones with clownfish, Leopardfish Sea Cucumbers, colourful Linckia sea stars, Feather Duster

Worms, Christmas-tree Worms and lots of small reef fish. There is good snorkelling all along this reef edge.

2 CORAL GARDENS
★★★☆☆☆☆

Location: The west face of Medio Island.
Access: 15min by *banca*.
Conditions: Usually calm, but can get rough. Best dived on a flood tide for visibility, which can reach 20m (65ft).
Average depth: 6m (20ft)
Maximum depth: 9m (30ft)
Considered the best snorkelling in the area and a good dive for the novice. The terrain shelves out from the shore to 9m (30ft). Lots of corals, both stony and soft, are found around the 2m (6½ft) level, with more sand and coral heads in the deeper water. The corals in the shallow water which live in symbiosis with algae were affected by coral bleaching associated with the 1998 El Niño-Southern Oscillation phenomenon, but there are now signs of recovery.

There are some crevices deeper down with moray eels and the occasional immature Whitetip Reef Shark.

3 SWEETLIPS HOLE/MARCUS' CAVE

★★★★

Location: Straight out from Batangas Channel.
Access: 15min by *banca*.
Conditions: Generally calm but can have strong currents.
Average depth: 51m (167ft)
Maximum depth: 58m (190ft)
Suitable for technical divers with recent deep experience only. Usually the hole and the cave areas would be done on two separate dives. Sweetlips has a hole to swim through at 45m (150ft) where you can watch resident shoals of batfish and sweetlips. Marcus' Cave has a wall running east to west with large gorgonian sea fans and schooling bannerfish. There are often Whitetip Sharks resting on the sand at 50m (165ft). Surgeonfish school here and Mantas have been seen overhead. The cave itself is quite large and contains a memorial stone to Marcus (he did not die diving).

4 BATANGAS CHANNEL

★★★★

Location: The northern end of the channel between Medio Island and Coco Beach.
Access: 10min by *banca* to the west end of Coco Beach.
Conditions: Usually calm with some strong currents. Visibility can reach 20m (65ft).
Average depth: 14m (45ft)
Maximum depth: 27m (90ft)
Experienced divers would treat this as a drift-dive on a strong flood tide. There are lots of barrel sponges up to 2m (6½ft) high around the 14m (45ft) depth. When the current is running there are shoals of jacks, sweetlips, snappers and fusiliers. There are many reef fish, several stingrays and the occasional Whitetip or Grey Reef Shark.

5 THE HILL

★★★☆☆☆

Location: The southeast end of the channel between Medio Island and Coco Beach.
Access: 10min by *banca* west around Coco Beach to the southeast end of Batangas Channel.
Conditions: Usually calm, but can be rough with strong currents. Visibility can reach 20m (65ft).
Average depth: 12m (40ft)
Maximum depth: 12m (40ft)
This is a safe dive for novices so long as they accurately hit slack water. Good soft corals and sponges abound, with small reef fish teeming around them.

6 LA LAGUNA POINT

★★★☆☆☆

Location: Off La Laguna Point.
Access: A few minutes by *banca* west to La Laguna Point.
Conditions: Usually calm with a gentle current. Visibility can reach 20m (65ft).
Average depth: 12m (40ft)
Maximum depth: 15m (50ft)
A short wall from 12m (40ft) to 15m (50ft) with lots of small reef fish, nudibranchs and colourful crinoids. West of La Laguna Point, the 'Dry Dock' was originally designed for lifting small boats out of the water. Of steel and plywood construction, it was purposely sunk for divers by La Laguna Dive Center in 1998. Best dived at slack water, the average depth is 24m (79ft) and the maximum depth 30m (98ft).

7 ST CHRISTOPHER (ST ANTOINE'S WRECK)

★★★★☆☆☆

Location: 100m (330ft) out from Small La Laguna Beach.
Access: A few minutes by *banca*.
Conditions: Generally calm but can have strong currents.
Average depth: 18m (60ft)
Maximum depth: 24m (79ft)
Once owned by El Galleon's chef, Antoine, this 22m (72ft) wooden 'pig boat' was sunk by dive operators in 1995. Its hull is intact, with gaps to view snappers, lionfish, pufferfish, butterflyfish, emperors, jacks and occasionally frogfish. Finish west to Small La Laguna or east to the Point, looking out for stingrays, cuttlefish, frogfish and good corals in the shallows, where snorkelling is good. A small wreck, 'The Speedboat', is nearby at 12m (39ft) with a resident frogfish.

8 SABANG JUNK

★★★★☆☆☆

Location: Straight out from floating bar on Sabang Beach.
Access: A few minutes by *banca*.
Conditions: Generally calm but can have strong currents.
Average depth: 12m (40ft)
Maximum depth: 20m (65ft)
This 16m (52ft) wooden junk was sunk in 1993 by all the local dive operators, but only the hull remains. Numerous

Opposite: *A handsomely banded Common Clownfish (Amphiprion ocellaris) hovers near the anemone (Heteractis sp.) on which it relies for shelter.*

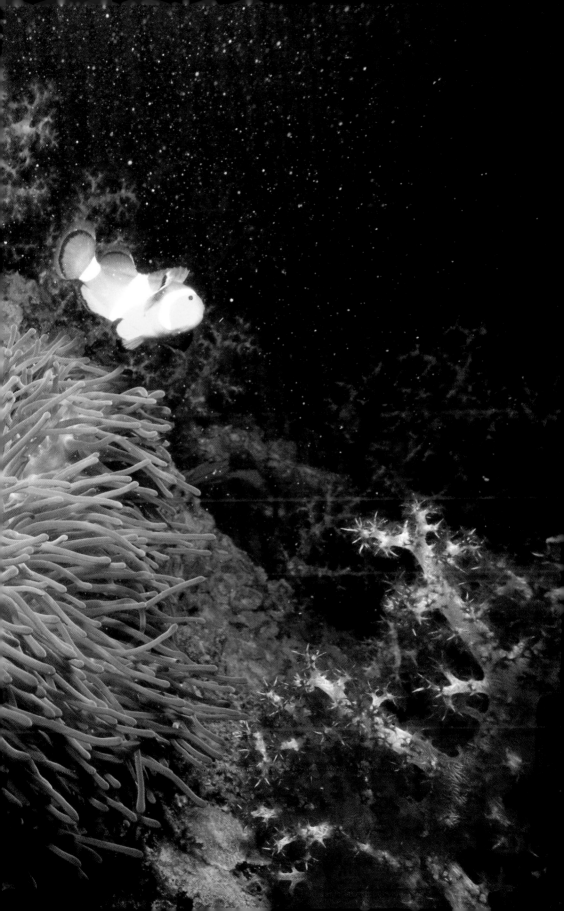

batfish and large surgeonfish come out to investigate divers. Large morays, scorpionfish, trumpetfish, lionfish, stonefish and the occasional frogfish may be found on the wreck, while there are snake eels, gobies with bulldozer shrimps, Bluespotted Ribbontail Rays and pipefish on the sand.

To the south-southeast there is sea-grass with interesting small creatures. To the east are parts of an aeroplane and Spanish anchors brought from other areas. The lengths of wood near the floating bar are all that remains from the *Nuestra Señora de la Vida*, a galleon that sank off Verde Island in 1621 (Site 28). Nearby is a small steel-hulled sailing yacht, intentionally sunk by divers from Capt'n Gregg's.

Snorkelling is good in the shallows.

9 SABANG POINT

★★★★

 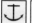

Location: Off Sabang Point.
Access: 5min east by *banca*.
Conditions: Usually calm with a slight current. Visibility can reach 20m (65ft).
Average depth: 15m (50ft)
Maximum depth: 22m (72ft)

A good wall dropping down to 22m (72ft), with stony corals, soft corals, fish and invertebrates. A ridge coming up from the wall to 5m (16ft) is covered with even more corals and colourful crinoids. A good night dive.

10 MONKEY WRECK

★★★★

Location: East of Sabang Point.
Access: 8min east by *banca*.
Conditions: Generally calm, but can have some current. Visibility can reach 20m (65ft).
Average depth: 35m (115ft)
Maximum depth: 40m (130ft)

A 20m (65ft) local island transport (pig boat), sunk by Asia Divers in early 1993, lies in 40m (130ft) of water and is a little dangerous, as it rolls around in the swell. It is already collecting its own resident fish, including a small shoal of batfish.

The author prepares to dive from a live-aboard dive boat.

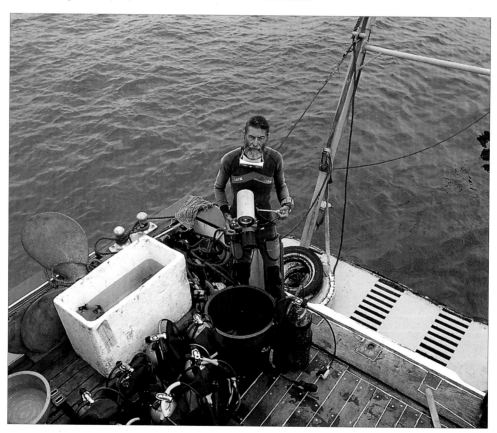

11 MONKEY BEACH

★★★

Location: Off Monkey Beach
Access: 10min by *banca* east until opposite Monkey Beach.
Conditions: Generally calm, often with less current than at the dive sites further east. Visibility can reach 20m (65ft).
Average depth: 12m (40ft)
Maximum depth: 18m (60ft)
A pretty coral slope down to 18m (60ft) makes this an easy dive, especially good for novices. Small coral heads have crinoids, nudibranchs and plenty of small reef fish. There are sea stars, sea urchins and sea cucumbers on the sand.

12 ERNIE'S CAVE

★★★★

Location: East of Monkey Beach.
Access: 10min by *banca*.
Conditions: Usually calm with a medium-strong current, but it can get rough with strong currents. Visibility can reach 20m (65ft).
Average depth: 22m (72ft)
Maximum depth: 30m (100ft)
Ernie was a large lone grouper, sadly departed. There are in fact two small caves, one at 22m (72ft) and the other at 27m (90ft). There is plentiful fish life, including shoals of surgeonfish, unicornfish, jacks, snappers and fusiliers, as well as the smaller reef fish and occasionally Whitetip Reef Sharks. There are good stony and soft corals, sponges, small gorgonian sea fans and crinoids.

13 DUNGON

★★★

Location: West of Wreck Point (Site 14).
Access: 15min by *banca* until just west of the point.
Conditions: Generally choppy; on occasion it can get very rough, with strong currents. Visibility can reach 20m (65ft).
Average depth: 18m (60ft)
Maximum depth: 30m (100ft)
An easy, multilevel dive with drop-offs from 12m (40ft) to 27m (90ft), lots of good soft corals, colourful crinoids, most reef fish and the occasional tuna.

(Note that all the dives described east of here past Escarceo Point get into rough surface water and strong currents. Escarceo Point itself is named after the tide-rips off it, which are considerable, causing strong eddies. Some of the later dives are very close together; others are hard to find underwater and easily missed in a strong current. It is wise to have a good local dive guide, both for these reasons and because he or she would be familiar enough with the underwater terrain to know when to come up if, say, you were being swept out to sea or too far away from your boat cover.)

14 WRECK POINT

★★★★

Location: The first point west of Escarceo Point.
Access: 18min by *banca* east to Wreck Point.
Conditions: Usually a bit choppy on the surface with a strong current, but it can sometimes get very rough with fierce currents. Visibility can reach 25m (80ft) on a flood tide.
Average depth: 25m (80ft)
Maximum depth: 30m (100ft)
There is one wreck on the beach, and a further two small wooden wrecks – one 12m (40ft) long and the other 15m (50ft) long – sunk by Asia Divers in early 1993 in 27m (90ft) of water.

You will find a gentle slope of sand with large heads of all types of stony corals and some rock boulders. There are a lot of small reef fish, including angelfish, butterflyfish, damselfish, sergeant majors, parrotfish, groupers, surgeonfish, triggerfish, trumpetfish, lionfish and anthias. There are also pufferfish, jacks, sweetlips, juvenile Pinnate Batfish and moray eels, together with lizardfish, goatfish, gobies, Leopardfish Sea Cucumbers and Linckia sea stars down on the sand. In addition there are colourful crinoids everywhere.

15 WEST ESCARCEO

★★★★

Location: Just west of Escarceo Point and Hole in the Wall.
Access: 20min east by *banca*.
Conditions: Usually a bit choppy on the surface with strong currents, but it can get very rough with fierce currents. Visibility can reach 25m (80ft) on a flood tide.
Average depth: 18m (60ft)
Maximum depth: 27m (90ft)
On a gentle slope from 9m (30ft) to 27m (90ft) you will find many large coral heads on sand. Other attractions include very large, healthy table corals, good boulder corals with Christmas-tree Worms and Feather Duster Worms, blue and white sponges, large barrel sponges, blue and yellow sea squirts, nudibranchs, flat worms, sea cucumbers, sea stars and colourful crinoids. There are many male Titan Triggerfish guarding eggs in nests, groupers, trumpetfish, shoals of Ehrenberg's Snappers, jacks, fusiliers, sweetlips, Moorish Idols and lone Blacktail Snappers, lionfish and Zebra Lionfish. The abundance of marine life makes this a good dive for photographers.

Further offshore here is a deep dive for technical diving, known as 'Joshua's Wall'. Standing 10–15m (33–49ft) high, it runs north–south, tops out at 60m (197ft) and drops off to sand and rocks at around 76m (250ft). There are shoals of Midnight Snappers along the wall and shoals of batfish across the sand. Best dived at slack water, the maximum depth is 80m (263ft).

16 HOLE IN THE WALL

★★★★★

Location: Just west of Escarceo Point.
Access: 20min east by *banca*. You need a good local dive guide who can take account of the currents if you are to find the 'hole in the wall'.
Conditions: Usually choppy on the surface, with strong currents, but it can be very rough with fierce currents. Visibility can reach 25m (80ft).
Average depth: 12m (40ft)
Maximum depth: 19m (62ft)
Allowing for currents, you drop into 9m (30ft) of well-lit water, with fields of table corals as good as anywhere in the world. You descend in several stepped drop-offs, each about 3m (10ft), and eventually reach the hole in the wall at 12m (40ft). The hole is about 1¹/₂m (5ft) high and 0.8m (2¹/₂ft) wide, covered with multicoloured sponges and crinoids, leading to the Canyons (Site 18).

The area teems with small reef fish, angelfish and butterflyfish. There are male Titan Triggerfish guarding

eggs in nests, parrotfish, pennantfish, Moorish Idols, snappers, sweetlips, trumpetfish, pufferfish, Scrawled Filefish, lionfish and jacks, plus some tuna and groupers. There are several species of nudibranchs on the wall, sea stars and sea cucumbers on the sand, and moray eels in crevices.

17 THE FISH BOWL

★★★★★

Location: Northeast of Escarceo Point.
Access: 25min east by *banca*.
Conditions: Usually choppy on the surface with strong currents, but can get really rough with fierce currents. Visibility can reach 30m (100ft) on a flood tide.
Average depth: 40m (130ft)
Maximum depth: 60m (200ft)
This is an advanced dive within a bowl-shaped depression at 40m (130ft), where you sit on the edge and look down. You need a good dive guide to allow for the currents. When you enter the water you will be swept down to where you hope to arrive; photographers can operate only by getting into the shelter of large rocks.

There is just about everything here, in quantity, but the main reason for this dive (as Site 18) is to see bigger fish and shoals. Whitetip Reef Sharks and Grey Reef Sharks are common, as are large tuna. There are Rainbow Runners, smaller tuna, batfish, snappers, Oriental Sweetlips, Spotted Sweetlips and jacks, plus some barracuda and groupers.

18 THE CANYONS

★★★★★

Location: Northeast of Escarceo Point.
Access: 25min by *banca*.
Conditions: Usually choppy on the surface, with strong currents, but can get very rough with fierce currents. Best dived on a strong flood tide, when visibility can reach 30m (100ft).
Average depth: 29m (95ft)
Maximum depth: 60m (200ft)
This advanced dive needs a good dive guide to allow for currents and get you into position. You drift past the hole in the wall and race over several small drop-offs covered in soft corals and sponges. There are a couple of smaller canyons where you can briefly shelter; moray eels have been seen in one. The main attraction is the teeming fish life – just about everything is here, including Six-banded Angelfish, Royal Angelfish and Emperor Angelfish. There are some large barrel sponges and gorgonian sea fans in the deeper water.

If you get the current right, you are eventually swept onto a 1¹/₂m (5ft) anchor, where your group can gather together before letting go, to be swept away in the current and decompress in open water. A high-voltage dive.

19 HORSEHEAD

★★★★

Location: East of The Canyons.
Access: 25 minutes east by *banca*.
Conditions: Usually choppy with strong currents.
Average depth: 36m (118ft)
Maximum depth: 50m (165ft)
This site is only suitable for advanced and technical divers. A flat, rolling seabed with a wall and slope to the north and east, it is best treated as a drift dive from The Canyons on a flood tide. It has very large gorgonian sea fans, turtles and sea snakes, shoals of jacks, sweetlips and snappers, large groupers in a hole, enormous starfish and occasionally Spanish Dancers during the day.

20 SHARK CAVE

★★★★

Location: East of Escarceo Point.
Access: 25min east by *banca*.
Conditions: Very rough with fierce currents. Visibility can reach 20m (65ft).
Average depth: 25m (80ft)
Maximum depth: 30m (100ft)
The Shark Cave is an overhang 30m (100ft) long at a depth of 29m (95ft). It is 1m (3ft) high at the opening but closes to 15cm (6in) about 4m (13ft) back. Whitetip Reef Sharks rest up here during the day. Nearby is a large boulder covered in soft corals, green Tubastrea corals, small gorgonian sea fans and small barrel sponges.

There are lots of different species of nudibranchs, Six-banded Angelfish, Longnose Butterflyfish, shoals of Moorish Idols and pennantfish, filefish, triggerfish, parrotfish and shoals of soldierfish under the overhang. The area is teeming with the smaller reef fish and colourful crinoids, which open out when the current is running.

21 THE BIG ROCK (THE ATOLL)

★★★★

Location: Southeast of Escarceo Point.
Access: 25min by *banca* east round Escarceo Point to just south of Shark Cave.
Conditions: Usually choppy, with a medium-strong current, but can get very rough. Visibility can reach 25m (80ft).
Average depth: 20m (65ft)
Maximum depth: 33m (108ft)
An atoll-shaped rock, 15m (50ft) wide, rises from 33m (108ft) to 21m (70ft). There are lots of fish around but, in particular, several lionfish under the overhangs and in crevices and Bluespotted Ribbontail Rays on the sand.

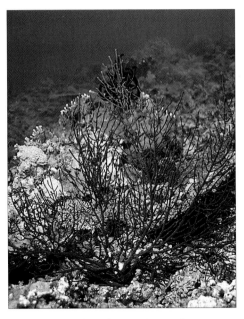

The branches of a red gorgonian sea fan (Acabaria sp.) all but conceal a black feather star.

22 PINK WALL

★★★★★★

Location: East of the southeast corner of the southern headland of Escarceo Point.
Access: 25min east by *banca*.
Conditions: Usually calm with little current, but can become rough with a strong current. Must be dived on a flood tide, when visibility can reach 20m (65ft).
Average depth: 10m (33ft)
Maximum depth: 15m (50ft)
Here an overhanging wall at 10m (33ft) is covered in pink soft corals and cup corals. This can be recommended as a good night dive.

23 KILIMA STEPS

★★★

Location: South of the southern headland of Escarceo Point.
Access: 25min by *banca* east around Escarceo Point to the south of Pink Wall (Site 18).
Conditions: Usually choppy on the surface, with a strong current, but can get really rough with a fierce current. Visibility can reach 20m (65ft).
Average depth: 20m (65ft)
Maximum depth: 40m (130ft) plus

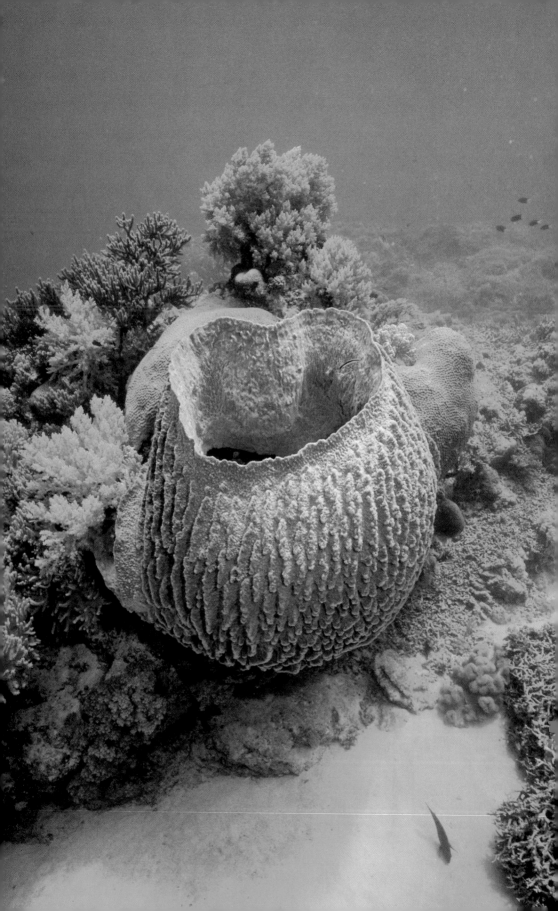

This series of several small drop-offs, descending in steps, is best dived as a fast drift-dive on an ebb tide. There are plenty of good stony corals, soft corals, fish and invertebrates. There is no point going deeper than 30m (100ft).

24 SINANDIGAN WALL

★★★★

Location: Off the headland at the southern extremity of Escarceo Point.
Access: 30min by *banca* east around Escarceo Point to the bottom southeast corner.
Conditions: Usually a bit choppy on the surface, with a strong current, but it can get really rough with fierce currents. Visibility can reach 25m (80ft).
Average depth: 25m (80ft)
Maximum depth: 40m (130ft) plus
A real wall goes down to 40m (130ft), with all manner of corals – especially soft corals – plus at least seven different varieties of nudibranchs and plenty of the larger fish species: groupers, snappers, jacks, trevallies, tuna, barracuda and occasionally Whitetip Reef Sharks.

25 THE BOULDERS

★★★

Location: The next headland south of Escarceo Point.
Access: 30min by *banca* east around Escarceo Point until you reach the next headland south of Pink Wall (Site 18).
Conditions: Usually choppy with some current, but can get rough with strong currents. Visibility can reach 15m (50ft).
Average depth: 20m (65ft)
Maximum depth: 24m (80ft)
Several big boulders, down to 24m (80ft), form overhangs, tunnels and swim-throughs. Big fish are often seen here, but the visibility tends to be poor.

South of The Boulders, the 'Japanese Wreck' is the engine block and propeller shaft of a World War II Japanese patrol boat on a flat sandy bottom at 42m (138ft).

26 VERDE (GREEN) ISLAND – EAST POINT

★★★★★

Location: The east point of Verde Island.
Access: By *banca* or live-aboard boat.
Conditions: Usually calm with some current. It can be really rough, but you would not normally come out here then.

Opposite: *Large basket sponge (Petrosia sp.).*

Average depth: Whatever you like
Maximum depth: 60m (200ft) plus
This is a true wall, from the surface to 60m (200ft) with all the large soft corals, gorgonian sea fans, fish and pelagic visitors you would expect. The dive is done as a day trip.

27 THE WASHING MACHINE

★★★★★

Location: The centre of the south side of Verde Island.
Access: By *banca* or live-aboard boat.
Conditions: An advanced dive; can be very rough.
Average depth: 15m (50ft)
Maximum depth: 30m (100ft)
This high-voltage dive comprises a series of small canyons at 15m (50ft) with currents going in all directions, throwing you around. The dive is generally done as a day trip.

28 THE GALLEON

★★★★★

Location: The centre of the west side of Verde Island.
Access: By *banca* or live-aboard boat.
Conditions: Usually calm with a strong current; you would not come out here when conditions are rough.
Average depth: 12m (40ft)
Maximum depth: 20m (65ft)
Popular with divers having barbecues on the beach, this was the site of the wreck of the *Nuestra Señora de la Vida*, which sank in 1621. Built in Cebu she was bound for Mexico but ran aground in a storm. The wreck has been excavated, but you can still find porcelain and shards in the sand between 5m and 20m (16ft and 65ft) and on the beach. There are staghorn corals, anthias, garden eels, mantis shrimps and moray eels.

29 VERDE ISLAND – WEST POINT

★★★★

Location: The westernmost point of Verde Island.
Access: By *banca* or live-aboard boat.
Conditions: Usually calm with a strong current. It can be really rough but you would not normally come out here in such conditions.
Average depth: 18m (60ft)
Maximum depth: 18m (60ft)
A good fast drift-dive on a rich coral slope teeming with fish life. This dive is done as a day trip.

HOW TO GET THERE

Puerto Galera is on the northern tip of Mindoro Island, 2hr by road from Manila to Batangas, followed by 2hr by ferry. The easiest way to get there is to take the SIKAT bus and ferry service that departs every morning at 08:00 from the City State Tower Hotel, 135A Mabini Street, Ermita, Manila. It is not possible to buy a return ticket; this has to be bought at Puerto Galera. The return ferry leaves Poblacion at 09:00 daily. Ferries do not run during typhoon warnings.

Alternatively, BLTB buses depart from E. de los Santos Avenue, Pasay City, for Batangas City, from where you can get a jeepney to the pier or the ferry terminal. Other buses run from the terminus in Plaza Lawton.

At Batangas ferry terminal there is a choice of *bancas* that will take you directly to some of the more popular beaches at Puerto Galera. Asia Divers arrange ferries from Mainaga Pier directly to El Galleon Pier at Puerto Galera. Make sure, on the ferry, that you are in position to have a good view of the beautiful approach to Puerto Galera.

If you disembark at Poblacion, jeepneys may be hired to reach Sabang, from where it is a 15min walk to the beaches, although you would not want to carry luggage. In fact, the easiest way to get to most of the beaches from Poblacion is to hire a *banca*. You can cut costs by sharing, but they are not very big. Due to their outriggers, *bancas* are not capable of mooring side-on to a jetty, so they are awkward to board without getting wet, and you will have to wade ashore at your beach destination: it is useful to wear shorts and sandals.

Pandan Island is nearest to the town of Sablayan on the Mindoro mainland. To reach Pandan Island by air you fly from Manila to San Jose, take either a public or pre-arranged jeepney to Sablayan and then a water taxi to Pandan Island. By land and sea you take a bus or car to Batangas from where there are weekly ferries to Sablayan. Alternatively, from Puerto Galera you can charter a *banca* to Abra de Ilog and then take a jeepney to Sablayan.

WHERE TO STAY

Puerto Galera
Accommodation has improved, though even in the best places mosquitoes can be a nuisance after rain.

Upper Price Range
Atlantis Hotel Sabang Beach, Puerto Galera, Oriental Mindoro, 5203; tel/fax 43-2873066/fax 43-2873068; e-mail: puertogalera@atlantishotel.com; website: www.atlantishotel.com
Spanish/Mexican design – the rooms are unusual in being mainly whitewashed concrete.

Portofino Small La Laguna Beach, Puerto Galera; tel/fax 0973-776704; e-mail: resort@portofino.com.ph; website: www.portofino.com.ph
Hotel and condominium resort.

Medium Price Range
El Galleon Beach Resort/Asia Divers
Small La Laguna Beach, Puerto Galera; tel/fax 02-8453248; e-mail: admin@asiadivers.com; website: www.elgalleon.com
Part of Asia Divers, with all facilities, the popular Point Shooter Bar and excellent restaurant.

Coral Cove Resort Puerto Galera, Oriental Mindoro. Manila: tel 2-8450674/ fax 2-7533316; e-mail: info@coral-cove.com; website: www.coral-cove.com
Set in a secluded cove away from bustle of the popular beaches.

Capt'n Gregg's Sabang Beach, Puerto Galera; tel 0973-496691, tel/fax 0912-3065267; e-mail: info@captngreggs.com; website: www.captngreggs.com
Various standards of accommodation.

Sabang Inn Beach Resort And Dive Center Sabang Beach, Puerto Galera; tel 43-2873198; e-mail: info@sabang-inn.com; website: www.sabang-inn.com
Various standards of accommodation.

Pandan
Pandan Island Resort 5104 Sablayan; tel 2-2537007/fax 2-5251811; e-mail: info@pandan.com; website: www.pandan.com

WHERE TO EAT

At Puerto Galera, the Corsican chef at El Galleon has made this restaurant a popular place to eat. In the evenings Asia Divers bar, on the point beside El Galleon, is a popular meeting point for divers and instructors.

On Pandan, eat at Pandan Island Resort.

DIVE FACILITIES

Puerto Galera
Action Divers Small La Laguna Beach and Sabang Beach, Puerto Galera; tel 43-2873320/fax 0973-776704; e-mail: info@actiondivers.com; website: www.actiondivers.com
PADI courses and IANTD Technical Diving Nitrox courses.

Asia Divers/El Galleon Beach Resort
Small La Laguna Beach and Sabang Beach, Puerto Galera; tel/fax 0973 865252/ mobile 0912 3050652; e-mail: admin@asiadivers.com; website: www.asiadivers.com
Manila contact: Asia Divers Manila, 57 Gil Puyat Avenue, Villaflor Building, Unit 3, Palanan, Makati City; tel/fax 02-8453248, fax 02-5223663, e-mail: asiadivers@vasia.com; website: www.asiadivers.com
A PADI 5-Star IDC Centre and PADI Career Development Centre, including IANTD Technical Diving, Nitrox, Trimix and Rebreather courses. Established at Small La Laguna Beach in 1987, by Alan Nash and Andy Norman and joined by Tommy Soderstrom in 1988, Asia Divers added their Sabang operation in 1990 and a new one at Small La Laguna Beach in late 1994. Asia Divers trained most of the resort dive masters that now compete with them. Alan Nash is a full PADI Course Director.

Atlantis Hotel Sabang Beach, Puerto Galera, Oriental Mindoro, 5203; tel/fax 43-2873066/fax 43-2873068; e-mail: puertogalera@atlantishotel.com; website: www.atlantishotel.com
PADI, IANTD and TDI training.

Big Apple Dive Resort Sabang Beach, Puerto Galera; tel 43-2873134/ tel/fax 0912-3081120; e-mail: bigapple@pulo.ph; website: www.dive-bigapple.com
PADI 5-Star Gold Palm Resort with courses up to Assistant Instructor plus Nitrox.

Capt'n Greggs Sabang Beach, Puerto Galera; tel 0973-496691, tel/fax 0912-3065267; e-mail: info@captngreggs.com; website: www.captngreggs.com
BSAC and PADI courses up to Assistant Instructor, IANTD Technical Diving and Nitrox courses.

Coral Cove – Neptune's Habitat Inc.
Coral Cove Resort, Puerto Galera; tel 097-371571/fax 2-7533316.

Manila: tel 02-8450674;
e-mail: info@coral-cove.com;
website: www.coral-cove.com
A secluded resort where the diving is run
by Jim Carrol of Scotty's Dive Center in
Cebu; PADI courses up to Assistant
Instructor.

**Fishermen's Cove Beach Resort & Dive
Center** Sto. Niño, Puerto Galera;
tel 0917-5332985/fax 0917-8765902;
e-mail: info@fishermenscove.com;
website: www.fishermenscove.com
Away from the main beaches. Italian-run
with top Italian food.

Frontier Scuba Sabang Beach, Puerto
Galera; tel 43-2873077;
e-mail: fdivers@mozcom.com;
website: www.frontierscuba.com
Rick Kirkham, another highly experienced
operator with knowledge of much of
Philippines diving, is a TDI Instructor Trainer
and PADI Master Instructor. Naturalist, reef
surveying and photography are among the
speciality courses. Whale Shark tours are
also available.

La Laguna Beach Club & Dive Centre
Big La Laguna Beach, Puerto Galera;
tel 0973-855545, tel/fax 0973-878409;
e-mail: lalaguna@llbc.com.ph;
website: www.llbc.com.ph
PADI courses up to Assistant Instructor and
IANTD Technical diving courses on Nitrox,
Trimix and Rebreathers.

Mabuhay Dive Resort Small La Laguna
Beach, tel 43-2873232;
e-mail: info@mabuhay-dive-resort.com;
website: www.mabuhay-dive-resort.com
PADI 5-Star Gold Palm Resort.

Octopus Divers Villa Sabang, PO Box
30413, Sabang Beach, 5203 Puerto Galera,
Oriental Mindoro; tel 43-2873019;
e-mail: info@octopusdivers.org;
website: www.villa-sabang.com
PADI Gold Palm Resort.

Pacific Divers White Beach, Puerto
Galera; tel 916-3728658/
fax 916-2839418;
e-mail: pacificdivers@yahoo.com;
http://pacificdivers.free.fr/p2001001.htm
Away from the popular beaches. PADI
courses up to Assistant Instructor level.

Rudy's Dive Center Small La Laguna Beach,
Puerto Galera; tel 0973-679096/
fax 02-5223663;
e-mail: rudy@rudysdivecenter.com;
website: www.rudysdivecenter.com

PADI Course Director offering Instructor
Development Courses, PADI Nitrox courses.

**Sabang Inn Beach Resort and Dive
Center** Sabang Beach, Puerto Galera;
tel 43-2873198;
e-mail: info@sabang-inn.com;
website: www.sabang-inn.com
PADI courses up to Assistant Instructor.

Scuba World Sabang, Puerto Galera;
tel 43-2873456/fax 43-2873158;
e-mail: pg@scubaworld.com.ph;
website: www.scubaworld.com.ph
An operation of the Scuba World Group,
this PADI 5-Star IDC facility offers courses
up to Assistant Instructor level. TDI Nitrox
and rebreather training.

South Sea Divers Sabang Beach, Puerto
Galera; tel 43-2873052/
fax 0912-3476993;
e-mail: dive@southseadivers.com;
website: www.southseadivers.com
'Sky' Tellman has been around since
1983 and discovered much of the original
diving in the area. PADI courses up to
Advanced Open Water Diver level.

Triton Divers Sabang Beach, Puerto
Galera; tel 43-2873135;
website: www.tritondivers.com
PADI courses up to Assistant Instructor level.

Pandan
Pandan Island Resort 5104 Sablayan,
Occidental Mindoro; tel 919-3057821/
fax 2-5251811;
e-mail: info@pandan.com;
website: www.pandan.com
Manila agent tel 02-5237007;
PADI AND NAUI courses to all levels, diving
at Apo Reef and safaris to the wrecks at
Coron, Busuanga.

DIVING EMERGENCIES

Makati Medical Center 2 Amorsolo
Street, Makati, Metro Manila;
tel 02-8159911/fax 02-8195423

The nearest recompression chamber is at
AFP Medical Center, V. Lunar Road, Quezon
City, Metro Manila; tel 02-9207183.

TIPS ON NIGHT DIVING

- Choose an area with the least wave
 and current action, and with easy
 marks for navigation
- Dive the area during daylight first to
 familiarize yourself with the topography
- The easiest night dives for navigation
 are along reef edges, where you can
 go out and back along the face at
 different depths to give variety
- If there is a current, go out against it
 and back with it
- If you are new to night diving, begin
 with a dusk dive.
- Avoid lights that are too bright, and
 carry a backup; underwater lights are
 notorious for failing
- Rechargeable nickel-cadmium battery
 torches go out suddenly, without
 warning, so use alkaline batteries in
 your backup light
- Set up 2 marker lights in line on the
 beach to find your place of exit from
 the water

LOCAL HIGHLIGHTS

If you tire of water sports and sunbathing,
you can walk to Tamaraw Waterfalls, visit
nomadic Mangyan tribespeople who have
settled at Baclayan and Talipanan, and
look at nearby Python Cave. All are a
short jeepney ride followed by a 2hr walk.
Marble quarrying and gold panning can
be seen near Dulangan (10km; 6 miles), or
you can climb Mt Malisimbo (15km;
9 miles).

Creatures whose colours, patterns and shapes are unsuited to their environment pay the ultimate penalty for being less efficient hunters or easily distinguished prey. Because they have a smaller chance of surviving until sexual maturity, they are unlikely to be able to mate and pass on their genes. But creatures which are correctly 'designed' thrive and multiply. Over millions of years this process of natural selection has produced animals with highly efficient mechanisms that enable them to be effective survivors.

THE BATTLEGROUND

The marine environment, like the terrestrial one, is a constant battleground. Even the natural predators are themselves another species' prey. As divers we can see some of the fantastically ingenious ways in which evolution has patterned, shaped or coloured different species to maximize their chances of perpetuation.

Top: *Parrotfish (Scarus sp.) in cocoon.*
Bottom: *Tassled Scorpionfish
(Scorpaenopsis Oxycephala).*

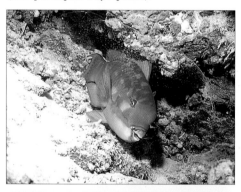

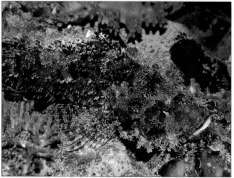

MIRRORED FISH

An obvious coloration of many fish is silvery. The silveriness is produced by iridescent scales, each capable of reflecting one third of the visible spectrum; where three scales overlap, the product is a mirror-like effect, reflecting some of the background and breaking up the image of the fish's outline, so that the fish becomes more difficult for predators or prey to discern. An interesting elaboration of this is the dual coloration, or countershading, of many fish. The source of light underwater is of course the sun overhead. Thus most open-water fish are coloured dark blue, green or grey on top and paler or white underneath. Seen from the side their complicated image tends to blend in with the background; from above they are only poorly contrasted with the darkness of the depths; and seen from below their image tends to get lost in the brilliance from the surface.

Top: *Stonefish (Synanceia Verrucosa).*
Bottom: *Blackback Butterflyfish (Chaetodon
Melannotus).*

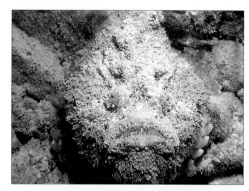

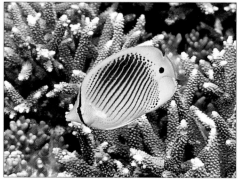

COLOUR CODING

Coral reefs harbour thousands of species of fish and invertebrates, many closely related and thus of similar shape. Clearly it is important that members of a single species should be able to recognize each other – for mating and other purposes – and this is achieved through distinctions of colour and pattern. In the shallow, well-lit waters around the reef most hues are visible, and thus the range of them displayed by the fish can be very wide. Often the creatures are extremely brightly coloured – this fact is one of the main reasons why divers dive! – with very obvious coloration differences between the species. Colours may become yet brighter at breeding time to attract mates. A bold, easily distinguishable colour may also serve as a warning to potential predators that the creature tastes awful or is toxic; some perfectly innocuous fish mimic the same colours as other, poisonous species. In addition, juvenile fish may go through many changes of shape and colour pattern to advertise that they are no threat to their mature counterparts.

CAMOUFLAGE

Many marine animals can vary their colour. This is effected through signals from the central nervous system causing muscles to expand sacs (chromatophores) of black, yellow and yellow-orange pigment that lie beneath the skin; reinforcing the black are bodies called iridocytes, which reflect greenish light. By using a combination of pigments, the fish can change – often quite rapidly – to match most colours. In their relaxed state the sacs are barely visible; if, however, all the creature's yellow sacs (say) are expanded, the creature appears yellow-bodied. Cephalopods can change their colour fastest of all, and octopuses can supplement this by raising bumps on their skin.

Stonefish are among those species that change colour to match their background – they also allow algae to grow on them as further camouflage. As with cuttlefish and squid, the stonefish's camouflage is for predatory purposes: unsuspecting prey come near enough to be caught. More usually camouflage is both defensive and offensive. Frogfish, for example, can be bright red, canary-yellow, orange, brown or black, while some have a spotted pattern. Each version is capable of exactly mimicking a locally prevalent sponge. Comparatively safe from predation, the frogfish extends a lure which it wiggles about, thereby attracting the smaller fish that are its own prey.

MIMICKING

The possibilities are legion. Razorfish hang vertically in shoals to mimic whip corals, while trumpetfish hide among those corals by adopting the same vertical position. Predatory hawkfish hide on corals and gorgonians of similar colours and patterns to themselves. Ghost Pipefish reproduce the colour and shape of algae. Lionfish can easily be mistaken for feather stars. Leaf Scorpionfish look like leaves, and the Mimic Blenny has managed to produce a fairly convincing impersonation of the Cleaner Wrasse. The Crocodilefish not only can change body colour and patterning but has a protective lacy covering that effectively camouflages its eyes.

Many patterns contain false eyes or stripes at the fish's rear, a deceptive effect further enhanced by stripes or masks appearing around the creature's real eyes. A predator pouncing at what it believes to be the head of the prey is thus likely to be snapping at the tail; since fish swim mostly forwards, not backwards, the potential prey has the maximum chance of escaping the encounter unscathed or, at the very least, having suffered only cosmetic damage – this is why fish with chunks of their tails missing are such a common sight.

Finally, one very simple colouring effect provides an extremely useful form of visual deception. Many fish that normally inhabit dark places – in the depths, in caves, or in the shade under corals or overhangs – are red. Water disproportionately filters out the red end of the spectrum. The consequence is that these fish appear grey or black against the dark background of their chosen habitats.

PALAWAN

Palawan is one of the Philippines' last frontiers – still relatively undeveloped, it offers spectacular landscapes, world-class diving and a wildlife that has more in common with nearby Borneo than that of the other Philippine islands. Borneo and Palawan would have been connected by a land bridge during the last Ice Age.

The Coron Wrecks

Busuanga is the largest island in the Calamian Group, covering some 900 square miles. The island is home to a game reserve and wildlife sanctuary, as well as being the pathway to some truly outstanding dive sites. Fishing, farming and cottage industries are the main activities of the islanders although the improvement of travel links to the island is now showing results and Busuanga is gradually receiving tourists.

The World War II wrecks around Busuanga Island, particularly in Coron Bay, have been one of Philippine diving's best-kept secrets. Here is a condensed version of Truk Lagoon in the Caroline Islands, Micronesia – a legendary (and, unfortunately, expensive) destination among divers for its large concentration of World War II Japanese wrecks. Admittedly the Coron sites are not easy to get to and accommodation is limited, but the area is rewarding to visit and prices are reasonable. The visibility is not brilliant, but the wrecks are not that deep and the currents not that strong, though it is always best to choose neap tides and, if possible, slack water.

Twelve wrecks have so far been located in diveable depths, though those nearest to the Busuanga mainland suffer from poor visibility due to water run-off and plankton bloom. Most of the wrecks are long day trips from Coron Town, and some are best treated as an overnight trip, so you are not likely to dive here in really bad weather, though you can dive quite happily in heavy rain. The deeper wrecks have many fishing nets caught on them, so approach these with care.

Opposite: *Beautiful Coron Island has many secluded coves with fine beaches.*
Above: *Staghorn coral (Acropora humilis) flourishing in a sheltered corner of the reef.*

Early research on some of these vessels was done by wreck expert Brian Homan. More recently, in 1993-4, Peter Heimstaedt and Mike Rohringer from Germany did extensive research both on the wrecks themselves and in Japan, through the Military History Department of the Japanese National Institute for Defence Studies in Tokyo. Heimstaedt, a former officer in the Federal German Navy, is currently writing up this research.

The scenery of Coron Island's limestone cliffs and tiny isolated beach coves is spectacular, as is that around its freshwater lakes. The diving is not confined exclusively to the wrecks, though these are the reason most divers would come here. Due mainly to typhoon damage, the coral is not that spectacular, but there is some perfect snorkelling to be had where it is good. Areas near to seven pearl farms, a fish farm and lobster farm are patrolled by armed security guards against illegal fishing.

One of the freshwater lakes contains a hot spring and is only a short climb over limestone pinnacles from the sea. In it you find creatures of both salt and fresh water, plus a lone habituated barracuda nearly 1m (40in) long; as you go deeper, the water gets hotter. There is also a delightful hidden cavern to explore, with an underwater entrance to the sea.

The diving is best from October to May. All access details given in the following site descriptions are from Coron Town.

> **ORIGIN OF THE CORON WRECKS**
>
> In 1944 US Admiral 'Bull' Halsey had the task of checking out the Japanese firepower in preparation for the US landing on Leyte. To find safe passage for an aircraft carrier, he sent reconnaissance aircraft to photograph the Linapacan Strait and the Calamian group of islands. This resulted in a mapping officer noticing that some of the islands were moving about – a camouflaged Japanese fleet had been found.
>
> At 0900 hours on 24 September 1944 Task Force 45 carrier-based bombers attacked and sank 24 vessels around Busuanga and Coron Islands.

Opposite: *Dendronephthya soft tree corals, a gorgonian sea fan (Melithaea squamata) and a feather star together make a delightful 'garden'.*

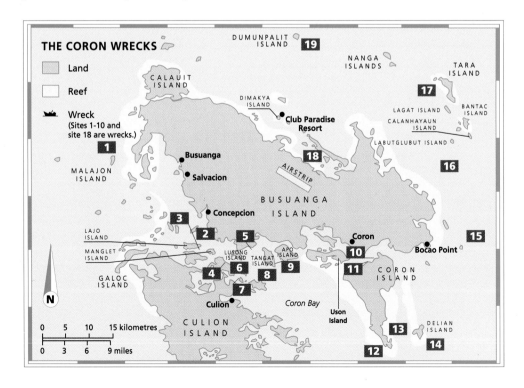

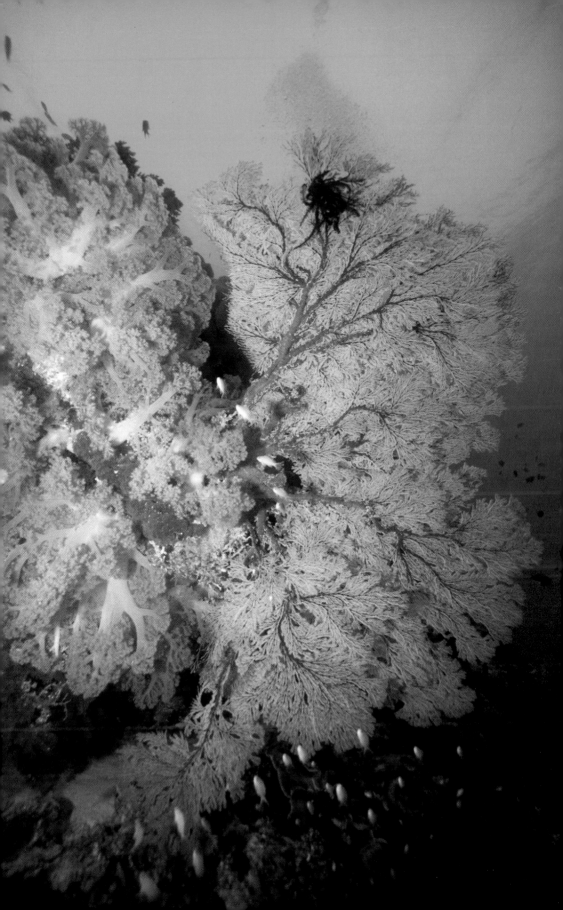

1 NANSHIN MARU

★★★★★

 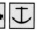

Location: The east side of Malajon Island, called Black Island because of its black rocks. The wreck is just off the beach in front of a stranded vessel on the shore.

Access: By *banca* 3–5hr west to the west side of Busuanga Island. If you are going to dive on other wrecks en route, you can stay overnight at the little resort of Las Hamacas resort.

Conditions: Normally calm with little current, but this area, out in the South China Sea, does not have protection like Coron Bay, so conditions can get rough with fierce currents. You would not normally make this journey in bad conditions. Visibility can reach 20m (65ft).

Average depth: 20m (65ft)
Maximum depth: 32m (104ft)

The origin of this 45m (150ft) coastal vessel is not known. It sits upright but down the sandy slope from the shore, with the bow bottoming at 32m (104ft) and the stern bottoming at 20m (65ft).

Relatively shallow, this dive is great for wreck-diving novices, photographers and night divers, and has plenty of fish. There are many large scorpionfish and lionfish on the superstructure, small shoals of batfish, large shoals of sweepers, snappers, fusiliers and groupers, trumpetfish, Six-banded Angelfish and Emperor Angelfish. The hull has lots of sponges and hydroids. There are crinoids, although not in the numbers seen elsewhere in the Philippines. The western side of Malajon Island has poor corals but at times of strong currents is good for sighting large pelagic species, including Hammerhead Sharks.

2 TAIEI MARU/OKIKAWA MARU

★★★★★

Location: South of Concepcion village on Busuanga Island, on the outer edge of the Lusteveco Company Pearl Farm. This wreck no longer breaks the surface.

Access: 2¹⁄₂hr by *banca* west until south of Concepcion village, on the edge of the buoys of the pearl farm.

Conditions: Normally calm but fierce currents are common. Novices should check the tide tables first and penetrate the wreck only with an experienced divemaster. Use the shotline for descent and a safety stop on ascent. Visibility 10m (33ft) to 20m (65ft).

Average depth: 16m (52ft)
Maximum depth: 26m (85ft)

An auxiliary oil tanker of the Imperial Japanese Navy Combined Fleet in World War II, this wreck, 168m (550ft) long, 10,045 gross tons, was sunk on 9 October 1944 by US aircraft. Some recent research suggests it

may be the *Okikawa Maru*. In any case it sits almost level, with a slight list to port, pointing 330° (compass bearing), with the bow broken off in 26m (75ft) of water. The main deck is at 16m (52ft). A good wreck for penetration and wreck-diving courses, it has everything, including good corals (very large lettuce corals), sponges and shoals of fish such as fusiliers, snappers and batfish, plus the ubiquitous lionfish and scorpionfish.

3 AKITSUSHIMA

★★★★★

Location: Between Lajo Island and Manglet Island, south of Concepcion village on Busuanga Island.

Access: 2¹⁄₂hr west by *banca*.

Conditions: Normally calm but with some strong currents. Not a dive for novices. Visibility 10m (33ft) to 20m (65ft).

Average depth: 28m (92ft)
Maximum depth: 38m (125ft)

One of the few true warships among the Coron wrecks (the others were mostly auxiliary vessels), the *Akitsushima*, sunk on 24 September 1944 by US aircraft, was a flying boat tender. The wreck (148m [487ft] long, 4650 gross tons) lies on its port side pointing 290° (compass bearing) in 38m (125ft) of water, with the starboard side hull at 20m (65ft). The arm of the stern crane used to load and unload the flying boat lies broken to port in 34m (112ft). The main deck is split between this crane and the funnel. There is no sign of the flying boat.

This is an advanced dive due to the depth. The ship can be penetrated with care, but is also good for fish life. Large groupers lurk in the hull and shoals of barracuda, tuna and snapper are found along it.

4 GUNBOAT AT LUSONG ISLAND

★★★★★★★★★

Location: The southern end of Lusong Island.

Access: 2hr west by *banca*. The stern breaks the surface at low tide.

Conditions: Clear, calm, shallow water. Visibility can reach 30m (100ft).

Average depth: 6m (20ft)
Maximum depth: 10m (33ft)

A shallow wreck, lying from the surface to 10m (33ft), this is equally good for snorkelling and wreck photography, and is often used as a relaxation between main dives. The wreck has been salvaged, and all the top has gone. It is nicely covered with sponges and soft corals, and has many Copperband Butterflyfish, Six-banded Angelfish, pufferfish of all sizes, batfish and various sea

cucumbers. The lack of crinoids and sea stars is perhaps surprising. There is also good snorkelling on the reef beside the wreck.

5 UNKNOWN WRECK

★★★★★

Location: Between the northern end of Lusong Island and Tangat Island.
Access: 2hr west by *banca*.
Conditions: Normally calm with some current, even in a heavy rainstorm, which I could hear while deep in the wreck. Visibility 10m (33ft) to 20m (65ft).
Average depth: 19m (62ft)
Maximum depth: 25m (80ft)
This Japanese freighter – 137m (450ft) long, 5617 gross tons – was sunk by US aircraft on 24 September 1944. It lies on its starboard side pointing 050° (compass bearing) in 25m (80ft) of water. The port-side hull is at a shallower 12m (40ft).

This is a pretty dive. The port-side hull has many large lettuce corals, hydroids, black corals, brown finger sponges with Alabaster Sea Cucumbers wrapped around them, white sponges and sea anemones with clownfish. The fish life includes shoals of small fusiliers, batfish, large groupers, Golden Rabbitfish, damselfish and pairs of Whitecheek Monocle Bream. Be careful when penetrating the wreck: scorpionfish hide all over it.

6 KOGYO MARU

★★★★★

Location: East of the southeast corner of Lusong Island, south of Site 5.
Access: 2hr west by *banca*.
Conditions: Normally calm with some current. Visibility 10m (33ft) to 20m (65ft).
Average depth: 28m (92ft)
Maximum depth: 34m (110ft)
A Japanese freighter sunk on 24 September 1944 by US aircraft, this wreck – 158m (520ft) long, 6352 gross tons – lies on its starboard side pointing 230° (compass bearing) in 34m (110ft) of water. The port-side hull is at 22m (72ft). This is a very similar dive to that at Site 5, but deeper, giving you less time to explore the wreck and less light for photography.

The `fishing boat' wreck off Coron Island is an ideal novices' dive.

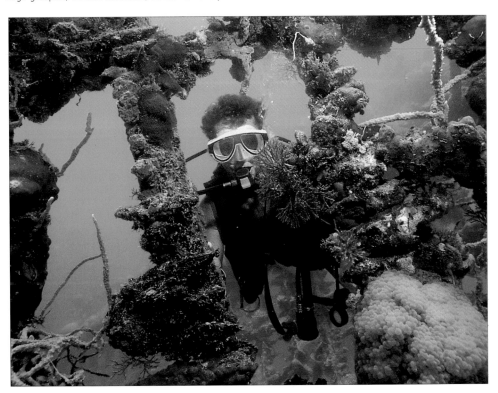

7 IRAKO

★★★★★

Location: Southeast of Lusong island.
Access: 2hr west by *banca*.
Conditions: Normally calm with some strong currents. Visibility 10m (33ft) to 20m (65ft).
Average depth: 35m (115ft)
Maximum depth: 42m (138ft)
The *Irako* is a Japanese refrigerated provision ship, sunk on 24 September 1944 by US aircraft; 147m (482ft) long, 9570 gross tons, the wreck is almost upright, listing about 10° to port in 42m (138ft) of water pointing 260° (compass bearing). The main deck is at 34m (112ft). Penetration represents an advanced dive due to the depth, but the superstructure is interesting, with soft corals and sponges. Large groupers hover inside the wreck, while lionfish, shoals of barracuda and batfish are outside it.

8 OLYMPIA MARU

★★★★★

Location: West of the southwest end of Tangat Island.
Access: 1³/4hr west by *banca*.
Conditions: Normally calm, with light currents that can be strong at spring tides. When I was there conditions stayed calm after a rainstorm. Visibility 8m (25ft) to 15m (50ft).

Below: *A lionfish on the* Nanshin Maru *wreck.*

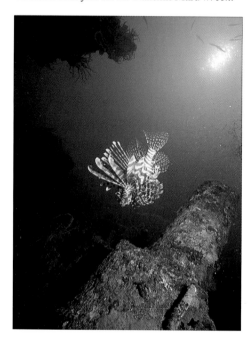

Average depth: 19m (62ft)
Maximum depth: 25m (80ft)
Yet another Japanese freighter sunk on 24 September 1944 by US aircraft. Some 137m (450ft) long, 5617 gross tons, the wreck lies on its starboard side in 25m (80ft) of water. The port side hull is at 12m (40ft).
It provides a good introduction to wreck diving for novices. There are several large pufferfish, lots of large lionfish and scorpionfish, Bumphead Parrotfish, shoals of batfish, snappers and sweepers, Six-banded Angelfish, Golden Rabbitfish, damselfish and pairs of Whitecheek Monocle Bream and lots of sponges. In good visibility this would be a good wreck for photographers.

9 EAST TANGAT WRECK

★★★☆☆☆

Location: Close to the southwest side of Tangat Island.
Access: 1¹/2hr west by *banca*.
Conditions: Shallow calm water. Visibility 8m (25ft) to 15m (50ft).
Average depth: 10m (33ft)
Maximum depth: 22m (72ft)
Believed to be either a tugboat or an anti-submarine craft, this was sunk on 24 September 1944 by US air-craft; 40m (130ft) long, 500 gross tons, it lies listing to starboard down a sandy slope, with the stern at 22m (72ft) and the top of the bow at 3m (10ft), pointing 320° (compass bearing). This small wreck looks as though it has seen some recent salvage work. The water is mostly shallow enough for snorkellers, good for novices and photographers and for relaxation between dives.
There are no corals on the wreck, but there are large lettuce corals beside it. There are angelfish, butterflyfish – particularly Copperband Butterflyfish – and white sponges. Crinoids and sea stars are conspicuous by their absence.

10 CORON ISLAND – FISHING BOAT

★★★★☆☆☆☆☆

Location: A few hundred metres southwest of the entrance cove to the freshwater Barracuda Lake, which is midway between Limaa Point and Balolo Point on the northwest face of Coron Island.
Access: 45min south–southeast by *banca*.
Conditions: Shallow and calm with almost no current. Visibility 10m (33ft) to 25m (80ft).
Average depth: 4–8m (13–25ft)
Maximum depth: 12m (40ft)
There are several dive/snorkel sites here, with a beautiful background of limestone rock formations, and sandy coves for picnics and sunbathing between dives. Most of the sites are shallow coral gardens, one around a limestone pinnacle which rises several metres above the water. Against the point are the remaining ribs and part of the hull of an old

wooden boat, 35m (115ft) long, that go down to 12m (40ft). This is an ideal site for photography, the wreck itself being inhabited by sponges, sea stars, butterflyfish, shoals of fry and shoals of immature barracuda. It is perfect for novices' first dives and also good for night dives.

11 CAYANGAN LAKE (BARRACUDA LAKE)

★★★★★☆☆☆☆☆

Location: 30m (100ft) inland from the centre of the northwest face of Coron Island.
Access: 45min south–southeast by *banca* to a cove of lime-stone cliffs midway between Limaa Point and Balolo Point on the northwest face of Coron Island. In the centre of the cove the cliffs have a gap at sea level. You climb through this gap for 3m (10ft), turn right and climb easily up lime-stone pinnacles for 8m (25ft), traverse to the right 4m (13ft), then turn left and descend, continuing across two small channels to the entrance to the lake. The rock is sharp, so you will need to wear bootees or sandals.
Conditions: Calm lake, sheltered on all sides. Visibility varies with the mixing of hot and cold water, being 30m (100ft) near the surface but hazy where the water mixes.
Average depth: Whatever you like
Maximum depth: 40m (130ft) plus
This is a unique dive. The turquoise freshwater lake, sur-rounded by spectacular limestone pinnacles, is served by a hot spring. As you move out from the walls and descend, the water gets hotter and hotter. At 30m (100ft) my ther-mometer read 40°C (105°F) and deeper down would have gone even higher. There is little to see in the very hot water, but when you get back to the walls of the lake, a lone habituated barracuda, nearly 1m (40in) long, will be waiting to be hand-fed.

There is obviously interaction between fresh and salt water around the seaward side, as you can find sea-water species there. As well as the barracuda there are a small shoal of Golden Rabbitfish, some snappers, catfish, several species of shrimp and shellfish.

In 1990, while filming in the lake, Brian Homan and his search company, ASR, found a neolithic campsite, complete with jade axe-heads, at 5m (16ft), and a further site on the upper slope that may be 5000 years old.

12 CORAL GARDEN

★★★★★☆☆☆☆☆

Location: A few hundred metres northwest of Calis Point, the south point of Coron Island.
Access: 2hr south by *banca*.
Conditions: Calm water, by the cliffs and coves at the southwest end of Coron Island. Visibility up to 25m (80ft).
Average depth: Whatever you like
Maximum depth: 40m (130ft) plus

You first enter a beautiful shallow coral garden at 4m (13ft), then go over the drop-off to 40m (130ft) plus. The shallow reef-top is covered with stony, leathery and soft corals, including very large Acropora table corals and some small gorgonians. There are plenty of small reef fish, Linckia sea stars (blue and grey) and anemones with clownfish.

Over the drop-off are more table corals, some fire corals, stinging hydroids, Dendronephthya soft tree corals, whip corals and many small gorgonian sea fans.

13 GUNTER'S CATHEDRAL

★★★★★

Location: Gunter, of Discovery Divers (see page 87), prefers to keep this secret, but his *banca* crews know where it is and will soon pass the information on. The entrance is north-northeast of Calis Point on Coron Island, where several undercut limestone cliffs lead to small caves and keyholes. Having found the large cave entrance, the secret is finding a narrow channel in the floor that leads to the Cathedral cavern.
Access: 2hr south by *banca* to just northeast of Calis Point.
Conditions: Normally calm with good visibility, but clumsy divers or changes in tides can stir up the silt inside making it hard to find the exit. Visibility 0m (0ft) to 20m (65ft).
Average depth: 8m (25ft)
Maximum depth: 13.5m (44ft)
This is another unique dive! You swim to a large cavern entrance, over coral-encrusted fallen rocks. The bottom of this main entrance is at 7m (23ft) to 8m (26ft). You then descend an apparently dead-end narrow cleft in the floor of this cavern, find a tunnel at the bottom, continue through this, admiring the many Spiny Lobsters and cowrie shells, and continue towards a gleam of light ahead. You come out at the bottom of a chamber some 20m (65ft) high and slightly narrower in width.

This 'Cathedral' is beautiful, particularly when shafts of sunlight descend vertically through the water from a large hole in the roof where a large tree grew until it broke through and fell into the chamber. The chamber itself is about one-third full of water, so you can rise to the surface and chat to each other in air.

Finding your way out again can become difficult if the sediment at the bottom of the chamber is stirred up.

14 DELIAN ISLAND – NORTH & SOUTH

★★★☆☆☆

Location: Delian Island, 5km (3 miles) east-northeast of Calis Point on Coron Island.
Access: 2hr south by *banca*.
Conditions: You would come here only in calm condi-tions. Visibility can reach 25m (80ft).
Average depth: 8m (25ft)
Maximum depth: 25m (80ft)

The north and south ends of this island give good snorkelling or shallow diving over coral gardens with many small reef fish and shoals of immature fish.

15 FRAMJEE BANK

★★★☆☆☆

Location: 19km (12 miles) east of Bocao Point, the southeast extremity of Busuanga Island.
Access: 2½hr east by *banca*. This is a sunken bank in 5m (16ft) of water so it can be rather difficult to find without either a local boatman or GPS (Global Positioning System).
Conditions: You would make this journey only in calm conditions and would expect strong currents. Visibility can reach 30m (100ft).
Average depth: 15m (50ft)
Maximum depth: 40m (130ft) plus
The site begins with a gentle slope of corals to 25m (80ft), where it becomes sand sloping out to infinity. The corals are not too good. This is a dive for when the currents are running and large pelagic species come in to feed. Sharks, tuna, Rainbow Runners and trevallies are common.

16 BROWN ROCKS (BUTULAN ROCKS)

★★★☆☆☆

Location: Two brown rocks 50m (163ft) high, 2km (1¼miles) south of Bantac, Calanhayaun and Lubutglubut Islands, 37km (23 miles) southeast of Coconogon Point, which is the northeast point of Busuanga Island.
Access: 3hr journey by *banca* around the east coast of Busuanga Island.
Conditions: You would make this journey only in calm conditions. Visibility can reach 25m (80ft).
Average depth: 18m (60ft)
Maximum depth: 25m (80ft)
The best diving is on the west, south and east sides of the southern rock, and the best snorkelling on the west side. With coral gardens sloping down to 25m (80ft), the area is a breeding ground for Cuttlefish. There are lots of reef fish and occasionally Hammerhead Sharks.

17 TARA ISLAND – WEST SIDE

★★★

Location: Opposite the village on the west side of Tara Island, 7km (4½ miles) southeast of the Nanga Islands, 29km (18 miles) northeast of Coconogon Point, the northeast extremity of Busuanga Island.
Access: 4–5hr in an overnight trip by *banca* around the east side of Busuanga Island.

Conditions: You would make this journey only in calm conditions. Currents are normally light. Visibility can reach 25m (80ft).
Average depth: 20m (65ft)
Maximum depth: 30m (100ft)
The corals have been heavily blast-fished, but despite the light currents, pelagic fish are common, including jacks, tuna, trevallies and Spanish Mackerel. Whitetip Reef Sharks are common and Guitar Sharks can be found on the sand. The island houses a Vietnamese refugee camp.

18 KYOKUZAN MARU (DIMILANTA WRECK)

★★★★★

Location: Close to the Club Paradise Resort, which is located on Dimakya Island (also known as Eric's Island after its owner).
Access: By *banca* from Club Paradise or overnight from Coron Town around the east coast of Busuanga Island to its north coast, southwest of Coconogon Point.
Conditions: Normally calm with medium currents and generally better visibility than the wrecks to the south of Busuanga Island. Visibility is often around 20m (65ft).
Average depth: 30m (100ft)
Maximum depth: 43m (131ft)
A Japanese freighter sunk on 24 September 1944 by US aircraft, the ship (152m [500ft] long, 6492 gross tons) sits almost upright with a 15° list to starboard, pointing 160° (compass bearing) in 43m (131ft) of water. The main deck slopes from 22m (72ft) to 28m (92ft). The wreck is almost intact and easily penetrated, with cars and trucks in the holds. An excellent dive. This site is also known as the Dimalanta Wreck, as it lies close to and in the shelter of Dimalanta Island.

19 DUMUNPALIT ISLAND – SOUTHWEST

★★★

Location: The southwest side of Dumunpalit Island, 45km (28 miles) north of Port Carlton.
Access: 5–6hr (in calm conditions) by *banca* around Busuanga Island.
Conditions: Relatively sheltered. Can be dived all year round if the sea conditions allow boats to reach it. Visibility averages 20m (65ft).
Average depth: 15m (50ft)
Maximum depth: 25m (80ft)
With a gentle slope from the shore to 25m (80ft), the site is unusual in the area for having pink soft corals. At 25m (80ft) the slope becomes sand with intermittent coral heads, among which groupers and snappers are common. Visiting pelagic species are found on the slope.

HOW TO GET THERE

The little dirt airstrip on the Yulo King Ranch is served by Air Ads, Asian Spirit, Pacific Air and Sea Air. Checked baggage allowance is 10kg (22lb) – you will be charged for extra.

If you are using Club Paradise/Maricaban Bay Marina Resort, they will meet your flight and transfer you by jeepney to Maricaban Bay or to a 450m (500yd) foot-bridge over a mangrove swamp, followed by a 45min *banca* ride to Club Paradise on Dimakya Island.

If you are heading for Coron Town, you board one of the waiting jeepneys for a dusty 45min ride, mostly on dirt tracks. Coron Town is small. If there are several of you they will drop you at your destination, otherwise you will be dropped in the centre of town, from where you can pick up motorized tricycles.

There are now good ferry connections from Manila, which are useful to divers as there is no baggage limit or worries about flying after diving. The WG & A Super Ferry 3 leaves from Manila's Pier 4 and takes 12hr, while MBRS Lines leaves from Manila's Pier 8 and takes 14hr. There are also boats from Batangas and Taytay.

WHERE TO STAY

Upper Price Range
Club Paradise on Dimakya Island Manila Booking Office: Regent Building, Malunggay Road, FTI Complex, Metro Manila 1604; tel 2-8384956/fax 2-8384462; e-mail: reservations@clubparadisepalawan.com; website: www.clubparadisepalawan.com A quality resort with landscaped gardens and Calamian Deer on a 19ha (47-acre) island.

Medium Price Range
Maricaban Bay Marina Resort Situated on nearby mainland Busuanga. Now managed by Mariposa Travel International Corporation, Ground Floor, Eastgate Centre Building, 169 EDSA, Mandaluyong City; tel 2-5336120/fax 2-5343223; e-mail: inquiry@mariposa-travel.com; website: www.mariposa-travel.com

Sangat Island Reserve Sangat Island, Coron Bay; tel 919-2050198; e-mail: andy@sangat.com.ph; website: www.sangat.com.ph Eco-tourism beach resort in Coron Bay, with fascinating wildlife including large monitor lizards around the outbuildings.

Lower Price Range
Bayside Divers Lodge at Coron Coron, Busuanga; e-mail: info@abcdive.com; website: www.abcdive.com On the waterfront, with bar and good restaurant.

Discovery Divers Scuba & Technical Diving Center & Resort Decanituan Island,
Barangay 5, Coron; tel/fax 02-9124868; e-mail: info@ddivers.com; website: www.ddivers.com An island just offshore of Coron Town with a full shuttle service at any time.

Kokos Nuss RP-5316 Coron, Palawan; tel 0919-4487879; e-mail: info@kokosnuss.info; website: www.kokosnuss.info Just outside Coron town on the road to the airstrip. Nipa palm huts in a garden setting, with a small restaurant.

WHERE TO EAT

You would normally eat at the accommodation you are using.

DIVE FACILITIES

ABC Dive/MY Maribeth ABC Dive Coron, Bayside Divers Lodge, Coron 5316, Busuanga; e-mail: info@abcdive.com; website: www.abcdive.com Live-aboard dive safaris, PADI courses and Nitrox training.

Club Paradise Manila Booking Office: Regent Building, Malunggay Road, FTI Complex, Metro Manila 1604; tel 2-8384956/fax 2-8384462; e-mail: reservations@clubparadisepalawan.com; website: www.clubparadisepalawan.com PADI courses up to Assistant Instructor and IANTD Nitrox courses. As well as the main Coron dive sites and wrecks, Club Paradise have a number of local dive sites, trips to Apo Reef and one of the best house reefs in the Philippines. Also regular sightings of Dugongs.

Discovery Divers Scuba & Technical Diving Center & Resort Decanituan Island, Barangay 5, Coron; tel/fax 02-9124868; e-mail: info@ddivers.com; website: www.ddivers.com Wreck fanatic Gunter Bernert is one of the original local experts, operating since 1989. PADI courses to Assistant Instructor, TDI Technical diving from Nitrox Diver to Advanced Wreck Diver and diving safaris.

Dive Right Coron; e-mail: diveright@mozcom.com; website: www2.mozcom.com/~diving PADI courses to Advanced Open Water and PADI Nitrox Diver.

Lamud Island Resort Coron, Busuanga; tel 0921-2170404; e-mail: dive@lamudisland.info; website: www.lamudisland.info

Maricaban Bay Marina Resort Now managed by Mariposa Travel International Corporation, Ground Floor, Eastgate Centre Building, 169 EDSA, Mandaluyong City; tel 2-5336120/fax 2-5343223; e-mail: inquiry@mariposa-travel.com; website: www.mariposa-travel.com

PADI courses up to Assistant Instructor and IANTD Nitrox courses. As well as the main Coron dive sites and wrecks, there are a number of local dive sites and trips to Apo Reef.

Sangat Island Reserve Sangat Island, Coron Bay; tel 919-2050198; e-mail: andy@sangat.com.ph; website: www.sangat.com.ph PADI courses up to Advanced Open Water and IANTD Nitrox courses.

DIVING EMERGENCIES

There is a small clinic in Coron Town, but you would be best off returning to Manila:

Makati Medical Center 21 Amorsolo Street, Makati, Metro Manila; tel 02-8159911/fax 02-8195423 A private hospital, considered to be the best.

The nearest recompression chamber is in Manila: **AFP Medical Center**, V. Lunar Road, Quezon City, Metro Manila; tel 02-9207183.

LOCAL HIGHLIGHTS

Apart from the area's many islands, beautiful sandy coves and striking limestone rock formations, Coron Island has lakes, forests and hot springs. Makinit Hot Springs is one of the best in the Philippines; you can soak in two hot sulphurous pools, then cross 5m (16ft) of beach to cool off in the sea. Lake Abuyok, 110m (360ft) deep, is worth a visit. Coron island also has some Tagbanua – semi-nomads of Negrito descent.

On Busuanga, the Yulo King Ranch (40,000ha [99,000 acres]) was the largest cattle ranch in Southeast Asia. There are waterfalls near Concepcion and, at the northwest of the island, Calauit has a collection of African animals plus animals endemic to the Philippines.

At Club Paradise on Dimakya Island, Dugongs are regularly spotted feeding on the sea-grasses off the docking area. After the Dugongs settle down, clients are ferried to the site and allowed into the shallow water. WWF-Philippines are studying the Dugongs and the sea-grasses that they feed on here.

El Nido and Taytay Bay

The northern part of Palawan has hundreds of tiny, picturesque islands, which cover the richest fishing areas in the Philippines. Those either side of the main island are often reminiscent of southwest Thailand, combining sheer cliffs rising out of the water and white sandy beaches.

El Nido on the west side of northern Palawan and Taytay on the east are among the remotest areas to get to in the Philippines – most tourists get there by using the small aircraft that serve the two tourist complexes of Ten Knots El Nido and Club Noah Isabelle.

El Nido, formally called Bacuit, is the most northerly town on mainland Palawan. The spectacular scenery here is among the best in the Philippines, but apart from fishing and the collection of swiftlets' nests, the local people exist on subsistence agriculture. As in southwest Thailand and Borneo, the swiftlets' nests, which are made from the birds' saliva, are collected for use in the making of bird's nest soup.

Taytay is remote nowadays but was not so out-of-the-way in the past. When southern Palawan was ruled by the Islamic Sultan of Borneo via Jolo, Taytay was the Spaniards' provincial capital – founded in 1622 and then known as Estrella del Norte. An old church and the ruins of a stone fort still remain. Taytay is otherwise known for its squid fishing and cashew nut harvest.

Although this is not an area notable for its diving opportunities, there are a number of good dive sites in Taytay Bay and most likely more to be found. The ban on fishing within one mile (2km) of Apulit Island has had a beneficial effect on nearby sites, with larger species and food species now common. Two resorts in the region currently merit special attention.

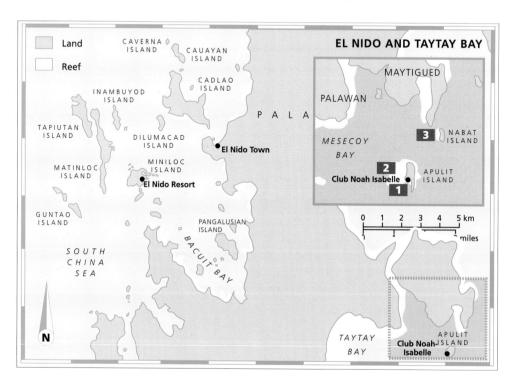

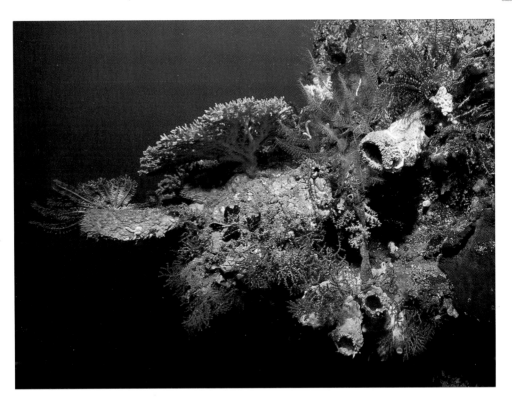

EL NIDO

The Ten Knots El Nido Resort on Miniloc Island, west of El Nido in the South China Sea, is another expensive resort in a beautiful setting. At the time of writing the resort was going through a change in its local managing company. It offers diving as part of a spectrum of other facilities.

TAYTAY BAY

Noah Century, whose staff used to manage the El Nido Resort off the northwest coast of Palawan, now run Club Noah Isabelle on the Dragon Island of Apulit, in Taytay Bay, northeast Palawan. Headed by Tommy Lopez, one of the pioneers of Philippines diving, Noah Century has a strong commitment to ecotourism and preservation of the marine environment: 10% of the resort's annual income goes to active management of the island ecosystems and the conservation of the remaining Dugong population. Japan's Toba Aquarium, which is noted for its scientific studies on endangered species, has set up an Earth Station at Isabelle. The islands in Taytay Bay are known for turtles laying eggs in November and December and no fishing is allowed within one mile (2km) of the island.

A colourful mix of stony corals, sponges and feather stars.

DUGONGS

Dugongs (*Dugong dugong*), known also as 'sea-cows', are herbivorous marine mammals found in reasonable quantities around Australia. Very few survive in the Indian and Pacific Oceans; those that occur normally do so between latitudes 30°N and 30°S. They are slow to reach sexual maturity, give birth to only one calf at a time, have a gestation period of 12 months and take several years between births.

The numbers of these shy lumbering animals have been decimated by hunters, for their good-tasting meat, and, in rivers used by man for recreation, by speedboats. The related Steller's Sea Cow (*Hydrodamalis stelleri*) was the largest marine mammal of cold waters. Within a mere 27 years of its discovery in Alaska it had been hunted to extinction. Worldwide, the remaining dugongs are sorely in need of effective protection.

GIANT WRASSE

Wrasse are the most diverse of fish, with some 300 species ranging from the 2cm (³/₄ in) *Minilabrus striatus* to the immense Humphead Wrasse (*Cheilinus undulatus*), which have been caught measuring 2.3m (7¹/₂ft) long and weighing 190kg (420 pounds). Wrasse are usually brightly coloured and often change colour and from female to male as they grow from juvenile through intermediate phase to terminal phase. Once sex reversal occurs, males set up territories and maintain a harem of females.

Humphead Wrasse are diurnal, hiding in caves and hollows at night. Blue-green in colour, they darken with age; terminal males develop a pronounced hump on their forehead. They are carnivorous, having prominent canine teeth adapted to pull molluscs off rocks or seize crustaceans, urchins and other invertebrates, which are then crushed with their pharyngeal teeth. At the moment of predation, the jaw is extended forward – catching out many divers, who find themselves scarred after feeding eggs to wrasse!

But spare your sympathies: the divers shouldn't have been fish-feeding in the first place.

1 APULIT FRONT

★★★★★

Location: Around and to the east of the floating platform that is approximately 140m (150yd) south of Club Noah Isabelle's main boat pier.
Access: A few minutes by boat or swimming from the resort pier.
Conditions: Calm and sheltered.
Average depth: 14m (45ft)
Maximum depth: 24m (79ft)
Whatever environmentalists may think of fish-feeding, it has been regularly conducted here using fish scraps. The result is an impressive gathering of unusually large fish, seven Napoleon Wrasse, many Marble, Peacock and Coral Groupers, jacks and trevallies as well as angelfish, sweetlips, batfish, snappers, rabbitfish, Bluespotted Ribbontail Rays and a multitude of smaller fish.

Around the floating platform the water is quite shallow, but east of the stage there are several deeper canyons where you will find *Acropora* table corals, staghorn corals, lettuce corals and patches of seagrass above, as well as larger Marble Groupers deeper down. Being so shallow, if you swim away from the platform following gullies full of interesting and tame fish, you can end up a long way from the jetty when you finally surface, so it is best to warn the boat so that they look out to pick you up.

2 GHOSTING

★★★

Location: West of the west beach of Apulit Island
Access: 15min by speedboat from Club Noah Isabelle's main boat pier.
Conditions: Normally calm, though it can sometimes get choppy.
Average depth: 9m (30ft)
Maximum depth: 15m (50ft)
This is a submerged reef with a fairly flat top at depths varying between 6m (20ft) and 15m (50ft), where it descends to sand. There are signs that the reef is recovering from blast fishing, with lots of leathery sponges in evidence and a surprising amount of medium sized and small fish. Jacks, trevallies, parrotfish, surgeonfish, pufferfish, sweetlips, fusiliers, Red Breasted Wrasse, crocodilefish and numerous smaller fish may all be found.

3 NABAT WEST

★★★★

Location: The west side of a large isolated wall of rock known as Nabat Island that towers more than 30m (100ft) out of the water to the northeast of Apulit Island.
Access: 20min choppy ride by speedboat from Club Noah Isabelle's main boat pier.
Conditions: A strong current and swell.
Average depth: 14m (45ft)
Maximum depth: 24m (79ft)
The wall of Nabat Island continues steeply down underwater to sand at 24m (79ft). If the current permits, you can start your dive on the lee side, swim into the current around either corner and return to the lee side to regain the boat.

Despite lying outside of the no-fishing zone, there is a lot of life here, ranging from large fish to several species of nudibranchs. Huge trevallies, Napoleon Wrasse and Bumphead Parrotfish, as well as juvenile and adult lionfish, pufferfish, angelfish, butterflyfish, batfish, snappers and soldierfish, may all be found. There are also plenty of large and tiny sea cucumbers, flatworms, shrimps, lobsters, *Tubastrea* coral, soft corals, gorgonian sea fans and sponges.

If the current is strong, you may be limited to swimming back and forth along the lee side, so do this at different depths beginning deep and slowly working your way up. There will be more surge in shallow water.

How to Get There

Club Noah Isabelle in Taytay Bay is serviced by Sea Air small aircraft (baggage allowance 10kg [22lb]), flying from Manila to Sandoval Airstrip on Palawan, from where it is a short jeepney ride and then a 45min *banca* ride to the island.

Ten Knots El Nido is serviced by an A. Soriano Aviation private aircraft (baggage allowance 10kg [22lb]) from Manila to El Nido on Palawan, then a 45min *banca* ride to the island where you may get wet.

Where to Stay/Dive Facilities

Club Noah Isabelle, Maytagued, Taytay, Palawan. Manila Address: Unit 6D, Sixth Floor Multinational Bancorporation Centre, 6805 Ayala Avenue, Makati City, 1226 Metro Manila; tel 2-8446688/fax 2-8452380; e-mail info@clubnoah.com.ph; website: www.clubnoah.com.ph

Ten Knots El Nido Miniloc Island, Buena Suerte, El Nido, Palawan, tel 2-8945644/fax 2-8103620; e-mail: sales@elnidoresorts.com

Manila address: Second Floor, Builders Center Building, 170 Salcedo Street, Legaspi Village, Makati City, Metro Manila; tel 02-7520308/fax 02-8945725; e-mail: elnido@mailstation.net; website: www.elnidoresorts.com

Where to Eat

You have to eat at your accommodation.

Diving Emergencies

Palawan Adventist Hospital Junction 2, San Pedro, Puerto Princesa

The nearest recompression chamber is in Manila: **AFP Medical Center**, V. Lunar Road, Quezon City, Metro Manila; tel 02-9207183.

Local Highlights

Forming the edge of the ancient Sunda Shelf, Palawan is more closely related to Borneo than to the rest of the Philippines. The rich and unique flora and fauna encompass many endemic species; over 600 species of butterflies, 300 of which are endemic, attract

Eyes Underwater

Over aeons of time, nature evolved light sensitive photoreceptors and then the eye, an organ that could use its own physical structure to refract light. First the cornea and then the lens, refract photons to strike the retina, where individual photoreceptors convert the radiation received into signals from which the brain constructs an image.

Photons are first slowed down and bent by the clear tissue of the cornea, but corneas have a similar refractive index to water, so the corneas of fish and sea mammals are flattened. They have no light refracting function, just a protective one.

butterfly tours from all over the world.

Remember to take sensible precautions against malaria.

View of the El Nido resort on Miniloc Island. Dive trips can be made to the surrounding reefs.

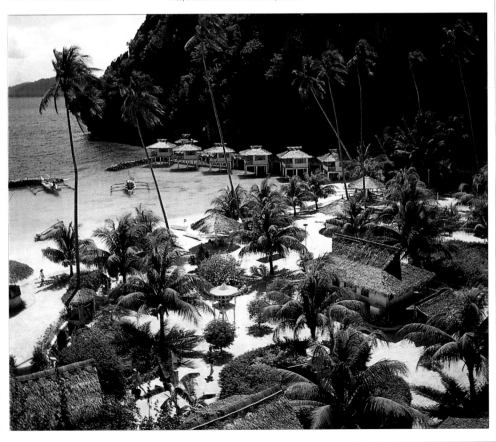

The Sulu Sea

The Sulu Sea has hundreds of isolated reefs and islets that, were it not for blast-fishing, would have diving as good as anywhere in the world. Fortunately some of them are so remote that, because of weather conditions, they can be visited for only four months of the year and thus, although they have not entirely escaped destructive fishing, have survived comparatively well.

This is strictly a live-aboard destination. If you can afford the better live-aboard boats and do not mind currents, then here is where you will find the Philippines' best diving. Everything is BIG, and large animals are guaranteed. The area can have very bad weather, so you should pick your vessel with care. All the boats give excellent personal service, but some of them fall down on maintenance. A fresh coat of paint does not make a boat reliable!

THE TUBBATAHA REEF NATIONAL MARINE PARK

The best-known reefs for diving are the Tubbataha Reefs, 182km (98 nautical miles) southeast of Puerto Princesa on Palawan Island; together with Jessie Beazley Reef these make up the Tubbataha Reef National Marine Park. The Tubbataha reefs consist of two extensive atoll-like reefs (with inner lagoons) separated by a channel 7km (4 nautical miles) wide. At low water there are several sand cays. At the northeast end of the north reef is Bird Islet, a cay with sand, grass and some mangroves; it is used as a rookery by Brown Boobies and terns and as a nesting beach by turtles. The South Islet has a prominent black rock and some sandy cays at the northeast end, and at the southern end a solar-powered lighthouse where gulls and terns nest. To the east of the lighthouse, high and dry on the reef, is the wreck of the *Delsan*, an old log-carrier.

COMPUTER DIVING

Computers are not infallible. Just because you carry one, don't think you can forget about the normal rules of diving. Battery failure is common, so either carry two computers or take along tables and a depth gauge as backup. Remember:
- Go to the maximum depth at the beginning of the dive and progressively work up
- Ascend slower than your bubbles (less than 10m per minute)
- Always finish non-compression dives with a 5min safety stop at 5m (16ft)
- If making repetitive dives, reduce the limits progressively
- If diving over several days, take a day off after the fourth day
- Do not dive to the computer's limits – the chances of decompression sickness increase with exertion, dehydration, cold, drugs and poor physical fitness

JESSIE BEAZLEY AND BASTERRA REEF

Jessie Beazley Reef, 23km (12 nautical miles) northwest of North Islet, is a mound of broken coral surrounded by white sand and reef. Basterra Reef, called Mæander Reef on the charts after its discovery by HMS *Mæander* in 1849, is a sand cay 93km (50 nautical miles) southwest of South Islet. The wreck of the *Oceanic* is high and dry on the east side of the reef. Bancoran Island is a further 60km (33 nautical miles) southwest of Basterra Reef. Densely wooded, it reaches nearly 30m (100ft) high and is surrounded by shoals. When I first dived here it was uninhabited and notable for sightings of as many as 20 turtles on every dive, but nowadays the island has permanent inhabitants who have destroyed much of the marine life.

ARENA, CAVILI AND CALUSA ISLANDS

Northeast of Tubbataha, en route to the Cagayan Islands, Maniguin and Panay, are Arena, Cavili and Calusa Islands. Arena Island, 89km (48 nautical miles) northeast of Tubbataha North Islet, and Cavili Island, 9km (5 nautical miles) northeast of Arena Island, are small coral islets and sand cays lying on fringing reefs. Arena is on a long thin

reef split by a channel, with a lighthouse, a high-and-dry wreck and many huts on stilts over the water; the huts house families who farm seaweed (one wonders how they survive in bad weather). Calusa Island, covered in coconut palms up to 20m (65ft) high, is 19km (10 nautical miles) west–north–west of the southern extremity of Cagayan Island.

These three islands are less remote and have seen much more destruction by man. Like the Tubbataha Reefs they rise out of very deep water, but not so steeply – more drop-offs than walls. The reef-tops have been well blast-fished, but because the areas are so large you can still find beautiful areas. The drop-offs are less affected, and where they are deep are still healthy. The other islands in the Cagayan group are now rarely visited for diving.

DIVING CONDITIONS IN THE SULU SEA

All these reefs consist of vertical walls or near-vertical drop-offs rising out of great depths. There is evidence of some blast-fishing on the shallow reef-tops, but the reef areas are so large that it does not become a problem – more significantly, blast-fishing is not very efficient in deep water, so the walls are little affected.

The shallow reef-tops are teeming with all the local reef fish; in many places stingrays, Spiny Lobsters, immature Manta Rays, turtles, Leopard (Variegated) Sharks and Guitar Sharks are common. The walls are covered in huge barrel sponges, gorgonian sea fans, soft corals, hydroids, black corals and *Tubastrea* corals. Caves in the walls often contain resting

THE TUBBATAHA MARINE PARK FOUNDATION

In order to protect the Tubbataha Reefs, the Tubbataha Marine Park Foundation was set up in the mid-1980s and a National Marine Park, consisting of the Tubbataha Reefs and Jessie Beazley Reef, established. The Foundation was subsequently deputized by the Department of Environment and Natural Resources to patrol the Marine Reserve and undertake such measures as the setting up of permanent buoys and moorings.

It has to be said that the Foundation has not been very successful. It has prevented the arrival of commercial seaweed farming, but illegal fishermen from Palawan, Tawi-Tawi and Taiwan still get through. However, nowadays there are coast-guard personnel stationed on the islands who are treating their protection seriously.

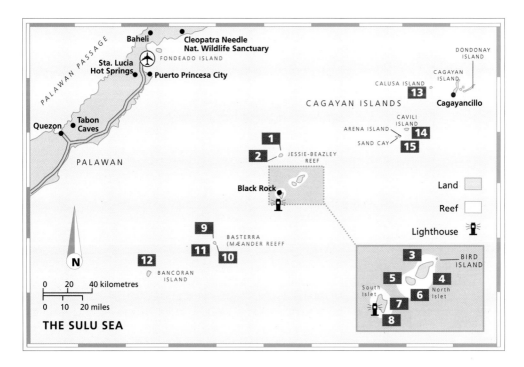

THE SULU SEA

Nurse Sharks and Whitetip Reef Sharks, as well as Spiny Lobsters; but it is off the walls in deeper water that these reefs show their true worth.

Shoals of angelfish, butterflyfish, pennantfish, Rainbow Runners, Moorish Idols, fusiliers, jacks, snappers and sweetlips follow you around. Large trevally, tuna and barracuda come out of the blue. Grey Reef Sharks and Whitetip Reef Sharks patrol; giant Manta Rays fly overhead; Eagle Rays and turtles pass by. Groupers, both large and small, Napoleon Wrasse, large pufferfish and squirrelfish hover around. There are many species of nudibranchs, flat worms, segmented worms, sea cucumbers, sea stars, sea squirts, Feather Duster Worms and, of course, colourful crinoids everywhere.

CURRENTS

You must expect strong currents. If the current is not strong at a particular moment it will probably pick up or reverse during the course of your dive, or as you round a corner. The chase boats will follow your bubbles, but it is advisable to carry bright orange rescue tubes anyway as groups often get separated, especially when photographers stop to take pictures. If you are a photographer it is worth picking a time of neap tides. You may miss out on some of the larger pelagics, but it will be easier to take photographs. The better operators publish the local tide tables daily – and understand them.

Sheltered moorings are rare, so live-aboard boats often have to cruise up and down off the reef or, if moored, move as the tides change; for this reason one cannot give any times for the chase boats to deliver divers to a given site. To get the maximum diving time for clients, live-aboard boats often sail on to the next reef overnight, aiming to arrive there soon after dawn.

All dives are drift-dives, and the best time to visit is March through June, but bad weather can occur at any time. As with others who have dived here more than once, I still find plenty to enthuse about. Novices should stay close to their divemaster and good chase-boat cover is essential.

PIRATE RAIDS

Historically the South China Sea has a record of pirate activity, concerned mostly with the rich pickings of cargo ships and latterly oil tankers but occasionally with the smaller prize of booty from yachts, small fishermen or coastal villages. These pirates have generally been able to disappear among fishing villages on the many small islands, where the territorial waters of different countries meet and are sometimes disputed.

There are similar tales of piracy in the Celebes (Sulawesi) and Sulu Seas. The WWF's boat on Pulau Sipadan still sports three large-horsepower outboard engines as a legacy of the WWF's work around the islands off Semporna in the early 1980s, when they felt it was necessary to be able to outrun any possible pirate interest.

Today the Philippines Navy and Coastguard patrol the diving areas in Philippines waters.

DIVING OFF PUERTO PRINCESA

There is also some diving around Puerto Princesa itself, used for training novices. On the far side of Honda Bay, some 45min by *banca* north of Puerto Princesa, Fondeado Island (4.5km [2½ nautical miles] south–southwest of Castillo Point) and Panglima Reef (9km [5 nautical miles] southeast of Pasco Point), and Table Head Reef (off Table Head Point, 30min south of Puerto Princesa) have sloping reefs from 6m (20ft) to small drop-offs around 25m (80ft). All have lots of dead coral, some small fish, algae, sea stars, sea cucumbers, sea urchins, nudibranchs and crinoids. These dives have strong and sometimes tricky currents.

As at Coron, at Fondeado island the fishermen sometimes find Horseshoe Crabs, living fossils of our world millions of years ago.

1 JESSIE BEAZLEY REEF
2 SOUTHERN END OF THE REEF

★★★★★

Location: 26km (14 nautical miles) northwest of Tubbataha Reef North Islet, 9hr from Puerto Princesa.
Access: By tender from live-aboard boats.
Conditions: Normally calm with a swell, with medium to strong currents. The currents can be very strong at times of spring tides and can often reverse suddenly. You would not normally dive here in bad conditions. Visibility can reach 40m (130ft). The currents can take you either way, east or west, along the drop-off. The reef is small enough to be covered in two dives.
Average depth: 28m (92ft)
Maximum depth: 60m (200ft) plus
You first come across a rich coral slope, from 5m (16ft) to 10m (33ft), then a wall, often undercut to 40m (130ft), sloping out into the depths. The reef-top is covered in lettuce and leathery *Sarcophyton* corals. It is teeming with small reef fish, but the walls have everything. Huge gorgonian sea fans, black corals, *Dendronephthya* soft tree corals and barrel sponges are everywhere. Whitetip Reef Sharks, Blacktip Reef Sharks, Grey Reef Sharks, large groupers, Napoleon Wrasse, tuna, trevallies, barracuda and mackerel appear out of the blue. Spiny Lobsters can be found in many small holes, and the overhangs have *Tubastrea* corals and Blue Sponges.

Most striking are the many large shoals of fish, some of which stay in one place, some of which follow you

around. There are unusually large numbers of Sabre Squirrelfish and Bigeyes, Midnight Snappers, Black and White Snappers, jacks, Vlaming's Unicornfish, Rainbow Runners, Emperors, pennantfish, batfish, Spotted Sweetlips and Lined Sweetlips. Angelfish (especially Royal, Emperor and Yellowmask) and butterflyfish (especially Dusky, Longnose, Chevron, Blackback, Lined and Racoon) flit around. All the possible triggerfish, including the Clown Triggerfish, groupers and hawkfish are here, and at the western end there are often Grey Reef Sharks and Whitetip Reef Sharks resting on the sand at the base of the wall.

The southern end of the reef has a more extensive reef-top, with good stony, whip and leathery corals plus very large table corals, and with parrotfish, trumpetfish, cornetfish, rabbitfish, hawkfish, anthias, boxfish and fire gobies among everything else. Every hole seems to be a home for Redtooth Triggerfish. Manta Rays and Eagle Rays are common, and pelagic visitors are possible anytime. This is tremendous diving and a great reef for photographers.

Divers from the MY Tristar A returning in the ship's tender from a dive on Tubbataha Reef.

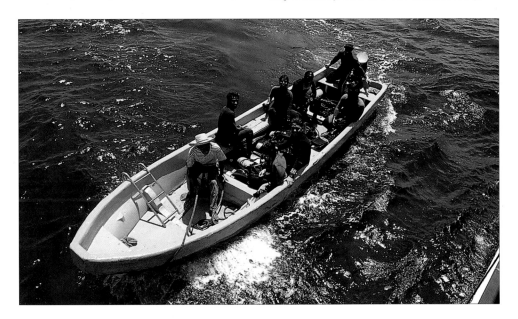

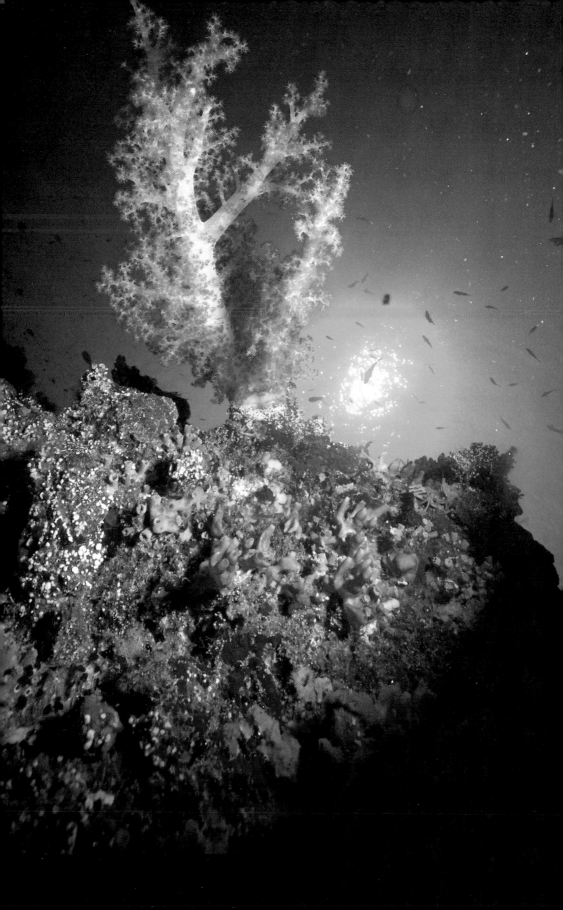

3 TUBBATAHA REEF – NORTH ISLET, NORTH FACE

★★★★★

Location: The north face of Tubbataha Reef North Islet, 182km (98 nautical miles) southeast of Puerto Princesa.
Access: By tender from live-aboard boats.
Conditions: Normally calm with some swell. Strong currents can take you in either direction and change without warning. These can become really fierce, but you would not normally dive here in bad conditions. Visibility can reach 40m (130ft).
Average depth: 30m (100ft)
Maximum depth: 60m (200ft) plus
This north end of the reef has a sandy slope with coral heads to 15m (50ft), then drops as a wall with caves and crevices to deeper than sports divers can dive. The coral cover on the reef-top is good, with plenty of stony, leathery and whip corals, among which you find large Guitar Sharks, Leopard (Variegated) Sharks, immature Manta Rays, Bluespotted Ribbontail Rays, Eagle Rays, flounders and turtles.

The wall, with its overhangs and crevices, has huge gorgonian sea fans, barrel sponges, black corals and soft corals, Grey Reef Sharks, Whitetip Reef Sharks, Blacktip Reef Sharks, snappers, Moorish Idols, sweetlips, jacks, trevallies, surgeonfish, squirrelfish, soldierfish and groupers. Large Manta Rays are common at the surface and pelagic visitors are possible at any time.

4 TUBBATAHA REEF – NORTH ISLET, EAST FACE

★★★★★

Location: The east face of Tubbataha Reef North Islet.
Access: By tender from live-aboard boats.
Conditions: Normally calm, with some swell and strong currents that can take you in either direction and change suddenly. A 1m (3ft) swell is divable. The currents can become really fierce but you would not normally dive here in bad conditions. Visibility can reach 40m (130ft).
Average depth: 20m (65ft)
Maximum depth: 60m (200ft) plus
A rich slope of corals on sand to between 14m (45ft) and 20m (65ft) leads to a wall with overhangs, caves and crevices down to deeper than sports divers can dive.

This is a great site for a dusk dive, when there is lots of action as the fish are feeding, though the current can be a nuisance to photographers.

Opposite: *Large soft tree coral (Dendronephthya rubeola) and Tubastrea cup corals.*

Just about every possible Pacific reef fish is in evidence, including trumpetfish, cornetfish, anthias, damselfish, anemones with clownfish, angelfish (including Six-banded Angelfish), butterflyfish, lionfish, scorpionfish, boxfish, Peacock Groupers, Titan, Clown, Orangestriped and Redtooth Triggerfish, pufferfish, parrotfish, hawkfish, Bird Wrasse and female Napoleon Wrasse. Guitar Sharks, sea stars, sea urchins, sea cucumbers, Feather Duster Worms, garden eels, segmented worms and nudibranchs are on the sand, and crinoids are everywhere.

The wall is wonderfully rich in gorgonian sea fans and soft corals, both of which are very large below 30m (100ft). Large fish patrol the wall, especially jacks, trevallies, tuna, Rainbow Runners, barracuda, Blacktip Reef and Whitetip Reef Sharks, snappers and various fusiliers (including Yellowdash Fusiliers), cardinalfish and emperors. Manta Rays and turtles are common near the surface.

5 TUBBATAHA REEF – NORTH ISLET, SOUTHWEST CORNER

★★★★★

Location: The southwest corner of Tubbataha Reef North Islet.
Access: By tender from live-aboard boats.
Conditions: Normally calm, with some swell and strong currents that can take you in either direction and change suddenly. A 1m (3ft) swell is divable. The currents can become really fierce but you would not normally dive here in bad conditions. Visibility can reach 40m (130ft).
Average depth: 20m (65ft)
Maximum depth: 60m (200ft) plus
A shallow reef slopes to between 10m (33ft) and 20m (65ft), and then drops off as a wall to deeper than sports divers can go. The slope is very rich, with stony, whip and leathery corals on sand, teeming with small reef fish and several Guitar Sharks. I have also come across a resting Leopard (Variegated) Shark here.

Huge gorgonian sea fans, barrel sponges (covered in Alabaster Sea Cucumbers) and *Dendronephthya* soft tree corals cover the wall together with shoals of most of the local reef fish. Among the angelfish are Six-banded Angelfish and Semicircle Angelfish. There are shoals of snappers, unicornfish, jacks, trevallies, barracuda and fusiliers.

GUITAR SHARKS

Guitar Sharks are usually found resting on sandy patches during the day. If you have a helpful buddy, he or she can hover 15m (50ft) above the reef and point out their position. You can then get quite close to the sharks by carefully approaching from behind coral heads.

6 TUBBATAHA REEF – NORTH ISLET, SOUTHEAST CORNER

★★★★★

Location: The southeast corner of Tubbataha Reef North Islet.
Access: By tender from live-aboard boats.
Conditions: Normally calm with some swell. Strong currents can take you in either direction and change without warning; these can become really fierce, but you would not normally dive here in bad conditions. Visibility can reach 40m (130ft).
Average depth: 20m (65ft)
Maximum depth: 60m (200ft) plus

A gentle slope rich in mixed corals reaches to 12m (40ft), then a wall drops to deeper than sports divers can dive. The reef-top, which covers quite a large area here, shows some signs of blast-fishing, but it also has some true Giant Clams and octopuses, Leopardfish Sea Cucumbers and Bohadschia sea cucumbers. On my last visit I saw a Star Pufferfish with two attendant remoras, and two Guitar Sharks.

Just over the wall, near the corner itself, is a cave that often contains resting a full-size Tawny Nurse Shark; other crevices contain Spiny Lobsters. Shoals of snappers, sweetlips, Moorish Idols, surgeonfish, fusiliers, angelfish and butterflyfish hang off the wall, which is rich in large gorgonian sea fans, barrel sponges, hydroids and soft corals. Whitetip, Blacktip and Grey Reef Sharks, groupers and Napoleon Wrasse can be seen in deeper water, while Manta Rays, Eagle Rays and turtles are frequently seen near the surface. A good dive for photographers.

7 TUBBATAHA REEF – SOUTH ISLET, NORTH/NORTHEAST END

★★★★★

Location: The north and northeast end of Tubbataha Reef South Islet.
Access: By tender from live-aboard boats.
Conditions: Normally calm, with some swell and strong currents that can take you in either direction and change suddenly. A 1m (3ft) swell is divable. The currents can become really fierce but you would not normally dive here in bad conditions. Visibility can reach 40m (130ft).
Average depth: 20m (65ft)
Maximum depth: 60m (200ft) plus

Not all sea cucumbers are as colourful as this specimen, but certain species are highly prized as gastronomic delicacies.

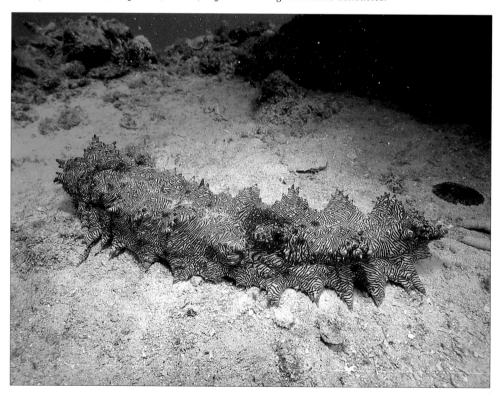

A rich reef sloping to between 10m (33ft) and 20m (65ft) ends in an equally rich wall going down to deeper than sports divers may go. There is some blast-fishing damage on the reef-top but this does not affect the wall, which has gorgonian sea fans and barrel sponges as good as those on the North Islet, and even better soft corals.

There are good shoals of reef fish and seemingly more pelagic species than at Tubbataha Reef North Islet, including mackerel, barracuda and Rainbow Runners. The many caves and crevices contain Spiny Lobsters, squirrelfish, soldierfish and occasionally resting Whitetip Reef Sharks. Green and Hawksbill Turtles, Eagle Rays and Manta Rays have been seen here.

8 TUBBATAHA REEF – SOUTH ISLET, SOUTH/SOUTHEAST/SOUTHWEST END

★★★★★

Location: Drifting with the current, either side of the Delsan wreck, which is high and dry on top of the reef.
Access: By tender from live-aboard boats.
Conditions: Normally calm with some swell. Strong currents can take you in either direction and change without warning; these can become really fierce, but you would not normally dive here in bad conditions. Visibility can reach 40m (130ft).
Average depth: 20m (65ft)
Maximum depth: 60m (200ft) plus
This is much the same as the dive at the islet's north/northeast end (Site 7), but with a far larger area of shallow reef-top, which has seen more blast-fishing. Despite this, it is rich in the smaller reef-fish life, leathery corals, whip corals, sponges, anemones with clownfish, other damselfish, chromis and anthias. Bluespotted Ribbontail Rays, sea cucumbers and sea stars are common on the sandy patches. The shallow water near the lighthouse has sea grass, which is attractive to turtles.

9 BASTERRA REEF, NORTH END

★★★★★

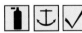

Location: The northern end of Basterra Reef, 93km (50 nautical miles) southwest of Tubbataha Reef South Islet, over the submerged remains of the *Tristar B*.
Access: By tender from live-aboard boats.
Conditions: A mild swell with strong currents which can change without warning, but there can be a heavy swell with fierce currents. You would not normally dive here in bad conditions. Visibility can sometimes reach 40m (130ft).
Average depth: 25m (80ft)
Maximum depth: 60m (200ft) plus

Basterra Reef is very small and has diving similar to that at Jessie Beazley Reef (Sites 1 and 2) and the Tubbataha Reefs (Sites 3–8), but with even more fish action. With a strong current you could cover more than half of the reef in one dive; it is quite normal to start at the wreck of the *Tristar B*, be carried by the current to the wreck of the *Oceanic* and then find that the current turns you back as you round the corner, or *vice versa*.

If you start over the *Tristar B*, the current takes you either east or south. There is a gentle slope to 10m (33ft), then a drop over a wall to deeper than sport divers can dive. The area immediately around the *Tristar B* has been heavily damaged by blast-fishing and bad weather. The engine is now separate, outside the wreck. Despite the blasting, there are plenty of fish on the remains of the wreck itself, including snappers, surgeonfish, parrotfish, triggerfish, fusiliers, sweetlips, pufferfish, trevallies, goatfish and wrasse. Several Whitetip Reef Sharks usually hover just on the edge of visibility.

Once you are 50m (165ft) away from the wreck, the reef is rich again. There are good stony corals, whip corals and sponges, Spiny Lobsters and octopuses. The healthy wall is just like those on Jessie Beazley Reef, with even larger shoals of fish.

10 BASTERRA REEF, EAST FACE

★★★★★

Location: Either side of the wreck of the Oceanic, which is high and dry on top of the reef.
Access: By tender from live-aboard boats.
Conditions: Normally a mild swell, with strong currents which can change without warning, but there can be a heavy swell with fierce currents. The currents often reverse deeper down. You would not normally dive here in bad conditions. Visibility can reach 40m (130ft).
Average depth: 25m (80ft)
Maximum depth: 60m (200ft) plus
After a rich coral slope to 8m (25ft), a wall drops to deeper than sport divers can go. This is possibly the best side of the reef for stony corals (on the reef-top), mushroom corals, large table and staghorn corals, lettuce corals, boulder corals and quite a lot of fire coral. The wall is rich in large gorgonian sea fans, barrel sponges, Elephant Ear Sponges, *Dendronephthya* soft tree corals, *Dendrophyllid* tree corals, whip corals and hydroids. Shoals of fish are everywhere, and there are lots of pelagic visitors: Manta Rays, turtles and reef sharks, Titan, Redtooth, Clown and Orangestriped Triggerfish, Moorish Idols, pennantfish, surgeonfish, Semicircle Angelfish, Royal and Emperor Angelfish, Yellowmask Angelfish, goatfish, Coral Trout, Peacock Groupers, batfish, barracuda, Napoleon Wrasse and all the smaller reef fish.

11 BASTERRA REEF, SOUTH WALL

★★★★★

Location: The south tip of Basterra Reef.
Access: By tender from live-aboard boats.
Conditions: Normally a mild swell, with strong currents which can change without warning, but there can be a heavy swell with fierce currents. The currents often reverse deeper down, and they also often reverse during the dive. You would not normally dive here in bad conditions. Visibility can reach 40m (130ft).
Average depth: 25m (80ft)
Maximum depth: 60m (200ft) plus
A sandy slope interspersed with good coral heads stretches down to 15m (50ft), then a wall drops into the depths. The sandy slope teems with smaller reef fish. Table corals, lettuce corals and leathery corals hide immature moray eels, Whitetip Reef Sharks and Bluespotted Ribbontail Rays. Out on the sand are flounders, garden eels, Sand Perch, blennies and gobies.

The wall is rich in gorgonian sea fans, barrel sponges, Elephant Ear Sponges and hydroids; off the wall you find pelagic visitors including tuna, mackerel, turtles, Manta Rays and Hammerhead Sharks, as well as the resident Whitetip, Blacktip and Grey Reef Sharks, barracuda, jacks and snappers. Big shoals of pennantfish, surgeons, butterflyfish, Midnight Snappers and fusiliers follow you around.

You often start this dive drifting with the current and later find that it reverses, pushing you back the way you came. The obvious thing to do is to come up 10m (33ft), so that you drift back over different terrain.

12 BANCORAN ISLAND

★★★

Location: 78km (38 nautical miles) west–southwest of Basterra Reef.
Access: By tender from live-aboard boats.
Conditions: Normally a mild swell, with strong currents

Large shoal of Bigeye Trevally (Caranx sexfasciatus). These swift, silver fish are active predators.

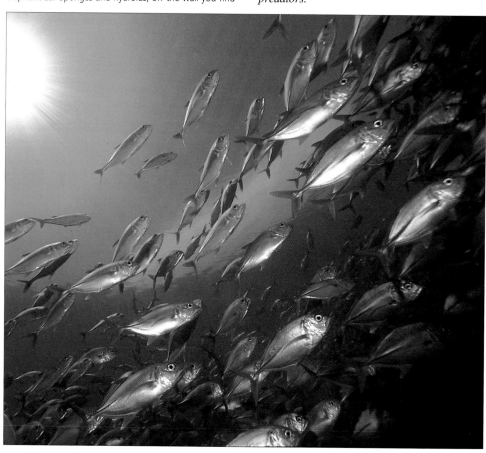

which can change without warning, but there can be a heavy swell with fierce currents. You would not normally dive here in bad conditions. Visibility can reach 40m (130ft).

Average depth: 20m (65ft)
Maximum depth: 40m (130ft)
This island used to be a popular dive site. The west and northwest faces were five-star dives with sandy slopes on which you saw lots of turtles, which nested there, and then a wall with many Spiny Lobsters, huge sponges and true Giant Clams, cuttlefish, barracuda, tuna and reef sharks. Sadly, the island is now inhabited, and its star rating has suffered accordingly.

13 CALUSA ISLAND

★★★★

Location: 19km (10 nautical miles) west–northwest of the southern tip of Cagayan Island.
Access: By tender from live-aboard boats.
Conditions: Normally a mild swell, with strong currents which can change without warning, but there can be a heavy swell with fierce currents. You would not normally dive here in bad conditions. Visibility can reach 40m (130ft).
Average depth: 20m (65ft)
Maximum depth: 45m (150ft)
You can dive all round this island, going whichever way the current takes you. There is a shallow reef-top at 5m (16ft), then a drop-off down to 45m (150ft). Between blast-fished shallow areas are good table, lettuce, whip and leathery corals, all harbouring small reef fish, many varieties of nudibranchs and flat worms, cornetfish, trumpetfish, Titan, Redtooth, Clown and Orangestriped Triggerfish, all the smaller angelfish and butterflyfish. There are patches of garden eels in the sand. The drop-offs have many overhangs and crevices, many of which are at 5m (16ft) to 7m (23ft) and contain good-sized Spiny Lobsters.

Big gorgonian sea fans exist in only 7m (23ft) of water, which indicates how strong the currents can get. Deeper down there are very big *Dendronephthya* soft-tree corals, reef sharks, tuna, Rainbow Runners, groupers and Napoleon Wrasse. All the expected fish are here, but not in the same quantities as at Sites 3–11.

14 CAVILI ISLAND

★★★★

Location: 50km (27 nautical miles) southwest of Cagayan Island, 9km (5 nautical miles) northeast of Arena Island, 98km (53 nautical miles) northeast of Tubbataha Reef North Islet, 3hr from Arena Island.

Access: By tender from live-aboard boats.
Conditions: Normally a mild swell, with strong currents which can change without warning, but a large swell is common and there can be a heavy swell with fierce currents. You would not normally dive here in bad conditions. Visibility can reach 40m (130ft).
Average depth: 20m (65ft)
Maximum depth: 35m (115ft)
Another island with dives all round. A blasted shallow reef-top goes to 4m (13ft), followed by a drop-off to 35m (115ft) on sand. In the shallow water on the drop-off are lots of big gorgonian sea fans, which are torn by bad weather. Deeper down are excellent gorgonians and sponges. On the shallower parts of the drop-off are some very large anemones harbouring clownfish and other damselfish. Plenty of good-sized pelagics follow you around, but there are not many large shoals of fish.

15 ARENA ISLAND, EAST END

★★★★

Location: 9km (5 nautical miles) southwest of Cavili Island, 59km (32 nautical miles) southwest of Cagayan Island, 89km (48 nautical miles) and 13hr northeast of Tubbataha Reef North Islet.
Access: By tender from live-aboard boats.
Conditions: Normally a mild swell, with strong currents which can change without warning, but a large swell is common and there can be a heavy swell at times with fierce currents. You would not normally dive here in bad conditions. Bad weather sweeps sand off the cays and seaweed farming can affect the visibility, which can reach 25m (80ft). One has to dive at the eastern end of the reef, well away from the inhabitation.
Average depth: 20m (65ft)
Maximum depth: 40m (130ft)
This is a similar site to Site 14. On the north side the reef-top is flat at 4m (13ft), and on the south side there is a gentle slope to 12m (40ft); both then slope off to 49m (160ft) on sand. The reef-top has suffered from blast-fishing and siltation, but the drop-off is colourful, with gorgonian sea fans, sponges and soft corals. Reef sharks are constantly patrolling. There are shoals of surgeonfish, snappers, pennantfish, Moorish Idols and fusiliers, lone pelagic species and the occasional Eagle Ray.

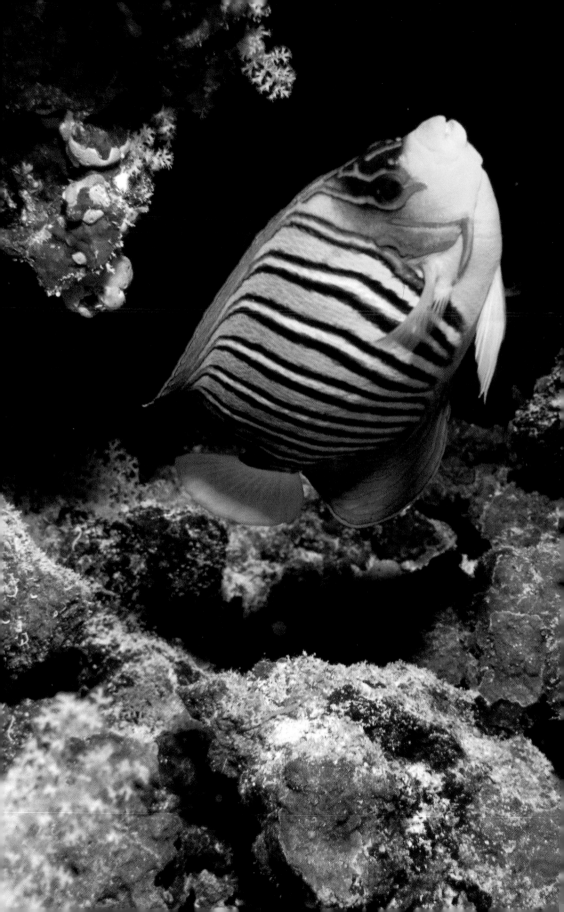

HOW TO GET THERE

Unless yours is a positioning trip, cruises start from Puerto Princesa, which is served by PAL flights from Manila and Cebu. You would normally have pre-booked your live-aboard so you would be informed which flight to take. You will be met at Puerto Princesa airport by crew members from your boat, who will take over all the chores of transferring you and your baggage to the yacht in the port, which is only a few minutes away. Most cruises sail overnight, so that you are on station at your first dive site soon after dawn the next day.

To travel around on your own thereafter you would need to use motorized tricycles.

WHERE TO STAY

Puerto Princesa is a very small town with limited accommodation.

Upper Price Range
Asiaworld Resort Hotel National Highway, San Miguel Street, Puerto Princesa; tel 2-2427250
Book through Asia Travel
website: www.asiatravel.com/star/philippines/grandpalawan/asiaworld

Medium Price Range
Badjao Inn and Restaurant 350 Rizal Avenue, Puerto Princesa City, Palawan 5300; tel 48-4332761/fax 48-4332180; e-mail: badjao_inn@yahoo.com; website: www.badjaoinn.com

Lower Price Range
Amelia Pensionne Rizal Avenue, Puerto Princesa City; tel 48-4337029/fax 48-4334895

Duchess Pension
Valencia Street, Puerto Princesa City; tel 48-4332873

WHERE TO EAT

There are several restaurants on Rizal and Valencia Streets.

DIVE FACILITIES

For the Sulu Sea proper you must use a live-aboard boat. Those running trips to the area change so often that I have not listed them.

Dive Operators and Diver Training
Queen Ann Divers Rizal Avenue, Puerto Princesa, 5300 Palawan; e-mail: queenanne@gmx.ch; website: www.queenannedivers.com.ph PADI courses.

DIVING EMERGENCIES

Palawan Adventist Hospital
Junction 2, San Pedro, Puerto Princesa

The nearest recompression chamber is in Manila: **AFP Medical Center**, V. Lunar Road, Quezon City, Metro Manila; tel 02-9207183.

LOCAL HIGHLIGHTS

Forming the edge of the ancient Sunda Shelf, Palawan is more closely related to Borneo than to the rest of the Philippines. The rich and unique flora and fauna encompass many endemic species; over 600 species of butterflies, 300 of which are endemic, attract butterfly tours from all over the world.

In 1962 excavations at the Tabon Caves in southern Palawan indicated habitation from 40,000 B.C. The caves are on the northwest side of Lipuun Point (Albion Head), the northwest tip of Malanut Bay, which is reached from Quezon, southwest of Puerto Princesa on the west coast (5–7hr by public bus). Don't expect too much: all the excavations have been removed to museums.

There are still interesting tribal groups and plenty of beautiful scenery in the area.

The best-known highlight, if you have the time for an overnight trip, is the underground river at Saint Paul's Subterranean National Park. The departure point is Baheli, 48km (30 miles) northwest of Puerto Princesa on the west coast. Said to be the largest underground river (8km; 5 miles) in the world, it flows out into the South China Sea at Saint Paul's Bay. You will require waterproof bags for cameras and other equipment.

Near to Puerto Princesa (30min), the Crocodile Farming Institute at Irawan is worth visiting. It is officially closed on Sundays, but they will usually let tourists in.

Within Puerto Princesa itself there are houses on stilts over the water, as you would find in Borneo.

Remember to take sensible precautions against malaria if you are likely to be outside Puerto Princesa in the evening.

PALAWAN

Palawan is particularly interesting to sea-soned travellers. Its former roles as penal colony and leper colony, and concern about malaria in the area, held back its development – which fact is now to its advantage. There is a rich flora and fauna and much of the forest cover is still intact.

The conservation-minded population keep the island very clean and have recently voted to stop any further logging and to replant areas where the mangroves have been destroyed. Further, the Binunsalian Bay Foundation exists to watch over the local marine environment. For information contact:

Ernesto Santa Cruz
President
Binunsalian Bay Foundation Inc.
29 Malvar Street
Puerto Princesa City
5300 Palawan
tel 048-212590.

TUBBATAHA AREA'S FIRST DIVE OPERATOR

The first dive operator to venture into this area was Betty Sarmiento's brother Tommy Lopez, with a group of Japanese divers from *Popeye Magazine* on board the original *Aquastar*, a 20m (65ft) outrigger boat. They visited the Tubbataha Reefs, Jessie Beazley Reef, Arena Island, Cavili Island and Calusa Island. In those early days they took soldiers with them, in case they had trouble with pirates.

Opposite: *The Royal Angelfish (Pygoplites diacanthus) is one of the most beautiful reef fish. Usually solitary, it is shy and hard to approach.*

Sea cucumbers – holothurians – may not be the most elegant of creatures, but these humble marine invertebrates shouldn't be dismissed as merely one of evolution's aesthetic failures: that unprepossessing appearance disguises the fact that holothurians are fascinating creatures, and vital elements of the marine ecology. Apart from anything else, they are very numerous, and are the most important sand-deposit feeders on reefs, ingesting sediment to extract food and then ejecting the indigestible material: it is estimated that, each year, holothurians shift a staggering 150 tonnes per hectare (2.47 acres) of sand in this way.

Belonging to the phylum Echinodermata and the family Holothuriidaea, holothurians are related to sea stars, sea urchins and crinoids (feather stars). They are sausage-shaped, with at one end a mouth and at the other an anus. Like other echinoderms – and unlike any other creatures – they have a water-vascular system, which operates their tube-feet by hydraulic pressure. In a few holothurians these tube-feet are equally spaced around the circumference, but in most they are modified, with those rows (usually two) on the upper side of the body having adopted sensory functions. The lower rows (usually three) may be distinct or distributed over a flattened bottom, and it is using these that the holothurian slowly crawls along. Several tube-feet around the mouth are modified as feeding tentacles; their tips are covered in sticky mucus and tiny crevices that trap food particles.

The skeletons of sea cucumbers have, over the course of evolutionary time, become reduced until they consist of no more than countless slender, pointed, microscopic ossicles (spicules) situated within the leathery body wall. Apodus ('no foot') sea cucumbers have anchor-shaped ossicles that are larger than in the other varieties; the flukes penetrate the body wall allowing the creature to drag itself along the seabed using rhythmic muscular contractions.

Holothurians of the Synapta genus breathe through their body walls, but the others do so

through their cloaca, drawing water in via the anus and circulating it around the body through their paired respiratory tree, absorbing oxygen from it as it goes. Pearlfish (Carapidae), small crabs and worms take advantage of this system, sheltering inside the holothurian's body cavity and emerging only to feed.

Sea cucumbers have some unusual defences. Some, including the Leopardfish Sea Cucumber (Bohadschia argus), when threatened eject a mass of expanding sticky white threads from their anus; these contain toxins that can kill small fish and crabs. (People in the Maldives use freshly ejected Cuverian tubules, as these are technically called, for splinting purposes in much the same way as we use Plaster of Paris.) The discharge ruptures the wall of the cloaca, so is irreversible, the damaged organs being subsequently regenerated. Some species go so far as to eject their entire intestines, later generating another set.

A PRIZED DELICACY

Despite their unappetizing shape and feel, certain species of *Aspidochirote* holothurians are highly valued gastronomic luxuries among people of Chinese origin; festive occasions are

marked by the eating of *trepang* or *bêche-de-mer*. (The latter name comes from the Portuguese *bich de mar*, meaning 'sea worm'.)

However, the preparation of such delicacies is no simple matter, especially since holothurians contain potent toxins. In some areas they are first buried in the sand for several days; they are boiled for 24hr, split open, cleaned, and dried in the sun; then they are smoked over wood (Red Mangrove is preferred) before being dried again. After this the flesh will, if kept dry, last indefinitely.

The dried flesh is used to produce stock for soups and curries. It is highly nutritious, having a typical composition of 43% protein, 27% water, 21% minerals, 7% insoluble ash and 2% fat.

Some thirty species are collected for *bêche-de-mer*, including the Prickly Red Fish Sea Cucumber (*Thelenota ananas*), the Edible Sea Cucumber (*Holothuria [Halodeima] Edulis*) and *Stichopus variegatus*. The most prized species of all, *Holothuria aculeata*, is saved for the lucrative Hong Kong market.

> ### HOLOTHURIAN TYPES
>
> - *Aspidochirote* holothurians are generally quite large, with leathery bodies. They feed on the sand on which they travel, using their rows of tube-feet for locomotion.
> - *Dendrochirote* holothurians, having found a place in a good current, attach themselves with their tube-feet and catch passing plankton with their finely branching feeding tentacles. Often brightly coloured, they are less common on reefs but abundant on the soft, muddy sand areas of the continental shelf between reefs.
> - *Apodus* holothurians have thin, almost translucent body walls. They are sticky to the touch and move by peristaltic contractions of the body, gathering detritus with their elongate, feather-shaped tentacles; those that live on sponges have been shown to supplement their normal diet with substances given off by the sponge. Some Apodus holothurians are tiny, but the huge *Synapta maculata* has been recorded at an amazing 5m (16ft).

Opposite: *Large sea cucumbers, such as this Thelenota ananas, can be nearly a metre (40 in) in length.*

Below: *The aptly named Leopardfish Sea Cucumber (Bohadschia argus).*

Bottom: *Tiny, bright yellow sea cucumbers (Cucumaria sp.) less than 25 mm (1 in) long.*

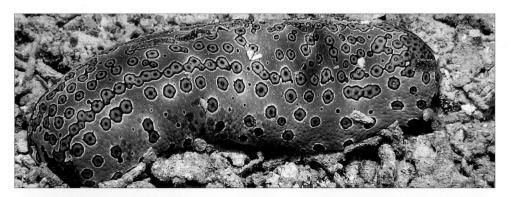

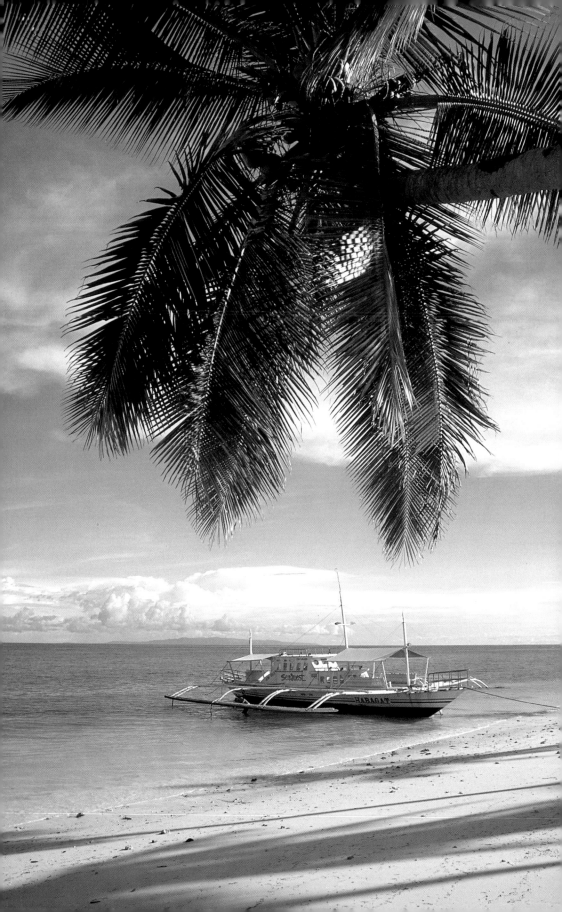

THE VISAYAS

The Visayas are the large central group of islands between Luzon and Mindanao, comprising Bohol, Cebu, Leyte, Negros, Panay and Samar, six of the Philippines' eleven major land masses, plus innumerable smaller islands, straits and channels.

For the visitor, apart from Cebu City, the area is known for its relaxed atmosphere and profusion of sun-drenched, palm-fringed, white sand beaches and calm waters. This is many vacationers' idea of paradise.

Boracay, Carabao and Maniguin Islands

Boracay is a classic tropical paradise: sun-scorched fine white sand, a turquoise sea and a background of swaying palm trees set against an azure sky. Add a variety of watersports, trekking trails, accommodation of all standards from simple nipa palm huts to air-conditioned de luxe resorts, a good international variety of restaurants and bars without too many discotheques, and you have the perfect holiday destination for all the family – although sand flies, locally called *nik-niks*, can be a nuisance after rain.

Lying between the Sibuyan and Sulu Seas, just to the north of Panay Island in the Visayas, Boracay was discovered by backpackers in the early 1970s. Initially its existence was a closely guarded secret, confined mainly to German and Swiss visitors, but slowly the word got out, and the trickle of visitors became a deluge.

As Boracay is only 7km (4½ miles) long and barely more than 1km (0.8 miles) wide, the quiet atmosphere could soon have been ruined, but there has been an active movement to control building development. Few tracks can take vehicles, motorized transport is limited to motorcycles and tricycles, and no vehicles are allowed along the beaches.

Boracay's diving industry has been slower to develop. There are still ill-informed people who will tell you that the diving is no good and that the currents are too fierce. This is

Opposite: *A dive banca pulled up on an idyllic palm-fringed beach.*
Above: *Alabaster Sea Cucumbers (Opheodesoma sp.) clinging to a red sponge.*

definitely not true. The well-established dive operators have aggressively explored the reefs, finding numerous top dive sites. Equally important, the better operators understand tide tables and regularly use them to their advantage when choosing where to dive and when. There is a healthy but friendly competition between these top operators, who are constantly increasing their standards of safety and professionalism and who take a lead in conservation.

New operators are constantly setting up on Boracay, but two continue to stand out as the best – for professionalism, efficiency and the quality of their equipment: Calypso Diving and Victory Divers. Calypso Diving, Victory Divers and also Lapu-Lapu have been on the island since 1987.

Boracay has a good variety of diving, from gentle and very pretty sites through to deep drop-offs and high-voltage drift-dives suitable for more experienced divers, with good chances of encounters with big fish. It is an ideal place to learn to dive. Accommodation is relatively cheap.

TURTLE VISION

Turtles are the most ancient of living reptiles. Like fish, marine turtles are short-sighted – they are even shorter-sighted on land. They see very poorly in dim light as a result of spending most of their lives in shallow water. Their eyes have red, orange and yellow oil droplets that serve to filter out light of shorter wavelengths (green, blue, violet), so that the mix of light reaching the turtle's optical pigments is deficient in these colours. Turtle vision is thus best in yellow, orange and red.

These droplets might seem a liability rather than a benefit, but in fact they do have a purpose. Turtles have eyelids, but they cannot contract their pupils as we do to compensate when the light around us is brilliant. By filtering the light, the oil droplets (which also increase contrast) protect against blinding when the light becomes too bright – for example, close to the surface.

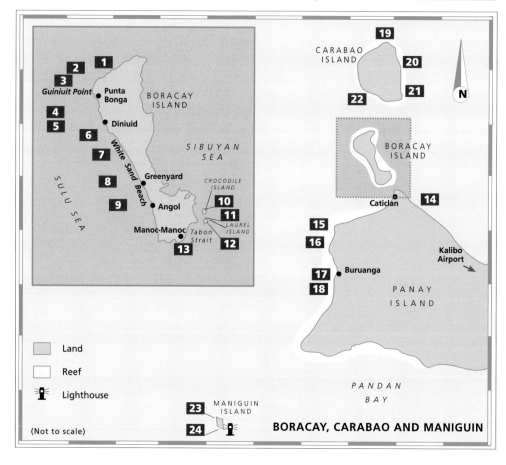

BORACAY, CARABAO AND MANIGUIN

Non-diving companions will find plenty to keep them occupied, though most non-diving visitors come here just to relax.

There are all varieties of colourful soft corals, particularly where currents are running, and most varieties of stony corals, particularly staghorns, large *Acropora* table corals, lettuce corals, mushroom and boulder corals. There are also plenty of leathery and whip corals, *Tubastrea* cup corals, gorgonians, some black corals, bubble corals, blue and yellow sponges, large barrel sponges, lots of sea squirts, nudibranchs, sea stars and sea cucumbers. The fish life includes most of the Pacific species. Reef fish are abundant and, on deeper dives, there is a chance of encountering many of the bigger species, including sharks and the occasional Manta Ray or turtle. Shells, lobsters and sea snakes can still be found on some dives.

The best time to dive is from November till June, but good diving can be had all year round and accommodation is cheaper in the low season, which can also offer some of the best visibility and access to some of the more exciting dive sites.

> ### BLAST-FISHING
>
> Blast-fishing became common soon after World War II. Initially dynamite from the construction or quarrying industries was used, but poor fishermen soon learned how to re-use the explosive from surplus, dumped or sunken munitions; and, when these supplies ran low, ammonium nitrate agricultural fertilizer became a readily available alternative.
>
> The explosive is usually packed into a beer or whisky bottle and sealed with pitch. The narrow flexible plastic tubes used for vehicle windscreen washers often serve to hold the fuse mixture; when fuses are not otherwise available, thinly beaten aluminium from old-style toothpaste tubes is rolled around the fuse mixture to keep it waterproof. Once the fuse is lit, combustion gases keep water from entering the open end when the device is thrown into the water.
>
> Such home-made fuses are notoriously unreliable and many blast fishermen have been severely injured by early detonation.

There is no spear-fishing, and since 1988 no blast-fishing. Many of the fishermen of old now use their *bancas* to make more income from tourists and divers and, together with the coastguard, police their own areas against fishermen from other areas, so the reefs are now regenerating well. Unfortunately, recent typhoons have done some damage to reefs in shallow water, but these areas are healing themselves quickly.

Underwater photographers should be warned that after typhoons the municipal electricity supply drops down below 180 volts between 17:00 and midnight, so it is wise not to charge batteries during this period.

Throughout this chapter the times quoted to reach the dive sites are from Greenyard.

CARABAO AND MANIGUIN ISLANDS

The dive sites of Carabao Island (Sites 19–22) are roughly 1hr by *banca* (in good weather) north of Boracay's White Sand Beach.

Maniguin (locally called Maningning) is 48km (26 nautical miles) southwest of Boracay. It can be reached as a long day or an overnight trip by *banca* in calm weather or on a live-aboard boat. Large live-aboard boats cannot always anchor and may have to cruise up and down the sheltered side of the island, so one cannot give fixed times for access to the dive sites. The reef goes a long way out from the island, with good snorkelling where it is shallow. The dive sites described here (Sites 23–4) are at the drop-offs. The drop-offs have many caves and crevices, which often contain resting Whitetip Reef Sharks and Nurse Sharks, while above the drop-offs every hole contains a Redtooth Triggerfish. The shallow reef-tops offer excellent snorkelling and have many species of nudibranchs.

1 BEL-AT BEACH

★★★

Location: Off the north beach of Boracay.
Access: 20min north by boat and around to the north–northwest face of Boracay, east of Yapak 2.
Conditions: Usually dived when the weather is rough, so expect a strong current. Visibility can reach 25m (80ft) on a flood tide.
Average depth: 35m (115ft)
Maximum depth: 50m (165ft)
This dive is for the experienced only. It is usually visited for excitement when the weather is too rough for Yapak 2 (Site 2), and is best dived on a flood tide. A wall rises to 30m (100ft), running east-to-west all the way to Yapak 1 (Site 3). Divers must quickly descend to the wall and get into its shelter.

The wall itself has plenty of interesting soft corals, gorgonians and stony corals, together with a myriad of reef fish; but the main object of the dive is to look out into the blue water where, in a strong current, almost anything could pass by. Shoals of jacks, surgeonfish, Rainbow Runners, sweetlips and batfish are common; but larger animals are often seen, including large groupers, Napoleon Wrasse, turtles, Whitetip Reef Sharks and Grey Reef Sharks.

2 YAPAK 2
3 YAPAK 1

★★★★

Location: Just northwest of Guiniuit Point, the northwest point of Boracay.
Access: 20min north by boat.
Conditions: These sites are best dived on a strong flood tide, when there are strong and unpredictable currents. Surface conditions can be rough. Visibility can reach 25m (80ft).
Average depth: 35m (115ft)
Maximum depth: 65m (210ft)
By common consent, this is the most exciting diving off Boracay and the site that all the divemasters head for when they have a strong enough group. A rich wall, rising to 30m (100ft), runs north-to-south except for the southernmost 50m (165ft), which goes west-to-east. At the southern end (Yapak 1) there is a chimney to descend and exit at 40m (130ft).

This dive requires a fast descent to the shelter of the wall, regardless of surface conditions. The wall itself is covered with large barrel sponges, *Linckia* starfish, soft corals and gorgonians, and is home to a vast quantity of reef and pelagic fish; but the main object of the dive is to look out into the blue. There Grey Reef Sharks and Whitetip Reef Sharks are common, and Hammerhead Sharks, Manta Rays and Eagle Rays have been seen. There are large shoals of surgeonfish, pennantfish, bannerfish, barracuda, jacks, tuna, snappers, sweetlips and Rainbow Runners, as well as the occasional large grouper and Napoleon Wrasse.

These are dives only for the experienced and not for *anybody* carrying two large cameras!

4 PUNTA BONGA

★★★

Location: West–southwest of Guiniuit Point.
Access: 15min north by boat until opposite Punta Bonga.
Conditions: This site is usually dived in calm conditions, with little current. Visibility can reach 20m (60ft).
Average depth: 18m (60ft)
Maximum depth: 45m (150ft)
This site is the start of the series of walls that run on to Yapak (Sites 2 and 3) and Bel-At (Site 1). The main site is an easy dive with a drop-off from 9m (30ft) to 24m (80ft) at the southern end. The drop-off is covered in soft corals, while the sandy bottom has patches of stony corals with jacks, stingrays, groupers, triggerfish, sweetlips, angelfish, butterflyfish, cornetfish, trumpetfish, pufferfish, lionfish, sea stars and sea cucumbers.

The northern end runs into a series of four short walls in steps down to sand at 45m (150ft) – a scaled-down version of Yapak 1 (Site 3).

5 BALING HAI BEACH

★★★

Location: Northwest of Diniuid.
Access: 10min north by boat.
Conditions: Generally calm with occasionally a slight current. Visibility can reach 25m (80ft).
Average depth: 15m (50ft)
Maximum depth: 24m (80ft)
A rich coral garden runs down a gentle slope from 7m (23ft) to 10m (33ft), then you go over the drop-off down to sand at 24m (80ft). The drop-off itself runs north-to-south for 200m (656ft).

The coral garden has profuse soft, leathery and

Acropora table corals, and there are good stony corals down the drop-off. There is a fine variety of reef fish, including surgeonfish, butterflyfish, angelfish, damselfish, lionfish, scorpionfish, pufferfish, parrotfish and chromis, with lizardfish, Bluespotted Ribbontail Rays, sea stars and sea cucumbers down on the sand.

6 FRIDAY'S ROCK

★★★

Location: Southwest of Diniuid.
Access: 10min north by boat.
Conditions: Calm but with some current. Visibility can reach 25m (80ft).
Average depth: 18m (60ft)
Maximum depth: 18m (60ft)
Friday's Rock itself is a large boulder rising from sand at 18m (60ft), with its top at 7m (23ft). The sand beside the rock is used by local dive operators as a fun dive with fish-feeding, so the fish come at you as you approach (but please don't be tempted to feed them). Some 20m (65ft) inshore of Friday's Rock there is a good coral garden at 14m (45ft).

While angelfish, butterflyfish, surgeonfish, damselfish and sergeant majors will approach you hoping to be fed, there are also many parrotfish, triggerfish, snappers, scorpionfish, lionfish, sweet-lips, groupers, cuttlefish and wrasse.

On the sand there are Bluespotted Ribbontail Rays, moray eels, ribbon eels, *Linckia* starfish, *Choriaster* Cushion Starfish, Pincushion Starfish and sea cucumbers.

7 LOBSTER ROCK

★★★

Location: West of Balabag.
Access: 10min north by boat.
Conditions: Generally calm with occasionally a slight current. Visibility can reach 20m (65ft).
Average depth: 14m (45ft)
Maximum depth: 16m (52ft)
Lobster Rock, a large rock rising from 16m (52ft) to 10m (33ft), is the standard night dive for advanced courses locally. There is a small colony of Spiny Lobsters, plus surgeonfish, angelfish, butterflyfish, damselfish and sergeant majors, most of which hide in holes in the reef at night, when crabs, shrimps, moray eels and shellfish come out to feed.

Yellowsaddle Goatfish (Parupeneus cyclostomus). This so-called 'bottom-dweller' uses the barbels under its chin to search for food on the sea floor.

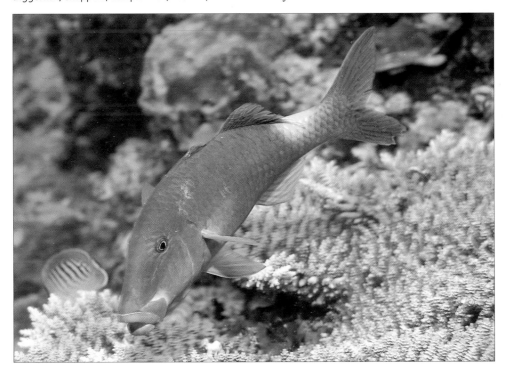

8 GREENYARD
9 ANGOL

★★★★★

Location: The reefs in front of Greenyard and Angol.

Access: 5min by boat or a long swim off White Sand Beach.

Conditions: Generally calm. Visibility can reach 15m (50ft).

Average depth: 7m (23ft)

Maximum depth: 10m (33ft)

This is the house reef that runs down the front of the beach, where it is used for novice training dives and check-out dives, as well as for its good snorkelling. The reef has a very gentle slope, mixed sand and small stony corals, with anemones and clownfish, sea grasses, damselfish, sea stars, sea cucumbers and sea urchins.

10 CROCODILE ISLAND, SOUTH SIDE

★★★★★★★★

Location: Northeast of Manoc-Manoc.

Access: 15min by boat south and then east along the Tabon Strait to the south side of Crocodile Island.

Conditions: Can be rough with strong currents. Visibility can reach 25m (80ft).

Average depth: 10m (33ft)

Maximum depth: 25m (80ft)

From a distance this island resembles a crocodile, hence its name. The shallow reef-top is good for snorkelling, although snorkellers should be careful of the currents. On the south side a drop-off 60m (197ft) long goes down from 7m (23ft) to 25m (80ft); it has prolific soft corals and leathery corals, and gorgonians as good as those at Sipadan in Borneo. The top of the drop-off is a gentle slope from 2m (7ft) to 3m (10ft) with several small canyons containing lots of squirrelfish, soldierfish, parrotfish, cardinalfish, Rainbow Wrasse and Bird Wrasse. There is a small drop-off to 7m (23ft), then a gradual shelving off on sand to 25m (80ft), with good soft, leathery and stony corals.

At 14m (45ft) there is a large congregation of garden eels and some large sea snakes, good-sized whip corals and gorgonians, black coral and anemones with clownfish.

The fish life is profuse, with parrotfish, angelfish, bannerfish, pennantfish, butterflyfish, Titan and Redtooth Triggerfish, Lined Sweetlips, anthias, chromis, Moorish Idols, damselfish, snappers, fusiliers, surgeonfish, groupers, goatfish, trumpet-

Nudibranch egg spiral camouflaged on a yellow sponge. The gelatinous ribbon will contain a huge number of tiny eggs.

fish, cornetfish, pipefish, hawkfish, moray eels, sea stars, sea cucumbers and many nudibranchs.

11 LAUREL I
★★★★☆☆☆☆☆

Location: The northeast side of Laurel Island, east of the southern tip of Boracay.
Access: 20min by boat south and then east along the Tabon Strait.
Conditions: Generally calm, but currents can be very strong. Visibility can reach 30m (100ft).
Average depth: 5m (16ft)
Maximum depth: 20m (65ft)
This small island has a remarkable tunnel, 8m (26ft) long, you can swim through at shallow depth; it is best dived as a drift when the current is strong and the soft corals on its wall fill up to a blaze of colour. It is also a good night dive for the *Tubastrea* cup corals on its roof. You then swim out into a valley, dropping to 20m (65ft), with large table corals, barrel sponges, gorgonians and black corals.

The fish life is prolific, including all the angelfish and butterflyfish, surgeonfish, trumpetfish, cornetfish, pufferfish, filefish, triggerfish, squirrelfish, soldierfish, fusiliers, rabbitfish, Moorish Idols, cardinalfish, hawkfish, snappers, sweetlips, pipefish, sea stars, sea cucumbers and various nudibranchs. I even saw a Pearl Cowrie feeding in daylight.

The top of the reef, at 4m (13ft), has good boulder corals with various Christmas-tree Worms, fan worms and algae, as well as whip corals and leathery corals.

This is a fine dive for photographers and suitable for snorkellers, though the latter should be careful of the currents.

12 LAUREL II
★★★

Location: Directly east of Laurel Island.
Access: 20min by boat south then east through the Tabon Strait.
Conditions: This site is usually drift-dived in the rainy season, when it is sheltered, but it can have strong currents. Visibility averages 20m (65ft).
Average depth: 15m (50ft)
Maximum depth: 20m (65ft)
A north-to-south wall that is not dived often, so there is little anchor damage and good fish life.

13 CHANNEL DRIFT
★★★★

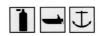

Location: The Tabon Strait.
Access: 15min south by boat to the Tabon Strait.
Conditions: Very strong currents (up to 7 knots); it can be rough on the surface. Visibility can reach 20m (65ft).
Average depth: 18m (60ft)
Maximum depth: 35m (115ft)
Strong tidal currents flow through the Tabon Strait with great force, taking divers along a sandy bottom with patches of coral, canyons and crevices where smaller fish take refuge and bigger fish wait for the current to bring them food. There is an excellent drift-dive at 18m (60ft), but it is important to have good buoyancy control.

On the south side a deeper drift-dive follows a ridge at 35m (115ft), where there are some caves that often contain resting Whitetip Reef Sharks. Other cracks and crevices shield groupers, batfish and sweetlips, and there are stingrays and garden eels on the sand.

14 UNIDOS POINT
★★

Location: On the east side of Caticlan.
Access: 20min by boat south and then east through the Tabon Strait.
Conditions: Usually dived as a sheltered site in bad weather. Visibility averages 20m (65ft).
Average depth: 15m (50ft)
Maximum depth: 25m (80ft)
A bad-weather site, shelving off to 25m (80ft) on sand with coral outcrops, groupers, snappers, batfish, sweetlips, moray eels, garden eels, angelfish and butterflyfish.

15 NASOG POINT
★★★

Location: The northwest corner of Panay Island.
Access: 25min south by boat.
Conditions: Generally calm with a gentle current, but it can become very rough with a strong current. Visibility averages 25m (80ft).
Average depth: Anything you like
Maximum depth: 35m (115ft)

The site is a slope from 5m (16ft) to 35m (115ft) with boulders and canyons, so that unwary novices may find themselves indulging in saw-tooth diving (i.e., going up and down in response to the bottom topography, and thereby risking ear problems or the bends). The top 10m (33ft) is the best, because of its soft corals and gorgonians. The fish life is limited, except when a strong current is running, but there is a good chance of seeing a turtle. But this is a dive to do for its topography – to swim through the rocks.

16 DOG DRIFT

★★★★

Location: South of Nasog Point.
Access: 25min south by boat to the west side of Panay Island.
Conditions: Usually calm, with a medium-strong current. Visibility averages 25m (80ft).
Average depth: 20m (65ft)
Maximum depth: 30m (100ft)
This 200 (656ft) to 300m (984ft) wall, running north-to-south, drops from 6m (20ft) to 30m (100ft) and abounds with caves, holes and crevices. There are lots more fish here than at

Nasog Point (Site 15), including groupers, snappers and pufferfish; there are also Spiny Lobsters, soldierfish, squirrelfish, cardinalfish, sweepers, shoals of juvenile sweetlips, batfish and fusiliers, lionfish, scorpionfish, stonefish, hawkfish, angelfish, butterflyfish, Moorish Idols, stingrays and moray eels. Manta Rays and turtles have also been seen here.

17 BURUANGA

★★★★★

Location: Offshore from Buruanga village.
Access: 35min south by boat until off Buruanga, on the west side of Panay Island, south of Dog Drift (Site 16) and Nasog Point (Site 15).
Conditions: Sheltered, though there can be strong currents. Visibility can reach 30m (100ft).
Average depth: 20m (65ft)
Maximum depth: 40m (130ft)
The reef-top is a gentle slope from 5m (16ft) to 7m (23ft) covered in good soft, leathery and stony corals. From 7m (23ft) the drop-off goes down to

The Splendid Squirrelfish (Myripristis melanosticta), also known as the Finspot Soldierfish, is a nocturnal species.

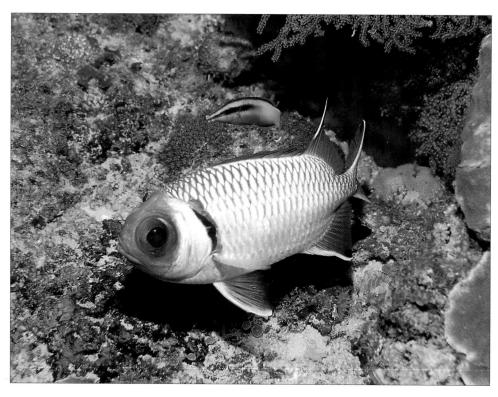

40m (130ft), where there is a cave. There is everything on this wall, including Spiny Lobsters, young squid, Titan, Redtooth and Clown Triggerfish, pufferfish, lionfish, scorpionfish, soldierfish, squirrelfish, cardinalfish, anthias, chromis, most angelfish and butterflyfish, Moorish Idols, bannerfish, pennantfish, hawkfish, jacks, tuna, barracuda, snappers and sweetlips. There are also many nudibranchs and *Bohadschia* sea cucumbers.

A photographers' dive.

18 BLACK ROCK
★★★★★

Location: South of Buruanga.
Access: 35min south by boat to the west face of Panay Island.
Conditions: Usually calm, but it can get rough with a strong current. Visibility can reach 25m (80ft).
Average depth: 25m (80ft)
Maximum depth: 40m (130ft)
Black Rock sticks out of the water and offers very good diving. The west side is a wall from 7m (23ft) to 40m (130ft), with caves at the bottom, good pelagic fish life and occasionally you may see Hammerhead Sharks.

The east side is shallow and sheltered, with canyons, caves and crevices. There are plenty of fish, including batfish, snappers, sweetlips, jacks, trumpetfish, cornetfish, cardinalfish, soldierfish, squirrelfish, hawkfish, fusiliers, Titan and Orangestriped Triggerfish, Map, Star and Bandit Pufferfish, anthias, chromis, damselfish, sergeant majors and anemones with clownfish, as well as pelagic species.

19 CARABAO ISLAND – CATHEDRAL CAVE
★★★

Location: The northern end of Carabao Island.
Access: 1hr 20min north by boat.
Conditions: One would make this journey only in good conditions, but there can be a strong current on occasion. Visibility can reach 25m (80ft).
Average depth: 35m (115ft)
Maximum depth: 40m (130ft)
This is a very big cave with a large entrance, so, apart

from the depth, it is safe for novice divers. At the back of the cave there are many cracks and fissures which often contain sleeping big fish, including Whitetip Reef Sharks. There is good fish life, and there is the chance you will see some large pelagic species.

20 CARABAO ISLAND – VILLAGE REEF
★★★

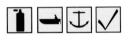

Location: The centre of the east face of Carabao Island.
Access: 1hr 10min north by boat.
Conditions: Generally calm, with occasionally a slight current. Visibility can reach 25m (80ft).
Average depth: 15m (50ft)
Maximum depth: 24m (80ft)
A rich coral garden on a gentle slope from 7m (23ft) to 10m (33ft) is followed by a drop-off down to sand at 24m (80ft). The drop-off itself runs north to south for 200m (660ft).

The coral garden has profuse soft, leathery and table corals, and there are good stony corals down the drop-off. The large variety of reef fish includes surgeonfish, butterflyfish, damselfish, lionfish, scorpionfish, pufferfish, parrotfish and chromis, with lizardfish, Bluespotted Ribbontail Rays, sea stars and sea cucumbers down on the sand.

21 CARABAO ISLAND – VILLAGE MOUNTAIN
★★★

Location: Just north of the southeast corner of Carabao Island.
Access: 55min north by boat.
Conditions: Generally calm, but there can on occasion be a strong current. Visibility can reach 25m (82ft).
Average depth: 20m (65ft)
Maximum depth: 30m (100ft)
A large coral head drops down to sand at 30m (100ft). There are lots of good fish, including shoals of jacks, fusiliers and snappers and plenty of colourful reef fish, such as Titan, Clown, and Redtooth Triggerfish, lionfish, scorpionfish, squirrelfish, angelfish, butterflyfish, Moorish Idols, sweetlips and Bluespotted Ribbontail Rays. With luck you may see some large pelagic species, such as barracuda, Rainbow Runners, tuna and trevally.

22 CARABAO ISLAND – WEST WALL

★★★★★

Location: The southwest face of Carabao Island.
Access: 50min north by boat.
Conditions: Generally calm, but can be rough; usually some current, which can be strong. Visibility can reach 25m (80ft).
Average depth: 25m (80ft)
Maximum depth: 40m (130ft)
A big wall, 200m (660ft) long, drops from 10m (33ft) down to 40m (130ft), with caves, good soft, leathery and stony corals on the reef-top and prolific fish life on and off the wall. Whitetip Reef and Grey Reef Sharks have been seen here.

The fish include batfish, snappers, sweetlips, jacks, trumpetfish, cornetfish, cardinalfish, soldierfish, squirrelfish, hawkfish, fusiliers, Titan and Orangestriped Triggerfish, Map, Star and Bandit Pufferfish, anthias, chromis, damselfish, Sergeant Major Fish and anemones with clownfish, as well as pelagic species.

23 MANIGUIN ISLAND – NORTH FACE

★★★★★★★★★

Location: The northernmost point of the reef.
Access: By boat.
Conditions: Variable – can be rough in bad weather; in good weather it is calm, with currents varying with the tide. Visibility can reach 30m (100ft).
Average depth: 15m (50ft)
Maximum depth: 45m (150ft)
Most of the reef-top is a gentle slope from 10m (33ft) to 17m (65ft) with a mixture of coral heads on sand interspersed with fresh blast-fishing damage. The blast-fished areas cover only a small portion of the total expanse, the rest being top-quality soft, leathery, stony and whip corals harbouring a myriad of reef fish. These include most Pacific species of triggerfish, pufferfish, trumpetfish, cornetfish, parrotfish, batfish, catfish, Moorish Idols, angelfish, butterflyfish, Bluespotted Ribbontail Rays, cuttlefish, moray eels, garden eels, sand perch, nudibranchs, anemones with clownfish, sea stars and sea cucumbers. Every small hole seems to contain a Redtooth Triggerfish.

From 17m (55ft) there is a wall dropping to 45m (150ft), though in some places it rises to 5m (16ft). At one of these higher points I found three large Spiny Lobsters in a hole at the top of the face, and within 20m (65ft) of moving on I found yet another two.

The wall itself is full of caves and crevices, many of which contain sleeping Whitetip Reef Sharks and Nurse Sharks. Overhangs are covered with large gorgonians and *Tubastrea* cup corals. There are shoals of surgeonfish, Midnight Snappers, jacks, sweetlips, batfish, Bumphead Parrotfish, bannerfish, pennantfish, fusiliers, barracuda, tuna, trevally, Eagle Rays, Whitetip Reef Sharks, Grey Reef Sharks, soldierfish, squirrelfish, sweetlips, parrotfish and Napoleon Wrasse. Hammerhead Sharks and Manta Rays have been seen here.

24 MANIGUIN ISLAND – SOUTH FACE

★★★★★★★★★

Location: The south face of the reef.
Access: By boat. To find the greatest number of sleeping Whitetip Reef Sharks in caves, line up the lighthouse with the prominent large white rock, while over the drop-off.
Conditions: Variable – can be rough in bad weather. In good weather it is calm, with currents varying with the tide. Visibility can reach 30m (100ft).
Average depth: 20m (65ft)
Maximum depth: 45m (150ft)
Drifting west with the current, it can be possible to cover most of the face in one very long dive. The wall and reef-top are very similar to the North Face (Site 23); perhaps slightly more areas have been damaged by blast-fishing, but the majority of the dive is beautiful, with abundant reef and pelagic fish life. There are caves, crevices and overhangs on the wall, many of the caves containing sleeping Whitetip Reef Sharks.

Again there are lots of large Spiny Lobsters and a large shoal of Bumphead Parrotfish, plus Napoleon Wrasse, large groupers, Eagle Rays, Whitetip Reef Sharks, Grey Reef Sharks, tuna, barracuda, snapper and trevally, as well as a myriad of reef fish, particularly in the centre of the face.

At the western end of the face the top of the wall becomes shallower; the reef-top offers excellent snorkelling when there is no surf running.

HOW TO GET THERE

If you are carrying diving equipment, PAL is the best airline to choose, as they use Boeing 737–300s on this route with the normal 20kg (44lb) checked baggage allowance (if you have a Flying Sportsman Card you can carry even more). They have several flights a day from Manila to Kalibo, as well as flights from other islands. You then take a 1½-2hr bus or jeepney ride from Kalibo to Caticlan, where you board *bancas* to ferry you across to Boracay.

(For the return journey, the buses leaving Caticlan are timed to meet the flights departing from Kalibo airport.)

This route is highly organized. You will be accosted at Manila domestic airport Terminal One by representatives of the two main transfer operators, Southwest and 7107 Islands Tour Management Inc., who will sell you an all-in ticket for both an air-conditioned bus and the *banca* transfer (the *bancas* have radio contact with the transfer organizers). You could save some money by getting a jeepney from Kalibo to Caticlan and haggling with the *bancas*, but it is hardly worth it if you are carrying any diving equipment.

The bus ride from Kalibo to Caticlan can be avoided by flying directly to the little airstrip at Caticlan with either Air Philippines, Asian Spirit or Pacific Air. Smaller aircraft are used on this route with a checked baggage limit of 10kg (22lb).

It is only a short crossing from Caticlan to Boracay but, depending on the tide, you will at least get your feet wet or possibly have to wade when embarking and disembarking, so it is worth wearing shorts and sandals. The *bancas* tend to be over-loaded and the crossing can be wet, so protect any equipment that you want to keep dry.

The *bancas* call at regular stopping points along White Sand Beach, so it is a good idea to know in advance where you are staying.

The only types of mechanized transport permitted on Boracay are motorcycles and motor tricycles and these are barred from the beach. If the weather is rough you will be dropped on the leeward (east) side of the island, where you will be met by motorized or pedal tricycles for transport.

Some of the larger up-market resorts have their own ferry service; also, if there are enough of you going to one particular resort, the *bancas* will drop you there.

On the way back, with my heavy extra weight of diving equipment and underwater cameras, I asked the staff at Nigi-Nigi Nu Noos to radio the *banca* operators and arrange for me to be picked up directly from there.

Bancas ply the route from other provinces as well.

WHERE TO STAY

Upper Price Range
Friday's Beach Resort tel 036-2886202/ fax 036-2886222. Manila: tel 02-7508459/ fax 02-7508457
Quality resort.

Paradise Garden Resort Hotel Manggayard, Boracay; tel 02883411/fax 036-2883557. Manila: tel 2-5249638/fax 2-5210086; e-mail: boracay@paradise-garden.com; website: www.paradise-garden.com
Top-quality resort

Medium Price Range
Nigi-Nigi Resort PO Box 11, Kalibo Post Office, Kalibo, Aklan; tel 36-2883101/ fax 36-2883112;
e-mail: niginigi@pworld.net.ph; website: www.niginigi.com
Nice rooms and friendly atmosphere.

Tonglen Beach Resort tel 036-2883457/ fax 036-2883919;
e-mail: info@philippines-boracay.com; website: www.philippines-boracay.com
A variety of accommodation available.

Lower Price Range
El Centro tel 36-2886352/fax 36-2886055; e-mail: elcentroresort@yahoo.com
For those on a budget.

Philippine Beach Resort (Behind Victory Divers); tel 036-2883657/fax 036-2883766
Various standards of accommodation.

Pinjalo Villas tel 36-2883206; email: info@pinjalo.com; website: www.pinjalo.com

Villa Camilla tel 36-2883354/fax 36-2883106; e-mail: front_desk@villacamilla.com; website: www.villacamilla.com
Various standards of accommodation.

WHERE TO EAT

There are many affordable restaurants along White Sand Beach. I enjoyed the Oriental Restaurant at Nigi-Nigi Nu Noos é Nu Nu Noos and True Food for Indian/Afghan dishes and Italian Pasta. The restaurants in Victory Diving School and Calypso Divers are good value. Sea Lovers has inexpensive seafood, Chez Paris has good French cuisine, Sulu Tha for Thai food, The Steak House above Fisheye has good steaks, and Flore Mar has excellent pizza.

DIVE FACILITIES

Aquarius Diving Centre (Formerly Calypso II) Balabag, Boracay; tel 036-2883132/ fax 036-2883189;
e-mail: aquarius@phildive.com; website: www.phildive.com
PADI 5-Star Centre, 15 years in Boracay. Diving safaris, Nitrox courses and 'Camaro Boutique' – a retail dive shop.

Calypso Diving School & Villas (Next to Boracay Tourist Centre) Boracay Island, Malay, Aklan; tel 036-2883206/fax 036-2883478; e-mail: calypso@boracay.i-next.net; websites: www.pinjalo.com, www.calypso-asia.com, www.calypsodiving.com, www.calypso.ph
The only licensed PADI 5-Star IDC Centre on Boracay. Brand new complex, IANTD Nitrox and Trimix technical instruction, safaris and day trips to Maniguin Island.

Fisheye Divers Balabag, Boracay; tel 036-2886090/fax 036-2886082; e-mail: info@fisheyedivers.com; website: www.fisheyedivers.com
PADI Courses to Divemaster level, plus dive safaris.

Lapu Lapu Balabag, Boracay; tel 036-2883302/fax 036-2883015; e-mail: info@lapulapu.com; website: www.lapulapu.com
PADI and IANTD Nitrox courses; specializes in the French-speaking market.

Scuba World Inc. Balabag, Boracay; tel 036-2883310/fax 036-2886443; e-mail: boracay@scubaworld.com.ph. Manila Office: 1181 Vito Cruz Extension, Kakarong Street, Makati City; tel 2-8953551/fax 2-8907805; e-mail: swidive@compass.com.ph; website: www.scubaworld.com.ph
PADI 5-Star facility and TDI technical training.

Victory Divers PO Box 11, Kalibo, Aklan; tel/fax 036-2883209;
e-mail: info@victorydivers.com; website: www.victorydivers.com
PADI 5-Star Gold Palm Resort. Nitrox and Technical Diving instruction, with three spacious *bancas* for regular dive safaris.

Whitebeach Divers Angol, Boracay; tel/fax 036-2883809;
e-mail: whitebeachdivers@hotmail.com
PADI courses and Nitrox.

DIVING EMERGENCIES

St Jude Hospital
Lopez Jaena Street, Kalibo, Aklan.

St Paul's Hospital
General Luna Street, Iloilo City; tel 03-72741

The nearest recompression chamber is in Manila: **AFP Medical Center**, V. Lunar Road, Quezon City, Metro Manila; tel 02-9207183.

LOCAL HIGHLIGHTS

Life on Boracay is mainly about lazing on the beach and watersports. You can stroll along the beach in the evening, and there are many inland trails to walk.

Danjugan Island

Situated in the Sulu Sea, 3km (2 miles) west of the small town of Bulata on the island of Negros, the little island of Danjugan is 1.5km (1 mile) long and 0.5km (⅓ mile) across at its widest point. It is surrounded by coral reefs and still retains most of its original forest cover on hills rising to 600m (1970ft).

Danjugan's coral reefs were a paradise until a nearby copper mine was temporarily closed down. The local fishermen found the explosives and used them for blast-fishing. There has also been recent typhoon damage to the shallow areas. Diving around the island with the Philippines project leader Gerry Ledesma and his conservation volunteers showed me the damage that blast-fishing does to a coral reef; but it also showed clearly how beautiful the undamaged areas are, and how quickly the faster-growing corals can regenerate once destructive fishing is curtailed. There is a profusion of leathery corals, colourful *Dendronephthya* soft corals, gorgonians and sponges. Sizable areas of large plate corals and lettuce corals are common, and *Acropora* staghorn and table corals are regenerating rapidly.

Although there is some small-scale subsistence fishing, the fish life is varied, with shoals of Moorish Idols, bannerfish, pennantfish, damselfish, Sergeant Major Fish, jacks, fusiliers and anthias. Chevron and Copperband Butterflyfish, Titan, Clown and Redtooth Triggerfish, pufferfish, Vlaming's Unicornfish, surgeonfish, nudibranchs and anemones with clownfish are plentiful. Colourful *Linckia* sea stars, sea urchins and sea cucumbers can be found on the sand. Green Turtles and Hawksbill Turtles, both of which are endangered species, are occasionally seen.

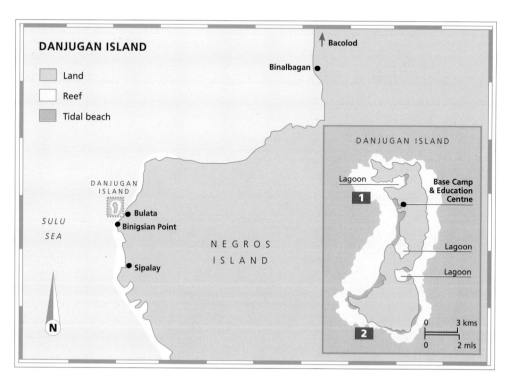

Opposite: *Gorgonian red polyp octocoral (Plexauridae) and mixed corals on the reef edge.*

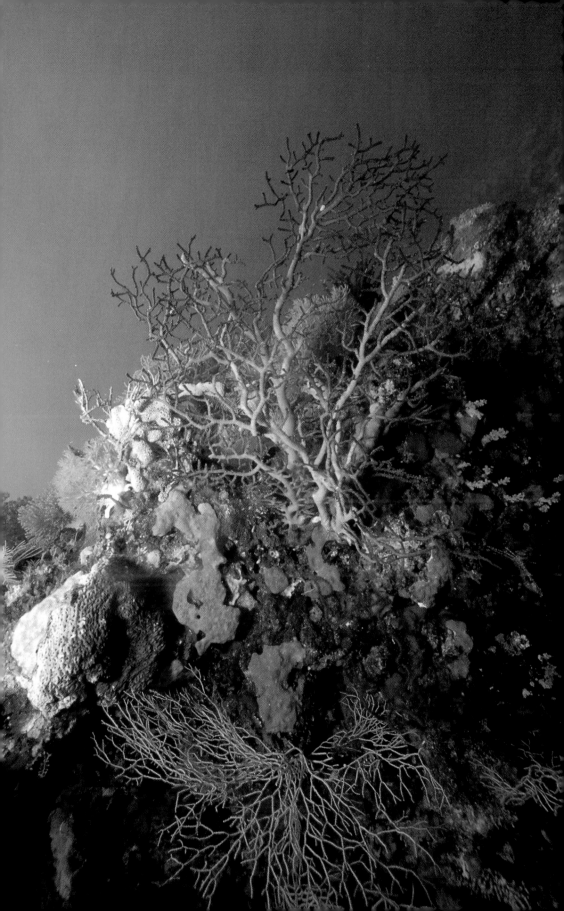

1 NORTHWEST FACE

★★★☆☆☆

Location: 200m (220yd) west–northwest of the base camp.
Access: 5min by *banca*.
Conditions: Normally calm or slightly choppy with a mild current. You would not dive here in rough conditions. Visibility can reach 20m (65ft).
Average depth: 20m (65ft)
Maximum depth: 40m (130ft) plus

There is a gentle slope out and down, with some spur-and-groove formations and shallow depressions. The site has been heavily damaged by both blast-fishing and typhoon winds, but has surprisingly prolific fish life in places and the obvious beginnings of coral regeneration, especially small *Acropora* table corals and soft corals.

There are sizable shoals of Moorish Idols, bannerfish, pennantfish, damselfish, Sergeant Major Fish, jacks, fusiliers and anthias. Chevron, Copperband and Pyramid Butterflyfish, Titan, Clown and Redtooth Triggerfish, pufferfish, Vlaming's Unicornfish and surgeonfish also abound. Nudibranchs and anemones with clownfish are plentiful. Colourful *Linckia* sea stars, sea urchins and sea cucumbers can be found on the sand, and crinoids on any high points.

It is worth diving at dusk when the fish are more actively feeding and shoaling.

2 SOUTH FACE

★★★★☆☆☆☆

Location: The drop-off at the centre of the south face.
Access: 20min by *banca* from the base camp.
Conditions: Normally calm or slightly choppy, with a mild current. You would not dive here in rough conditions. Visibility can reach 30m (100ft).
Average depth: 20m (65ft)
Maximum depth: 40m (130ft) plus

A delightful dive can be made over, in and out of gullies and narrow crevices between large rocks and coral heads liberally coated with leathery corals, soft tree corals and especially stony lettuce corals. There is some typhoon and blast damage deeper down, but in the shallower sunlit water the regeneration is striking.

There are good shoals of smaller reef fish and plenty fo nudibranchs, flatworms, Feather Duster Worms, sea stars and varieties of sea cucumbers and sponges. Colourful crinoids open out where there is current.

Feather star (Comanthus bennetti). Feather stars feed on plankton passing in the current which is filtered out with their plumy arms.

HOW TO GET THERE

Access to the island handled by the local project staff.

WHERE TO STAY/DIVE

Equally, all arrangements for use of the diving facilities are made through the project organizers.

DIVING EMERGENCIES

The nearest recompression chamber is **VISCOM Station Hospital,** Camp Lapu Lapu, Lahug, Cebu City; tel 032-310709

LOCAL HIGHLIGHTS

Birdwatching is the major – perhaps the only – non-diving attraction of the island apart from walking and exploring. The forest's birdlife includes warblers, flycatchers, bulbuls, weaverbirds and sunbirds, together with migrating swallows, swifts and kingfishers. Sea eagles, fish eagles, mangrove herons and night herons frequent the mangrove swamps. Colonies of bats inhabit the caves.

The Common Clownfish (Amphiprion ocellaris) acquires a mucous coating from its host anemone which provides it with protection against the stinging tentacles.

THE PHILIPPINES REEF AND RAINFOREST PROJECT

The Philippines Reef and Rainforest Project – launched by Professor David Bellamy on 29 March 1994 – recently succeeded in purchasing Danjugan Island with a view to turning it into a wildlife sanctuary, removing alien species, assisting the natural regeneration of original species, patrolling the protected water areas around the reefs and setting up an education centre.

This is the third project of the World Wide Land Conservation Trust, a non-profit-making company and registered charity, which through the generosity of its supporters previously helped to save large areas of tropical forests in Belize and Costa Rica. The Trust's expertise in managing land projects and fund raising is here directed towards conserving the forests, while Coral Cay Conservation, with their extensive experience of coral reefs and their conservation, develops the management of the marine environment.

On site, scientists from the Negros Forests and Ecological Foundation, the Philippines Wetlands and Wildlife Conservation Foundation, Silliman University and Coral Cay Conservation began by making initial surveys. A permanent base camp was later set up, and marine youth camps are now held, to teach young people about coral reefs and their conservation. The project offers volunteers the chance to join expeditions studying the marine and forest ecosystem.

In the UK the project is raising money for the continued protection of Danjugan Island. Many schools, clubs and individuals have already contributed, and school packs are available free of charge to teachers. Further information and a brochure may be obtained from:

Coral Cay Conservation
40–42 Osnaburgh Street
London NW1 3ND
United Kingdom
tel 0870-7500668/fax 0870-7500667;
e-mail: ct@coralcay.org;
website: www.coralcay.org

Negros Forests and Ecological
Foundation Inc.
South Capitol Road,
Bacolod City 6100,
Negros, Philippines
tel/fax 34-4339234;
e-mail: nfefi@mozcom.com; website:
www.quantum-conservation.org/NFEFI

R adiant energy exists in a diversity of forms – collectively described as the electromagnetic spectrum – distinguished by different frequencies. Radiant energy travels at a uniform velocity through free space, and a higher frequency implies a shorter wavelength; higher frequencies also indicate higher energy levels.

The human eye is able to perceive only a tiny fraction of the electromagnetic spectrum, the portion that we call visible light. It runs from violet (high frequency) through indigo, blue, green, yellow and orange to red (lower frequency). The 'window' of frequencies to which animal eyes are sensitive does not always accord exactly with this: some species can see some less energetic radiation (the infrared) but not all of the more energetic colours visible to us, while other creatures can see into higher energies (ultraviolet). A few – including dolphins and bats – can also 'see' at wavelengths quite different from those of the visible spectrum; but the organs used for this perception are in no sense eyes.

Light travels in essentially straight lines and at uniform velocity through any uniform medium, whether that medium be vacuum (as in outer space), gas (as in the atmosphere) or liquid (as underwater). When light moves from a more rarefied medium to a denser one, as from air into water or glass, its velocity decreases, and this slowing down is expressed partly in terms of a change in direction – in this instance the angle shifts away from the line between the two surfaces. The higher the energy of the light, the less it is affected: this is why a glass prism can be used to split up white sunlight into the different colours of the visible spectrum.

LIGHT UNDERWATER

We have been talking of air and water as if they were each of uniform constitution. However, nothing could be further from the truth: uniform mediums are unusual in nature. For example, the pressures in the atmosphere at any particular place are in a state of constant flux. Light travelling through a turbulent medium of any kind is, in effect, constantly going from one medium into another, with countless consequent changes of angle. Another factor affecting the light is interaction with the atoms and molecules of the medium (as well as with any particles of debris sus-

pended in it): the relationship between the typical sizes of these and the wavelengths (colours) of the light determines the degree to which the light is scattered; again, longer wavelengths (lower frequencies, lower energies) are more vulnerable to this than higher ones. The overall result of these processes is that, seen at a distance through a medium, an image appears less red than it does close up. Our eyes normally interpret this relative paucity of red to see the image as bluer.

As you dive deeper you are putting progressively greater thicknesses of an optical medium – water – between you and the lightsource. By the time you are 25m (80ft) deep almost all of the sunlight's red and orange have been filtered out; by 50m (165ft) the yellow has gone as well, and green light has given up the struggle by 100m (330ft). Only the highest-energy light – the blues – continues to penetrate much further, being weakly present beyond 200m (660ft).

To summarize, at whatever depth you are, things appear bluer than they would normally; the greater the depth, the more this effect becomes obvious. Some extraneous factors may affect this general pattern. For example, inshore waters contain large quantities of the products of plant decay. Since these are predominantly yellow, they filter out some of the blue, giving the water an overall greenish hue.

Since only the higher-energy colours can penetrate deep into the ocean, the colour vision of most saltwater fish is shifted towards the blue end of the spectrum. Deep-water fish have a golden visual pigment that is most sensitive to blue. Freshwater fish, on the other hand, which are accustomed to shallower environments, are more sensitive to reds than their oceanic cousins, and some – such as the perches – can see into the near infrared; that is, they can see colours 'redder' than any our own eyes can perceive.

Left: *Grey Reef Shark (Carcharhinus amblyrhynchos) being shadowed by a jack (Caranx sp.). Both are counter-shaded for camouflage purposes.*
Below: *Sabre Squirrelfish (Sargocentron (Adioryx) spinifer). Red-coloured fish are difficult to see, as red light is filtered out by water.*

Eastern Cebu and Mactan Island

Cebu is an island, a province and a city. Cebu City, the 'Queen City of the South', is the oldest and second-busiest metropolis in the Philippines after Manila. The combination of fine sandy beaches, nightlife and easy access to Mactan International Airport has made it the most highly developed resort area in the country; in particular, its more expensive resorts cater for visitors from the USA, Hong Kong, Japan, Taiwan and Singapore, either on holiday or as conference delegates. There are charter flights direct from Hong Kong, Japan, Taiwan and Sydney for holiday-makers.

Cebu City's location in the centre of the archipelago also makes it the crossroads of the country's shipping. Busier than Manila, the port is well sheltered by Mactan Island – particularly important as the area is on the edge of the typhoon belt.

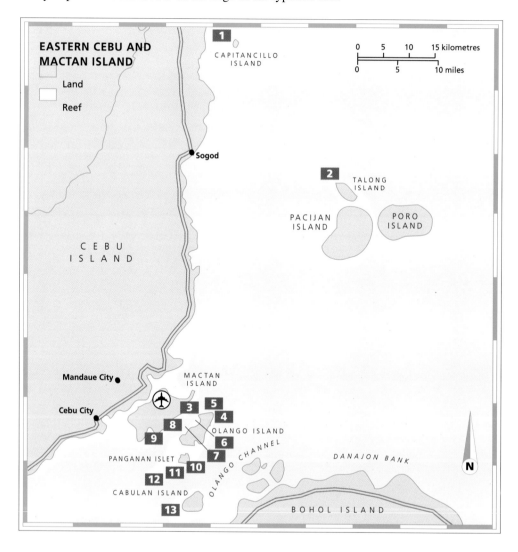

The International Airport is on Mactan Island, linked to Cebu City by a bridge.

DIVING

Almost all the resorts offer diving, but the standard offered and the commitment to conservation vary. Some actually offer spearfishing and shell-collecting, but the better ones have got together to encourage marine conservation With increasing financial returns from tourism, and the action of bigger resorts, most blast and cyanide fishing has stopped. As spearfishing is still common, larger reef fish are rare.

Strong currents are the norm, all the better dives being on steep drop-offs. Some sites regularly dived from Cebu – such as Capitancillo Island, Talong Island and Cabilao Island – are some distance away. Operators – such as Scotty's and Club Kontiki Divers – offer safaris aboard larger *bancas* to further dive sites off Cebu, Bohol and Negros.

Diving is possible all year round, the best time being from December to June. Live-aboard boats cruise the area from June to March. All access times are from Shangri-La's Mactan Island Resort.

The Danajon Bank, east of Olango Island, is a large area of reefs, shoals and islands off northern Bohol, and features one of the world's few double barrier reefs. Much of the bank is exposed at low tide. This area is explored by live-aboard boats in calm weather.

The two Caubyan Islands at its northwest corner can be reached by banca from Mactan Island (2hr) as a day trip. This part of the bank does not dry out, is a long way from land, and has unpredictable strong currents.

Cabilao Island, about 45km (30 miles) south, off southwestern Bohol, is regularly visited on day trips from Scotty's Dive Center, and is considered the best diving from Mactan Island (see page 125).

> **DOUBLE BARRIER REEFS**
>
> Barrier reefs usually start out as fringing reefs, where land meets sea, and are then isolated by changes in sea level; others are the crests of underwater ridges. The double barrier reef near the Caubyan islets on the Danajon Bank, east of Cebu, comprises two distinct reef formations with a channel between them. This is in fact one of only a few such double-barrier-reef formations in the world.

Squaretail Coral Grouper (Plectropomus areolatus) amid mixed corals.

1 CAPITANCILLO ISLAND

★★★★

Location: 100km (60 miles) north of Mactan Island, 10km (6 miles) southeast of Bogo.
Access: 2½–3hr by *banca* from Mactan, 1hr from Sogod, or by road to Bogo on Cebu's east coast and 30min by *banca*.
Conditions: You would not normally make this journey in bad conditions, but even in good conditions fierce currents can be a real problem. Advanced divers pick spring tides in the hope of spotting larger pelagic species, but less experienced divers should choose neap tides and be with an experienced divemaster. Visibility can reach 30m (100ft).
Average depth: 25m (80ft)
Maximum depth: 45m (150ft)
There are three sites here with similar profiles:

- the Ormoc Shoal, 5km (3 miles) to the northeast of Capitancillo Island
- the Nuñez Shoal, 3km (2 miles) southwest of Calangaman Islet, which is to the northeast of Capitancillo Island
- Capitancillo Island's own Southwest Wall

All have shallow reef-tops at 10m (33ft) leading to drop-offs with colourful soft corals, gorgonian sea fans, caves and black corals. The main interest of the dives are the walls, with their many caves and overhangs, small shoals of pelagic fish, all varieties of reef fish, Whitetip and Grey Reef Sharks and the ever-present possibility of encounters with larger pelagic species.

Shallow reef-flats extend 3km (2 miles) all around Capitancillo Island, but these three dive sites are the best in the area.

2 TALONG ISLAND

★★★★

Location: 55km (35 miles) north–northeast of Mactan Island, just north of the northwest point of Pacijan Island, the westernmost of the Camotes Islands.
Access: 1½–2hr by *banca* from Mactan Island or 1hr by *banca* from Sogod.
Conditions: Normally choppy with medium currents, but it can become really rough with fierce currents. You would not normally make the journey in rough weather. Visibility can reach 40m (130ft).
Average depth: Whatever you like
Maximum depth: 40m+ (130ft+)
Talong translates as 'eggplant'. The north and north-west sides of the island have long slopes out and down with fields of stony corals, particularly large table and boulder corals. Deeper down there are gorgonian sea fans, whip corals, black corals and *Dendronephthya* soft tree corals. There are all the expected reef fish, including Bumphead Parrotfish and small shoals of jacks, snappers, batfish and fusiliers. On the sand are stingrays, flounders, lizardfish, Sand Perch, sea stars, sea cucumbers and sea urchins. When the currents are running, novices should stay close to their divemaster. This is a good area to spot pelagic species.

3 MACTAN ISLAND – TAMBULI

★★★★★★

Location: Off Tambuli Beach Resort.
Access: 5–15min by *banca* from whatever local resort you are using.
Conditions: Usually calm with some current, though it can get rough with strong currents. A dive mainly for novices. You would not normally dive here in bad conditions. Visibility can reach 20m (65ft).
Average depth: 20m (65ft)
Maximum depth: 35m (115ft)
You descend to an easy dive, sloping to a shelf at 21m (70ft) – where the reef fish are used to being hand-fed – then the slope continues off into the depths. All the smaller reef fish will approach you looking for handouts, and there are many sea stars, sea cucumbers, sea urchins, nudibranchs and flat worms. A good dive for macro photography.

4 OLONGO ISLAND – MABINI POINT

★★★★

Location: The northern tip (also known locally as Tingo Point) of Olongo Island.
Access: 15–20min by *banca* from Mactan Island.
Conditions: Strong surges and fierce unpredictable currents; a site for advanced divers only. Visibility can reach 30m (100ft).
Average depth: 35m (115ft)
Maximum depth: 40m+ (130ft+)
This is a dive where one hopes to see larger pelagic species. There is comparatively little to see in the shallower water, so get down quickly to 35m (115ft) on the drop-off, settle down in some shelter and look out – anything can pass by. Sharks are common, but Hammerhead Sharks are the highlight and Whale Sharks have been seen.

5 OLONGO ISLAND – MABINI POINT TO BARING

★★★★

Location: Between the northern tip (Mabini Point, Site 4) of Olongo Island and the village of Baring.
Access: 15–20min by *banca* from Mactan Island.
Conditions: Strong surge and fierce unpredictable currents, not for novice divers. Visibility can reach 30m (100ft).
Average depth: 35m (115ft)
Maximum depth: 40m+ (130ft+)
There are several spectacular drop-offs, and there are large caves about 30 (100ft) to 35m (115ft) down. There is little to see in the shallow water, so get down quickly to 30m (100ft) and either have a fast drift at this depth or settle down in some shelter and watch the world go by.

Whitetip Reef and Grey Reef Sharks patrol the drop-offs, and there is a good chance of seeing tuna, barracuda, snappers, surgeonfish and jacks.

6 OLONGO ISLAND – SANTA ROSA
7 AND POO

★★★★

Location: 400m (440yd) offshore from the villages of Santa Rosa and Poo.
Access: 15–20min by *banca* from Mactan Island.
Conditions: Normally strong currents, but more predictable than the surges at Sites 4 and 5. Novices should be with a divemaster. Visibility can reach 30m (100ft) over the drop-off, but it is muddy on the shallow reef-flat from the drop-off to the shore.
Average depth: 30m (100ft)
Maximum depth: 40m (130ft)
It is possible to snorkel on the reef-flat at 9m (30ft) to 12m (40ft), but it is muddy well offshore and has strong currents, so you require *banca* cover.

For divers the drop-off starts around 9m (30ft) and falls to 40m (130ft). It is rich in marine life, stony and soft corals, gorgonian sea fans, barrel sponges, *Dendrophyllia* hard-tree corals and *Tubastrea* cup corals. There is a good variety of reef fish in the shallower waters, soldierfish and squirrelfish in caves and under overhangs, and lots of lionfish and scorpionfish, plus small shoals of jacks, snappers, batfish, sweetlips, Moorish Idols, catfish and fusiliers.

8 MACTAN ISLAND – AMBOUCUAN POINT
9 MACTAN ISLAND – MARIGONDON

★★★

Location: 100m (110yd) offshore in the Hilutangan Channel from Amboucuan Point to Marigondon.
Access: 10–15min by *banca* from most of the resorts on Mactan Island.
Conditions: Normally choppy with strong currents, but can become very rough with fierce currents. Only very experienced divers would dive here in bad conditions; less experienced divers should be with a divemaster and plan carefully for slack water. Visibility can reach 25m (80ft).
Average depth: 30m (100ft)
Maximum depth: 55m (180ft)
There are many diving possibilities between Engaño Point (Mactan's northernmost tip) and Amboucuan Point but, with so many beach resorts along this stretch, the tourist

Red Feather Star (Himerometra robustipinna) showing the cirri or jointed legs used for walking or for anchoring the creature to the reef.

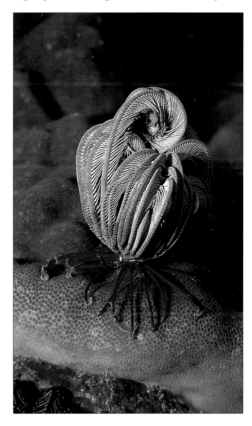

boat and jet ski traffic, it is too dangerous. Further south, however, this is not such a problem.

Between Amboucuan Point and Marigondon the strong currents make for good fish life, but in some areas there is heavy coral damage from dropped anchors. Divers planning shallow dives require an experienced local guide if they are to find the best areas.

A drop-off starting at 12m (40ft) and continuing to 55m (180ft) has soft corals, black corals, gorgonian sea fans, sponges, a good variety of reef fish, nudibranchs and sea stars, including some Crown-of-Thorns Starfish – a problem here in the past.

This area is used regularly for carefully planned night diving and is famous for Marigondon Cave, which has a large entrance some 12m (40ft) in diameter with its top at 28m (92ft) and its bottom at 40m (130ft). The entrance has black corals, sponges, *Tubastrea* cup corals, squirrelfish, soldierfish and lionfish. The cave goes back some 45m (150ft) and is roughly 24m (80ft) wide at the end. There are several small grottoes on the right, near to the back, that contain shoals of flashlight fish and bigeyes. Looking out of the cave entrance is spectacular.

Currents are strong, so divers should keep close to the wall while descending. The wall continues to 55m (180ft), with large *Dendronephthya* soft tree corals.

The shallow reef-top has coral heads in between grassed sandy areas well populated with small reef fish, garden eels, cuttlefish, squid, Snake Eels, frogfish, nudibranchs, sea stars, sea cucumbers and sea urchins.

About 100m (110 yd) south of Marigondon Cave is the 'Crevice', which is similar to the 'Cathedral' at Pescador Island (see page 119), bottoming out at 32m (105ft). There are some very large *Dendronephthya* soft tree corals, tuna and grouper. Whale Sharks have been seen here several times.

Continuing 20m (65ft) south of the 'Crevice', you find another vertical crack at 35m (115ft), with large soft corals, soldierfish and groupers.

10 EAST SIDE OF PANGANAN ISLET
11 EAST SIDE OF CAOHAGAN ISLET
12 EAST SIDE OF LASSUAN ISLET

★★★

Location: The east side of the extensive reef that extends south from Olongo Island to Lassuan Islet.
Access: 20–30min by *banca* from Mactan Island.
Conditions: Usually choppy with strong and localized currents. You would not dive here in rough conditions. It is best to keep to the east side of the reef in the Olango Channel, as conditions can get really tricky on its west side, in the Hilutangan Channel. Both channels have rip currents.

Novice divers should stay with a divemaster. The dives are mostly a long way from shore, so you need

good *banca* cover, fully alert to divers surfacing well away from the boat. Visibility can reach 30m (100ft).
Average depth: 18m (60ft)
Maximum depth: 40m+ (130ft+)

Unfortunately this large expanse of reef has been over-fished, but it offers good drift-diving over the drop-offs. Excellent stony corals can be seen down to 20m (65ft), beyond which there are overhangs, crevices and the occasional cave with colourful soft corals, gorgonian sea fans, sponges, soldierfish, squirrelfish, lionfish, snappers, jacks, surgeonfish, parrotfish and small groupers. A good local guide is necessary if you are to find the best points.

13 KANSANTIK

★★★★

Location: In the centre of the Olango Channel, east of Lassuan Islet.
Access: 45–50min by *banca*, depending on how long it takes to locate this underwater island and allow for its currents. GPS (Global Positioning System) is useful here.
Conditions: Open water, fierce currents and a fierce surge if you get the tide tables wrong. This dive is only for the most experienced divers, in small groups, and not for those with heavy cameras! A good *banca* operator is essential to find the site and drop a shotline and anchor onto it. Once in position, the best guides use a heavily weighted shotline, and some divers use individual lines to tie themselves to the weight on the shotline's bottom. Visibility can reach 40m (130ft).
Average depth: 30m (100ft)
Maximum depth: 50m+ (165ft+)

An underwater mountain rises from the depths to within 30m (100ft) of the surface. Descend the shotline and remember when you leave it that, even if you are presently in slack water, the current will soon pick up again. There are good stony corals, soft corals, whip corals, huge sponges and gorgonian sea fans. The reef fish is particularly prolific, with Titan, Orangstriped and Redtooth Triggerfish, parrotfish, Napoleon Wrasse, Bird Wrasse, rabbitfish, spinecheeks, squirrelfish, soldierfish, angelfish, butterflyfish, cardinalfish, lionfish, scorpionfish, stonefish, groupers, surgeonfish, clownfish, Sergeant Majors, anthias and chromis. Shoals of jacks, snappers and Moorish Idols may also be seen.

Opposite: *Gorgonian sea whip (Ellisella sp.).*
Sea whips are best seen at night when their polyps extend along the slender strands.

How To Get There

There are several flights daily from all over the Philippines to Cebu's Mactan International Airport, as well as international flights from Hong Kong, Japan and Singapore and direct charter flights from Hong Kong, Japan, Taiwan and Sydney for holiday-makers.

By road, several buses run daily from the northern bus terminal in Cebu City to Sogod, and several ABC buses daily from the southern bus terminal to Argao.

If you have booked in advance with an operator or hotel, they will arrange transport for you, so don't listen to the taxi drivers touting for your business. Unmetered PU cabs are relatively cheap, and there is an air-port shuttle bus to and from the Robinson Department Store on the Fuente Osmeña roundabout. Jeepneys go from Manalili Street in Cebu City to Lapu-Lapu City on Mactan Island (locally called Opon-Opon), from where you can get a motorized tricycle to the beach resort areas and anywhere else on the island.

There are regular ferries to Cebu Port from other Philippines' islands.

Where To Stay

Very High Price Range
Alegre Beach Resort PO Box 1094, Calumboyan, Sogod, Cebu;
tel 32-2311198/fax 32-2337944;
e-mail: cbusales@alegrebeachresort.com;
website: www.alegrebeachresort.com
Situated 2hr north of Cebu City at Sogod, and, together with the Shangri-La, leading the way for marine conservation. An easy day trip can be made from here to Capitancillo and Talong islands (sites 1 and 2).

Shangri-La's Mactan Island Resort
PO Box 86, Punta Engaño Road, Lapu-Lapu City, Mactan 6015; tel 32-2310288/fax 32-2311688;
e-mail: mac@shangri-la.com; website: www.shangri-la.com/cebu/mactanisland/en
The number one resort in the Philippines, setting new standards for accommodation and together with Alegre, leading the way for marine conservation. Hotel-style blocks with extensive gardens, so successful it has doubled in size.

Upper Price Range
Coral Reef Hotel
Barrio Agus, Lapu-Lapu City, Mactan Island;
tel 032-3404650/fax 032-3404766;
e-mail: coral@cebu.pw.net.ph;
website: www.cebu.pw.net.ph/coralreef
Quality resort.

Maribago Bluewater Beach Resort
Maribago, Mactan Island;
tel 32-4920100/fax 32-4920128
e-mail: bluwater@mozcom.com
website: www.bluwateresort.com
Individual bungalows and a beautiful beach

in a large protected bay. A native atmos-phere with all comforts.

Pulchra San Fernando;
tel 32-2320823/fax 32-2320816;
e-mail: rsvn@pulchraresorts.com;
website: www.pulchraresorts.com
Quality resort.

Tambuli Beach Club Buyong, Mactan Island; c/o 16 Borromeo Arcade, Fidel Ramos Street, Cebu City; tel 32-2324811/fax 32-2324913;
e-mail: reservations@tambuli.com;
website: www.tambuli.com
Well established quality resort.

Lower Price Range
Club Kontiki Maribago, Lapu-Lapu City, Cebu; tel 32-4952471/fax 32-4952216;
e-mail: 7seas@mozcom.com;
website: www.kontikidivers.com.ph
Caters specifically for divers

Metro Park Hotel Saint Lawrence Street, Lahug, Cebu City, Cebu 6000;
tel 32-2332352/fax 32-2330130;
e-mail: metropark@in-cebu.com;
website: www.in-cebu.com/metropark

Where To Eat

You would normally eat at your resort restaurant, unless staying in Cebu City, where there are restaurants of all types and prices.

Dive Facilities

Crispina Aquatics Costabella Tropical Beach Resort, Maribago; tel 32-4935746
PADI training.

Kontiki Divers Maribago, Lapu-Lapu City, Cebu; tel 32-4952471/fax 32-4952216;
e-mail: 7seas@mozcom.com;
website: www.kontikidivers.com.ph
Owner Manfred Langer is also a major shareholder in 'Savedra' in Moalboal. PADI 5-Star and Technical Diving Centre.

Savedra–Great White
(See Kontiki Divers)

Scotty's Dive Center Shangri-La's Mactan Island Resort, Punta Engaño Road, Lapu-Lapu City, Mactan; tel 32-2315060/fax 32-2315075; e-mail: scotty@divescotty.com;
website: www.divescotty.com
Scotty's is universally agreed to be the best and most expensive dive shop in Cebu and he also supplies water sports to many other resorts in Cebu. A PADI 5-Star Gold Palm IDC Centre. The area's top dive operator with several branches and safaris ranging from overnight trips to 14-day excursions.
Scuba World Cebu Address: 800 Ma. Cristina Street, Capitol, Cebu City;
tel 32-2459591/fax 32-2549554;
e-mail: cebu@scubaworld.com.ph;

Maribago Address: Datag, Maribago, Lapu-Lapu, Cebu City; tel 32-4952126;
e-mail: maribago@scubaworld.com.ph;
website: www.scubaworld.com.ph

Tropical Island Adventures Dive Center
Buyong Beach, Maribago, Lapu-Lapu City, Cebu 6015; tel 32-3401845/fax 32-3405909;
e-mail: info@cebudive.com;
website: www.cebudive.com
PADI training

Dive Shops in Cebu City
Aqua World Inc. 25H Nichols Heights Guadalupe, Cebu; tel 032-2539159/fax 032 2539151

Liquid Assets Cebu Grand Hotel Complex, N. Escano Street, Cebu; tel 032-2310816/fax 032-2314980

Scotty's Dive Center Shangri-La's Mactan Island Resort and Spa, Punta Engaño Road, Lapu-Lapu City, 6015 Cebu;
tel 32-2315060/fax 32-2315075;
e-mail: scotty@divescotty.com;
website: www.divescotty.com

Diving Emergencies

There is a recompression chamber at **VIS-COM Station Hospital,** Camp Lapu Lapu, Lahug, Cebu City; tel 032-310709

Local Highlights

As well as fine beaches and watersports, Cebu province is dotted with Spanish colonial churches, forts, monuments and ancestral homes.

Cebu City itself has Magellan's Cross (marking the spot where Rajah Humabon and some 800 followers were baptized into the Catholic faith in 1521); Fort San Pedro, the oldest fort in the country; the Basilica Minore del Santo Niño, on the site of the country's oldest church; Colon Street, the oldest in the Philippines (dating from 1565) and named after Columbus, now a busy commercial street; the Taoist and Phu-Sian temples in the wealthy Beverley Hills residen-tial area; the Heavenly Temple of Charity in Lahug; and several museums and collec-tions. The colourful Carbon Public Market is well worth a visit, but beware of pickpockets and bag-snatchers.

On Mactan there is the Lapu-Lapu Monument on the road to Punta Engaño (Chief Lapu-Lapu killed the explorer Ferdinand Magellan at Mactan in 1521). Maribago is a guitar-manufacturing centre – do not buy those decorated with shells or turtleshells.

There are further interesting churches at Argao and Dalaguete.

Opposite: Tambuli Beach Resort, Cebu, is popular as a centre for both diving and watersports.

Western Cebu and Moalboal

On the southwest coast of Cebu, about a 3hr drive across the island from Cebu City, lies Moalboal (the name means 'bubbling brook'). A further 3km (2 miles) down a bumpy dirt track from Moalboal Town, Panagsama Beach started out as a divers' resort area, but word of the good snorkelling, the white sand beach and the relaxed atmosphere here soon got out and it has now developed into a major holiday destination. As elsewhere in the Philippines, the accommodation in these areas is steadily being upgraded, with medium priced and upper medium priced rooms now becoming more and more common.

Pescador Island

Snorkelling is good along Panagsama Beach as well as around Pescador Island. In September 1984 a typhoon wrecked Panagsama Beach and most of the shallow corals, but the reefs have regenerated well since then.

There is good diving off the beach, particularly at its northern end near Copton Point, but the main attraction is Pescador Island, 2km (1¼ miles) offshore. Barely 100m (330ft) square and 6m (20ft) high, the tiny coralline limestone island is, like Balicasag and Cabilao Islands (see page 124), a microcosm of the best of Philippines diving. It was able to weather the recent typhoons and, being surrounded by deep water, is unsuitable for blast or *muroami* fishing; nowadays, anyway, the local fishermen make money from divers, so they police the area themselves.

The island is the focal point for several dive operators, and thus gets very crowded in the high season (December–April), but it can be dived all year round, with November–June being the best months.

Small enough to be circumnavigated in one dive, Pescador has several areas of specific interest but is open to the weather. Normally your *banca* drops you at the site you wish to dive and then goes to a fixed mooring at the sheltered end of the island; you continue your dive to finish at that point.

Underwater, the narrow coral reef surrounding the island slopes gently to between 3m (10ft) and 9m (30ft) and then drops vertically as a wall to 40m (130ft). Most of the corals in the shallow water are in good condition: large boulder corals, pillar corals, whip corals, *Acropora* table corals and leathery soft corals – beautiful for both underwater photographers and snorkellers.

The Walls

The walls have everything: caves, crevices, overhangs and a large vertical funnel called 'The Cathedral'. They are covered in *Tubastrea* cup corals, colourful soft corals and gorgonian sea fans.

The barrel sponges, Elephant Ear Sponges and blue tube sponges are covered in Alabaster Sea Cucumbers. Shoals of sweetlips, surgeonfish, snappers, fusiliers, anthias, catfish, chromis, jacks, damsels and Moorish Idols abound. Royal and Emperor Angelfish, pennantfish, rabbitfish, lizardfish, moray eels, lionfish, scorpionfish, triggerfish, pufferfish, soldierfish, squirrelfish, trumpetfish and cornetfish hover in holes among the corals. Stonefish are common.

There are many different varieties of sea cucumbers, sea stars, nudibranchs, flatworms, anemones and clownfish, while Napoleon Wrasse and small Whitetip Reef Sharks can be seen in deeper water. At times of strong currents pelagic species are common, so you might be lucky and occasionally see a Whale Shark or Manta Ray. Very large Spanish Dancer nudibranchs are found on night dives.

You can comfortably fill four days of good diving here, but for longer periods you would be best to spend another four days at Bohol and/or add a boat safari. Several live-aboard boats cruise this area when they are not busy elsewhere, and Seaquest offer *banca* safaris. *Banca* safaris can also be organized from Liloan or Dumaguete to take in Sumilon Island, Siquijor Island and Apo Island (Negros). All access times given in the following sites are from Panagsama Beach.

NOTE TO PHOTOGRAPHERS

Photographers should be aware that, as in many remote areas, the municipal electricity voltage in this region is too low for battery-charging except during the early hours of the morning.

> **CONDENSATION**
>
> Do not assemble underwater cameras in cool air conditioned rooms or cabins, or you are likely to get condensation inside them when you take them into the water. Normal cameras that have been in air conditioning will mist up when taken out into a warm atmosphere.
>
> You will have to wait at least 10 min for the condensation to clear before you can take any photographs.

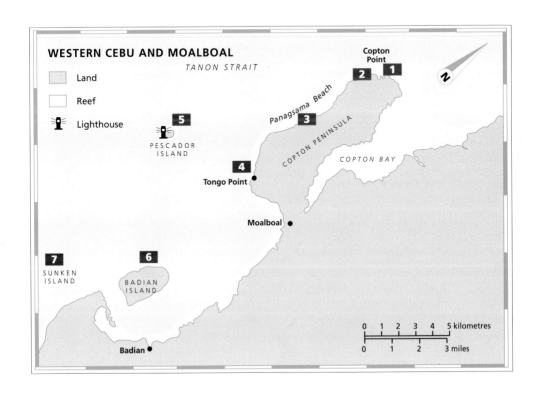

WESTERN CEBU AND MOALBOAL

Land

Reef

Lighthouse

TANON STRAIT

Panagsama Beach

PESCADOR ISLAND

Tongo Point

Moalboal

Copton Point

COPTON PENINSULA

COPTON BAY

SUNKEN ISLAND

BADIAN ISLAND

Badian

0 1 2 3 4 5 kilometres

0 1 2 3 miles

1 COPTON POINT

★★★★☆☆☆☆☆

Location: The west point of the northern end of the Copton Peninsula.
Access: 20min by *banca* north to Copton Point.
Conditions: Normally calm with strong to fierce currents. You would not normally make this journey if conditions were bad. Snorkellers can go in from the shore, but should be careful with the currents. Visibility can reach 30m (100ft).
Average depth: 25m (80ft)
Maximum depth: 40m (130ft)
You descend a steep sandy slope down to 25m (80ft), then go over the drop-off down to 40m (130ft). The slope is rich in healthy soft, leathery and stony corals, whip corals, *Tubastrea* corals, large gorgonian sea fans and barrel sponges. As the current takes you further north, the wall rises to 4m (13ft), with a level reef-top, ideal for snorkelling, with some very good staghorn and table corals. Clear areas on the slope have been used regularly for fish-feeding, so a myriad of fish chase you, hoping for food. (Please don't give in to their demands.)

The sandy slope has sponges, sea urchins (including Slate Pencil Urchins), *Linckia* and *Choriaster* sea stars, Bluespotted Ribbontail Rays, lizardfish, goatfish, gobies and various anemones with clownfish.

In among the corals are Titan and Redtooth Triggerfish, razorfish (shrimpfish), various pufferfish, trumpetfish, cornetfish, pipefish, bream, groupers, most angelfish and butterflyfish, anthias, chromis, catfish, damsels, fusiliers, Banded Sea Snakes, Spot-tail Sand Perch and Fire Gobies. We found, deeper down the walls because of the strong currents, larger groupers, Napoleon Wrasse, barracuda, snappers, lionfish and the occasional Grey and Whitetip Reef Sharks.

This is very much a drift-dive, but you can find sheltered spots. You may find the current deeper down is the reverse of that on the surface.

2 SAAVEDRA (WHITE BEACH)

★★★★☆☆☆☆☆

Location: Off White Beach, just south of Copton Point.
Access: 15min by *banca*.
Conditions: Normally calm with strong to fierce currents. Do not make this journey in bad conditions. Snorkellers can snorkel from the shore, but should be careful of the currents. Visibility can reach 30m (100ft).
Average depth: 25m (80ft)
Maximum depth: 40m (130ft)

This dive is much the same as at Copton Point (Site 1), but with more slope and less wall. The coral and fish life are equally healthy, with perhaps more nudibranchs, Feather Duster Worms, pipefish, anemones and clownfish, less of the bigger fish and slightly less current.

3 BAS DIOT

★★★☆☆☆

Location: This name really refers to the drop-off by the Moalboal Reef Club, but the description fits the reef edge from there all along Panagsama Reef.
Access: Either 5min by *banca* or a swim off the beach.
Conditions: Normally calm with a gentle current. Because of its position you might make this dive in bad conditions, rather than take a *banca* out, but you should then be careful of any increase in current. Visibility can reach 20m (65ft).
Average depth: 15m (50ft)
Maximum depth: 40m (130ft)
A gentle slope stretches out to 5m (16ft), followed by a drop-off in small steps to 40m (130ft). The reef-top exhibits typhoon damage, but down the drop-off there is a lot of life among dead and regenerating stony corals. In particular there is a variety of anemones and clownfish, lionfish, scorpionfish, moray eels, segmented worms, sea stars, sea urchins, sea cucumbers, Feather Duster Worms, pufferfish, chromis, anthias, damselfish, lizardfish, sand perch, gobies, goatfish and small shoals of catfish.

Colourful soft tree corals, small gorgonian sea fans and crinoids are plentiful, as are the smaller angelfish, butterflyfish and Bubble Coral. Sea snakes are occasionally seen and, at greater depths, the caves can contain many surprises.

4 TONGO POINT

★★★☆☆☆

Location: The southern point of the Copton Peninsula.
Access: 15min south by *banca*.
Conditions: This site is sheltered during the northeast monsoon, so it is usually dived from October to March when the other sites may be too rough – but you can still find fierce currents here. The drop-off is a long way out, so most snorkellers would need to go out by *banca*. Visibility can reach 20m (65ft).
Average depth: 25m (80ft)
Maximum depth: 40m (130ft)
There is a large area here, going north to Tapanan. At the northern end is a series of coral arches in 4m (13ft) to 8m (25ft) of water, and at the southern end there are large buttresses, away from the drop-off, to explore. The site is not very good for fish but has plenty of invertebrates and coral life, with large gorgonian sea fans. The currents can be very difficult here between tides.

A riot of underwater colour: anemones with clownfish (Amphiprion clarkii), basslets (or anthias) and mixed corals.

5 PESCADOR ISLAND

★★★★★☆☆☆☆☆

Location: 3km (2 miles) west–southwest of Tongo Point in the Tañon Strait.
Access: 45–50min, depending on sea conditions, by *banca* southwest from Panagsama Beach.
Conditions: Normally a bit choppy with strong currents, but it can get really rough with fierce currents. *Bancas* would normally drop you where you want to dive and then retreat to a fixed mooring at the sheltered end of the reef; you would aim to finish your dive at the *banca*. Since this is the main diving area of Moalboal these fixed moorings can become crowded, so be careful when you come to the surface. Visibility can reach 40m (130ft). Above water the island is ringed by short limestone cliffs, so snorkellers require a *banca*.
Average depth: Whatever you like
Maximum depth: 50m (165ft)
Pescador has the best diving off Cebu and really does provide almost everything in a very small area. The island is in fact a large pinnacle rising out of 35m (115ft) of open water to 6m (20ft) above the surface. Around the island is a healthy coral ledge, mostly at around 3m (10ft), though at the southern end it slopes to 9m (30ft).

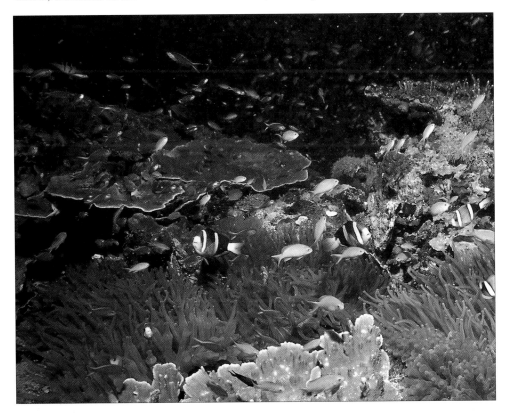

This ledge then drops as a vertical wall with overhangs and crevices to between 30m (100ft) and 50m (165ft) before sloping down and out on sand.

The famous Pescador 'Cathedral' is an open-top funnel that bottoms out at 34m (115ft); the funnel is open also on its outer side at 15m (50ft). Depending on the time of year, shafts of sunlight shine into the funnel around noon.

The deepest drop-off is on the north face, which goes down to 50m (165ft); the east and west faces drop to 40m (130ft) and the south face to 33m (108ft).

The shallow reef-top has some lovely boulder, pillar and *Acropora* table and staghorn corals, and good whip corals and leathery corals, and teems with reef fish of all varieties, including lizardfish, catfish, rabbitfish, bream (spinecheeks), Sand Perch, Fire Gobies and Bluestreak Gobies.

The walls have many overhangs, cracks and crevices with gorgonian sea fans, black coral, large barrel and tube sponges covered in Alabaster Sea Cucumbers, *Tubastrea* cup corals, colourful soft corals and crinoids, sea stars, sea cucumbers and nudibranchs.

The fish life includes just about everything you would expect to find in the area: shoals of jacks, fusiliers, barracuda, snappers, sweetlips, batfish, surgeonfish and catfish. Lone pufferfish, tuna, Napoleon Wrasse, Moorish Idols, parrotfish, Whitetip and Grey Reef Sharks, lionfish, Zebra Lionfish, scorpionfish, stonefish, moray eels and sea snakes are all likely to appear. Turtles, Whale Sharks (January–March), small schools of Hammerhead Sharks and Manta Rays have been seen here, and night dives are famous for very large Spanish Dancer nudibranchs.

6 BADIAN ISLAND (ZARAGOSA ISLAND) – WEST SIDE

★★★

Location: 0.75km (1/2 mile) north of Badian Point, to which it is connected by a reef that is exposed at low tide.
Access: 45min by *banca* from Panagsama Beach; 5min if you are staying on the island.
Conditions: Normally choppy with strong currents, but can be really rough with fierce currents. A good guide makes all the difference in finding a quality dive here. Visibility can reach 25m (80ft).
Average depth: 25m (80ft)
Maximum depth: 40m (130ft)
A drop-off goes down to 35m (115ft) and shelves on, out and down. Expect to find some big gorgonian sea fans, colourful soft corals, sponges, nudibranchs, lionfish, snappers, angelfish and butterflyfish. Whale Sharks pass by from January to March.

7 SUNKEN ISLAND

★★★★

Location: Southwest of Badian Point.
Access: 1–1½hr by *banca* from Panagsama Beach.
Conditions: An open-water dive, so normally choppy with a strong current. You require a good guide both to find the underwater reef and to allow for currents to get you down onto it. You would not make the journey in bad conditions. Visibility can reach 40m (130ft).
Average depth: 25m (80ft)
Maximum depth: 50m (165ft)
As this is an open-water dive where you have to get down to 25m (80ft) quickly, it is not for novices. The main reason for the dive is the chance of seeing large shoals of fish, big barrel sponges, large soft corals and huge gorgonian sea fans.

There are very large lionfish, scorpionfish, triggerfish, surgeonfish, tuna, groupers, snappers, most species of angelfish, butterflyfish and pufferfish, Moorish Idols, parrotfish, Napoleon Wrasse, sea snakes and sometimes Grey Reef Sharks.

Blue Tube Sponge (Aplysina sp.). Water taken into the sponge is expelled through the large orifices once any nutrients have been absorbed.

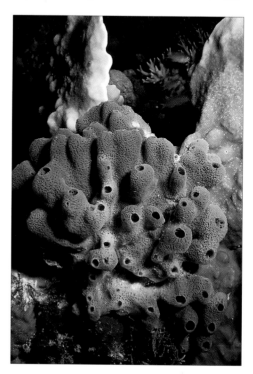

HOW TO GET THERE

There are several flights each day from all over the Philippines to Cebu's Mactan Island International Airport, plus international flights from Japan, Hong Kong and Singapore and charter flights direct from Hong Kong, Japan, Taiwan and Sydney for holiday-makers.

If you have booked with an operator in advance they will arrange transport for you from Cebu. Otherwise you must either hire a private minibus or take a taxi or jeepney to Cebu City's Southern Bus Terminal. Buses of the Villanueva and Philippine Eagle companies go to Moalboal and sometimes on to Panagsama Beach. The road journey takes $2^1/_2$–3hr, depending on the traffic and any fiesta or funeral processions, and runs down the east coast of Cebu then across the island. The road is mostly in good condition.

If dropped in Moalboal Town, you get a motorized tricycle/jeepney to Panagsama Beach.

Note that there are also regular ferries to Cebu Port.

WHERE TO STAY

Upper Price Range
Badian Island Beach Hotel Badian Island; tel 032-4751103/fax 032-4751101; e-mail: badiancebu@aol.com; website: www.badianhotel.com
High quality resort on a separate island away from the main beach.

Cabana Beach Club Resort Panagsama Beach; tel 032-4740034/fax 032-4740035; e-mail: cabana@skyinet.net
A small but quality resort.

Quo Vadis Beach Resort/Visaya Divers Panagsama Beach; tel 032-4740018/fax 032-4740019; website: www.moalboal.com
A small but quality resort.

Medium Price Range
Hannah's Place Panagsama Beach; tel 0918-7713439/fax 032-3460592; e-mail: hannah@seaquestdivecenter.ph; website: www.hannahs-place.com
Rooms of different standards.

Love's Lodge and Restaurant/Sea Explorers Private Road, Panagsama Beach; tel 032-4740060; e-mail: diveasia@ozemail.com.au
Rooms of varying standard.

Savedra Bungalows Panagsama Beach, Moalboal, 6032 Cebu; tel 32-4740014/fax 32-4740011; e-mail: info@savedra.com; website: www.savedra.com/resorts.htm
Small, though all rooms are of good quality.

Sumiside Lodge/Seaquest Dive Center Office Address: Ground Floor Door 1, RM Building, Hernan Cortes Street, Banilad, Mandaue City 6014, Cebu; tel 032-4740004; e-mail info@seaquestdivecenter.ph; website: www.seaquestdivecenter.ph

Lower Price Range
Eve's Kiosk/Nelsons Diving School Panagsama Beach; tel 32-470006
Also has some air-conditioned rooms.

Mollie's Place Panagsama Beach; tel/fax 032-4740021
Aimed at the budget traveller.

WHERE TO EAT

Surprisingly for such a small area there are many good restaurants, mostly attached to the accommodation but a few standing alone. All those attached to accommodation are good and if you want to eat cheaply try The Last Filling Station Restaurant, owned by Planet Action.

DIVE FACILITIES

Badian Island Beach Hotel Badian Island; tel 032-4751103/fax 032-4751101; e-mail: badiancebu@aol.com; website: www.badianhotel.com
PADI training to Divemaster level.

Blue Abyss Dive Shop Panagsama Beach; tel/fax 032-4740031; e-mail: info@blueabyssdiving.com; website: www.blueabyssdiving.com
PADI courses up to Divemaster level and PADI Nitrox courses.

Cabana Beach Club Resort Panagsama Beach; tel 032-4740034/fax 032-4740035; e-mail: cabana@cbu.skyinet.net
PADI courses.

Nelson V. Abenido/Eve's Kiosk Ocean Safari Philippines, Panagsama Beach; tel 32-4740122/fax 32-3460926; e-mail: oceansafariphilippines@hotmail.com
PADI courses up to Divemaster level.

Neptune Diving Adventure Panagsama Beach; tel/fax 032-4740087; e-mail: info@neptunediving.com; website: www.neptunediving.com
PADI 5-Star IDC Centre and Nitrox courses.

Savedra - PADI 5 Star Dive Center Panagsama Beach, Moalboal, 6032 Cebu; tel 32-4740014/fax 32-4740011; e-mail info@savedra.com; website: www.savedra.com/resorts.htm
PADI 5-Star IDC Centre and Technical Diving, Trimix and Nitrox. Also has a branch at Mollie's Place.

Sea Explorers/Love's Lodge Sea Explorers Philippines Head Office, 36 Archbishop Reyes Avenue, Knights of Columbus Square, Cebu City 6000; tel 32-2340248/fax 32-2340245; e-mail cebu@sea-explorers.com; website: www.sea-explorers.com
PADI 5-Star Gold Palm Dive Centre with several outlets in the Philippines

Seaquest Dive Center/Sumiside Lodge Office Address: Ground Floor Door 1, RM Building, Hernan Cortes Street, Banilad, Mandaue City 6014, Cebu; e-mail info@seaquestdivecenter.ph; website: www.seaquestdivecenter.ph
PADI 5-Star IDC Centre, with Nitrox courses and diving safaris; operating since 1981.

Visaya Divers/Quo Vadis Beach Resort Panagsama Beach; tel 032-4740018/fax 032-4740019; website: www.moalboal.com
PADI courses to Assistant Instructor and Nitrox.

DIVING EMERGENCIES

There is a recompression chamber at **VISCOM Station Hospital,** Camp Lapu Lapu, Lahug, Cebu City; tel 032-310709 (Contact: Mamerto Ortega or Macario Mercado)

LOCAL HIGHLIGHTS

17km ($10^1/_2$ miles) south of Moalboal, from the church just beyond Matutinao, you can walk (30min) to the Kawasan Waterfalls. From here you can go mountain-trekking, if you are feeling energetic, or you can just swim in the natural pools by the falls. Planet Action organize action tours, trekking, caving, canyoning in the river, mountain biking and off-road vehicle tours (e-mail: planet@action-philippines.com; website: www.action-philippines.com)

Sharks were popular figures of dread long before Peter Benchley wrote his best-selling novel *Jaws* (1974), which Steven Spielberg made into a phenomenally successful movie the following year. The truth about sharks' feeding habits is rather more prosaic – but the animals themselves are far more interesting than Hollywood ever realized.

Sharks feed infrequently and mostly at night – although they will feed opportunistically during the day. They detect vibration over long distances by means of sensitive cells along their lateral line, and are particularly attracted to low-frequency vibrations such as those emanating from distressed fish. Speared or hooked fish struggle violently, as do trapped lobsters, and these commotions draw sharks up from the depths. People splashing about in water can be attractants as well: sharks arriving in turbid water see only parts of limbs, which they assume to be separate animals of the same sort of size as their normal prey. A diver does not usually present this confusing image, so your risks of being attacked by a shark are minimal; that said, both sharks and groupers have taken chunks out of off-white fins when I've been wearing them.

REEF SHARKS

Sharks occurring on inshore reefs are usually smaller than man. Most common are the Whitetip Reef Shark, the Blacktip Reef Shark and the Grey Reef Shark. All are countershaded grey on top, fading to white underneath. Reef sharks are wise to cool, dull, rainy days, and often patrol turtle-laying beaches on such days, hoping the gloom will trick turtle hatchlings into leaving the sand for the sea during daylight.

Whitetip Reef Sharks can reach 1.7m (5¹/₂ ft) in length and are very shy; their dorsal fins and tails have white tips. They are easily distinguished from other whitetip sharks by their slender bodies and short blunt snouts. Primarily nocturnal, they hide in crevices or caves during the day. They feed mainly on reef fish and octopuses.

Blacktip Reef Sharks reach 1.8m (6ft) and have black-tipped dorsal fins, while their pec-

toral fins have dark ends. They are more inquisitive than Whitetip Reefs, with which they are often seen in shallow-reeftop environments. Blacktip Reefs patrol shallow water along beaches in the early morning, probably hoping to catch turtle hatchlings. Otherwise they feed on a variety of reef and inshore fish, octopuses, squid and cuttlefish.

Grey Reef Sharks can reach 2m (6¹/₂ ft), have white-tipped dorsal fins, are more heavily built than Whitetip Reefs, and have black shading on the rear half of their tails. They are usually seen in shoals of 5–35, sometimes together with Hammerhead or Silvertip Sharks. They feed mainly on bony fish but will take octopuses, squid, cuttlefish, lobsters and crabs. Their well documented attacks on humans are mainly related to territorial behaviour: the shark is aiming to drive off the diver rather than eat him. Grey Reefs exhibit an obvious threat display: exaggerated sinuous movements, the head arched upwards, the jaws snapping and the pectoral fins pointed down. Should a Grey Reef show these behaviours, slowly retreat and leave the water.

BOTTOM-DWELLERS

Bottom-dwelling sharks are usually found in inshore waters.

Nurse Sharks reach 3.2m (10¹/₂ft). Grey or grey-brown in colour, with less counter-

Grey Reef Sharks (Carcharhinus amblyrhynchos) attack in numbers.

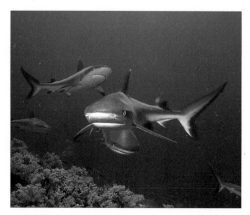

shading (they spend most of their time on the bottom), they are found resting in caves or under overhangs during the day. They are easily approached and rarely react unless provoked. They feed at night on bottom-dwelling fish, lobsters, crabs and octopuses. Their first dorsal fin is well back on the body and their tail lies almost horizontally, lacking a well developed lower lobe.

Variegated Sharks – often called Zebra Sharks (the young have dark bars) or Leopard Sharks (mature specimens have dark spots) – can reach 3.5m (11^1/2ft). They feed mainly on molluscs and crustaceans. Adults are brownish-yellow, fading to white ventrally, with dark spots of varying sizes. Their long tails lie almost horizontally, with hardly any lower lobe. Their spiracles are noticeably larger than their eyes. Males reach sexual maturity at about 1.5m (60in) and females at about 1.7m (67in).

FURTHER OFFSHORE

Deep-water offshore reefs are home also to larger sharks.

Scalloped Hammerhead Sharks reach 4m (13ft) and have hammer-shaped heads with a scalloped leading edge. Heavily built, brown/grey on top fading to white underneath, they can be found alone, in shoals of hundreds, or shoaling with Grey Reef Sharks; many are migratory. They prefer

depths greater than 70m (230ft), feeding on bottom-dwelling rays and fish, smaller sharks, squid, octopuses, cuttlefish, lobsters and crabs.

Great Hammerhead Sharks likewise feed on stingrays. For a long time the hammer-shape of the head was a mystery. It is now thought that the main reason is that it contains a larger number of *ampullae de Lorenzini* – the electroreceptors that sharks use to locate prey. You can see Hammerheads swinging their heads from side to side like metal detectors as they swim over the sand, then suddenly digging out buried fish.

Silvertip Sharks reach 3m (10ft), are heavily built and have white tips to their dorsal fins, pectoral fins and tails. They are black on top, fading to white below. Implicated in various attacks on humans, they are distinguished by their black upper bodies, pointed dorsal fins and shorter, pointed pectoral fins. They feed on smaller sharks and other fish.

Silky Sharks are rapid movers through the water. They reach 3.3m (11ft). Their bodies are slender – though broader than those of Whitetip Reef Sharks – and coloured light grey on top, fading to white underneath. Their very long, rounded pectoral fins are black-tipped. They feed on pelagic fish, squid, crabs and lobsters.

Diver fending off a bad-tempered male Silky Shark (Carcharhinus falciformis).

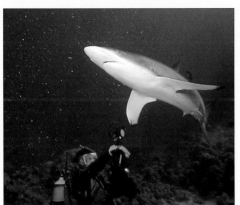

The migratory Scalloped Hammerhead Shark (Sphyrna lewini).

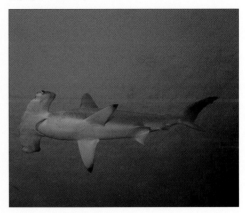

Panglao, Balicasag and Cabilao Islands

Panglao Island is somewhat out on a limb and so tends to be visited by travellers rather than tourists. For divers in the know, Balicasag and Cabilao Islands have some of the best diving in the Philippines, comparable to that off Sipadan Island in Malaysian Borneo though on a smaller scale. Cabilao Island is also easily visited from the Mactan Island resorts, off Cebu (see page 125).

PANGLAO ISLAND AND ALONA BEACH

Located off the southwestern tip of Bohol, Panglao is a small coralline limestone island joined to the mainland near Tagbilaran by a causeway with connecting bridges. The island is known for its quiet beach resorts. There are a few unsigned dirt tracks where even the local taxi drivers get lost, so you can imagine how difficult it can be to find your way about on your own!

There is good snorkelling all round the northwest and southeast coasts, with lots of sea stars, sea cucumbers, sea urchins, corals and a few sea snakes. The area has been a centre for the seashell trade, so there are not many shells left.

The best beach is the white-sand Alona Beach, a quiet friendly place which the locals and the dive resorts wish to keep that way, so that it remains attractive to families rather than

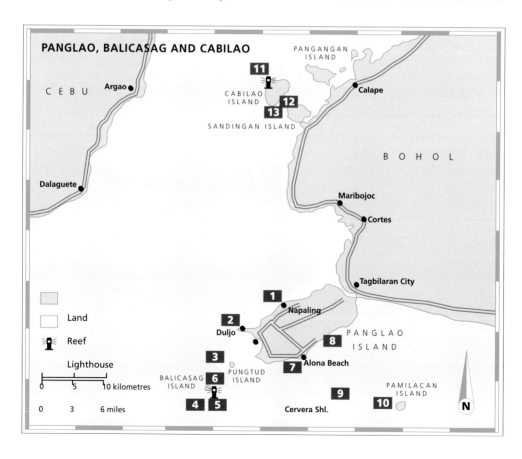

those looking for nightlife. Apart from the dive operators, there are a few small cottage resorts, quiet bars and restaurants. 'Bar girls' are kept out, and the gate to Alona Beach itself is closed at night (21:00–09:00) to keep out vehicles.

> **BALICASAG ISLAND'S STORY**
>
> The UK discovered Balicasag Island by accident in 1875 when one of their vessels went aground there. Shortly after the turn of the century, the USA set it up as a Naval Reservation. The lighthouse the Americans built in 1907 is still in use, guiding maritime traffic between Cebu, Bohol and Mindanao. Balicasag remains under the jurisdiction of the Philippine Navy.

Everyone is very friendly – they make a point of talking to you and learning your name. That said, it can sometimes be a little too laid-back – I could never get breakfast at what I considered to be a sensibly early time in the morning. I never experienced any power failures, but the voltage was often low. The tap water is too salty to drink, so the dive and resort operators buy fresh water daily from the mainland for cooking and for washing diving equipment.

The diving is varied, with good coral gardens near the surface which are also great for snorkelling, but the main attractions are the steep walls with caves, overhangs and crevices harbouring teeming fish and invertebrate life. The small offshore islands are in strong currents, so they too have large schools of fish and big pelagic species. Manta Rays, Hammerhead Sharks and even Whale Sharks may be seen here.

The diving *bancas* tend to be larger than elsewhere as they are often used for longer trips, including overnight safaris. Seaquest's *bancas* have two separate engines. You can easily fill four days just diving locally, but for longer periods you should add an overnight *banca* safari and/or another four days at Moalboal (see page 116). Genesis Divers also regularly run multi-day dive safaris as far afield as Camiguin Island and Southern Leyte. By combining diving at Alona Beach with that of Camiguin Island and Southern Leyte, clients can encounter a large variety of dive sites and scenery on land and meet friendly local people who have not seen many tourists.

The area can be dived all year round. November to May is considered the high season; if you want to make some overnight *banca* safaris the best time is April/May. Live-aboard boats cruise this area.

BALICASAG ISLAND

Balicasag Island, 6km (4 miles) southwest of Duljo Point, is a microcosm of some of the best diving in the Philippines. On the south side, from the buoy outside Balicasag Dive Resort, is 400m (440 yd) of Marine Sanctuary that has been successfully protected. Vertical walls over deep water in strong currents mean healthy corals and good fish life with plenty of pelagic visitors. Hammerhead Sharks, and even Whale Sharks, have been seen here in December and January. There are also lovely beaches.

CABILAO ISLAND

Cabilao Island is southwest of Pangangan Island, which is connected to the west coast of Bohol by a causeway. It is directly east across the Bohol Strait from Argao on Cebu. Like Balicasag Island and Pescador Island (see page 119), Cabilao has some of the best diving in the Philippines and is particularly noted for sightings of Hammerhead Sharks in the deeper waters off the northwest point (Site 11), an exciting dive for the more experienced. The island could be snorkelled all round, but the shallow areas have been damaged by typhoons and there are very strong currents.

Cabilao is 2hr by fast *banca* from Mactan Island (see page 108) or 3hr from Panglao Island. There is a little resort and restaurant, but the food cannot be recommended.

1 NAPALING

★★★★☆☆☆☆☆

Location: The centre of the northwest face of Panglao Island.

Access: 45min–1hr by *banca* from Alona Beach west around the southwest end of Panglao Island, then north-east along its northwest face to Napaling (at low tide the *bancas* have to go all the way out beyond the reef at the southwest end of Panglao Island, which adds 15min to the journey). Alternatively, you can cross the island in 15min by jeep or motorized tricycle and swim out from the beach, but this is not the best method when you are carrying underwater cameras as well as your full diving equipment.

Conditions: Usually calm with some current. You would not normally make the journey if conditions were rough, but the current can be strong on spring tides. Usually done as a drift-dive. Visibility can reach 30m (100ft).

Average depth: 15m (50ft)

Maximum depth: 20m (65ft)

This dive starts as a shallow coral shelf from 3m (10ft) to 7m (23ft), then drops as a vertical wall to 20m (65ft). The shallow shelf is a rich coral garden, great for snorkellers and underwater photographers. There is a small amount of blast-fishing damage, but not that much. A multitude of very large *Acropora* table corals, pillar and leathery corals act as home to large shoals of anthias and smaller shoals of chromis, butterflyfish, razorfish (shrimpfish), damselfish and anemones with clownfish. On my visit the damselfish were spawning and there were quite a few Crown-of-Thorns starfish and *Linckia* sea stars.

The wall has everything one would expect of such a site – good visibility, colourful soft corals, large sponges and crinoids, nudibranchs, flat worms, sea cucumbers and sea stars. Overhangs and caves have soldierfish, squirrelfish and *Tubastrea* corals. There are small groups of fusiliers, jacks, tuna and Rainbow Runners, as well as small Peacock Groupers and Coral Trout. Deeper down you find groupers and Napoleon Wrasse. The many holes often contain moray eels or Royal Angelfish, and there are Bluespotted Ribbontail Rays on the sand.

The wall is patrolled by Whitetip Reef Sharks and is covered with hydroids, large sponges and gorgonian sea fans, a sign that the current can be very strong.

2 DULJO POINT

★★★★

Location: The southwest point of Panglao Island.

Access: 35–50min by *banca* from Alona Beach west around the southwest end of Panglao Island to its south-west tip, which is Duljo Point. (At low tide the *bancas* have to make a wide sweep around the reef edge at the southwest end of Panglao Island, adding up to 15min to the journey.)

Conditions: Usually calm with a strong current, but it can be rough with fierce currents. Visibility can reach 40m (130ft).

Average depth: 20m (65ft)

Maximum depth: 35m (115ft)

A drift-dive takes you along the edge of a sandy slope with coral heads to 11m (36ft), then drops off to a wall down to 40m (130ft). Currents are usually strong, leading to good fish action and the chance of seeing some large pelagic species.

The wall is covered with large gorgonian sea fans, large Elephant Ear Sponges and barrel sponges (both covered with Alabaster Sea Cucumbers), basket sponges, hydroids, colourful crinoids and soft corals.

There are shoals of surgeonfish, fusiliers, razorfish, jacks, batfish, triggerfish, rabbitfish, catfish and squid. The prolific reef fish life includes angelfish, butterflyfish, triggerfish, pufferfish, chromis, anthias, damselfish, wrasse, groupers, snappers, batfish, scorpionfish, lionfish and parrotfish. Deeper down there are stingrays, moray eels, larger groupers, Napoleon Wrasse and the occasional Whitetip or Grey Reef Shark.

In the shallows you find goatfish, lizardfish, some Crown-of-Thorns Starfish, *Linckia*, *Choriaster* and *Fromia* sea stars, Pin Cushion Stars (*Culcita nouvaeguineae*), Nodular Starfish, nudibranchs and anemones with clown-fish, including the rarer *Heteractis aurora* anemone.

3 PUNGTUD WALL

★★★★☆☆☆☆

Location: The outer edge of Pungtud Islet.

Access: 35min west by *banca* from Alona Beach to the western edge of the reef at the southwest end of Panglao Island.

Conditions: Normally dived only in calm conditions, though there can be strong currents. Snorkellers should have *banca* cover when the currents are running. Visibility can reach 30m (100ft).

Average depth: 10m (33ft)

Maximum depth: 20m (65ft)

This beautiful coral garden slopes from 2m (6½ft) to 20m (65ft). There are good soft, leathery and stony corals with lots of small fish, sea stars, sea cucumbers and sea urchins, anemones with clownfish, angelfish, butterflyfish, pufferfish and wrasse. Despite being shallow, there are no signs of coral bleaching from the 1997/1998 El Niño-Southern Oscillation phenomenon – as elsewhere in the Philippines, strong currents with cooler water protected the corals from this problem.

4 BALICASAG ISLAND – SOUTHWEST WALL/RICO'S WALL

5 BALICASAG ISLAND – SOUTHEAST WALL/RUDY'S ROCK

★★★★★☆☆☆☆☆

Location: The southwest wall of Balicasag Island, 6km (4 miles) southwest of Panglao Island.

Access: 45min by *banca* from Alona Beach to the southwest of Duljo Point (Site 2).

Conditions: Normally calm with variable currents, but it can be rough and have fierce currents. You would not normally make this journey in rough weather, unless you were staying at the Balicasag Dive Resort. Visibility can reach 40m (130ft).

Average depth: 15m (50ft)

Maximum depth: 50m (165ft)

At Rico's Wall there is a coral garden on a shelf from 7m (23ft) to 11m (36ft); beyond that a wall drops to 35m (115ft). The coral garden is rich in soft, leathery and stony corals, hydroids, nudibranchs, sea stars, sea cucumbers, crinoids, all the smaller reef fish, anemones and clownfish. Shoals of fusiliers, surgeonfish, jacks, snappers, wrasse, batfish, Moorish Idols, anthias, chromis, damselfish, pennantfish and bannerfish frequent the reef edge and shallower parts of the wall.

There are many angelfish, butterflyfish, Titan and Orangestriped Triggerfish, Vlaming's Unicornfish, trumpetfish, cornetfish, snappers, pufferfish and some Crown-of-Thorns Starfish. At the eastern end, where this dive joins Rudy's Rock, there is a huge shoal of Big Eye Trevally that you can get in amongst. They will circle you for several minutes before becoming bored.

The wall itself has everything – small caves, overhangs and crevices with soldierfish, squirrelfish, lionfish and Moray eels. There are sea cucumbers, nudibranchs and huge gorgonian sea fans, plus Elephant Ear Sponges, barrel sponges and basket sponges, all with Alabaster Sea Cucumbers. Flatworms, Feather Duster Worms and crinoids are everywhere. Deeper down there are larger groupers, Napoleon Wrasse, the occasional Grey or Whitetip Reef Shark and tuna. Barracuda and Rainbow Runners often appear out of the blue.

Rudy's Rock is a continuation of Rico's Wall and much the same, except that large Green Turtles are often seen there.

These are both world-class dives.

Seaquest dive bancas at Alona Beach, a quiet friendly place with few signs of commercialism.

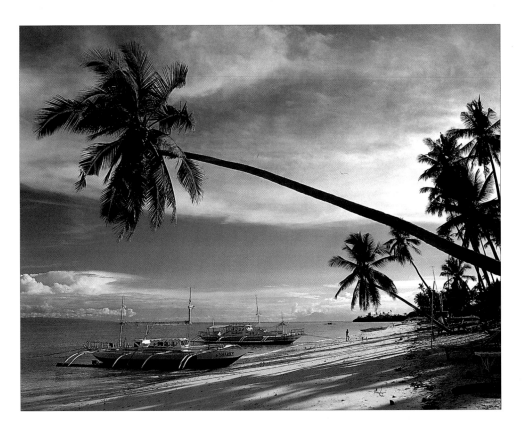

6 BALICASAG ISLAND – NORTHEAST SLOPE/BLACK FOREST

★★★★★

Location: The northeast of Balicasag Island, 6km (4 miles) southwest of Panglao Island.
Access: 45min from Alona Beach by *banca*, southwest of Duljo Point (Site 2).
Conditions: Normally calm with a strong current, but can get really rough with fierce currents. Visibility can reach 40m (130ft).
Average depth: 20m (65ft)
Maximum depth: 40m (130ft)
A fast drift-dive with the strong current, that on my visit was going south–north. We decompressed in open water as we eventually came to the end of the reef.

This is a steep sandy slope from the beach to 40m (130ft) plus, with coral heads, whip corals, soft corals and small gorgonian sea fans on the sand, until you get down below 30m (100ft) where you find forests of black corals. The deeper waters have large groupers, Napoleon Wrasse, barracuda, tuna, batfish and snappers.

The shallower waters have garden eels, moray eels, Titan and Orangestriped Triggerfish, shoals of surgeonfish, Moorish Idols, bannerfish and jacks, Emperor and Royal Angelfish, pufferfish, trumpetfish and cornetfish. There are also many *Linckia* sea stars, *Choriaster* cushion stars, *Bohadschia* sea cucumbers and colourful crinoids.

This is an advanced dive and novices should stay close to their divemaster.

7 KALIPAYAN

★★★☆☆☆

Location: Just off Alona Beach.
Access: 6min by *banca* from Alona Beach.
Conditions: Normally calm with no current. Visibility can reach 25m (80ft).
Average depth: 10m (33ft)
Maximum depth: 20m (65ft)
Known as the 'Happy Wall', this is a pleasant short wall descending from 3m (10ft) to 20m (65ft), with soft, leathery and stony corals, some small gorgonian sea fans, lots of small reef fish, small groupers and small barracuda.

Opposite: *Gorgonian sea fan (Acabaria sp.) on a reef wall. Gorgonians thrive when growing at right angles to strong currents.*

8 ARCO POINT (THE HOLE IN THE WALL)

★★★☆☆☆

Location: Off Arco Point.
Access: 12min by *banca* northeast of Alona Beach.
Conditions: Normally calm with little current. Visibility can reach 30m (100ft).
Average depth: 10m (33ft)
Maximum depth: 25m (80ft)
On a short wall where fish are regularly hand-fed there are small groupers, wrasse, triggerfish, butterflyfish, moray eels and sea snakes. This site is sometimes called the 'Hole in the Wall' because there is a vertical funnel which you can enter at 18m (60ft) and exit at 9m (30ft).

9 CERVERA SHOAL (SPAGHETTI SHOAL)

★★★★

Location: 15km (9½ miles) east of Balicasag Island.
Access: 50min by *banca* southeast of Alona Beach.
Conditions: Normally calm with currents. You would not normally dive here in rough weather and you should aim for slack water. Visibility can reach 30m (100ft).
Average depth: 15m (50ft)
Maximum depth: 60m+ (200ft+)
Often called 'Snake Island' because it harbours several black-and-white-banded sea snakes (hence the 'Spaghetti'), this sunken island is a sea mount rising to 12m (40ft). It is not too good for corals but recommended as a dive into the blue, with lots of snakes and the chance of seeing some large pelagic fish. Novices should stay close to their divemaster.

10 PAMILACAN ISLAND – NORTHWEST SIDE

★★★★☆☆☆☆

Location: 23km (14 miles) east of Balicasag Island.
Access: 60min by *banca* southwest of Alona Beach.
Conditions: Normally calm with medium-strong currents. You would not normally make this journey in bad conditions. Visibility can reach 40m (130ft).
Average depth: 20m (65ft)
Maximum depth: 30m (100ft)
Pamilacan translates as 'nesting place of Manta Rays'; these impressive creatures are occasionally seen here. A good drift-dive, the reef is a sandy 45° slope with many coral heads, anemones with clownfish, Napoleon

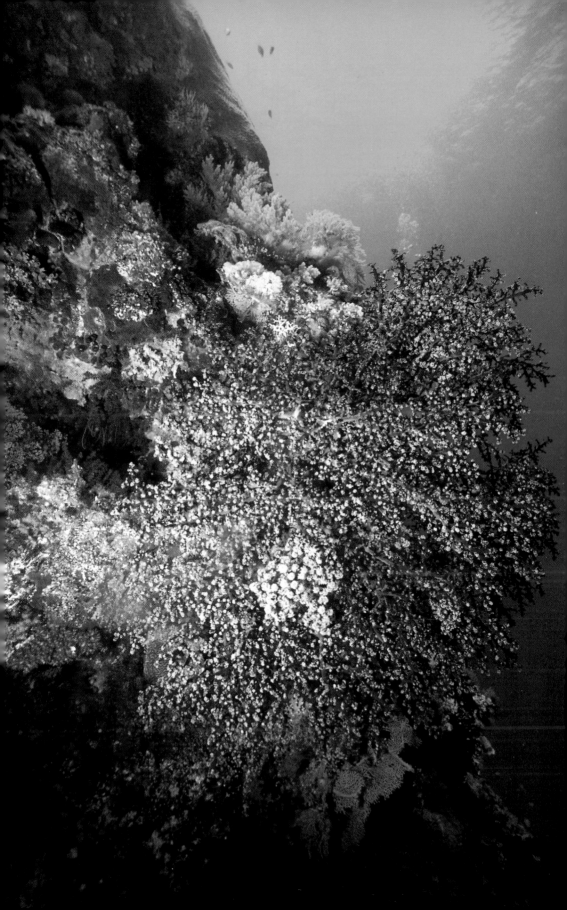

Wrasse, schools of fusiliers, mackerel, barracuda, jacks and Dogtooth Tuna. There are some good gorgonian sea fans, and Flashlight Fish inhabit some of the caves.

11 CABILAO ISLAND – HAMMERHEAD POINT (NORTHWEST POINT)

★★★★★

Location: The northwest point of Cabilao Island, by the lighthouse.
Access: 2hr by *banca* from Mactan Island (see page 108) or 3hr from Panglao Island.
Conditions: Usually calm, even during rain, with strong currents; can get really rough with fierce currents. You would not normally make this journey in bad conditions. Visibility can reach 40m (130ft).
Average depth: 30m (100ft)
Maximum depth: 40m+ (130ft+)
An interesting double drop-off, first to 30m (100ft) and then into deep water. With strong currents, this dive is noted for small shoals of Hammerhead Sharks in December and January. Grey and Whitetip Reef Sharks are common, as are barracuda. There are lots of small gorgonian sea fans, large barrel sponges with Alabaster Sea Cucumbers, whip corals, good soft corals, Leopardfish Sea Cucumbers, *Linckia* sea stars and crinoids. The numerous small shoals include fusiliers, jacks, needlefish, Moorish Idols, pennantfish, butterflyfish, snappers and sweetlips.

This dive has everything, but most divers would particularly want to go deep in the hope of seeing Hammerhead Sharks, large groupers and large Napoleon Wrasse.

12 CABILAO ISLAND – SOUTHWEST POINT (DRIFTING NORTH)

★★★★★

Location: The southwest point of Cabilao Island.
Access: 2hr by *banca* from Mactan Island or 3hr from Panglao Island.
Conditions: Normally calm even during rain, with strong currents; can get really rough with fierce currents. You would not normally make the journey in bad conditions. Visibility can reach 40m (130ft).
Average depth: 20m (65ft)
Maximum depth: 40m+ (130ft+)
Drifting north with the current, you are taken along a typhoon-damaged reef-top at 4m (13ft), from which a wall goes down in two steps to beyond 40m (130ft).

There are lots of small gorgonian sea fans, large barrel sponges, smaller Elephant Ear Sponges, basket

sponges, good soft corals, whip corals and more fire coral than is normal in the Philippines. Many varieties of nudibranchs, various *Bohadschia* sea cucumbers, *Linckia* sea stars and colourful crinoids nestle between the corals. There are, alas, a few Crown-of-Thorns Starfish. Ribbon Eels, garden eels and stingrays are also found on the sand.

The reef is teeming with angelfish, butterflyfish, chromis, anthias, needlefish, various fusiliers, soldierfish, squirrelfish, scorpionfish, lionfish, snappers, sweetlips, Moorish Idols, trumpetfish, cornetfish, wrasse and groupers, with larger groupers and Napoleon Wrasse in deeper water.

13 CABILAO ISLAND – SOUTHWEST POINT (DRIFTING SOUTH AND EAST)

★★★★★

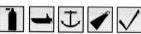

Location: The southwest point of Cabilao Island.
Access: 2hr by *banca* from Mactan Island or 3hr from Panglao Island.
Conditions: Normally calm even during rain, with strong currents; can get really rough with fierce currents. However, you would not normally make the journey to this site in bad conditions. Visibility can reach 40m (130ft).
Average depth: 20m (65ft)
Maximum depth: 40m (130ft) plus
From a typhoon-damaged reef-top at 4m (13ft), a good wall drops to 40m (130ft) plus. Enormous gorgonian sea fans, lots of black coral and Elephant Ear Sponges covered in Alabaster Sea Cucumbers, together with profuse fish and invertebrate life, make this a fine dive. There are plenty of species of sea cucumbers and sea stars, anemones with clownfish and the rarer tube anemones.

SHOALING

Shoaling produces a disruptive background or appears to be one large animal. Confused predators' cannot isolate a single prey to pursue unless it leaves the shoal. Light intensity plays an important role in shoaling, below a certain level of light the shoal will separate.

Where shoaling fish have striped patterns, experiments using mirrors have shown that they will line up with each other, changing direction almost as a single unit.

Researchers' have concluded that vision is used in maintaining the distance from, and angle to, the nearest neighbours, while the lateral line provides information on the speed and direction of other members of the shoal.

How to Get There

There are daily flights from both Manila and Cebu to Tagbilaran; the flight from Cebu is only 20min in a Fokker 50 turboprop aircraft. From Tagbilaran airport you have a choice between motorized tricycles, if you do not have much luggage, or taxis, if you do. The 40min journey to Alona Beach is on asphalt roads until you cross the causeway bridge onto Panglao Island, with dirt roads after that. Most taxi drivers tend to get lost. If you have warned your dive operator in advance, they will organize a car to pick you up at the airport.

Alternatively, there are daily passenger ferries from Manila and Cebu to Tagbilaran. Balicasag Island resort is reached by *banca* from Alona Beach or from Baclayon (east of Tagbilaran on mainland Bohol).

Where to Stay

The number of dive operators on Alona Beach has expanded considerably and most of them have accommodation, almost all of which has been upgraded.

Upper Medium Price Range
Alona Tropical Beach Resort/Sea Explorers Alona Beach.
Book through Sea Explorers: Sea Explorers Philippines Head Office, 36 Archbishop Reyes Avenue, Knights of Columbus Square, Cebu City 6000;
tel 32-2340248/fax 32-2340245;
e-mail: cebu@sea-explorers.com;
website: www.sea-explorers.com
Various standards of accommodation.

Bohol Divers Resort Alona Beach, Panglao Island, Bohol (PO Box 48, Tagbilaran City); tel/fax 38-5029005;
e-mail: info@boholdivers-resort.com;
website: www.boholdivers-resort.com
Various standards of accommodation.

Kalipayan Resort/Atlantis Dive Center Alona Beach, Tawala, Panglao Island, Bohol;
tel 038-5029058/fax 0912-8896227;
e-mail: info@atlantisdivecenter.com;
website: www.atlantisdivecenter.com
Various standards of accommodation.

Medium Price Range
Seaquest Divers Village/Seaquest Dive Center Office Address: Ground Floor Door 1, RM Building, Hernan Cortes Street, Banilad, Mandaue City 6014, Cebu;
e-mail: info@seaquestdivecenter.ph;
website: www.seaquestdivecenter.ph
Various standards of rooms available.

Where to Eat

All of the accommodations listed have good restaurants. I can recommend Alona Tropical Beach Resort.

Dive Facilities

Atlantis Dive Center/Kalipayan Resort Alona Beach, Tawala, Panglao Island, Bohol; tel 038-5029058/fax 0912-8896227;
e-mail: info@atlantisdivecenter.com;
website: www.atlantisdivecenter.com
PADI courses.

Bohol Divers Dive Center/Bohol Divers Resort Alona Beach, Panglao Island, Bohol (PO Box 48, Tagbilaran City);
tel/fax 38-5029005;
e-mail: info@boholdivers-resort.com;
website: www.boholdivers-resort.com
CMAS and PADI courses to Assistant Instructor level.

Genesis Divers Alona Beach, Panglao Island, 6340 Bohol; tel 38-5029056/fax 38-5029107;
e-mail: info@genesisdivers.com;
website: www.genesisdivers.com
PADI courses to Assistant Instructor and diving safaris. Genesis also have a branch at Camiguin Island.

Savedra PADI 5-Star Dive Center Panagsama Beach, Moalboal, 6032 Cebu; tel 32-4740014/fax 32-4740011;
e-mail: info@savedra.com;
website: www.savedra.com/resorts.htm
PADI 5-Star and Technical Diving Centre.

Sea Explorers/Alona Tropical Beach Resort Sea Explorers Philippines Head Office: 36 Archbishop Reyes Avenue, Knights of Columbus Square, Cebu City 6000; tel 32-2340248/fax 32-2340245;
e-mail: cebu@sea-explorers.com;
website: www.sea-explorers.com
PADI 5-Star Gold Palm Dive Centre with several outlets in the Philippines

Seaquest Dive Center Office Address: Ground Floor Door 1, RM Building, Hernan Cortes Street, Banilad, Mandaue City 6014, Cebu; e-mail: info@seaquestdivecenter.ph;
website: www.seaquestdivecenter.ph
PADI 5-Star IDC Centre, with Nitrox courses and diving safaris; operating since 1981.

Diving Emergencies

The nearest recompression chamber is at **VIS-COM Station Hospital,** Camp Lapu Lapu, Lahug, Cebu City; tel 032-310709 (Contact: Mamerto Ortega or Macario Mercado)

Local Highlights

Apart from beaches and water sports, Panglao Island itself has Hinagdanan Cave, usually quoted for underwater swimming, but because of the resident bats the water is not too clean. There are the remains of old churches at Dauis and in Panglao Town.

On the mainland there are the Inambacan Waterfalls near Antequera ($1\frac{1}{2}$hr), which also has a good Sunday market. The oldest stone church in the Philippines is at Baclayon. Near Carmen are the famous Chocolate Hills (2hr), which are at their brownest between February and May.

There is an interesting river safari up the Loay River from Loboc to Busay Waterfalls ($1\frac{1}{2}$hr), and Bohol's forests are famous for butterflies from November to May, attracting many collectors from all over the world.

Bioluminescence

Bioluminescence occurs when luciferin is oxidized by the enzyme luciferase, as in fireflies, for example.

Flashlight fish, *Anomalopidae*, have glands under their cheek bones in which they keep a culture of bioluminescent bacteria. The bacteria feed on chemicals from the fish and produce the enzymes that emit light. The fish can shut off the light by using an eyelid-like structure raised from below. They use the light to attract and illuminate their Zooplankton prey, confuse predators and communicate with one another.

The formation of a coral reef is in a state of constant flux. Storms, freshwater floods, siltation and changes in currents, sea levels and water temperature, as well as disease, predation and the excesses of man, can kill corals. Faster-growing species may block out the sunlight falling on others and restrict their growth, and table corals eventually snap under their own weight.

Many species compete for the best areas down to 30m (100ft), so they have devised methods to defend their territory or to expand at the expense of other colonies.

In areas of strong current, corals that have many branching arms are prevalent. Their shape slows down the flow of water over their polyps, giving them more chance to catch prey. *Acropora* corals have more species, grow faster and occupy more reef area than any other species.

When some corals detect a competing species nearby, they grow extra-long tentacles towards it, with a higher concentration of stinging organs (nematocysts). These tentacles wave about in the direction of the intruder and kill it on touch. Over shorter distances – less than 2cm (0.8in) – some corals open a hole in their body wall and send out digestive filaments to digest intruders.

Soft and gorgonian corals usually lose when competing with reef-building species in well-lit water, except where their flexibility makes them self-cleaning in areas of high siltation. They manage better in poorly lit locations, in caves, under overhangs or in deep water. Gorgonians do best in strong currents where their position at right angles to the current, and their construction, with polyps so close as to be almost touching, slows down the current enough for their tentacles to trap prey.

PREDATORS

Coral reefs give home and shelter to many marine creatures, but are themselves preyed upon. Planktonic shrimps, crabs and mussels feed on their mucus, and some starfish, urchins, crabs and fish eat the coral tissue.

When predators such as butterflyfish feed on coral tissue, the coral responds to the disturbance by retracting its other tentacles, so the predator does not do too much damage to any one colony before having to turn to anoth-

One of the many species of fast-growing Acropora corals regenerating a reef.

A Crown-of-Thorns Starfish (Acanthaster planci) can cause 90% destruction of acropora coral.

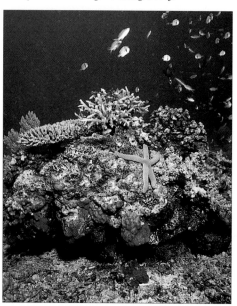

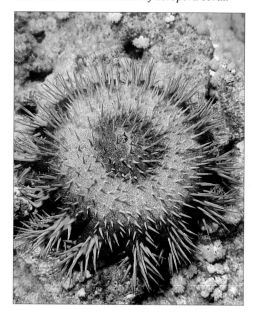

er for sustenance. Some triggerfish eat both tissue and skeleton, but not in large quantities. More serious is the damage done by Crown-of-Thorns Starfish and Bumphead Parrotfish.

Crown-of-Thorns Starfish kill large areas of coral, especially when their populations explode. They often return to the same specimen every night until the whole colony is dead. They prey mainly on fast-growing *Acropora* corals. Bumphead Parrotfish occur in large shoals, with some individuals exceeding 1m (40in) in length; they charge into the coral, breaking it off with their forehead and eating both tissue and skeleton.

El Niño

Accompanied by a change in the atmospheric circulation called the Southern Oscillation, the El Niño–Southern Oscillation (ENSO) phenomenon has recently been associated with the bleaching and, in some cases, ultimate death of shallow-water corals in many parts of the world. Scientists are not fully sure of the exact mechanism for this.

Under normal conditions the trade winds push water towards the Western Pacific such that the sea level in the Philippines is some

60cm (23in) higher than that in the Eastern Pacific. When an El Niño occurs, the trade winds collapse or even reverse, so sea levels drop. In theory the Philippines should be hit badly by coral bleaching but fortunately this has not been the case, possibly due to upwellings of colder water from the depths.

Human Destruction

Sewage adds to siltation and often spreads disease. Industry discharges toxic chemicals. Shipwrecks can leak oil for decades – crude oil is toxic and its heavier constituents eventually sink, smothering corals and bottom-dwelling creatures. Detergents and agricultural fertilizers release nitrates and phosphates, which contribute to algal blooms that poison people, smother corals and cut out sunlight.

Anchors, divers and swimmers kill any corals that they touch. Fortunately many Marine Parks supply fixed moorings, and environmentally aware captains set up their own – though often to have them stolen by local fishermen.

Despite the doom and gloom of some ill-informed writers, coral reefs are surviving. But they do need our help. We must clean up our act if we are to help them survive.

In an ideal world, all coral reefs would look like this healthy colony of mixed corals.

A dead giant clam is the substratum for corals and a brown sponge.

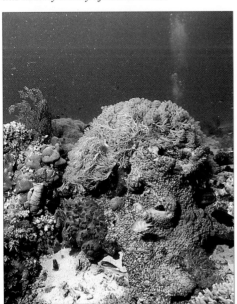

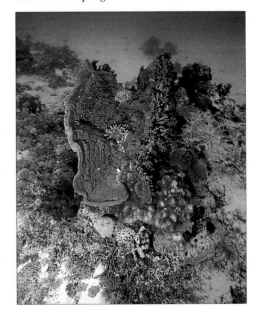

Sumilon, Apo, Siquijor and Camiguin Islands

These areas used to be good diving until destructive fishing methods damaged the reefs. However, since then the situation has improved considerably. Local communities are learning to protect their reefs, live coral cover and fish populations have increased and fish traps have replaced destructive fishing methods. Diving operators now either have their own local resorts or use beach resorts for overnight stays while on diving safaris. The best time to dive is April till November.

SUMILON ISLAND

Sumilon Island once had the first marine sanctuary in the Philippines, developed and preserved by Silliman University on Negros. Unfortunately, local politicians kicked out the conservationists and condoned *muroami*, blast and cyanide fishing. Some unscrupulous dive operators even organized spear fishing. Now at last things appear to be on the mend.

APO ISLAND

Destructive fishing ceased completely around Apo Island (not to be confused with Apo Reef off Mindoro) in 1997. Silliman University staff helped organize the local people into marine management committees who then set up marine reserves that included a no-fishing

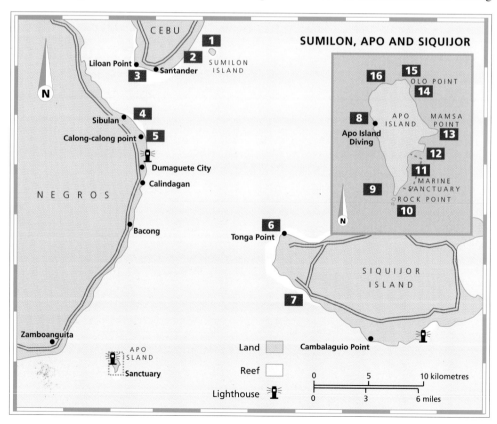

sanctuary on one portion of the reef. With the aid of municipal governments, residents have continued to prevent reef damage from fishermen and divers, both within and outside the sanctuary. Generally considered to be the most successful marine sanctuary in the Philippines, surveys indicate that live coral cover and fish density has increased substantially along with fish yields per unit area off the Island.

Current rules are that divers and snorkellers must register and pay a fee before diving; gloves are banned and there is a limit of 15 divers including three dive guides. *Bancas* must use the fixed moorings where provided and only use anchors in designated areas, while larger boats must use the moorings.

There are fish traps outside of the sanctuary, but please resist the temptation to cut the fish free as this would antagonize the local population – and fish traps are much better for the health of the reefs than *muroami*, blast or cyanide fishing.

> ### ARTIFICIAL REEFS
>
> Artificial reefs in shallow waters are a well proven, successful way of enhancing fish stocks, as any fisherman will tell you.
>
> Shipwrecks rapidly take on the appearance of a reef. They form a good substratum for coral larvae to settle on, provide shelter for bigger fish and serve as breeding sites for smaller fish and invertebrates.
>
> Purpose-built artificial reefs, placed either on damaged reefs or on the sea bed near to reefs, are now common. Old tyres chained together, sometimes stabilized with concrete blocks, are most often used. There is a risk of the tyres gradually breaking down and releasing toxic pollutants, but the system is cheap and highly effective. The only real problem is that such constructions often break up when caught in trawl nets. Concrete slabs or small pyramids chained or linked together with chain-link fencing would seem the best, if more expensive, system to use.

CAMIGUIN ISLAND

Camiguin Island is really part of Mindanao but it is usually dived from the Visayas. As around Apo Island, there are several fish traps here, but divers should resist the temptation to cut the fish free as this would antagonize the local population and fish traps are much better for the health of the reefs than *muroami*, blast or cyanide fishing. Access times are by *banca* from Caves Resort.

1 SUMILON ISLAND

★★★☆☆

Location: 5km (3 miles) east–northeast of Tañon Point on Cebu.
Access: By *banca* from either Mactan Island or Santander/Liloan on Cebu or Dumaguete/Sibulan on Negros.
Conditions: Normally calm with strong currents, but it can get very rough with fierce currents, particularly on spring tides. Visibility can reach 30m (100ft).
Average depth: 20m (65ft)
Maximum depth: 35m (115ft)
The old marine sanctuary covers all of the west side where the reef flat goes over a drop-off at 18m (60ft) to sand at 35m (115ft), with good stony corals, black corals, gorgonian sea fans and some small caves. There are lots of juvenile fish. In contrast, the east and south sides are sandy slopes with coral heads. There are still some good soft corals on the walls, with a reasonable variety of reef fish and sometimes sharks. The sandy slopes also have

Garden Eels and mushroom corals.

Occasionally, sea snakes, turtles and Manta Rays are seen. Snorkelling is good on the west, north and east sides, but snorkellers should always be careful of the currents.

2 LOOC
3 LILOAN POINT

★★★☆☆

Location: All around the southern tip of Cebu.
Access: By *banca* from either Santander/Liloan or Mactan Island on Cebu or Dumaguete/Sibulan on Negros.
Conditions: Normally calm with strong currents, though it can get really rough with fierce currents. Visibility can reach 25m (80ft).
Average depth: 20m (65ft)
Maximum depth: 35m (115ft)

Liloan translates as 'strong currents' so it is not surprising that these can occur. The best diving is off the west of Liloan Point, where there are large areas of sandy slopes with large rocks and coral heads, which may be drift dived down to 25m (80ft) – below which is sandy bottom. Soft corals, stony corals and a good variety of reef fish, plus Bluespotted Ribbontail Rays and Garden Eels, can be seen. Manta Rays often appear between March and June.

Further out from Liloan Point, the currents rage across a wall that goes down to 60m (200ft), giving healthy soft corals and whip corals. Known as 'The Wall of Death', this is for experienced divers only.

4 TACOT

★★★★

Location: Off the shore at Sibulan, Negros.
Access: By *banca* from either Dumaguete/Sibulan on Negros or Santander/Liloan or Mactan Island on Cebu.
Conditions: Normally calm with a strong current, but it can get really rough with a fierce current. Visibility can reach 30m (100ft).
Average depth: 20m (65ft)
Maximum depth: 23m (75ft)
This is an underwater mountain that rises from 23m (75ft) to 13m (43ft). Being in open water, the site often attracts large pelagic species as well as the smaller reef fish. There are some large gorgonian sea fans, boulder corals, *Acropora* table corals and plenty of crinoids.

5 CALONG-CALONG POINT

★★★☆☆☆

Location: Calong-Calong Point southeast of Sibulan, Negros.
Access: By *banca*, usually from Sibulan.
Conditions: Normally calm with some current, but it can get very rough with strong currents. Visibility can reach 20m (65ft).
Average depth: 20m (65ft)
Maximum depth: 24m (79ft)
The reef extends for 2.5km (1.5 miles) of reef slope with coral heads from 4m (13ft) to 24m (79ft), where it becomes sandy bottom. There are many varieties of soft and stony corals, some large gorgonian sea fans, barrel sponges, and most reef fish including lots of pufferfish and Bluespotted Ribbontail Rays.

6 TONGA POINT/SIMBAHAN

★★★☆☆☆

Location: The northern end of the southwest arm of Siquijor Island.
Access: By *banca* from local beach resorts, Dumaguete/Sibulan on Negros or Santander/Liloan or Mactan Island on Cebu.
Conditions: Normally calm with some current, but it can become really rough with fierce currents. Visibility can reach 25m (80ft).
Average depth: 20m (65ft)
Maximum depth: 40m+ (130ft+)
A slope down to 12m (40ft), then a drop-off down to 40m plus (130ft plus). There are spur-and-groove coral formations, with *Acropora* table corals, lettuce corals, gorgonian sea fans and good soft corals. The fish life is prolific but skittish.

7 SAN JUAN

★★★☆☆☆

Location: Offshore from San Juan town, Siquijor Island.
Access: By *banca* from local beach resorts, Dumaguete/Sibulan on Negros or Santander/Liloan or Mactan Island on Cebu.
Conditions: Usually calm with some current, but it can become really rough with strong currents. Visibility can reach 25m (80ft).
Average depth: 20m (65ft)
Maximum depth: 40m plus (130ft plus)
This has a sandy slope with coral heads, then a drop-off much the same as Tonga Point (Site 6), with the addition of Ribbon Eels.

8 CHAPEL POINT

★★★☆☆☆

Location: The buoy off Apo Island Diving
Access: By *banca* from Apo Island Diving.
Conditions: Normally calm with strong currents, but it can become really rough with fierce currents. Visibility can reach 30m (100ft).
Average depth: 15m (50ft)
Maximum depth: 40m (130ft)
A gentle slope to 10m (33ft) then a drop-off to sand at 40m (130ft). You drift southeast in the current, though

in fact the best part of the dive is under the buoy. There are good coral heads, soft corals, sea stars, several species of nudibranchs, gorgonian sea fans, whip corals and basket sponges. The fish life is prolific, including jacks, tuna, barracuda, Black-and-white Snappers, Vlaming's Unicornfish, triggerfish, trumpetfish, angelfish and butterflyfish.

9 KATIPANAN POINT

★★★★

Location: On the west side of the island, south from Apo Island Diving to the bay north of Rock Point.
Access: By *banca*.
Conditions: Normally calm with strong currents, but it can become really rough with fierce currents. Visibility can reach 30m (100ft).
Average depth: 15m (50ft)
Maximum depth: 30m (100ft)
This has a slope to 30m (100ft) with large rocks, coral heads, *Sarcophyton* corals and *Dendronephthya* soft tree corals, nudibranchs, sea stars, sea cucumbers and sea snakes. The prolific fish life in the area includes shoals of barracuda, sweetlips and tuna, clownfish in anemones, jacks, snappers, Vlaming's Unicornfish, triggerfish, trumpetfish, angelfish, damselfish and butterflyfish.

Bearded Triggerfish (Xanthichthys auromarginatus)
with didemnid sea squirts, a yellow sponge
(Adocia sp).

10 ROCK POINT

★★★★

Location: Offshore of the rocks rising from the water as an extension of Rock Point
Access: By *banca* from Apo Island Diving.
Conditions: Normally choppy with strong currents; can become rough with fierce currents. Visibility up to 25m (80ft).
Average depth: 10m (33ft)
Maximum depth: 40m (130ft)
This point gets some heavy weather, but that in turn produces good fish life. The dive begins on the east side of the point and you go around the point with the current to the west side. The topography is a gentle slope made up of rocks and coral heads with columnar *Acropora palifera* corals, green *Tubastrea* corals, *Dendronephthya* soft tree corals, feather stars, turtles, cushion stars and sea squirts. The prolific fish life includes many clownfish in anemones, surgeonfish, Picasso Triggerfish, moray eels, lionfish, scorpionfish, Black-and-white Snappers, a shoal of tuna, Blacktip and Whitetip Reef Sharks and large Bumphead Wrasse.

11 MARINE SANCTUARY

★★★★★★★★

Location: The buoy off the marine sanctuary to the east of Rock Point (Site 10)
Access: By *banca* anticlockwise from Apo Island Diving.
Conditions: Normally calm, but can become really rough with strong currents. Visibility can reach 30m (100ft).
Average depth: 10m (33ft)
Maximum depth: 30m (100ft)

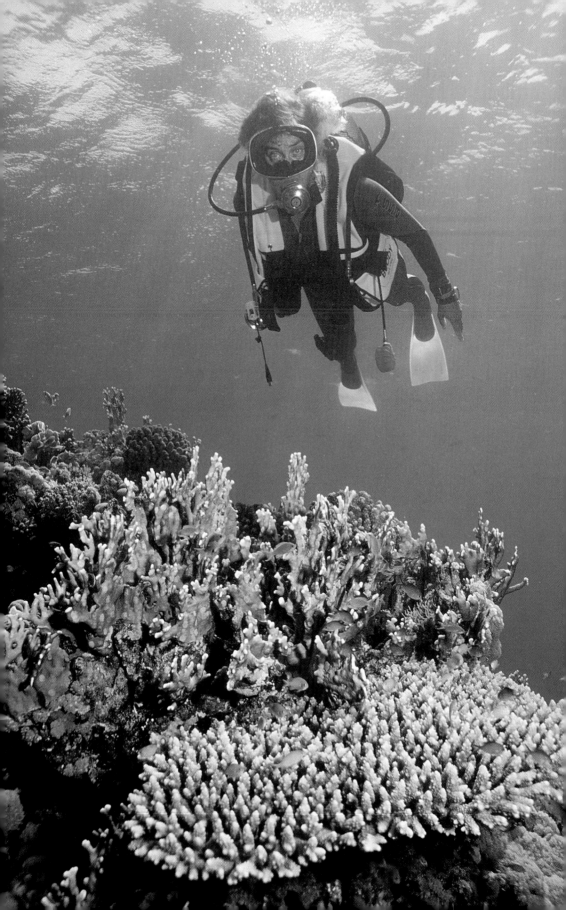

A mixture of walls, slopes with coral heads and sandy patches with black corals. The best diving seems to be at the western side of the sanctuary where Giant Clams have been seeded and there are nudibranchs, sea stars, feather stars and a huge expanse of anemones with hundreds of clownfish. The fish life includes groupers, surgeonfish, triggerfish, angelfish, butterflyfish, moray eels, lionfish, scorpionfish, Black-and-white Snappers, tuna, Vlaming's Unicornfish, and a shoal of jacks. Turtles and Manta Rays are common.

12 KAN-URAN POINT
★★★

Location: Off the point to the right of the marine sanctuary
Access: By *banca* from Apo Island Diving.
Conditions: Normally calm with strong currents, but it can become really rough with fierce currents. Visibility can reach 30m (100ft).
Average depth: 15m (50ft)
Maximum depth: 40m (130ft)
To the west this site is a gentle slope with coral heads and stands of staghorn coral while to the east is a wall with soft corals. Sea stars, feather stars and sea cucumbers are common on the slope and nudibranchs on the wall. The fish life includes groupers, surgeonfish, triggerfish, angelfish, butterflyfish, moray eels, lionfish, scorpionfish, Vlaming's Unicornfish and a shoal of jacks.

13 MAMSA POINT
★★★★☆☆☆

Location: Off Mamsa Point
Access: By *banca* from Apo Island Diving.
Conditions: Normally calm with strong currents, but it can become really rough with fierce currents. Visibility can reach 30m (100ft).
Average depth: 15m (50ft)
Maximum depth: 25m (80ft)
This has a slope to 25m (80ft) with a mixture of stony corals, black corals and whip corals. There is prolific fish life, including jacks, tuna and other pelagic species, groupers, triggerfish, angelfish, butterflyfish, moray eels, lionfish, scorpionfish and Blacktip and Whitetip Reef Sharks.

Diver hovering over healthy shallow mixed corals where numerous anthias and chromis hide.

14 COGON POINT
★★★★

Location: South of Olo Point (Site 15) on the east side of the island.
Access: By *banca* from Apo Island Diving.
Conditions: Normally calm with strong currents, but it can become really rough with fierce currents. Visibility can reach 30m (100ft).
Average depth: 25m (80ft)
Maximum depth: 30m (100ft)
A slope to 20m (65ft), then an overhanging wall to 30m (100ft). There are good stony corals, *Tubastrea* corals and prolific fish life, including groupers, triggerfish, angelfish, butterflyfish, lionfish, scorpionfish, Vlaming's Unicornfish, barracuda and tuna.

15 OLO POINT
★★★★

Location: Off Olo Point
Access: By *banca* from Apo Island Diving.
Conditions: Normally calm with strong currents, but can get rough with fierce currents. Visibility up to 30m (100ft).
Average depth: 25m (80ft)
Maximum depth: 35m (115ft)
This is a slope with coral heads, *Tubastrea* coral, black corals, cushion stars, feather stars, sea cucumbers and nudibranchs. The fish life includes groupers, surgeonfish, triggerfish, angelfish, butterflyfish, moray eels, lionfish, scorpionfish, Vlaming's Unicornfish, Whitetip Reef Sharks and a shoal of jacks.

16 COCONUT POINT
★★★★

Location: West of the centre of the north side of the island.
Access: By *banca* from Apo Island Diving.
Conditions: Normally choppy with strong currents, but it can become really rough with fierce currents. Visibility can reach 30m (100ft).
Average depth: 25m (80ft)
Maximum depth: 40m (130ft)
There is usually a strong current here, so treat the dive as a drift-dive. The slope goes from the shallows to 40m (130ft) with coral heads, black corals, gorgonian sea fans, whip corals, *Sarcophyton* soft corals and *Dendronephthya* soft tree corals. The currents attract fish, including shoals of barracuda, sweetlips, jacks and tuna, surgeonfish, fusiliers, triggerfish, moray eels, lionfish, Vlaming's Unicornfish and Whitetip Reef Sharks.

⓱ WHITE ISLAND

★★★★

Location: Northwest of Caves Resort.
Access: 5min by *banca*.
Conditions: Usually calm with a current, but it can become really rough with strong currents. Visibility can reach 30m (100ft).
Average depth: 12m (40ft)
Maximum depth: 26m (85ft)
This is not the visible sand cay of the same name (unusual for its white sand, as most of the beaches on the main island are made up of course dark brown or black volcanic sand) but a submerged reef not far from it. Being quite large and with no marker, it can be difficult to find the best area of reef.

A gentle slope runs from 6m (20ft) to 26m (85ft) with a forest of black corals, columnar *Acropora palifera* corals, *Dendronephthya* soft tree corals, feather stars, cushion stars, sea squirts, nudibranchs and huge Basket Sponges on light-coloured sand. The fish life includes many clownfish in anemones, surgeonfish, angelfish, butterflyfish, Bluespotted Ribbontail Rays, moray eels, lionfish, a shoal of tuna and the rarely seen Clown Grouper (*Pogonoperca punctata*), also known as a Spotted Soapfish or Leaflip.

⓲ TANGUB BAY

★★★☆★★

Location: Offshore from Tangub Bay, southwest from Caves Resort.
Access: 15min by *banca*.
Conditions: Usually calm with some current, but can get very rough with strong currents. Visibility up to 30m (100ft).
Average depth: 14m (45ft)
Maximum depth: 26m (85ft)
This has a slope from 3–26m (10–85ft), with large volcanic rocks with soft corals on dark coloured sand. Hawksbill Turtles, triggerfish, surgeonfish, scorpionfish, lionfish, Blue Ribbon Eels, angelfish, butterflyfish, Bluespotted Ribbontail Rays and moray eels are common. The site makes a good night dive, with lots of molluscs and Spanish Dancer Nudibranchs

⓳ TANGUB HOT SPRINGS

★★★★★★

Location: Just south of Tangub (Site 18).
Access: By *banca*.
Conditions: Usually calm with some current, but it can become really rough with strong currents. Visibility can reach 30m (100ft).
Average depth: 20m (65ft)
Maximum depth: 35m (115ft)

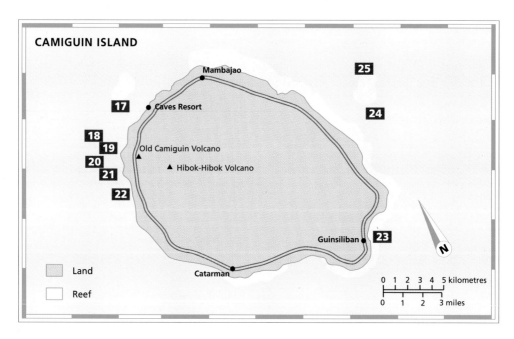

CAMIGUIN ISLAND

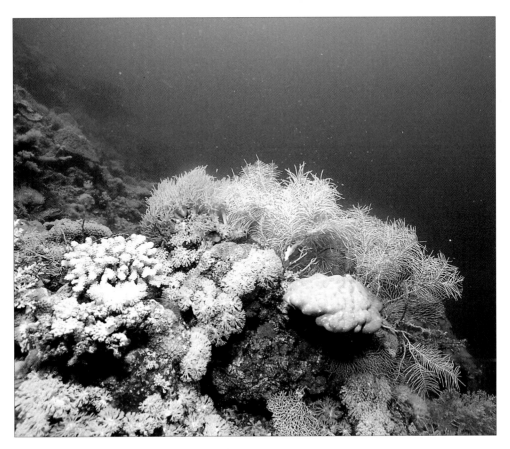

This features terraces of dark-coloured sand from 6–35m (20–115ft). Gorgonian sea fans, *Dendronephthya* soft tree corals, turtles, triggerfish, surgeonfish, scorpionfish, lionfish, snake eels, angelfish, butterflyfish, Bluespotted Ribbontail Rays and moray eels are all in evidence.

20 OLD VOLCANO

★★★★★☆☆☆

Location: West of Camiguin Old Volcano, anticlockwise around the island from Caves Resort.
Access: 25min by *banca*.
Conditions: Usually calm with some current, but it can become really rough with strong currents. Visibility can reach 30m (100ft).
Average depth: 20m (65ft)
Maximum depth: 40m+ (130ft+)
Like a lunar landscape, the volcanic cliffs here continue underwater and some very large rocks have broken away. There are good *Dendronephthya* soft tree corals, wire corals, Hawksbill Turtles, sea cucumbers and

Mixed soft corals, stinging hydroids, a gorgonian sea fan and stony corals on the reef edge.

Choriaster and Linckia starfish. There are also plenty of fish, including clownfish in anemones, anthias, Titan Triggerfish, Longfin Batfish, jacks, tuna and occasionally Manta and Eagle Rays.

21 SUNKEN CEMETERY

★★★★☆☆☆

Location: Offshore from the large white cross that commemorates an old cemetery that was destroyed by volcanic eruption. Anticlockwise around the island from Caves Resort.
Access: 30min by *banca*.
Conditions: Usually calm with some current, but it can become really rough with strong currents. Visibility can reach 30m (100ft).
Average depth: 20m (65ft)
Maximum depth: 40m+ (130ft+)

There is nothing visible remaining of the cemetery. You swim or drift with the current, which gets noticeably faster and colder deeper down. A gentle slope with coral heads and basket sponges recovering from blast-fishing goes from 3m to 12m (10–40ft), then several small drop-offs and walls descend into the depths. The stony corals get better as you go deeper. As well as a tremendous number of blue *Linckia* starfish there are turtles, ribbon eels, barracuda, jacks, angelfish, butterflyfish, surgeonfish, triggerfish, Bluespotted Ribbontail Rays and Eagle Rays. In the shallower areas the fish are quite skittish while those in the deeper water are not scared by divers.

22 CANYONS
★★★★★★★

Location: Offshore south of Bonbon, anticlockwise around the island from Caves Resort.
Access: 40min by *banca*
Conditions: Usually calm with some current, but it can become really rough with strong currents. Visibility can reach 25m (80ft).
Average depth: 16m (52ft)
Maximum depth: 40m+ (130ft+)
A sandy slope starts at 3m (10ft), with rocks and corals, gorgonian sea fans covered with feather stars, turtles, ribbon eels, juvenile Longfin Batfish, barracuda, jacks, snappers, angelfish, butterflyfish and surgeonfish.

23 KABILA
★★★★★★

Location: Offshore south of Guinsiliban, anticlockwise around the island from Caves Resort.
Access: 2hr by *banca*
Conditions: Usually calm with some current, but it can become really rough with strong currents. Visibility can reach 30m (100ft).
Average depth: 20m (65ft)
Maximum depth: 35m (115ft)
A slope from 3m to 35m (10–115ft) with coral heads, soft corals, *Choriaster*, *Linckia* and cushion starfish, sea cucumbers, nudibranchs, groupers, snappers, angelfish, butterflyfish surgeonfish, rabbitfish, cuttlefish, Bluespotted Ribbontail Rays and Eagle Rays.

24 MANTIGUE (MAGSAYSAY ISLAND)
★★★

Location: Well offshore to the east of Camiguin, clockwise around the island from Caves Resort.
Access: 90min by *banca*
Conditions: Usually calm with some current, but it can become really rough with strong currents. Visibility can reach 40m (130ft).
Average depth: 20m (65ft)
Maximum depth: 40m (130ft)
A large area of reef-top with a good variety of stony corals descends to a mixture of walls, stony corals and whip corals, with turtles, angelfish, butterflyfish, surgeonfish, rabbitfish, triggerfish, fusiliers, trumpetfish, cuttlefish, pufferfish, Napoleon Wrasse, Bluespotted Ribbontail Rays, Eagle Rays and visiting pelagic species.

25 JIGDUP REEF, EAST AND WEST
★★★★★★★

Location: Well offshore north of Mantigue (Magsaysay) Island, clockwise around the island from Caves Resort.
Access: 60 min by *banca*
Conditions: Usually calm with some current, but it can become really rough with strong currents. Visibility can reach 25m (80ft).
Average depth: 20m (65ft)
Maximum depth: 40m (130ft)
The east side is a slope with ledges from 3m to 35m (10–115ft), with coral heads, large sponges, gorgonian sea fans, whip corals, black corals and feather stars. It is a good site for novices and underwater photographers. The deeper water has a healthy fish life, including rabbitfish, triggerfish, angelfish, butterflyfish, batfish, barracuda, jacks, lionfish, surgeonfish, fusiliers, trumpetfish, cuttlefish, pufferfish, snappers, tunas, Bluespotted Ribbontail Rays and Eagle Rays. In open water there are shoals of unicornfish, Red Snappers and Black-and-White Snappers.

The west side features a wall from 3m to 40m (10ft–130ft) with small caverns. The fish life is the same as on the east side, only with the addition of Manta Rays from December to March.

How to Get There

There are regular flights, both international and domestic, to Mactan island on Cebu and domestic flights from both Manila and Mactan Island to Dumaguete. There are modern ferry services to Dumaguete and older ones to Siquijor and Camiguin.

Liloan in southern Cebu is best reached by taking the good road that runs down the east side of Cebu island. Otherwise it can be reached on a lower standard road running down the west side of Cebu island from Moalboal. Some of the bridges on this road are occasionally washed out. Sumilon Island is easily reached by *banca* from Santander/Liloan. Apo Island, 6km (4 miles) east of Zamboanguita, the nearest town on Negros, is reached by *banca* from Zamboanguita or Dumaguete on Negros. All four areas are dived by dive operators at Liloan on Cebu, Dumaguete on Negros or on diving safaris run by these operators and some of those on Mactan Island, Cebu.

Camiguin Island has a weekly ferry service and a tiny airstrip for light aircraft. Despite being nearest to Mindanao Island, it is mostly dived on diving safaris from Alona Beach, Panglao Island in Bohol.

Where to Stay

Sumilon Island
The only resort has closed, so this island is only accessible by day trip or live-aboard boat.

Dumaguete
Upper Price Range
Pura Vida Beach & Dive Resort/Sea Explorers Dauin, Dumaguete. Sea Explorers Philippines Head Office: 36 Archbishop Reyes Avenue, Knights of Columbus Square, Cebu City 6000; tel 032-2340248/ fax 032-2340245; e-mail: cebu@sea-explorers.com; website: www.sea-explorers.com Quality resort.

Siquijor Island
Medium Price Range
Sea Explorers at Coco Grove Beach Resort Sea Explorers Philippines Head Office: 36 Archbishop Reyes Avenue, Knights of Columbus Square, Cebu City 6000; tel 32-2340248/fax 32-2340245; e-mail: cebu@sea-explorers.com; website: www.sea-explorers.com Various standards of rooms available.

Apo Island
Lower Price Range
Liberty's Community Based Lodge and Paul's Diving School Apo Island, PO Box 1, Dauin, Negros Oriental 6217; tel Office 921-3316325/ tel Apo 920-2385704; e-mail: dive@apoisland.com; website: www.apoisland.com

Camiguin Island
Medium Price Range
Secrete Cove Beach Resort Yumbing, Camiguin Island; tel/fax 088-3879084 Various standards of accommodation.

Where to Eat

On Siquijor Island, try the Coco Grove Beach Resort. Liberty's Community Based Lodge is the place to eat on Apo Island.

On Camiguin Island, Caves Resort is fine for Filipino food though not for western food. The Canadian-run Secrete Cove Beach Resort is only 15min walk southwest along the main road behind Caves Resort and serves excellent western food.

Dive Facilities

Siquijor Island
Sea Explorers at Coco Grove Beach Resort Sea Explorers Philippines Head Office: 36 Archbishop Reyes Avenue, Knights of Columbus Square, Cebu City 6000; tel 32-2340248/fax 32-2340245; e-mail: cebu@sea-explorers.com; website: www.sea-explorers.com PADI 5-Star Gold Palm Dive Centre with several outlets in the Philippines.

Apo Island
Liberty's Community Based Lodge and Paul's Diving School Apo Island, PO Box 1, Dauin, Negros Oriental 6217; tel Office 921-3316325/tel Apo 920-2385704; e-mail: dive@apoisland com; website: www.apoisland.com PADI and NAUI courses to Assistant Instructor, as well as speciality courses including Naturalist.

Dumaguete
Pura Vida Beach & Dive Resort/Sea Explorers Dauin, Dumaguete. Sea Explorers Philippines Head Office: 36 Archbishop Reyes Avenue, Knights of Columbus Square, Cebu City 6000; tel 32-2340248/fax 32-2340245; e-mail: cebu@sea-explorers.com; website: www.sea-explorers.com PADI 5-Star Gold Palm Dive Centre with several outlets in the Philippines.

Note The larger dive operators on Mactan Island (Cebu) will organize diving safaris to these areas if requested.

Camiguin Island
Johnny's Dive 'N' Fun at Caves Dive Resort Agoho, Mambajao 9100, Camiguin Island; tel 88-3879588; e-mail: info@johnnysdive.com; website: www.johnnysdive PADI training at three locations across Camiguin.

Diving Emergencies

The nearest recompression chamber is at **VISCOM Station Hospital**, Camp Lapu Lapu, Lahug, Cebu City; tel 032-310709

Local Highlights

These islands and Dumaguete City are well away from the popular areas for tourist divers, so they are not crowded with divers. Siquijor Island in particular is not used to foreigners, and is home to people practising Voodoo, witchcraft and faith-healing rituals.

Apo Island is mostly rocks and cliffs; only 10% of its 27ha (67 acres) is habitable. Dumaguete is a small and pleasant city with everything within walking distance. Silliman University has a small Anthropological Museum as well as the marine laboratory. Some 18km (11 miles) north of the city, you can walk on forest trails to the two crater lakes of Balinsasyao and Danao, while there is a good Wednesday market at Malatapay, 25km (15 miles) south of the city.

Camiguin is an idyllic island, with seven volcanoes, hot springs and waterfalls. In 1871, the old capital Cotta Bato was destroyed and its cemetery submerged when the Old Camiguin Volcano erupted; there is nothing left to see of the cemetery but a large cross marks the site and gives a nearby dive site its name. Mount Hibok-Hibok erupted in 1951, asphyxiating many inhabitants.

Artificial Reef at Dumaguete

The Philippines' first artificial reef, just off the beach in front of Dumaguete, was built in 1977 by the marine laboratory of Dumaguete's Silliman University. 30m (100ft) long and 11m (36ft) wide, with an arm 20m (65ft) long on one side, it is made of old vehicle tyres chained together. Lying at 24m (79ft) on a sandy slope in strong currents, the reef has attracted a multitude of reef fish and invertebrates.

Southern Leyte

A long with Samar, Leyte forms the eastern edge of the Visayas, protecting the central part of the Philippines from the force of the Pacific Ocean. Leyte is as yet largely unexplored by foreign visitors.

The mainland has interesting waterfalls and rugged mountains, while the island of Limasawa, a 30–45min *banca* crossing from Padre Burgos, has a shrine commemorating the site of the first Catholic Mass in the Philippines and the grave of Rajah Kolambu who welcomed Magellan when he landed.

DIVING OFF SOUTHERN LEYTE

Southern Leyte is a new location for diving in the Philippines. With beautiful coral gardens and drop-offs right on the doorstep, diving exploration here has only just begun. Besides the coral gardens, which are mostly in pristine condition, the quality of the corals improves as you get deeper. As diving here is new, the fish are curious of divers and will approach them. The 2.5km (1.6 mile) coral garden on the west side of Tancaan Point can produce five separate dives.

In 1543 Leyte and Samar were the first islands to be called 'Felipinas' by the Spanish expedition leader Villabos; later this name was to be applied to the whole archipelago.

Skunk Anemonefish (clownfish) in a striking Stichodactyla spp. anemone.

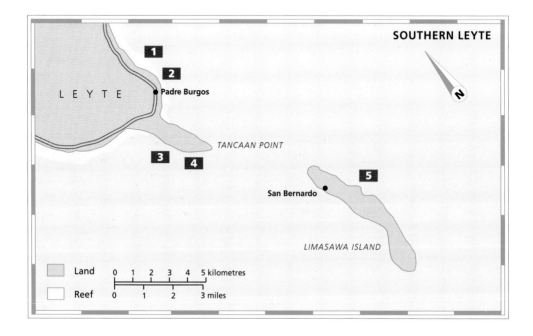

SOUTHERN LEYTE

LEYTE

Padre Burgos

TANCAAN POINT

San Bernardo

LIMASAWA ISLAND

Land

Reef

0 1 2 3 4 5 kilometres

0 1 2 3 miles

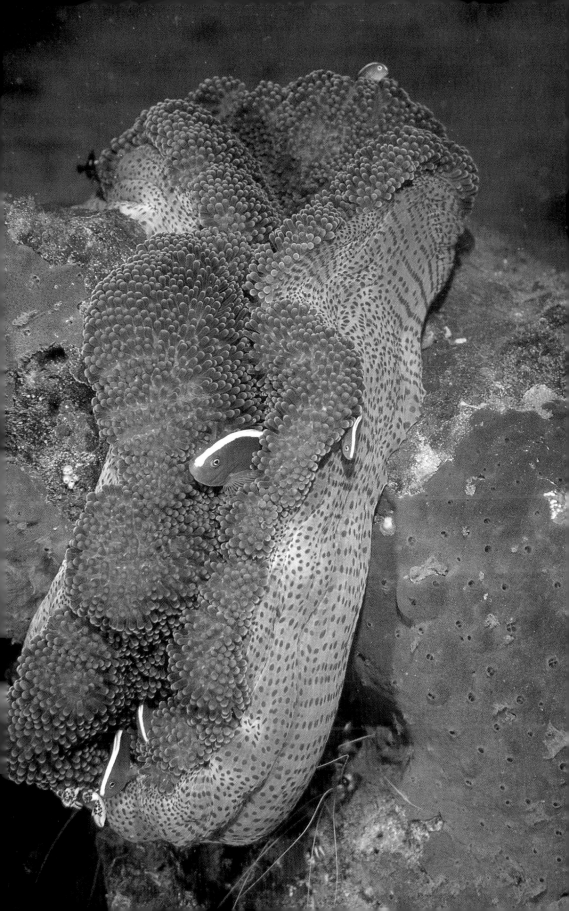

1 ROY'S LANGUB

★★★☆☆☆

Location: North of Davliz Travelodge Hotel/Padre Burgos Village.
Access: 10min by *banca*, or from the shore.
Conditions: Usually calm with some current, visibility can reach 30m (100ft).
Average depth: 12m (65ft)
Maximum depth: 40m+ (130ft+)

'Langub' is the Visayan word for cave. This site has a gentle sandy slope to 10m (33ft), then a drop-off to sand at 44m (144ft), with a small cave near the bottom containing Black-and-white Snappers, batfish and sweetlips. Coral heads, *Dendronephthya* soft tree corals, gorgonian sea fans, whip corals and Basket Sponges litter the slope, while there are snappers, lots of anthias, damsels and chromis, Sabre Squirrelfish, pufferfish, angelfish, butterflyfish, parrotfish, catfish, lizardfish, Bluespotted Ribbontail Rays, moray eels and sea snakes all around.

2 WALTER'S ROCK

★★★☆☆☆

Location: North of Davliz Travelodge Hotel/Padre Burgos Village.
Access: A few minutes by *banca*, or from the shore.
Conditions: Usually calm with some current. Visibility can reach 30m (100ft).
Average depth: 20m (65ft)
Maximum depth: 40m+ (130ft+)

This site is very similar to Roy's Langub (Site 1), only with a longer slope above the drop-off. It features another cave with snappers, sweetlips and batfish on the drop-off and similar fish life plus scorpionfish, Zebra and Clearfin Lionfish, Shrimpfish, trumpetfish, nudibranchs and turtles.

3 DOCTOR DOCTOR

★★★★☆☆☆☆

Location: The northwestern end of a 2.5km (1.6 mile) coral garden on the west side of Tancaan Point.
Access: 15min by *banca*, or from the shore.
Conditions: Usually calm with some current, but it can have fierce currents. Visibility can reach 30m (100ft).
Average depth: 15m (50ft)
Maximum depth: 40m+ (130ft+)

This can be a good dive for novices if they keep to the shallows. The coral garden is mostly in good condition, with a large variety of stony corals on a gentle slope; it is possible to go deep but the corals at 10–18m (33–60ft) make for the best dive. The fish life includes snappers, anthias, damsels, chromis, Sabre Squirrelfish, pufferfish, angelfish, butterflyfish, parrotfish, catfish, lizardfish, Bluespotted Ribbontail Rays, moray eels, Napoleon Wrasse and sea snakes. Turtles are common.

4 CORAL GARDEN

★★★★☆☆☆☆

Location: The southeastern end of a 2.5km (1.6 mile) coral garden on the west side of Tancaan Point.
Access: By *banca* or from the shore.
Conditions: Usually calm with some current, but it can have fierce currents. Visibility can reach 30m (100ft).
Average depth: 15m (50ft)
Maximum depth: 40m+ (130ft+)

Another good dive for novices if they keep to the shallows. The site is mostly in good condition, with a large variety of stony corals on a slope. It is possible to go deep, but the corals at 10–18m (33–60ft) make for the best dive. Fish life includes snappers, anthias, damsels, chromis, Sabre Squirrelfish, pufferfish, angelfish, butterflyfish, parrotfish, Shrimpfish lizardfish, Bluespotted Ribbontail Rays, moray eels, Napoleon Wrasse and sea snakes.

5 ADRIAN'S COVE

★★★★☆☆☆☆

Location: The east side of Limasawa Island.
Access: 30–45min by *banca*.
Conditions: Usually calm with some current, but it can become really rough with strong currents. Visibility can reach 30m (100ft).
Average depth: 20m (65ft)
Maximum depth: 40m+ (130ft+)

There are six possible dive sites along the east side of Limasawa Island. For the most part the cliffs that are above water continue as drop-offs below it, with the best diving in deeper water. A mixture of drop-offs and gullies, the beauty of this site is the deeper rock and coral formations. There are small caves harbouring fish, and many varieties of stony corals including some big *Acropora* table corals being consumed by aggregations of Crown-of-Thorns Starfish. Black corals, green and orange *Tubastrea* Corals, gorgonian sea fans and *Dendronephthya* soft tree corals carpet the drop-offs, while the fish life includes snappers, Sabre Squirrelfish, pufferfish, angelfish, butterflyfish, surgeonfish, scorpionfish, lionfish, parrotfish, moray eels, Napoleon Wrasse jacks, tuna and barracuda.

HOW TO GET THERE

You can fly from Manila or Cebu to Tacloban or take one of the daily 'Supercat' fast ferries from Cebu to Maasin and then travel by road.

WHERE TO STAY/DIVE FACILITIES

Blue Depth Dive Center Padre Burgos; e-mail: bluedepth@gmx.de

Sogod Bay Scuba Resort Lungsodaan, Padre Burgos, Southern Leyte; tel 53-5730131; e-mail: info@sogodbayscubaresort.com; website: www.sogodbayscubaresort.com PADI training.

Southern Leyte Divers Günter Mosch, San Roque, 6601 Macrohon, Southern

Leyte; tel 53-5724011; e-mail: info@leyte-divers.com; website: www.leyte-divers.com PADI training.

Whale Of A Dive Peter's Dive Resort, Barangay Lungsodaan, Padre Burgos, Southern Leyte; tel 53-5730015; e-mail: info@whaleofadive.com; website: www.whaleofadive.com

WHERE TO EAT

You have to eat at your accommodation unless you have transport.

DIVING EMERGENCIES

The nearest recompression chamber is at - **VISCOM Station Hospital,** Camp Lapu Lapu, Lahug, Cebu City; tel 032-310709

LOCAL HIGHLIGHTS

Leyte is the island where General MacAthur fulfilled his famous pledge to return – in October 1944 US troops landed at Red Beach near Tacloban and proceeded to push the Japanese out of the Philippines.

Between dives on Limasawa Island you can go ashore on the west side at San Bernardo and wander around the village or visit the shrine to the spot where Ferdinand Magellan's priest Pedro de Valderrama held the first Catholic Mass in the Philippines in 1521.

Marbled Groupers càn grow up to 75cm (30in).

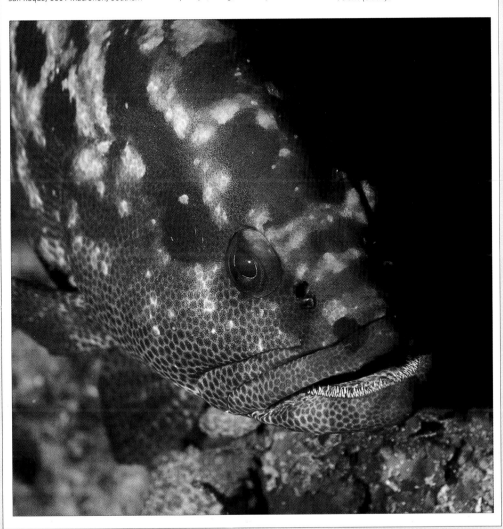

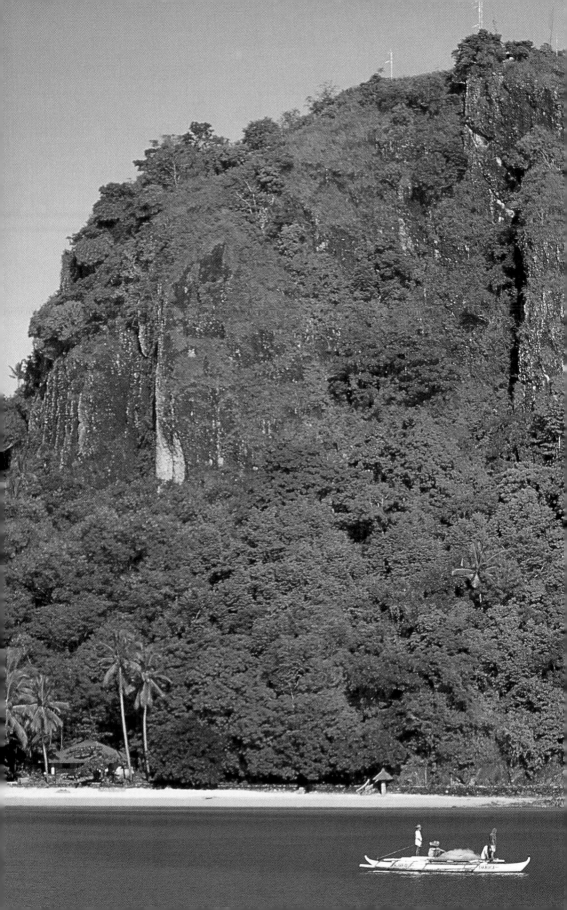

MINDANAO

South of the Visayas, Mindanao is the Philippines' second largest island after Luzon. Mountainous with several ranges, it is popular for trekking, picturesque lakes and interesting tribes. Historically there has been bad feeling towards central government on the part of some of the Muslims on Mindanao, but this is not a problem in the areas listed here.

The Jolo group of islands in the Sulu Archipelago are near to Borneo and are so divorced from the mainstream that many have small populations speaking a different dialect to those on the next island. One has to ask permission to dive from the local chiefs and this often requires different interpreters. Apart from those old enough to remember the Japanese occupation during World War II, many of these people have never seen foreigners so it is fascinating to visit them.

Dakak, Davao and General Santos

At Dakak there are several dive sites along the coast and around Liuay Rock that are fine for novices. However, the better sites are at Tagolo Point and the offshore islands and reefs.

DAVAO AND GENERAL SANTOS

Pearl Farm Beach Resort near Davao has two very good wrecks just in front of its accommodation bungalows, which can only be dived if you are staying at the resort. There are several other dive sites close to Pearl Farm around Malipano Island and around Talicud Island which, together with other dive sites in the Gulf of Davao, are also dived by Whitetip Divers Davao. At Talicud Island there is a long stretch of fringing reef generally called Coral Gardens, which has recently been declared a Marine Sanctuary. A string of mooring buoys runs along the reef so you can dive almost anywhere along it.

Further south, Sarangani Bay has a wealth of good diving and much more to be found. There has been some blast-fishing but large areas remain pristine. I was shown one coral

Opposite: *Scenery at Dakak Park Resort.*
Above: *One of the most colourful sea stars, Fromia monilis.*

garden that was as good as any that I have seen anywhere in the world. The local divers have long known about it, but until now have kept it quiet. Many of the dive sites found so far are accessed from private land, so you require both permission and a key to the gate. Tuna City Scuba Centre with Chris Dearne have the necessary local knowledge and contacts.

1 WEST SILINOG

★★★

Location: West side of Silinog Island.
Access: By boat.
Conditions: Normally calm. Visibility can reach 20m (65ft).
Average depth: 20m (65ft)
Maximum depth: 40m+ (130ft+)
Gradual slopes and coral thickets, soft corals, Basket Sponges and many species of invertebrates characterize this site. Shoals of jacks and surgeonfish, anthias, chromis, damselfish, pufferfish, Bluespotted Ribbontail Rays, snappers and groupers may be seen.

2 CESAR'S REEF
3 OCTOPUS WALL

★★★★

Location: East side of Silinog Island.
Access: By boat.
Conditions: Normally calm. Visibility up to 30m (100ft).
Average depth: 20m (65ft)
Maximum depth: 40m+ (130ft+)
There are several possible dives here, from areas with limited coral cover but large fish such as Napoleon Wrasse, to areas with large coral heads and shoals of surgeonfish, Barracuda and snappers. Other common sights are tuna, parrotfish, hawkfish, Bluespotted Ribbontail Rays, scorpionfish, sponges, *Tubastrea* coral and octopuses. For experienced and Technical Divers only there is Conrad's Wreck, a 12-year old sunken passenger liner with a bottom depth of 55m (180ft) and 40m (130ft) at its highest point. This wreck attracts shoals of Black-and-white Snappers, Red Snappers, jacks and groupers.

4 WEST ALIGUAY

★★★

Location: West side of Aliguay Island.
Access: By boat.
Conditions: Normally calm. Visibility up to 30m (100ft).

Average depth: 20m (65ft)
Maximum depth: 40m+ (130ft+)
This has sloping sand with stony coral heads and soft corals, angelfish, butterflyfish, parrotfish, soldierfish, various species of rays, sea snakes, trumpetfish, rabbitfish, cardinalfish, damselfish and anemones. There is very little current so it is ideal for novices or 'muck diving' - looking hard for small fish and invertebrates.

5 ESKUELAHAN
6 ROMY'S REEF

★★★★

Location: East side of Aliguay Island.
Access: By boat.
Conditions: Normally calm but there can be strong currents. Visibility can reach 30m (100ft).
Average depth: 20m (65ft)
Maximum depth: 40m+ (130ft+)
Again there are at least two dives running into one another. There are many coral heads, large Basket Sponges, a good selection of invertebrates and shoals of fish of all sizes, feeding. The fish include snappers, jacks, Rainbow Runners, surgeons, Redtooth Triggerfish, angelfish, Pennant Bannerfish, Moorish Idols, sea snakes, trumpetfish, rabbitfish, cardinalfish, tuna and Bluespotted Ribbontail Rays; turtles and frogfish have also been sighted. The currents could be a problem for novices.

7 CHALLENGER REEF

★★★★

Location: The northeast of Challenger Reef
Access: By boat
Conditions: Normally calm conditions, though there can be strong currents on occasion. Visibility can reach 30m (100ft).
Average depth: 40m+ (130ft+)
Maximum depth: 40m+ (130ft+)
A submerged reef nearly half as big as Aligua Island. The shallowest point is 38m (125ft) with stony corals, soft corals, gorgonian sea fans, whip corals, black

corals, sea snakes, snappers, Redtooth Triggerfish, sur-
geonfish, groupers and parrotfish. To the northern
end you also find, jacks, Rainbow Runners and
crevices with soldierfish. This is a dive for experienced
divers only.

8 TAGOLO POINT

★★★★

Location: Off Tagolo Point
Access: By boat
Conditions: There are usually strong currents. Visibility
can reach 30m (100ft).
Average depth: 20m+ (65ft+)
Maximum depth: 40m+ (130ft+)
Except at slack water this area has strong currents that
attract pelagic species and the predators that prey on
them – barracuda, jacks, tuna, Rainbow Runners and
Whitetip Reef Sharks. Various sea stars, sea cucum-
bers, flatworms and nudibranchs abound while the
reef fish include anthias, hawkfish, surgeonfish, trig-
gerfish, angelfish, butterflyfish, Moorish Idols, trum-
petfish, pufferfish and Bluespotted Ribbontail Rays.
There are some caves and crevices where small fish
shelter or Whitetip Reef Sharks rest, and the currents
produce healthy soft corals. Another dive for experi-
enced divers.

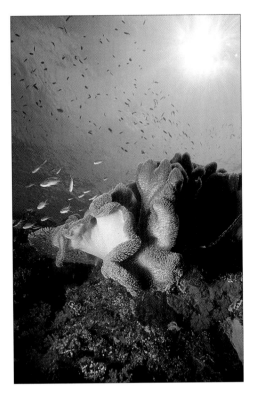

*Large Sarcophyton trocheliophorum soft coral
with its polyps expanded.*

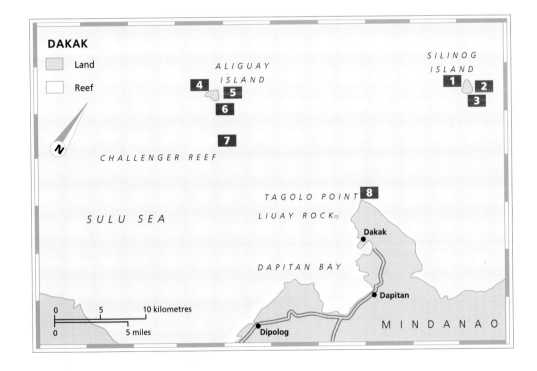

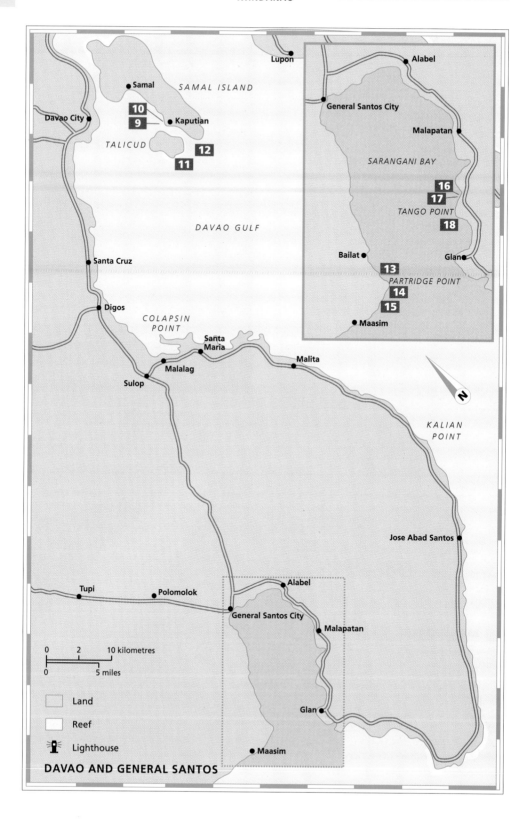

Lupon

Samal

SAMAL ISLAND

10

Davao City

9 Kaputian

TALICUD

12

11

DAVAO GULF

Santa Cruz

Digos

COLAPSIN POINT

Santa Maria

Malalag

Sulop

Malita

Alabel

General Santos City

Malapatan

SARANGANI BAY

16
17

TANGO POINT

18

Bailat

Glan

13

PARTRIDGE POINT

14

15

Maasim

KALIAN POINT

Jose Abad Santos

Tupi

Polomolok

Alabel

General Santos City

Malapatan

Glan

Maasim

0 2 10 kilometres

0 5 miles

Land

Reef

Lighthouse

DAVAO AND GENERAL SANTOS

9 WRECK I

★★★★

Location: The furthest marker/mooring buoy from Pearl Farm jetty.
Access: By dinghy or shore, descend the shotline from the buoy.
Conditions: Normally calm. Visibility can reach 20m (65ft).
Average depth: 30m (100ft)
Maximum depth: 35m (115ft)
A 40m (130ft) Japanese Freighter sunk during World War II lies on the sand here at 35m (115ft), with a mast from 20–27m (65–89ft). Covered in marine organisms, there are many sponges, shoals of small fry, jacks, lionfish, scorpionfish, batfish, pufferfish, Copperband Butterflyfish and moray eels. An easy ship for penetration by more experienced divers, it is also good for photography.

10 WRECK II

★★★

Location: The nearest marker/mooring buoy to Pearl Farm jetty.
Access: By dinghy or shore, descend the shotline from the buoy.
Conditions: Normally calm. Visibility can reach 20m (65ft).
Average depth: 25m (80ft)
Maximum depth: 28m (92ft)
This has a slightly smaller 35m (115ft) Japanese Freighter sunk during World War II, lying on its side on the sand at 28 (92ft). Although not quite as good a dive as Wreck 1, she is also covered in marine organisms, feather stars, sponges, shoals of small fry, jacks, lionfish, scorpionfish, Copperband Butterflyfish and moray eels.

11 MANSUD WALL

★★★★★★★★

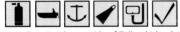

Location: Southwest side of Talicud Island
Access: By *banca* from Pearl Farm (20min) or Davao wharf (1hr).
Conditions: Normally calm but there can be a current. Visibility can reach 30m (100ft).
Average depth: 20m (65ft)
Maximum depth: 30m (100ft)

Considered to be one of the best dives in the Gulf of Davao, this site is usually sheltered when the weather is bad elsewhere. A gentle slope leads to 10m (33ft), then a drop-off to sand at 30m (100ft). There is a good variety of stony and soft corals, large gorgonian sea fans, large sponges, parrotfish, fusiliers, jacks, lionfish, scorpionfish, moray eels, shrimpfish, sea snakes and snake eels.

12 CORAL GARDENS

★★★★★★★★

Location: Southeast side of Talicud Island
Access: By *banca* from Pearl Farm (30min) or Davao wharf (1hr).
Conditions: Normally calm but there can be a current. Visibility can reach 30m (100ft).
Average depth: 12m (40ft)
Maximum depth: 40m+ (130ft+)
This is a 4km (2.5 miles) stretch of good stony corals, soft corals and Bubble Corals, gently sloping from 5m (16ft), with several buoys located a few hundred metres apart for mooring. Local divers know best which sections to dive – the buoys are all identical with no marking system. Various species of starfish, parrotfish, fusiliers, jacks, lionfish, scorpionfish, moray eels, and Eagle Rays are present, as well as numerous corals, making the area ideal for snorkelling and photography.

13 LAUTENGCO – NORTH OF PARTRIDGE POINT (TAMPUAN POINT)

★★★★★★★★

Location: Just north of the steps from the Partridge Family Estate.
Access: By dinghy or shore.
Conditions: Normally calm. Visibility can reach 30m (100ft).
Average depth: 20m (65ft)
Maximum depth: 40m+ (130ft+)
A gentle slope runs down to 10m (33ft), then the reef drops off in steps to deeper than sport divers should dive. Further down, the stony and soft corals are good, together with large gorgonian sea fans littered with feather stars, sea stars and a variety of fish species, including angelfish, butterflyfish, surgeonfish, parrotfish, snappers, Bluespotted Ribbontail Rays, jacks, trevallies and tuna.

In the shallows there are lots of juvenile fish.

14 PARTRIDGE POINT (TAMPUAN POINT)

★★★★☆☆☆☆

Location: Down the steps from the Partridge Family Estate, north of Tampo Point.
Access: By dinghy or shore.
Conditions: Normally calm. Visibility can reach 30m (100ft).
Average depth: 20m (65ft)
Maximum depth: 40m+ (130ft+)
A gentle slope leads to 10m (33ft), then the reef drops off in steps to deeper than sport divers should dive. Once you are over the drop-off the stony and soft corals are good, together with large gorgonian sea fans littered with feather stars, sea stars, lots of clownfish in anemones, nudibranchs and a variety of fish species including angelfish, butterflyfish, surgeonfish, parrotfish, Napoleon Wrasse, snappers, Bluespotted Ribbontail Rays, jacks, trevallies and tuna.

To the left of this dive site there are lots of juvenile fish.

15 TAMPUAN WALL – CORAL GARDENS

★★★★★☆☆☆☆

Location: 200m (660ft) to the south of the steps from the Partridge Family Estate, north of Tampo Point.
Access: By dinghy or shore.
Conditions: Normally calm. Visibility can reach 30m (100ft).
Average depth: 8m (25ft)
Maximum depth: 40m+ (130ft+)
There is a gentle slope to 10m (33ft), then the reef drops off in steps to deeper than sport divers should dive. Between small areas that have been damaged by blast-fishing, the *Acropora* corals above the drop-off are as good as those seen anywhere in the world. Once you are over the drop-off the stony and soft corals are good together with large gorgonian sea fans littered with feather stars, sea stars, lots of clownfish in anemones and a variety of nudibranchs. The fish species include angelfish, butterflyfish, surgeonfish, triggerfish, parrotfish, Napoleon Wrasse, snappers, sweetlips, Bluespotted Ribbontail Rays, jacks, trevallies and tuna.

16 NORTH KAPATAN

★★★★★☆☆☆☆

Location: 50m (165ft) north of the 81 steps down to the beach on Mike Kingery's estate; 300m (990ft) north of Tango Point.
Access: By dinghy or shore.
Conditions: Normally calm. Visibility can reach 30m (100ft).
Average depth: 20m (65ft)
Maximum depth: 40m+ (130ft+)
This site has a gentle slope that gets steeper as you swim away from the shore, with more sandy gullies and coral heads and pinnacles. There are many varieties of nudibranch including the large Yellow and Black Notodoris minor, very large flatworms and cuttlefish laying eggs. Among fish species are angelfish, butterflyfish, surgeonfish, triggerfish, parrotfish, Napoleon Wrasse, Snappers, sweetlips, Bluespotted Ribbontail Rays, jacks and tuna.

17 SOUTH KAPATAN

★★★★★☆☆☆☆☆

Location: 50m (165ft) south of the 81 steps down to the beach on Mike Kingery's estate; 200m (660ft) north of Tango Point.
Access: By dinghy or shore.
Conditions: Normally calm. Visibility can reach 30m (100ft).
Average depth: 20m (65ft)
Maximum depth: 40m+ (130ft+)
The gentle slope here gets steeper as you swim away from the shore, with more sandy gullies and coral heads and pinnacles. The site has many varieties of sea stars and nudibranchs, Christmas-tree Worms, angelfish, butterflyfish, surgeonfish, triggerfish, parrotfish, Snappers, sweetlips, Bluespotted Ribbontail Rays, jacks and tuna.

18 TANGO GLAN

★★★★☆☆☆☆

Location: 400m (1320ft) south of the 81 steps down to the beach on Mike Kingery's estate; 200m (660ft) south of Tango Point.
Access: By dinghy or shore.
Conditions: Normally calm. Visibility can reach 30m (100ft).
Average depth: 20m (65ft)
Maximum depth: 40m+ (130ft+)
This site is similar to Partridge Point, only sloping at a steeper angle. It has less *Acropora* coral and more *Porites* coral heads and pinnacles covered in Christmas-tree Worms, plus sandy patches with Spaghetti Worms (*Loimia medusa*). There are also numerous species of sea stars, feather stars and sea cucumbers.

How to Get There

For Dakak, there are regular flights from both Manila and Cebu to Dipolog City from where you travel by road to Dapitan City and then 45min by boat to Dakak Park Beach Resort. There are also fast ferries from Cebu to Dapitan City

There are regular flights to Davao City from Manila, Cebu and other major cities in the Philippines, as well as international flights from Indonesia, Malaysia and Singapore. From the airport near Davao it is a short journey by road into the city. If you are travelling to Samal Island, for Pearl Farm Beach Resort for example, then there is a further 45min journey by *banca* from Davao wharf.

There are regular flights from both Manila and Cebu to General Santos City, which has one of the best airports in the Philippines. From the airport it is a short journey by road into the city. There are also air-conditioned buses linking General Santos with Davao and ferries to other major islands.

Where to Stay

Dakak
Upper Price Range
Dakak Park Beach Resort Taguilon, Dapitan City, 7101 Zamboanga del Norte; tel 0918-5950714/fax 0918-5950713 Quality resort.

Davao
There is accommodation of all standards in Davao City.

Upper Price Range
Pearl Farm Beach Resort Kaputian, Samal Island, Davao; tel 082-2219970/fax 082-2219979. Manila Office: 15th Floor, 139 Corporate Center, Valero Street, Salcedo Village, Makati City; tel 2-7501894; e-mail: info@pearlfarmresort.com; website: www.pearlfarmresort.com Quality resort.

General Santos
There is also accommodation of all kinds in General Santos City.

Lower Price Range
Cambridge Farm Hotel PO Box 41, Nuñez Street, Purok Malakas; tel/fax 083-5536310.
Bayan: tel 083-5545614
e-mail: info@cambridgefarm.com;
website: http://cambridgefarm.com
Comfortable rooms in a garden oasis.

Where to Eat

At Dakak Park and Pearl Farm Beach Resorts you have no choice but to use the resort's restaurants. At Davao and General Santos you have all the choices of a city.

Dive Facilities

Dakak
Dakak Park Beach Resort Taguilon, Dapitan City, 7101 Zamboanga del Norte; tel 0918-5950714/fax 0918-5950713 PADI courses.

Davao
Wind And Wave Davao PPA Building, Sta. Ana Wharf, 8000 Davao City; tel 82-3007914; tel/fax 82-2270234; e-mail: info@windandwavedavao.com; website: www.windandwavedavao.com PADI courses up to Divemaster level.

General Santos
Tuna City Scuba Centre Cambridge Farm Hotel, PO Box 41, Purok Malakas, General Santos City 9500; tel/fax 83-3016130; e-mail: chrisdearne@tunadive.com; website: www.tunadive.com PADI courses up to Divemaster level.

Diving Emergencies

All three cities have general hospitals but the nearest recompression chamber is in Cebu.

VISCOM Station Hospital Camp Lapu Lapu, Lahug, Cebu City; tel 032-310709.

Local Highlights

In the north of Mindanao, around Dakak, highlights are the wonderful sunsets and bathing beaches. Dakak Park is very picturesque, as are the nearby islands of Aliguay and Silinog with their white-sand beaches.

In the south, Davao is the second largest city in the Philippines. It has the largest Buddhist temple in Mindanao, Lon Wa, and the Shrine of the Holy Infant Jesus of Prague. The surrounding area is famous for trekking in Mount Apo National Park – Mount Apo (3143m [10311ft]) is the highest mountain in the Philippines. There is a breeding centre for the Philippine Eagle, a crocodile park and good beaches on Samal Island.

Locally known as GenSan, General Santos is also referred to as Tuna City because of its large tuna fishing industry.

The surrounding area is known as Socsksargen (South Cotabato-Sultan Kudarat-Sarangani-General Santos City). The country around Sarangani Bay has crystal clear spring resorts, rich coral reefs, undeveloped coves and white sand beaches, most of which are easily reached on good quality paved roads. General Santos is also an important base for trekking in the surrounding highlands. The region is home to the B'laan tribe and the colourfully dressed T'boli tribe.

Anemones and Anemonefish

Sea anemones are closely related to stony reef-building corals except that they do not secrete calcareous skeletons. They remain attached to their substrate most of the time but can move about by sliding on their base or pedal disk. Sea anemones are carnivorous, feeding in the same way as coral polyps except that when one tentacle detects a source of food the other tentacles also fasten onto it, thus enabling the capture of larger prey such as fish.

Anemones have symbiotic zooxanthellae and can grow to more than 1m (3⅓) feet across, though they only grow to such a size in areas of high water movement. Sea anemones are known to have lived for 50–70 years.

Anemonefish, usually referred to as clownfish, also live in symbiosis with anemones – they attempt to see off intruders, keep the anemone clean of food scraps and parasites, and aerate the anemone with their movement. In return the anemone gives the clownfish protection and a safe place to lay their eggs. Clownfish are not immune to the anemone's sting, but coat themselves with the anemone's mucus, which contains chemicals that prevent one tentacle from stinging another, or itself. Most clownfish always live with one particular species of anemone. It would appear that clownfish cannot survive for long without an anemone, but anemones thrive without clownfish.

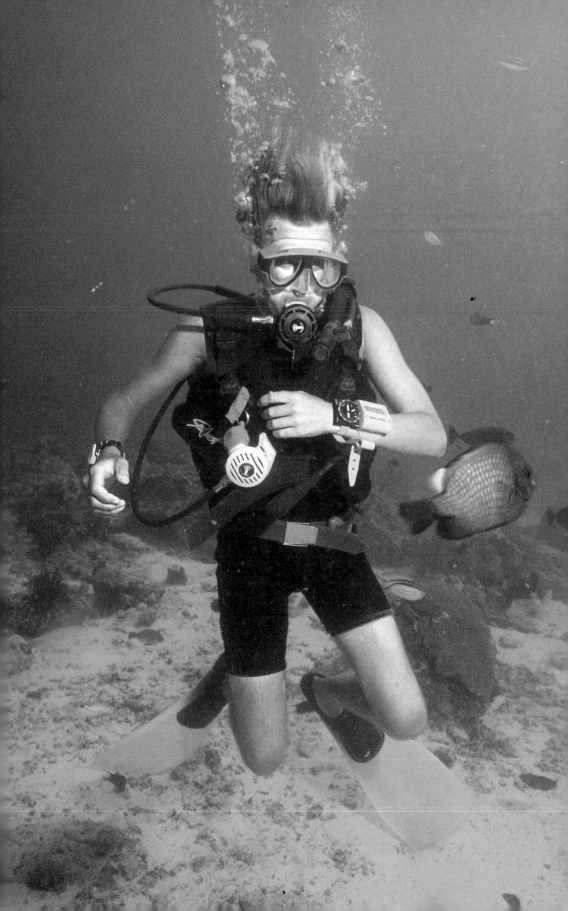

The Marine Environment

SOUTHEAST ASIAN REEFS AND REEF LIFE

Most of the reefs around Southeast Asia are – at least in geological terms – quite young. Towards the end of the last ice age, sea levels were as much as 100m (330ft) lower than they are today, and much of the area between the large islands of Borneo, Sumatra and Java was dry land. Since then the sea has reasserted itself, so that now this area is flooded with warm, shallow water dotted with islands and reefs.

THE NATURE OF CORALS AND REEFS

Tropical reefs are built mainly from corals, primitive animals closely related to sea anemones. Most of the coral types that contribute to reef construction are colonial; that is, numerous individuals – polyps – come together to create what is essentially a single compound organism. The polyps produce calcareous skeletons; when thousands of millions of them are present in a single colony they form large, stony (in fact, limestone) structures which build up as reefs.

What happens is that, when corals die, some of the skeleton remains intact, thus adding to the reef. Cracks and holes then fill with sand and the calcareous remains of other reef plants and animals, and gradually the whole becomes consolidated, with new corals growing on the surface of the mass. Thus only the outermost layer of the growing reef is alive.

There are about 450 species of reef-building coral in the seas around Southeast Asia. Corals grow slowly, adding about 1–10cm (0.4–4in) growth in a year. Once over a certain age they start being able to reproduce, releasing tiny forms that float freely among the plankton for a few weeks until settling to continue the growth of the reef. The forms corals create as they grow vary enormously according to the species and to the place on the reef where it is growing.

Colonies range in size from a few centimetres in diameter to giants several metres across and many hundreds of years old. Some are branched or bushy, others tree-like, others in the form of plates, tables or delicate leafy fronds, and yet others are encrusting, lobed, rounded or massive.

Microscopic plants called zooxanthellae are of great importance to the growth and health of corals. These are packed in their millions into the living tissues of most reef-building corals (and of various other reef animals, such as Giant Clams). Although reef corals capture planktonic organisms from the water, a significant amount of their food comes directly from the zooxanthellae. It is for this reason that the most prolific coral growths are in the shallow, well lit waters that the zooxanthellae prefer.

The presence of coral communities does not, in fact, necessarily lead to the development of thick deposits of reef limestone; for example, the Krakatoa Islands off the southern tip of Sumatra consist mainly of slabs of volcanic rock with a patchy veneer of corals.

Types of Reef

In most regions with plentiful coral communities, the calcareous skeletons have built up to form a variety of different types of reef:

- fringing reefs
- patch reefs, banks and shoals
- barrier reefs
- atolls

Fringing Reefs

Fringing reefs occur in shallow water near to land. Typically they extend to depths of 15m–45m (50–150ft), depending on factors such as the profile and depth of the seabed and the clarity of the water. Islands that stand in deep water, like Pulau Sipadan, have precipitous fringing reefs that descend hundreds of metres, but these are exceptions rather than the rule.

Many mainland coastlines in Southeast Asia are too close to river estuaries for reefs to develop, and instead support stands of mangroves – another marine ecosystem of enormous importance in the region. But the offshore islands, away from the influence of freshwater run-off, are often surrounded by reefs. In Malaysia and Thailand a large proportion of reefs are of this type.

Patch Reefs, Banks and Shoals

In theory, reefs can develop anywhere that the underlying rock has at some time been close enough to the surface for corals to become established and grow. Sea levels may have risen considerably since then, or other geological changes may have occurred to lower the depth of the bed beneath the surface; either way, there are many places where reefs exist as isolated mounds or hillocks on the seabed. Such patch reefs are widespread throughout the Southeast Asian region in relatively shallow waters surrounding the islands and on the continental shelves. They vary in size from tens to thousands of metres in diameter, usually with their tops coming to within a few metres of the surface – indeed, some emerge above the surface and are topped by sand cays. Patch reefs further offshore, lying in waters hundreds of metres deep and with even their tops 20m (66ft) or more below the surface, are usually referred to as banks or shoals. Some of the most extensive lie in the South China Sea.

Opposite: *Diver on the sand at Friday's Rock, Boracay Island.*

Barrier Reefs

Barrier reefs occur along the edges of island or continental shelves, and are substantial structures. The major difference, apart from size, between them and fringing reefs is that they are separated from the shore by a wide, deep lagoon. The outer edge of the barrier drops away steeply to the ocean floor beyond. Initially these reefs formed in shallow waters; then, as sea levels increased, they built progressively upwards so that their living topmost parts were still near the surface of the water.

There are a few barrier reefs in the Philippines and Indonesia, but the best-developed are to be found around Papua New Guinea – for example, the 180km (110-mile) barrier running along the outside of the Louisiade Archipelago off the southern tip of the mainland.

Atolls

These are formations of ancient origin – millions of years ago – and take the form of ring-shaped reefs enclosing a shallow lagoon and dropping away to deep water on their outsides. Atolls begun life as fringing reefs around volcanic islands and kept growing as the underlying base gradually subsided beneath the water level.

Most of the world's atolls are in the Indian and Pacific oceans, but there are a number to explore in Southeast Asian waters, particularly around Papua New Guinea and the eastern provinces of Indonesia; what is reputedly the third largest atoll in the world, Taka Bone Rate atoll, is off the southern coastline of Sulawesi.

REEF LIFE

The reef ecologies of Southeast Asia – and those off northern Australia – harbour a greater range of species than anywhere else in the Indo-Pacific: they are packed with all manner of bizarre and beautiful plants and exotic animals.

It is likely the region became established as a centre of evolutionary diversification millions of years ago; it has remained so, despite changes in sea levels and in the fortunes of individual reefs, right up until the present day.

On most reefs your attention is likely to be held initially by the fish life: in a single dive's casual observation you might see well over 50 different species, while a more concentrated effort would reveal hundreds. Even that is only part of the story.

The reefs and associated marine habitats of most Southeast Asian countries support well over 1000 species, but many are hidden from view within the complex framework of the reef – gobies, for example, usually in fact the most numerous of all the fish species on a reef, are seldom noticed.

Reef Zones and Habitats

Reefs can be divided into a number of zones reflecting differences in such features as depth, profile, distance from the shore, amount of wave action, and type of seabed. Associated with each zone are characteristic types of marine life.

The Back Reef and Lagoon

The back reef and lagoon fill the area between the shore and the seaward reef. Here the seabed is usually a mixture of sand, coral rubble, limestone slabs and living coral colonies. The water depth varies from a few metres to 50m (165ft) or more, and the size of the lagoon can be anywhere from a few hundred to thousands of square metres. The largest and deepest lagoons are those associated with barrier reefs and atolls, and may be dotted with islands and smaller reefs.

Sites within lagoons are obviously more sheltered than those on the seaward reef, and are also more affected by sedimentation. Here you will find many attractive seaweeds; most of the corals are delicate, branching types. Large sand-dwelling anemones are often found, and in places soft corals and 'false corals' are likely to form mats over the seabed. Especially where there is a current you may encounter extensive beds of seagrasses, the only flowering plants to occur in the sea. Among the many species of animals that make these pastures their home are the longest sea cucumbers you will find anywhere around the reef.

Although some typical reef fishes are absent from this environment, there is no shortage of interesting species. On the one hand there are roving predators – snappers, wrasse, triggerfish, emperors and others – on the lookout for worms, crustaceans, gastropods, sea urchins and small fish. Then there are the bottom-dwelling fishes that burrow into the sand until completely hidden, emerging only when they need to feed.

Most entertaining to watch – if you spot them – are the small gobies that live in association with Pistol Shrimps. In this partnership the shrimp is the digger and the goby, stationed at the entrance to the burrow, is the sentry. The small fish remains ever on the alert, ready to retreat hurriedly into the burrow at the first sign of disturbance. The shrimp has very poor eyesight; it keeps its antennae in close touch with the goby so that it can pick up the danger signal and, likewise, retire swiftly to the safety of the burrow.

The Reef Flat

Reef flats are formed as their associated reefs push steadily seaward, leaving behind limestone areas that are eroded and planed almost flat by the action of the sea. The reef flat is essentially an intertidal area, but at high tide it can provide interesting snorkelling.

The inner part of the reef flat is the area most sheltered from the waves, and here you may find beautiful pools full of corals and small fish. Among the common sights are 'micro-atolls' of the coral genus Porites; their distinctive doughnut (toroidal) shape, with a ring of coral surrounding a small, sandy-bottomed pool, occurs as a result of low water level and hot sun inhibiting the

upward growth of the coral. In deeper water, as on the reef rim, the same coral forms huge rounded colonies.

Towards the outer edge of the reef flat, where wave action is much more significant, surfaces are often encrusted with calcareous red algae, and elsewhere you will usually find a fine mat of filamentous algae that serves as grazing pasture for fish, sea urchins, gastropods, molluscs and other animals. Some fish are permanent inhabitants of the reef-flat area, retreating to pools if necessary at low tide; but others, like parrotfish and surgeonfish, spend a great deal of their time in deeper water, crowding over onto the reef flat with the rising tide.

The Seaward Reef Front
Most divers ignore the shoreward zones of the reef and head straight for sites on the reef front, on the basis that here they are most likely to see spectacular features and impressive displays of marine life. Brightly lit, clean, plankton-rich water provides ideal growing conditions for corals, and the colonies they form help create habitats of considerable complexity. There is infinite variety, from shallow gardens of delicate branching corals to walls festooned with soft corals and sea fans.

The top 20m (66ft) or so of the seaward reef is especially full of life. Here small, brilliantly coloured damselfish and anthias swarm around the coral, darting into open water to feed on plankton. Butterflyfish show their dazzling arrays of spots, stripes and intricate patterns as they probe into crevices or pick at coral polyps – many have elongated snouts especially adapted for this delicate task. By contrast, you can see parrotfish biting and scraping at the coral, over time leaving characteristic white scars.

Open-water species like fusiliers, snappers and sharks cover quite large areas when feeding, and wrasse often forage far and wide over the reef. But many species are more localized and can be highly territorial, on occasion even being prepared to take on a trespassing diver. Clownfishes (*Amphiprion spp*) and *Premnas biaculeatus* are among the boldest, dashing out from the safety of anemone tentacles to give chase.

Fish-watching can give you endless pleasure, but there is much else to see. Any bare spaces created on the reef are soon colonized, and in some places the surface is covered with large organisms that may be tens or even hundreds of years old. These sedentary reef-dwellers primarily rely on, aside from the omnipresent algae, water-borne food. Corals and their close relatives – anemones, sea fans and black corals – capture planktonic organisms using their tiny stinging cells. Sea squirts and sponges strain the plankton as seawater passes through special canals in their body-walls. Other organisms have rather different techniques: the Christmas-tree Worm, for example, filters out food with the aid of its beautiful feathery 'crown' of tentacles.

Apart from the fishes and the sedentary organisms there is a huge array of other lifeforms for you to observe on the reef. Tiny crabs live among the coral branches and larger ones wedge themselves into appropriate nooks and crannies, often emerging to feed at night. Spiny lobsters hide in caverns, coming out to hunt under cover of darkness. Gastropod molluscs are another type of marine creature seldom seen during the day, but they are in fact present in very large numbers, especially on the shallower parts of the reef; many of them are small, but on occasion you might come across one of the larger species, like the Giant Triton (*Charonia tritonis*).

Some of the most easily spotted of the mobile invertebrates are the echinoderms, well represented on Southeast Asian reefs. Most primitive of these are the feather stars, sporting long delicate arms in all colours from bright yellow to green, red and black. The best-known of their relatives, the sea urchins, is the black, spiny variety that lives in shallow reef areas and is a potential hazard to anyone walking onto the reef.

Many of the small, brightly coloured starfish that wander over the reef face feed on the surface film of detritus and micro-organisms. Others are carnivorous, browsing on sponges and sea mats, and a few feed on living coral polyps. The damage they cause depends on their size, their appetite and, collectively, their population density. Potentially the most damaging of all is the large predator *Acanthaster planci*, the Crown-of-Thorns Starfish; fortunately populations of this creature have so far reached plague proportions on relatively few of the Southeast Asian reefs, and so extensive damage caused by it is not yet commonplace.

Whether brilliantly attractive or frankly plain, whether swiftly darting or sessile, all the life forms you find on the reef are part of the reef's finely balanced ecosystem. You are not: you are an intruder, albeit a friendly one. It is your obligation to cause as little disturbance and destruction among these creatures as possible.

MARINE CONSERVATION
Reefs in the Southeast Asian region are among the most biologically diverse in the world; they are also valuable to the local people as fishing grounds and as sources of other important natural products including shells. Unfortunately, in the past few decades they have come under increasing pressure from human activities, and as a result they are, in places, showing signs of wear and tear.

Corals are slow-growing: if damaged or removed they may require years to recover or be replaced. In the natural course of events, storm-driven waves from time to time create havoc on coral reefs, especially in the typhoon belt. But some human activities are similarly destructive, especially blast fishing and the indiscriminate collection of corals to sell as marine curios.

Overfishing is a further deadly hazard to reef environments, and has already led to perilously declining populations of target species in some areas. Another way overfishing can cause grave damage is through altering the balance of local ecosystems; for example, decreasing the

populations of herbivorous fish can lead to an explosive increase in the algae on which those species feed, so the corals of the reef may be overgrown and suffer.

Some areas are being damaged by pollution, especially where reefs occur close to large centres of human population. Corals and other reef creatures are sensitive to dirty, sediment-laden water, and are at risk of being smothered when silt settles on the bottom. Sewage, nutrients from agricultural fertilizers and other organic materials washed into the sea encourage the growth of algae, sometimes to the extent that – again – corals become overgrown.

One final point affects us divers directly. Although, like other visitors to the reef, we wish simply to enjoy ourselves, and although most of us are conscious of conservation issues and take steps to reduce any deleterious effects of our presence, tourism and development in general have created many problems for the reefs. Harbours, jetties and sea walls are on occasion built so close to reefs – sometimes even on top of them! – that the environment is drastically altered and populations of reef organisms plummet. Visiting boats often damage the corals through inadvertent grounding or careless or insouciant anchoring. And divers themselves, once they get in the water, may, unintentionally cause damage as they move about on the reef.

Growing awareness of environmental issues has given rise to `ecotourism'. The main underlying principle is often summarized as `take nothing but photographs, leave nothing but footprints', but even footprints – indeed, any form of touching – can be a problem in fragile environments, particularly among corals. A better way to think of ecotourism is in terms of managing tourism and the tourists themselves in such a way as to make the industry ecologically sustainable. The necessary capital investment is minimal, and thereafter much-needed employment becomes available for the local population. In the long term the profits would exceed those from logging or overfishing.

Although divers, as well as many dive operators and resorts, have been at the forefront in protecting reefs and marine ecosystems, we all need somewhere to eat and sleep. If a small resort is built without a waste-treatment system, the nearby reefs may not be irreparably damaged; but if those same reefs start to attract increasing numbers of divers and spawn further resorts, strict controls become necessary.

In such discussions of ecotourism we are looking at the larger scale. It is too easy to forget that `tourists' and `divers' are not amorphous groups but collections of individuals, with individual responsibilities and capable of making individual decisions. Keeping reefs ecologically sustainable depends as much on each of us as it does on the dive and resort operators. Here are just some of the ways in which you, as a diver, can help preserve the reefs that have given you so much:

- Try not to touch living marine organisms with either your body or your diving equipment. Be particularly careful to control your fins, since their size and the force of kicking can damage large areas of coral. Don't use deep fin-strokes next to the reef, since the surge of water can disturb delicate organisms.

- Learn the skills of good buoyancy control – too much damage is caused by divers descending too rapidly or crashing into corals while trying to adjust their buoyancy. Make sure you are properly weighted and learn to achieve neutral buoyancy. If you haven't dived for a while, practise your skills somewhere you won't cause any damage.

- Avoid kicking up sand. Clouds of sand settling on the reef can smother corals. Snorkellers should be careful not to kick up sand when treading water in shallow reef areas.

- Never stand on corals, however robust they may seem. Living polyps are easily damaged by the slightest touch. Never pose for pictures or stand inside giant basket or barrel sponges.

- If you are out of control and about to collide with the reef, steady yourself with your fingertips on a part of the reef that is already dead or covered in algae. If you need to adjust your diving equipment or mask, try to do so in a sandy area well away from the reef.

- Don't collect or buy shells, corals, starfish or any other marine souvenirs.

- On any excursion, whether with an operator or privately organized, make sure you take your garbage back for proper disposal on land.

- Take great care in underwater caverns and caves. Avoid lots of people crowding into the cave, and don't stay too long: your air bubbles collect in pockets on the roof of the cave, and delicate creatures living there can `drown in air'.

- If booking a live-aboard dive trip, ask about the company's environmental policy – particularly on the discharge of sewage and anchoring. Avoid boats that cause unnecessary anchor damage, have bad oil leaks, or discharge untreated sewage near reefs.

- Don't participate in spearfishing for sport – it is anyway now banned in many countries. If you are living on a boat and relying on spearfishing for food, make sure you are familiar with all local fish and game regulations and obtain any necessary licensing.

- Don't feed fish. It may seem harmless but it can upset their normal feeding patterns and provoke aggressive behaviour – and be unhealthy for them if you give them food that is not part of their normal diet.

- Don't move marine organisms around to photograph or play with them. In particular, don't hitch rides on turtles: it causes them considerable stress.

COMMON FISH

Angelfish (*family Pomacanthidae*)
These beautiful fish, with their minute, brushlike teeth, browse on sponges, algae and corals. Their vibrant colouring varies according to the species, like those of the butterflyfish (q.v.) and were once thought part of the same family. However, they are distinguishable by a short spike extending from the gill cover. Angelfish are territorial in habit and tend to occupy the same caves or ledges for a period of time.

Royal Angelfish, 15-20cm (6-8in) *Pygoplites diacanthus*

Barracuda (*family Sphyraenidae*)
With their elongated, streamlined, silvery body and sinister-looking jaws, barracudas tend to appear rather fearsome. However, even though they rarely threaten divers, caution on approach is advisable. Barracudas are effective reef predators. They tend to school in large numbers when young but by the time they mature to a length of two metres or longer, they prefer to hunt singly or in pairs.

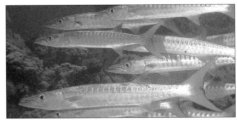

Pickhandle Barracuda, 1.5m (5ft) *Sphyraena Jello*

Bigeyes (*family Priacanthidae*)
As their name suggests, these small, nocturnal fish have extremely large eyes. Bigeyes are effective predators which hide in protective holes in the coral by day and venture out at night to feed on other small fish, crabs, larvae and the larger planktonic animals (the organic life which is found floating at various levels in the sea).

Goggle-eye (bigeye), 30cm (12in) *Priacanthus Hamrur*

Blenny (*family Blennidae*)
Blennies are often incredibly hard to spot, since they are usually well camouflaged and blend into the rubble- or algae-covered reef bottom where they live. The carnivorous blennies are ferocious hunters, whipping out so quickly from their hiding places to snatch small prey that the entire split-second action can go completely unnoticed unless you know exactly what you're looking for and where to look.

Blenny, 15cm (6in) *Blennidae*

Butterflyfish (*family Chaetodontidae*)
Among the most colourful of reef inhabitants, butterflyfish have flat, thin bodies, usually with a stripe through the eye and sometimes with a dark blotch near the tail: this serves as camouflage and confuses predators, who lunge for the wrong end of the fish. Butterflyfish can also swim backwards to escape danger. Many species live as mated pairs and have territories while others school in large numbers.

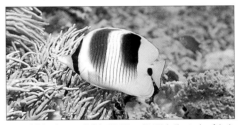

Saddleback Butterflyfish, 20-25cm (8-10in) *Chaetodon falcula*

Damselfish and Clownfish (*family Pomacentridae*)
These pugnacious little fish often farm their own patch of algae, aggressively driving away other herbivores. Found almost everywhere on the reef, they also sometimes form large aggregations to feed on plankton. Clownfishes (Amphiprion spp) and *Premnas Biaculeatus*, which live among the stinging tentacles of sea anemones, are also members of this family.Of the 27 clownfish species known from the Indo-Pacific, 15 are found on the reefs of Southeast Asia.

Damselfish, 5cm (2in) *Chrysiptera sp.*

Cardinalfish (*family Apogonidae*)
These tiny fish live in a wide range of depths down the reef. Their colours vary widely, but most have large eyes which help their night vision as they come out of hiding to feed on the plankton that rises up through the water as night falls. Cardinalfish also have large mouths and, in some species, the males incubate the eggs inside their mouths.

Golden Cardinalfish, 3-5cm (1-2in) *Apogon aureus*

Goatfish (*family Mullidae*)
Easily recognized by their chin whiskers, a pair of long barbels which they use to hunt for food, goatfish are often seen moving along sandflats, stirring up small clouds of sand as they feel beneath the surface for prey. They sometimes forage in small groups or large schools. Goatfish are 'bottom dwellers', which is the term for fish that either feed or lie camouflaged on the ocean floor.

Yellowsaddle Goatfish, 25-30cm (10-12in) *Parupeneus Cyclostomus*

Goby (*family Gobiidae*)
The Goby is a 'bottom dweller' which can remain unde-tected on the sea bed for long periods of time. They have large, protruding eyes which are raised above the level of the head and powerful jaws which enable them to snatch prey and dart back to the safety. Gobies are among the most successful reef families, with literally hundreds of species. Their colouring varies from brightly coloured to quite drab.

Goby, 10cn (3-4in) *Amblygobius rainfordi*

Grouper (*family Serranidae*)
Groupers range from just a few centimetres long to the massive Giant Grouper, 3.5m (12ft) long. They vary enormously in colour; grey with darker spots is the most common. Movement is slow except when attacking prey with remarkable speed. All groupers are carnivorous, feeding on invertebrates and other fish. Like wrasse and parrotfish, some start out as females and become males later while others are hermaphroditic.

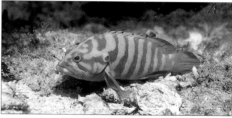
Grouper, 35cm (14in) *Epinephelus sp.*

Jack and Trevally (family Carangidae)
Jacks and trevallies are fast predators which range in size from small to very large. They are usually found in the open water but are occasional visitors to the reef since they follow the current as they feed. Cruising the outer slopes, they dash in with lightning speed to snatch unwary reef fish. They can be seen singly, schooling or in small groups.

Bluefin Trevally, 30cm (12in) *Caranx melampygus*

Moray Eel (family Muraenidae)
This ancient species of fish have gained their undeserved reputation for ferocity largely because, as they breathe, they open and close the mouth to reveal their numerous sharp teeth. They do not have fins or scales. Moray eels anchor the rear portion of their bodies in a selected coral crevice and stay hidden during the day. They emerge at night to feed on shrimp, octopuses and mussels.

Blue Ribbon Eel, 23-25cm (9-10in) *Rhinomuraena quaesita*

Moorish Idol (family Zanclidae)
This graceful and flamboyant fish reaches a maximum size of 20cm. It is easily distinguished by its long dorsal fin, thick protuding lips and pointed snout. It probes for food (mostly algae and invertebrates) in nooks and crannies. Moorish Idols are usually seen individually, but may sometimes form large aggregations prior to spawning. Moorish Idols are related to surgeonfish even though their body shape is different.

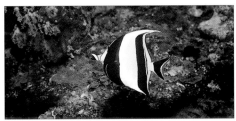

Moorish Idol, 20-25cm (8-10in) *Zanclus cornutus*

Parrotfish (family Scaridae)
So-called because of their sharp, parrot-like beaks and bright colours, the parrotfishes are among the most important herbivores on the reef. Many change colour and sex as they grow, the terminal-phase males developing striking coloration by comparison with the drabness of the initial-phase males and females. Many build transparent cocoons of mucus to sleep at night, the mucus acting as a scent barrier against predators.

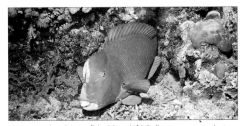

Bumphead Parrotfish, 90cm (4ft) *Bolbometopon muricatum*

Pipefish and Seahorse (family Syngathidae)
The long thin pipefish swim with their bodies vertical, which is not very efficient. Like seahorses, which are also poor swimmers, they tend to lurk in seagrass beds away from currents. Seahorses use their tails to wrap themselves around corals and seagrasses to stop themselves being swept away. Their vulnerability has forced them to become masters of disguise, sometimes mimicking a blade of grass or a gorgonian.

Pipefish, 20cm (8in) *Corythoichthys intestinalis*

Pufferfish (*family Tetraodontidae*)
These small to medium-size omnivores feed on algae, worms, molluscs and crustaceans. Pufferfish are found all the way down the reef to depths of around 30m (100ft). They are slow moving but when threatened, they inflate themselves into big, round balls by sucking water into the abdomen, so that it becomes almost an impossible task for predators to swallow them.

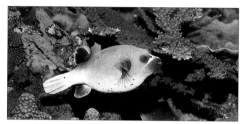

Blackspotted Pufferfish, 30cm (12in) *Arothron nigropunctatus*

Snapper (*family Lutjanidae*)
Snappers are important carnivores on the reef, feeding mostly at night. Many are inshore-dwellers, although the Yellowtail Snapper is a midwater fish and the commercially exploited Red Snapper dwells at all depths. Snappers are becoming much rarer on the reefs because they are long-lived and slow-growing which means that once populations are drastically reduced they take a long time to replenish.

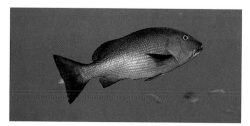

Snapper, 30cm (12in) *Lutjanus bohar*

Soldierfish and Squirrelfish (*family Holocentridae*)
Both species are nocturnal fish and are often confused with each other. Soldierfish have a rounder, bulkier body and are more evenly coloured than squirrelfish. The red or reddish-orange coloration and large eyes are common also among other nocturnal fishes like bigeyes. Dozing under rocks or corals by day, they emerge by night to feed. They have serrated, spiny scales and sharp defensive fins.

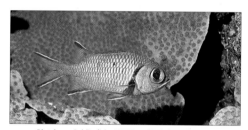

Blotcheye Soldierfish, 15-20cm (6-8in) *Myripristis murdjan*

Triggerfish (*family Balistidae*)
Medium to large fish with flattened bodies and often striking markings (e.g., the Picasso Triggerfish [Rhinecanthus aculeatus]), these have powerful teeth and feed on crustaceans and echinoderms on the mid-reef. When a triggerfish is threatened it squeezes itself into a crevice and erects its first dorsal spine, locking it into place with a second, smaller spine: this stays wedged until the 'trigger' is released.

Clown Triggerfish, 25-38cm (10-15in) *Balistoides conspicillum*

Wrasse and Hogfish (*family Labridae*)
Wrasse vary enormously in size, from the tiny Cleaner Wrasse (Labroides spp) to the giant Napoleon Wrasse (Cheilinus undulatus), which can reach nearly 2m (6½ft) in length. Wrasse are usually brightly coloured and go through various colour and sex changes as they mature. Their distinctive buck teeth are well adapted to pulling molluscs from rocks or picking off crustaceans. Most live in shallow reef areas, although some (e.g., the hogfishes) are frequently at greater depths.

Redbreasted Wrasse, 15-25cm (6-10in) *Cheilinus fasciatus*

Underwater Photography

Underwater still photography requires some technical competence and dedication. You cannot change films or prime lenses in this environment so if you have a clear idea of what you wish to photograph before you take the plunge, you are likely to get better results. Another possibility is to have a zoom lens on a housed camera. If the water is calm you can carry two camera outfits: one for wide-angle and another for close-up or macro. In strong currents a non-reflex camera will be smaller and therefore easier to handle.

DEDICATED UNDERWATER CAMERAS

There are several waterproof non-reflex cameras, both film and digital, that do not need waterproof housings, but if you want to use the best lenses at this level you will have to find a Nikonos V, which has a Through-The-Lens (TTL) automatic exposure system and dedicated flash guns (strobes) made by Nikon and other manufacturers. This camera is now discontinued but there are still plenty of them around because they are so popular — more diving magazine front covers have been shot with this camera and its 15mm lens than all other cameras put together. However, the lack of reflex focusing makes it difficult to compose pictures and it is easy to cut off part of a subject.

Prime lenses for the Nikonos range from 15-80mm in focal length but these must be changed in air. The 35mm and 80mm lenses are really only useful underwater when fitted to extension tubes or close-up outfits. The 28mm should be considered as the standard lens.

Independent companies supply lenses, lens converters, extension tubes and a housing for fish-eye and superwide land camera lenses to fit the Nikonos. Lens converters are convenient as they can be changed underwater; some cameras make good use of converters for wide-angle and macro. The Nikonos close-up kit can be changed underwater.

HOUSED CAMERAS

Huge increases in the technical advances of land cameras are the main reason for the demise of the Nikonos. Land cameras are used underwater in specialist metal or Plexiglas waterproof housings. Metal housings are strong, reliable, work well at depth and last a long time if properly maintained. They are heavy to carry, especially if travelling by air, but have buoyancy in water. Their higher cost is justified if one is using an expensive camera that deserves the extra protection.

Plexiglas housings are cheaper but more fragile and require careful handling, both above and below the water. Some models compress at depth, making the control rods miss the camera controls. These control rods can be adjusted to work at depth, but then do not function properly near the surface. Most underwater photographs are taken near the surface, so this drawback is not serious. These housings are lightweight to carry on land, but often too buoyant in the water where you have to attach extra weights to them.

'O' Rings and Other Equipment

Underwater cameras, housings, flash guns and cables have 'O' ring seals to keep the water out; these and their mating surfaces or grooves must be kept scrupulously clean. 'O' rings should be lightly greased with special grease (usually silicone) to prevent flooding.

When not in use it is best to store any user-removable 'O' rings off the unit to avoid them becoming flattened. The unit itself should then be sealed in a plastic bag to keep out moisture. User-removable 'O' rings on cameras and flash synchronization cables are best replaced every 12 months. Non-user-removable 'O' rings on the Nikonos should be serviced every 12-18 months; those on housings usually last the life of the housing.

Housings without controls, designed for auto-everything cameras, need fast films to obtain reasonable shutter speeds and lens apertures in the low ambient light underwater.

When balancing flash with daylight, cameras with faster flash synchronization speeds, 1/125 or 1/250 of a second, avoid the double images associated with fast moving fish.

Masks hold your eyes away from the viewfinder, so buy the smallest volume mask you can wear. Cameras fitted with optical action finders or eyepiece magnifiers are useful in housings but this is not so important with autofocus systems.

Good buoyancy control is essential. Remember not to touch coral and do not wear fins over sandy bottoms, they will stir up sand. Photographers do not swim around much, so wear a wet suit for warmth.

Light refraction through your mask and through the camera lens causes objects to appear one third closer and larger than in air. Reflex focusing or visually estimated distances remain correct, but if you measure distances by ruler, these must be reduced by one third when setting the lens focus if it is inscribed in 'in-air' distances.

If you are using a waterproof housing with a flat port (window) in front of the lens, refraction increases the focal length of the lens and decreases its sharpness, due to the individual colours of light being refracted at different angles and speeds (chromatic aberration). This is most pronounced with wide-angle lenses, but can be corrected with a convex dome port. Dome ports require lenses to be able to focus on a virtual image at around 30cm (1ft) so you may have to fit supplementary positive dioptre lenses to some camera lenses.

PHOTOGRAPHIC TIPS

Point-and-shoot does not work – get closer than arm's length and make sure the subject fills more than half of the frame. Wide-angle close-up shots have impact.

Limit people shots to head and shoulders, unless you have very wide-angle lenses. For smaller creatures use macro lenses, close-up kits or extension tubes with framers.

Wherever possible do not aim the camera down, but aim it horizontally or better still upwards, otherwise the background in the picture will be dark.

FLASH

When the sun is at a low angle, or in choppy seas, much of the light fails to enter the water. To take advantage of the maximum light available, it is best to shoot two hours either side of the sun's highest point.

Water acts as a cyan (blue/green) filter, cutting back red, so colour film will have a blue/green cast. For available light photography different filters are sold to correct this in either temperate or tropical waters, but they reduce the already limited amount of light available. Flash will put back the colour and increase apparent sharpness.

Modern flash guns (strobes) have TTL automatic exposure systems. Underwater, large flash guns have good wide-angle performance usable up to 1.5m (5ft). Smaller flash guns have a narrow angle and only work up to 1m (40 inches), diffusers widen the angle covered but you lose at least one F-stop in output. Most land flash guns are more advanced than underwater flash guns, they can be housed for underwater use (refer to flash guns for digital cameras page 167).

Flash guns used on or near to the camera, will light up suspended matter in the water like white stars in a black sky (back scatter). The closer these particles are to the camera, the larger they will appear. The solution is to keep the flash as far as possible above and to one side of the camera. Two narrow angle flash guns, one on each side of the camera and each pointing slightly outwards but with their light output overlapping in the centre, often produce a better result than a single wide-angle flash gun. However the result will be a little flat as two flash guns of the same power will not give the modelling light that photographers rely on to distinguish features by showing shadows.

When photographing divers, remember the golden rule that the eyes within the mask must be lit and in focus. Flash guns with a colour temperature of 4500° Kelvin will give more accurate skin tones and colour by replacing some of the red that the water has filtered out.

In a multiple flash set-up the prime flash gun will meter by TTL if this is available, and unless it has TTL Slave, any other flash gun connected will give its pre-programmed output so this should be set low to achieve modelling light. TTL Slave flash guns should have a lower output than the main flash for the same reason.

Multiple segment matrix flash exists with some land cameras in housings that are connected to housed matrix-metering flash guns. With other TTL systems, although the ambient light metering may be multiple segment matrix, the flash metering is by a single segment in the centre of the frame. This means that flash on smaller off-centre fore-ground subjects may not be correctly metered with these systems (see also flash guns for digital cameras page 167).

Although objects appear closer to both your eye and the camera lens underwater, the flash must strike the subject directly to illuminate it. Narrow angle flash guns must there-fore be aimed behind the apparent subject, to hit the real subject. Built-in aiming/focusing lights, or a torch strapped to the flash will aid both this problem and focusing during night photography. Built-in aiming/focusing lights are best powered by separate batteries or the main flash battery will not last for a complete dive.

The easiest way to balance flash with the ambient available light is to use TTL flash with the camera on aperture priority metering. Take a meter reading of the mid-water background that agrees with your chosen flash synchronization speed, set your flash to TTL and it will correctly light the subject. If you do not have multi-segment matrix flash then your subject should be in the central part of the frame.

If you use manual exposure, using an aperture half a stop higher than the meter recommends will give a darker back-ground and make the subject stand out more. At distances of less than 1m (40 inches) most automatic flash guns tend to overexpose so you must allow for this.

DIGITAL CAMERAS AND THEIR USE UNDERWATER

Digital cameras are taking over from film cameras because without the cost of film they appear to work out cheaper. They particularly appeal to underwater photographers because, if they use lower-resolution images, they can get a lot more shots onto a memory card than they could on a film. They can discard any failures and can keep on photographing a subject until they get it right.

However, electronics give more problems in a saltwater environment; you have to carry a portable computer or several memory cards to download the images and, if used heavily, the camera's service life is only about three years so the saving in film costs is soon negated.

Digital cameras often produce images that lack the punch, contrast or sparkle that a film-based model delivers. The results can be wishy-washy and lack detail in the highlights. You may have to 'up' the colour depth and contrast with image manipulation software. Many sensors cannot handle the extremes between bright and normal light in sunburst shots.

Images files are stored in various formats: uncompressed as TIFFs (Tagged Image File Format) or compressed as JPEGs (Joint Photographic Experts Group), which can reduce the file size by eight or ten to one. Some modern cameras allow storage as RAW (the raw data as it comes directly off the sensor). There is no standard for this – it uses the proprietary software of the camera manufacturer and is a much larger file – but it has the best quality and allows photographers to change exposure and white balance, and to apply any future software enhancements to the original image.

Digital & optical zoom

Digital zoom is electronic enlargement of the image coupled with cropping to emulate 'zooming in', whereas in reality all that is being done is enlargement of the pixels. An optical zoom 'brings the subject closer' optically before recording the image on the sensor – thus giving better resolution and a higher quality result.

Image capture, noise, temperature, ISO (International Standards Organization) speeds and white balance:

Noise is the visible effect of electronic interference; it usually appears as coloured lines across the image. Two of the major causes are temperature and ISO sensitivity; in both cases high equals worse and low equals better. Try not to let the camera get hot and use slower ISO speeds such as 100.

All digital cameras, including video cameras, have an automatic white balance setting that enables the camera to calculate the correct colour balance for the image. Some have pre-set values for different types of lighting, either by colour temperature on professional models or such settings as sunny, cloudy, incandescent or fluorescent lighting on others. For underwater use some divers use the 'cloudy' setting or you can experiment with 'manual' using a white plastic card as the subject. Some divers use the RAW image format for the freedom of adjusting the white balance setting after the dive.

Flash with digital cameras

Most digital cameras are not compatible with normal TTL flash guns as they cannot read the flash reflected off film. This is addressed with either a light sensor on the camera body to judge proper exposure or with special flash guns for different digital cameras, many of which send out several pre-flashes and read their intensity when they are reflected back from the subject (DTTL). You can still use manual flash, shoot the picture, make any necessary adjustments and shoot again but this takes time and the subject may have moved. One solution to TTL flash problems is to house a land flash gun that is dedicated to your digital camera; the problem with this method is that land flash guns will not cover the field of view of very wide-angle lenses. A second is that independent manufacturers of wide-angle underwater flash guns now have models that feature special electronic circuitry for use with the newest digital cameras, yet they are still compatible with the popular film cameras used underwater including the Nikonos. A third solution is that the Fuji S2 Pro digital camera will work with all standard Nikonos-compatible underwater flash guns. Due to this and the fact that it is based on the Nikon F80/N80 camera body and utilizes Nikkor lenses, this camera has become popular for use in a waterproof housing.

Another problem is that you cannot rely on a second, slave flash gun as the pre-flash will set it off earlier than the main flash. There are underwater colour-correction filters for use when taking photographs without flash, but pictures taken in this way may suffer from lack of light in shadow areas or on the lower parts of large subjects.

Shutter lag

Cheaper digital cameras suffer from 'shutter lag', making photographing moving subjects difficult. More expensive cameras solve this by saving to a buffer (extra memory).

Image storage

At the higher definition settings, underwater photographers will require a large capacity memory card to hold a reasonable number of pictures before they have to return to the surface and download them to another storage medium.

Another problem is storage and accessibility of images. Those who store negatives or transparencies in transparent viewpacks can view 36 frames of film by eye and know what is there very quickly. Viewing them on a computer is nowhere near as fast, and finding a particular image can be a slow business even with special software. Also, a 40Gb hard drive is soon full and one has to resort to saving images onto CDs/DVDs. Even the best CDs/DVDs start dropping pixels after 3 years so it make further copies after this time.

Digital cameras and their batteries

Some digital cameras consume their battery power very quickly. There are two types of camera: those that accept standard AA-size batteries and those that use a rechargeable proprietary battery.

AA-compatible cameras can often use disposable alkaline batteries. These make acceptable emergency backups, but rechargeable Nickel Metal Hydride (NiMH) batteries or Lithium Ion batteries are better and have a longer life.

Sensor size

Most digital cameras have much smaller image sensors than 35mm cameras so all lenses appear to have a longer focal length. Canon and Kodak have brought out full-frame CMOS sensors that cover the same area as 35mm film but there are still problems with these and wide-angle lenses because of the angle at which the light from the outer edge of the lens strikes the sensor. This can lead to less sharpness at the edges of the picture. For this and other reasons, Nikon and other manufacturers have so far preferred to stick with the smaller sensors and manufacture special lenses for them. Critics point out that because these lenses cover a smaller area than 35mm film they are cheaper to produce.

Where digital cameras have interchangeable or zoom lenses, tiny bits of dust and lint are attracted to the sensor due to static charge. Keep the sensor clean of dust.

UNDERWATER VIDEOGRAPHY

When compared with underwater still photography, taking video is much easier and the fact that the subject moves often covers mistakes. Most underwater videographers just set the camera on automatic, place it in a waterproof housing and go. Macro subjects may require extra lighting but other shots can be taken with available light. Back scatter is much less of a problem.

More expensive cameras have more controls and professional cameras have three chips: three CCD or CMOS sensors each receiving the image through a coloured filter: one filter is red, one green and one blue.

When purchasing a waterproof housing you have to choose between electronic controls and manual controls. Electronic controls can be easier to operate and, with fewer holes in the housing, there is less chance of leakage. Some divers prefer manual controls because if something does go wrong with electronic controls when you are out at sea, the whole housing can become unusable.

There are underwater colour-correction filters for use without lights, but if you want more professional results you will require proper lights. When visibility is poor, video macro subjects. When videoing a night scene, normal lights will make the scene look as though it was shot during the day unless you have lights that can be dimmed.

Most video cameras have dedicated battery packs so carry at least one spare and keep it charged.

Health and Safety for Divers

The information in this section is intended as a guide only, it is no substitute for thorough training or professional medical advice. The information is based on currently accepted health and safety information but it is certainly not meant to be a substitute for a comprehensive manual on the subject. We strongly advise that the reader obtains a recognised manual on diving safety and medicine before embarking on a trip.

- Divers who have suffered any injury or symptom of an injury, no matter how minor, related to diving, should consult a doctor, preferably a specialist in diving medicine, as soon as possible after the symptom or injury occurs.
- No matter how confident you are in formulating your own diagnosis remember that you remain an amateur diver and an amateur doctor.
- If you yourself are the victim of a diving injury do not be shy to reveal your symptoms at the expense of ridicule. Mild symptoms can later develop into a major illness with life threatening consequences. It is better to be honest with yourself and live to dive another day.
- Always err on the conservative side when considering your ailment; if you discover you only have a minor illness both you and the doctor will be relieved.

GENERAL PRINCIPLES OF FIRST AID

The basic principles of first aid are:
- doing no harm
- sustaining life
- preventing deterioration
- promoting recovery

In the event of any illness or injury a simple sequence of patient assessment and management can be followed. The sequence first involves assessment and definition of any life threatening conditions followed by management of the problems found.

The first thing to do is to ensure both the patient's and your own safety by removing yourselves from the threatening environment. Make sure that whatever your actions, they in no way further endanger the patient or yourself.

Then the first things to check are:
- A : for AIRWAY (with care of the neck)
- B : for BREATHING
- C : for CIRCULATION
- D : for DECREASED level of consciousness
- E : for EXPOSURE (the patient must be adequately exposed in order to examine them properly)

- **Airway (with attention to the neck):** - is there a neck injury? Is the mouth and nose free of obstruction? Noisy breathing is a sign of airway obstruction.
- **Breathing:** Look at the chest to see if it is rising and falling. Listen for air movement at the nose and mouth.

Feel for the movement of air against your cheek.
- **Circulation:** Feel for a pulse next to the wind pipe (carotid artery)
- **Decreased level of consciousness:** Does the patient respond in any of the following ways:
 - A - Awake, Aware, Spontaneous speech
 - V - Verbal Stimuli, does he answer to 'Wake up!'
 - P - Painful Stimuli, does he respond to a pinch
 - U - Unresponsive
- **Exposure:** Preserve the dignity of the patient as far as possible but remove clothes as necessary to adequately effect your treatment.

Now, send for help
If you think the condition of the patient is serious following your assessment, you need to send or call for help from the emergency services. Whoever you send for help must come back and tell you that help is on its way.

Recovery Position
If the patient is unconscious but breathing normally there is a risk of vomiting and subsequent choking on their own vomit. It is therefore critical that the patient be turned onto his/her side in the recovery position. If you suspect a spinal or neck injury, be sure to immobilize the patient in a straight line before you turn him/her on his/her side.

Cardiopulmonary Resuscitation (CPR)
Cardiopulmonary Resuscitation is required when the patient is found to have no pulse. It consists of techniques to:
- ventilate the patient's lungs - expired air resuscitation
- pump the patient's heart - external cardiac compression

Once you have checked the ABCs you need to do the following:

Airway
Open the airway by gently extending the head (head tilt) and lifting the chin with two fingers (chin lift). This will lift the tongue away from the back of the throat and open the airway. If you suspect a foreign body in the airway sweep your finger across the back of the tongue from one side to the other. If one is found, remove it. Do not attempt this is in a conscious or semi-conscious patient because he or she may either bite your finger or vomit.

Breathing
- If the patient is not breathing you need to give expired air resuscitation — in other words you need to breath air into their lungs.
- Pinch the patient's nose closed.
- Place your mouth, open, fully over the patient's mouth, making as good a seal as possible.
- Exhale into the patient's mouth hard enough to cause

the patient's chest to rise and fall.
- If the patient's chest fails to rise you need to adjust the position of the airway.
- The 16% of oxygen in your expired air is adequate to sustain life.
- Initially you need to give two full slow breaths.
- If the patient is found to have a pulse, in the next step continue breathing for the patient once every five seconds, checking for a pulse after every ten breaths.
- If the patient begins breathing on his own you can put him/her into the recovery position.

Circulation

After giving the two breaths as above you now need to give external cardiac compression.
- Kneel next to the patient's chest
- Measure two finger breadths above the notch at the point where the ribs meet the lower end of the breast bone
- Place the heel of your left hand just above your two fingers in the centre of the breast bone
- Place heel of your right hand on your left hand
- Straighten your elbows
- Place your shoulders perpendicularly above the patient's breast bone
- Compress the breast bone 4 to 5cm to a rhythm of 'one, two, three . . .
- Give thirty compressions

Continue giving cycles of two breaths and thirty compressions checking for a pulse after every five cycles. The aim of CPR is to keep the patient alive until more sophisticated help arrives in the form of paramedics or a doctor with the necessary equipment. Make sure that you and your buddy are trained in CPR. It could mean the difference between life and death.

TRAVELLING MEDICINE

Many doctors decline to issue drugs, particularly antibiotics, to people who want them 'just in case'; but a diving holiday can be ruined by an otherwise trivial ear or sinus infection, especially in a remote area or on a live-aboard boat where the nearest doctor or pharmacy is a long and difficult journey away.

Many travelling divers therefore carry with them medical kits that could lead the uninitiated to think they were hypochondriacs! Nasal sprays, eardrops, antihistamine creams, anti-diarrhoea medicines, antibiotics, sea-sickness remedies ... Forearmed, such divers can take immediate action as soon as they realize something is wrong. At the very least, this may minimize their loss of valuable diving time.

Two new Cholera vaccines, Dukoral and Mutacol, were recently licensed for use in many countries other than the USA. Dukoral helps protect travellers against enterotoxigenic Escherichia coli (ETEC), the most common cause of travellers' diarrhoea, and in the UK it is recommended for adventurous people travelling to remote regions with limited access to medical care.

Remember that most decongestants and sea-sickness remedies can make you drowsy and therefore should definitely not be taken before diving.

DIVING DISEASES AND ILLNESS

Acute Decompression Illness

Acute decompression illness means any illness arising out of the decompression of a diver, in other words, by the diver moving from an area of high ambient pressure to an area of low pressure. It is divided into two groups:
- Decompression Sickness
- Barotrauma with Arterial Gas Embolism

It is not important for the diver or first aider to differentiate between the two conditions because both are serious and both require the same emergency treatment. The important thing is to recognise Acute Decompression Illness and to initiate emergency treatment. For reasons of recognition and completeness a brief discussion on each condition follows:

Decompression Sickness

Decompression sickness or 'the bends' arises following inadequate decompression by the diver. Exposure to higher ambient pressure underwater causes nitrogen to dissolve in increasing amounts in the body tissues. If this pressure is released gradually during correct and adequate decompression procedures the nitrogen escapes naturally into the blood and is exhaled through the lungs. If this release of pressure is too rapid the nitrogen cannot escape quickly enough and physical nitrogen bubbles form in the tissues.

The symptoms and signs of the disease are related to the tissues in which these bubbles form and the disease is described by the tissues affected, e.g. joint bend.

Symptoms and signs of decompression sickness include:
- Nausea and vomiting
- Dizziness
- Malaise
- Weakness
- Joint pains
- Paralysis
- Numbness
- Itching of skin
- Incontinence

Barotrauma with Arterial Gas Embolism

Barotrauma refers to the damage that occurs when the tissue surrounding a gaseous space is injured followed a change in the volume or air in that space. An arterial gas embolism refers to a gas bubble that moves in a blood vessel usually leading to obstruction of that blood vessel or a vessel further downstream.

Barotrauma can therefore occur to any tissue that surrounds a gas filled space, most commonly the:
- Ears (middle ear squeeze) — burst ear drum
- Sinuses (sinus squeeze) — sinus pain/nose bleeds
- Lungs (lung squeeze) — burst lung
- Face (mask squeeze) — swollen, bloodshot eyes
- Teeth (tooth squeeze) — toothache

Burst lung is the most serious of these and can result in arterial gas embolism. It occurs following a rapid ascent during which the diver does not exhale adequately. The

ROUGH AND READY NONSPECIALIST TESTS FOR THE BENDS

A Does the diver know:
- who he or she is?
- where he or she is?
- what the time is?

B Can the diver see and count the number of fingers you hold up?

Place your hand 50cm (20in) in front of the diver's face and ask him/her to follow your hand with his/her eyes as you move it from side to side and up and down. Be sure that both eyes follow in each direction, and look out for any rapid oscillation or jerky movements of the eyeballs.

C Ask the diver to smile, and check that both sides of the face bear the same expression. Run the back of a finger across each side of the diver's forehead, cheeks and chin, and confirm that the diver feels it.

D Check that the diver can hear you whisper when his/her eyes are closed.

E Ask the diver to shrug his/her shoulders. Both sides should move equally.

F Ask the diver to swallow. Check the Adam's apple moves up and down.

G Ask the diver to stick out the tongue at the centre of the mouth — deviation to either side indicates a problem.

H Check there is equal muscle strength on both sides of the body. You do this by pulling/pushing each of the diver's arms and legs away from and back towards the body, asking him/her to resist you.

I Run your finger lightly across the diver's shoulders, down the back, across the chest and abdomen, and along the arms and legs, both upper and lower and inside and out, and check the diver can feel this all the time.

J On firm ground (not on a boat) check the diver can walk in a straight line and, with eyes closed, stand upright with his/her feet together and arms outstretched.

If the results of any of these checks do not appear normal, the diver may be suffering from the bends, so take appropriate action (see previous page).

rising pressure of expanding air in the lungs bursts the delicate alveoli of lung sacs and forces air into the blood vessels that carry blood back to the heart and ultimately the brain. In the brain these bubbles of air block blood vessels and obstruct the supply of blood and oxygen to the brain, resulting in brain damage.

The symptoms and signs of lung barotrauma and arterial gas embolism include:
- shortness of breath • chest pain • unconsciousness

Treatment of Acute Decompression Illness
- ABCs and CPR as necessary
- Position the patient in the recovery position with no tilt or raising of the legs
- Administer 100% oxygen by mask (or demand valve)
- Keep the patient warm
- Remove to the nearest hospital as soon as possible
- The hospital or emergency services will arrange the recompression treatment required.

Carbon Dioxide or Monoxide Poisoning Carbon dioxide poisoning can occur as a result of contaminated air cylinder fill, skip breathing (diver holds his breath on SCUBA); heavy exercise on SCUBA or malfunctioning rebreather systems. Carbon monoxide poisoning occurs as a result of: exhaust gases being pumped into cylinders; inferior systems; air intake too close to exhaust fumes. Symptoms and signs would be: Blue colour of the skin; shortness of breath; loss of consciousness.

Treatment: Safety, ABCs as necessary; CPR if required; 100% oxygen through a mask or demand valve; remove to nearest hospital.

Head Injury All head injuries should be regarded as potentially serious.

Treatment: The diver should come to the surface, the wound should be disinfected, and there should be no more diving until a doctor has been consulted. If the diver is unconscious, of course the emergency services should be contacted; if breathing and/or pulse has stopped, CPR (page 169) should be administered. If the diver is breathing and has a pulse, check for bleeding and other injuries and treat for shock; if wounds permit, put sufferer into recovery position and administer 100% oxygen (if possible). Keep him or her warm and comfortable, and monitor pulse and respiration constantly. **DO NOT** administer fluids to unconscious or semi-conscious divers.

Hyperthermia (increased body temperature) A rise in body temperature results from a combination of overheating, normally due to exercise, and inadequate fluid intake. The diver will progress through heat exhaustion to heat stroke with eventual collapse. Heat stroke is an emergency and if the diver is not cooled and rehydrated he will die.

Treatment: Remove the diver from the hot environment and remove all clothes. Sponge with a damp cloth and fan either manually or with an electric fan. Conscious divers can be given oral rehydration salts. If unconscious, place the patient in the recovery position and monitor the ABCs. Always seek advanced medical help.

Hypothermia (decreased body temperature) Normal internal body temperature is just under 37°C (98.4°F). If for any reason it is pushed much below this – usually, in diving, through inadequate protective clothing – progressively more serious symptoms may occur, with death as the ultimate endpoint. A drop of 1°C (2°F) leads to shivering and discomfort. A 2°C (3°F) drop induces the body's self-heating mechanisms to react: blood flow to the peripheries is reduced and shivering becomes extreme. A 3°C (5°F) drop leads to amnesia, confusion, disorientation, heartbeat and breathing irregularities, and possibly rigor.

Treatment: Take the sufferer to sheltered warmth or otherwise prevent further heat-loss: use an exposure bag, surround the diver with buddies' bodies, and cover the diver's head and neck with a woolly hat, warm towels or anything else suitable.

In sheltered warmth, re-dress the diver in warm, dry clothing and then put him/her in an exposure bag; in the open the diver is best left in existing garments. If the

diver is conscious and coherent, a warm shower or bath and a warm, sweet drink should be enough; otherwise call the emergency services and meanwhile treat for shock, while deploying the other warming measures noted. Never give alcohol.

Near Drowning Near drowning refers to a situation where the diver has inhaled some water. He or she may be conscious or unconscious. Water in the lungs interferes with the normal transport of oxygen from the lungs into the blood.
Treatment: Remove the diver from the water and check the ABCs. Depending on your findings commence EAR or CPR where appropriate. If possible, administer oxygen by mask or demand valve. All near drowning victims may later develop secondary drowning, a condition where fluid oozes into the lungs causing the diver to drown in his own secretions, therefore all near drowning victims should be observed for 24hr in a hospital.

Nitrogen Narcosis The air we breathe is about 80% nitrogen; breathing the standard mixture under compression, as divers do, can lead to symptoms very much like those of drunkenness — the condition is popularly called 'rapture of the deep'. Some divers experience nitrogen narcosis at depths of 30-40m (100-130ft). Up to a depth of about 60m (200ft) — that is, beyond the legal maximum depth for sport diving in both the UK and USA - the symptoms need not (but may) be serious; beyond about 80m (260ft) the diver may become unconscious. The onset of symptoms can be sudden and unheralded. The condition itself is not harmful: dangers arise through secondary effects, notably the diver doing something foolish.
Treatment: The sole treatment required is to return to a shallower depth but do not skip any necessary decompression stops.

Shock Shock refers not to the emotional trauma of a frightening experience but to a physiological state in the body resulting from poor blood and oxygen delivery to the tissues. As a result of oxygen and blood deprivation the tissues cannot perform their functions. There are many causes of shock, the most common being the loss of blood.
Treatment: Treatment is directed at restoring blood and oxygen delivery to the tissues, therefore maintain the ABCs and administer 100% oxygen. Control all external bleeding by direct pressure, pressure on pressure points and elevation of the affected limb. Tourniquet should only be used as a last resort and only then on the arms and legs. Conscious victims should be laid on their backs with their legs raised and head on one side. Unconscious, shocked victims should be placed on their left side in the recovery position.

GENERAL MARINE RELATED AILMENTS
Apart from the specific diving related illnesses, the commonest divers' ailments include sunburn, coral cuts, fire-coral stings, swimmers' ear, sea sickness and various biting insects.

Cuts and Abrasions
Divers should wear appropriate abrasive protection for the environment. Hands, knees, elbows and feet are the commonest areas affected. The danger with abrasions is that they become infected so all wounds should be thoroughly rinsed with fresh water and an antiseptic as soon as possible. Infection may progress to a stage where antibiotics are necessary. Spreading inflamed areas should prompt the diver to seek medical advice.

Swimmers' Ear
Swimmers' ear is an infection of the external ear canal resulting from constantly wet ears. The infection is often a combination of a fungal and bacterial one. To prevent this condition, always dry the ears thoroughly after diving and, if you are susceptible to the condition, insert:
• 5% acetic acid in isopropyl alcohol *or*
• aluminium acetate/acetic acid solution
drops after diving. Once infected, the best possible treatment is to stop diving or swimming for a few days and apply anti-fungal or antibiotic ear drops.

Sea or Motion Sickness
Motion sickness can be an annoying complication on a diving holiday involving boat dives. If you are susceptible to motion sickness, get medical advice prior to boarding the boat. A cautionary note must be made that the antihistamine in some preventative drugs may make you drowsy and impair your ability to think while diving.

Biting Insects
Some areas are notorious for biting insects. Take a good insect repellent and some antihistamine cream for the bites.

Sunburn
Take precautions against sunburn and use high protection factor creams.

Tropical diseases
Visit the doctor before your trip and make sure you have the appropriate vaccinations for the country you are visiting.

Fish that Bite
• **Barracuda** Barracuda are usually seen in large safe shoals of several hundred fish, each up to 80cm (30in) long. Lone individuals about twice this size have attacked divers, usually in turbid or murky shallow water, where sunlight flashing on a knife blade, camera lens or jewellery has confused the fish into thinking they are attacking their normal prey, such as sardines.
Treatment: Thoroughly clean the wounds and use antiseptic or antibiotic cream. Bad bites will also need antibiotic and anti-tetanus treatment.
• **Moray Eels** Probably more divers are bitten by morays than by all other sea creatures added together – usually through putting their hands into holes to collect shells or lobsters, remove anchors or hide

FIRST-AID KIT

Your first-aid kit should be waterproof, compartmentalized and sealable, and, as a minimum, should contain:

- a full first-aid manual – the information in this appendix is for general guidance only
- relevant contact numbers for the emergency services
- coins for telephone
- pencil and notebook
- tweezers
- scissors
- 6 large standard sterile dressings
- 1 large Elastoplast/Band-Aid fabric dressing strip
- 2 triangular bandages
- 3 medium-size safety pins
- 1 pack sterile cotton wool
- 2 50mm (2in) crepe bandages
- eyedrops
- antiseptic fluid/cream
- bottle of vinegar
- sachets of rehydration salts
- sea-sickness tablets
- decongestants
- painkillers
- anti-AIDS pack (syringes/needles/drip needle)

baitfish. Often a moray refuses to let go, so, unless you can persuade it to do so with your knife, you can make the wound worse by tearing your flesh as you pull the fish off.

Treatment: Thorough cleaning and usually stitching. The bites always go septic, so have antibiotics and anti-tetanus available.

- **Sharks** Sharks rarely attack divers, but should always be treated with respect. Attacks are usually connected with speared or hooked fish, fish or meat set up as bait, lobsters rattling when picked up, or certain types of vibration such as that produced by helicopters. The decompostion products of dead fish (even several days old) seem much more attractive to most sharks than fresh blood. The main exception is the Great White Shark, whose normal prey is sea lion or seal and which may mistake a diver for one of these. You are very unlikely to see a Great White when diving in Southeast Asian waters, but you might encounter another dangerous species, the Tiger Shark, which sometimes comes into shallow water to feed at night. Grey Reef Sharks can be territorial; they often warn of an attack by arching their backs and pointing their pectoral fins downwards. Other sharks often give warning by bumping into you first. If you are frightened, a shark will detect this from the vibrations given off by your body. Calmly back up to the reef or boat and get out of the water.

Treatment: Victims usually have severe injuries and shock. Where possible, stop the bleeding with tourniquets or pressure bandages and stabilize the sufferer with blood or plasma transfusions **before** transporting to hospital. Even minor wounds are likely to become infected, requiring antibiotic and

antitetanus treatment.

- **Triggerfish** Large triggerfish – usually males guarding eggs in 'nests' – are particularly aggressive, and will attack divers who get too close. Their teeth are very strong, and can go through rubber fins and draw blood through a 4mm (⅙ in) wetsuit.

Treatment: Clean the wound and treat it with antiseptic cream.

Venomous Sea Creatures

Many venomous sea creatures are bottom-dwellers, hiding among coral or resting on or burrowing into sand. If you need to move along the sea bottom, do so in a shuffle, so that you push such creatures out of the way and minimize your risk of stepping directly onto sharp venomous spines, many of which can pierce rubber fins. Antivenins require specialist medical supervision, do not work for all species and need refrigerated storage, so they are rarely available when required. Most of the venoms are high-molecular-weight proteins that break down under heat. Apply a broad ligature between the limb and the body — remember to release it every 15 minutes. Immerse the limb in hot water (e.g., the cooling water from an outboard motor, if no other supply is available) at 50°C (120°F) for 2 hours, until the pain stops. Several injections around the wound of local anaesthetic (e.g., procaine hydrochloride), if available, will ease the pain. Younger or weaker victims may need CPR (page 169). Remember that venoms may still be active in fish that have been dead for 48 hours.

- **Cone Shells** Live cone shells should never be handled without gloves: the animal has a mobile tube-like organ that shoots a poison dart. The result is initial numbness followed by local muscular paralysis, which may extend to respiratory paralysis and heart failure. *You should not be collecting shells anyway!*

Treatment: Apply a broad ligature between the wound and the body. CPR may be necessary.

- **Crown-of-Thorns Starfish** The Crown-of-Thorns Starfish has spines that can pierce gloves and break off under the skin, causing pain and sometimes nausea lasting several days.

Treatment: The hot-water treatment (30min) helps the pain. Septic wounds require antibotics.

- **Fire Coral** Fire corals (*Millepora* spp) are not true corals but members of the class Hydrozoa – i.e., they are more closely related to the stinging hydroids. Many people react violently from the slightest brush with them, and the resulting blisters may be 15cm (6in) across.

Treatment: As for stinging hydroids .

- **Jellyfish** Most jellyfish sting, but few are dangerous. As a general rule, those with the longest tentacles tend to have the most painful stings. The Box Jellyfish or Sea Wasp (*Chironex fleckeri*) of Northern Australia is the most venomous creature known, having caused twice as many fatalities in those waters as have sharks; it has yet to be found in Asian waters

but its appearance one day cannot be precluded. Its occurrence is seasonal, and in calmer weather it invades shallow-water beaches; it is difficult to see in murky water. It sticks to the skin by its many tentacles, causing extreme pain and leaving lasting scars. The victim often stops breathing, and young children may even die.

Treatment: Whenever the conditions are favourable for the Box Jellyfish, wear protection such as a wetsuit, lycra bodysuit, old clothes or a leotard and tights. In the event of a sting, there is an antivenin, but it needs to be injected within three minutes. The recommended treatment is to pour acetic acid (vinegar) over animal and wounds alike and then to remove the animal with forceps or gloves. CPR may be required.

- **Lionfish/Turkeyfish** These are slow-moving except when swallowing prey. They hang around on reefs and wrecks and pack a heavy sting in their beautiful spines.
Treatment: As for stonefish.

- **Rabbitfish** These have venomous spines in their fins, and should on no account be handled.
Treatment: Use the hot-water treatment.

- **Scorpionfish** Other scorpionfish are less camouflaged and less dangerous than the stonefish, but they are more common and dangerous enough.
Treatment: As for stonefish.

- **Sea Snakes** Sea snakes have venom 10 times more powerful than a cobra's, but luckily they are rarely aggressive and their short fangs usually cannot pierce a wetsuit.
Treatment: Apply a broad ligature between the injury and the body and wash the wound. CPR may be necessary. Antivenins are available but need skilled medical supervision.

- **Sea Urchins** The spines of sea urchins can be poisonous. Even if not, they can puncture the skin – even through gloves – and break off, leaving painful wounds that often go septic.
Treatment: For bad cases give the hot-water treatment; this also softens the spines, helping the body reject them. Soothing creams or a magnesium-sulphate compress will help reduce the pain, as will the application of wine or the flesh of papaya fruit. Septic wounds require antibiotics.

- **Stinging Hydroids** Stinging hydroids often go unnoticed on wrecks, old anchor ropes and chains until you put your hand on them, when their nematocysts are fired into your skin. The wounds are not serious but are very painful, and large blisters can be raised on sensitive skin.
Treatment: Bathe the affected part in methylated spirit or vinegar (acetic acid). Local anaesthetic may be required to ease the pain, though antihistamine cream is usually enough.

- **Stinging Plankton** You cannot see stinging plankton, and so cannot take evasive measures. If there are reports of any in the area keep as much of your body covered as possible.
Treatment: As for stinging hydroids.

- **Sting Rays** Sting rays vary from a few centimetres to several metres across. The sting consists of one or more spines on top of the tail; although these point backwards they can sting in any direction. The rays thrash out and sting when trodden on or caught. Wounds may be large and severely lacerated.
Treatment: Clean the wound and remove any spines. Give the hot-water treatment and local anaesthetic if available; follow up with antibiotics and anti-tetanus.

- **Stonefish** Stonefish are the most feared, best camouflaged and most dangerous of the scorpionfish family. The venom is contained in the spines of the dorsal fin, which is raised when the fish is agitated.
Treatment: There is usually intense pain and swelling. Clean the wound, give the hot-water treatment and follow up with antibiotic and anti-tetanus.

- **Others** Venoms occur also in soft corals, the anemones associated with Clownfish and the nudibranchs that feed on stinging hydroids; if you have sensitive skin, do not touch any of them. Electric (torpedo) rays can give a severe electric shock (200–2000 volts); the main problem here is that the victim may be knocked unconscious in the water and drown.

Cuts

Underwater cuts and scrapes – especially from coral, barnacles or sharp metal – will usually, if not cleaned out and treated quickly, go septic; absorption of the resulting poisons into the body can cause bigger problems. After every dive, clean and disinfect any wounds, no matter how small. Larger wounds will often refuse to heal unless you stay out of seawater for a couple of days. Surgeonfish have sharp fins on each side of the caudal peduncle; they use these against other fish, lashing out with a sweep of the tail, and occasionally may do likewise when defending territory against a trespassing diver. These 'scalpels' are often covered in toxic mucus, so wounds should be cleaned and treated with antibiotic cream. As a preventative measure against cuts in general, the golden rule is do not touch! Learn good buoyancy control so that you can avoid touching anything unnecessarily - remember, anyway, that every area of the coral you touch will be killed.

Fish-feeding

You should definitely not feed fish: you can harm them and their ecosystem. Not only that, it is dangerous to you, too. Sharks' feeding frenzies are uncontrollable, and sharks and groupers often bite light-coloured fins. Triggerfish can come at you very fast, and groupers and moray eels have nasty teeth. Napoleon Wrasse have strong mouth suction and can bite. Even little Sergeant Majors can give your fingers or hair a nasty nip.

Bryson, Dr P.J.: *Underwater Diving Accident Manual* (3rd edn 1993), Diving Diseases Research Centre, Plymouth, UK

Chou Loke Ming, and Porfirio, M. Alino: *An Underwater Guide to the South China Sea* (1992), Times Editions, Singapore

Dawood, Dr Richard: *Travellers' Health - How to Stay Healthy Abroad* (3rd edn 1992), Oxford University Press, Oxford, UK

Eichler, Dieter and Lieske, Ewald (1994) *Korrallenfische Indischer Ozean*, Tauchen, Jahr Verlag Hamburg, Germany

Gale de Villa, Jill (1988) *Philippines Vacations and Explorations.* Devcon/Philippines Airlines, PO Box 1843 MCPO, 1299 Makati, Metro Manila, Philippines

George, J., and George, J. David: *Marine Life - An Illustrated Encyclopedia of Invertebrates in the Sea* (1979), Harrap, London, UK

Harper, Peter, and Peplow, Evelyn (1991) *Philippines Handbook.* Moon Publications, 722 Wall Street, Chico, CA 95928, USA

Kuiter, Rudie H. (1992) *Tropical Reef Fishes of the Western Pacific, Indonesia and Adjacent Waters.* PT Gramedia Pustaka Utama, Jakarta, Indonesia

Lieske, Ewald and Myers, Robert (1994) *Collins Pocket Guide to Coral Reef Fishes of the Indo-Pacific and Caribbean,* Harper Collins, London

Myers, Robert F.: *Micronesian Reef Fishes* (2nd edn 1991), Coral Graphics, Barrigada, Guam

Stafford-Deitsch, Jeremy: *Reef - A Safari through the Coral World* (1991), Headline, London, UK

Stafford-Deitsch, Jeremy: *Shark - A Photographer's Story* (1987), Headline, London, UK

Wells, Sue, and Hanna, Nick: *The Greenpeace Book of Coral Reefs* (1992), Blandford, London, UK

Wells, Sue, et al.: *Coral Reefs of the World* (3 vols, 1988), United Nations Environmental Program/International Union for Conservation of Nature and Natural Resources, Gland, Switzerland

White, Alan: *Philippine Coral Reefs - A Natural History Guide* (1987), New Day Publishers, Quezon City, Philippines

Wood, Elizabeth M.: *Corals of the World* (1983), T.F.H. Publications, Neptune, NJ, USA

Index